ART AFTER PHILOSOPHY AND AFTER

The MIT Press
Cambridge, Massachusetts
London, England

ART AFTER PHILOSOPHY AND AFTER

Collected Writings, 1966–1990

Joseph Kosuth

edited with an introduction by Gabriele Guercio

foreword by Jean-François Lyotard

This book was set in Trump Medieval by DEKR
Corporation and printed and bound in the United States
of America.

Library of Congress Cataloging-in-Publication Data

Kosuth, Joseph.
Art after philosophy and after : collected writings, 1966–1990 /
Joseph Kosuth : edited with an introduction by Gabriele Guercio.
 p. cm.
Includes bibliographical references and index.
ISBN 0-262-11157-8
1. Kosuth, Joseph—Aesthetics. 2. Conceptual art—United States.
I. Title.
N6537.K65A35 1991
701'.17—dc20 90-24722
 CIP

To C.L.

CONTENTS

CONTENTS

LIST OF ILLUSTRATIONS

FOREWORD: AFTER THE WORDS

Jean-François Lyotard

After philosophy comes philosophy. But it is altered by the after. After the *Tractatus* come the *Philosophische Untersuchungen* and the unpublished works. After the coveting of an absolute and pure language that speaks of the world comes the deceptive discovery of the plurality of tongues entangled in the world.

Between the two philosophies of before and after, words are revealed as things (as expressed by the Hebrew word *davar*), signifiers are grasped as enigmas, writing is set down as a material thing. In other words, thought is art. One mad act is completed, that of giving the world a picture, a *Bild*, of well-formed propositions. Sentences are not propositions concerning events; they are events that happen in the world of speakers, under the same rubric as resonant, plastic, visual, or tactile arrangements. After-philosophy was there well before philosophy.

The work of art "presents" in the perceptible space-time-matter, which here is visual, something—a gesture—that cannot be presented there. This "presence" cannot be a presentation. It remains silent. And this is its sign. The work is mute not because it is made of colors and forms but because it is inhabited, squatted on, by this "presence." Thought is also an art, because we think in sentences, and the sentences themselves also "present" gestures of the space-time-matter of language—gestures made in the thickness of words. Sentences, supposedly speaking of something to someone, remain tacit on the subject of their referent and their destination.

The space-time-matter of language is made perceptible, visible, by writing. Kosuth's work is a meditation on writing. According to the moderns, this writing is represented as the actualization (performance) of a system of arbitrary elements, the graphemes, which are the equivalents of what

the phonemes are for spoken language (competence). Their function is to convey distinctively the meaning of words. Decodable, transparent, they efface themselves for the benefit of meaning—they become forgotten.

Kosuth's visual work questions this forgetfulness and forbids it. Writing conceals some gesture, a remainder of gesture, beyond readability. The obvious meaning of the writing hides other meanings. The written sentence is never transparent like a windowpane or faithful like a mirror. Thought is art because it yearns to make "present" the other meanings that it conceals and that it does not think. There is, in art as in thought, an outburst, the desire to present or signify to the limit the totality of meanings. This excess in art and in thought denies the evidence of the given, excavates the readable, and is convinced that all is not said, written, or presented.

Limpid writing is therefore turbid, disturbed by the "presence" of the other in itself. This other erases its readability. The erasure can even infiltrate into the readability itself, confusion can lurk in clarity, the gesture of the sentence can be lost in the philosopher's coherent proposition. For example, the almost perfect gesture of the *Tractatus* must recognize *in extremis* that which it neglects or excludes, which does not enter into the picture.

But still that which, written neither black on white nor white on black, indicates the other in writing must be written. Writing leaves the remainder to be written, by the mere fact that it writes. There will always be the remainder. It is not words or letters that are the signs; it is what is between them. Writing is finite; its infinity inhabits its finitude.

Kosuth's visible works manifest this remainder secluded in readability. The visual is employed to "manifest" the unreadable of writing, to advance an absent "presence" from and to the perceptible, visible presentation. For the perceptible presentation is also affected by a disturbance, a darkness. The perceptible is not entirely perceived; the visual is more than the visible. In making a visible work out of writing, Kosuth immerses it in the visual field, and by the same token he establishes its opacity, its invisible and therefore unreadable otherness, its oblique remainder, its unseen and unwritten "context." The visible and readable tautology, *This is a sentence,* insinuates the necessarily unreadable antinomy, *This is not a sentence, but a thing. Davar* signifies both the word that commands *and* the thing that is done.

The absence of the visual from the visible evokes the absence of meaning from the readable signification. There are many ways of deciphering and interpreting the Letters that are consigned to scrolls by the Voice. Almost no one has heard the Voice. The Letters include no sign allowing them to be grouped into words, no punctuation to guide intonation, not a single mark of vocalization. There is no end to the completion of this

definitive and unfinished testament of the Voice. Already, few know how to read the Letters, even in Babylon. While the rabbis try to decipher Hebrew aloud, the commentators translate it into Aramaic, vocalize it and chant it, for the sake of the assembled people who have forgotten their language.

Language is forgotten, always. There are many ways of forgetting it (one of which is linguistic). Vocalizing writing in order to actualize it, like visualizing it, is not without danger. It is a kind of incarnation, but one made under the responsibility of mouths or eyes of the flesh, and not through the gracious gift of the Voice. It is an incarnation that marks and recalls the "present" absence of the Voice from the letter in making the Voice heard in the equivocality and multiplicity of earthly voices. This gesture of vocalized and chanted commentary pays homage to the gesture of language hidden in the Letters. Oral tradition is perpetuated by adding earthly gesture to earthly gesture; thus it presents the remainder of meaning that haunts the Letters, not by remaining silent but by proliferating. That which cannot be spoken of must be silenced, but it cannot be silenced except in speaking still.

While they were constructing the tower at Babel, nations spoke many languages, but they all understood each other. In constructing the single tower, they were saying to each other, let us make a single language out of all our languages; it will be the absolute language. The Voice forbade them to do this; it sent forth confusion. Babel signifies confusion and not mastery. You shall translate in anguish. Among the letters, among the commentaries, you shall not cease to die and to be born to meaning, condemned to misreading.

All translation interprets. It moves toward the other language and returns to its own language, as toward things whose meaning is not obvious, in the same way that the visible both hides and signals the transcendence of the visual. It is necessary to risk leaving the given and returning to it, to rewrite it and expose it. In visibly exposing written sentences, Kosuth presents them for translation, for interpretation. The words and sentences explode, in the tradition of a carnal exodus, an exodus from Babel. Nothing need be added to them. They possess the indefiniteness of their commentaries. We imagine they seek to deliver themselves from it.

I compare Kosuth's visual works with the square letters of the Torah. These letters are also texts, but they are waiting for their accents, their vowels, their punctuation, their intonation, their putting into practice. The words wait to be cut up and defined. It is this incarnation that ventures with severity and humility into the centering, the formatting, the neon underlining, the variation of typefaces and sizes. And the lexical definitions in several languages manifest that they are themselves made of

words and are still waiting for their meanings. The definition of a word is its usage. And usage is a homeless wandering and a faithfulness to an absent Voice. It is without end.

Kosuth's work makes very little concession to the color medium, not to say none at all. The work is certainly visual since it is located in space-time and develops there its space-time, but it neglects the visible medium, color. A text differs from a painting by its medium. The distinctive medium of a text is made not of color but of words. In inscribing these words in perceptible space-time, it is only a question of giving them the thickness that is theirs and that is forgotten in the reading of the printed word, the immaterial thickness of the forgotten language. To color them would be to treat them as visible things, to ornament them, and to waste them.

Words are a medium for speech as colors are for vision or sound is for hearing. They rebel against being mastered because they already "speak" by themselves, and we no longer know what they are saying. Senior citizens of meaning, they are also children ready to give voice to historical events and to an endless tradition. In this way they wait coldly for the visitor when he enters a room set up by Kosuth.

Such is the paradox: to plunge the written in the perceptible without offering it to be perceived, on the one hand, or read, on the other, but only for it to be scrutinized according to its specific depth, the enigma of the tacit.

Kosuth can write "theoretical" texts because he knows that this sort of writing, in spite of its cognitive and referential claim, also conceals some gesture and remainder—that it is no more transparent than a picture. He has annulled, with Wittgenstein, the mad right that modern logic has presumptuously claimed—that of reflecting correctly the referent of the discourse in the clean mirror of its propositions. What are we doing, what is he doing, in commenting on his work? Are we hoping to reflect it clearly? We are making gestures of language that try to decipher, translate, and interpret his gestures of exposing writing. Why should Kosuth not do the same? Certainly he has no special privilege to comment on what he signs, but he is not forbidden to sign his comments. For commenting— that is, thinking and writing—is again and already an art.

After philosophy is before it. A man takes his finger, a stick, or a paintbrush, plunges it into an oxide paste or an ink, and draws some strokes on a support. Is he writing or painting? Neither one nor the other; this distinction will come later. He appeals by means of the visible-readable to a "presence" that is more than the calm acts of sight and reading. Today a man remakes this gesture with the typographic characters of our informationalized world. He calls us to this other, near and far, that is the only motif of art.

ACKNOWLEDGMENTS

These writings appeared mainly in art periodicals, catalogues, and as announcements for gallery exhibitions. After some speculation as to whether to render the format of the texts more homogeneous, the author and I concluded that, apart from occasional clarifications required by the context of their new appearance, the texts should be left untouched.

Many people have contributed to the realization of this book. I am indebted to Bettina Lauf for her responsibility and dedication in helping to clarify, amend, and prepare the text for publication. My thanks to Tod Lippy, whose research skills and ideas proved to be essential in the making of the bibliography that enriches the volume. I would like to express my gratitude also to the following individuals: Anne Livet, Nina Schroeder, Jill McArthur, Lincoln Tobier, Martin Zimmerman, and David Nolta. Finally, I am grateful to Charles Le Vine, who helped to prepare the index at the end of the volume.

Besides those named in the list of illustrations, the following supplied photographs for this project: Brian Albert, New York; Rudolf Burkhardt, New York; Jay Cantor, New York; Geoffrey Clements, New York; Bevan Davies, New York; Jon-Eric Eaton; Bruce C. Jones, New York; André Morain, Paris; Paolo Mussat Sartor, Turin; Pedicini Inc., Naples; Skunk-Kender.

G.G.

INTRODUCTION

Gabriele Guercio

*I see the reason, Ion. . . . The gift which you possess of speaking excellently
about Homer is not an art, but, as I was just saying, an inspiration; there
is a divinity moving you, like that contained in the stone which Euripides
calls a magnet, but which is commonly known as the stone of Eraclea.
This stone not only attracts iron rings, but also imparts to them a similar
power of attracting other rings; and sometimes you may see a number of
pieces of iron and rings suspended from one another so as to form quite
a long chain: and all of them derive their power of suspension from the
original stone. In like manner the Muse first of all inspires men herself;
and from these inspired persons a chain of other persons is suspended,
who take the inspiration.*

Plato, Ion.

Thus Socrates, characterizing the artistic process, incidentally but no less
definitively jeopardizes the artist's claims to a consciousness of art. But
what of all those artists who have attempted to confute Socrates' dictum?
Joseph Kosuth is certainly among them. Although, as he argues through-
out the following pages, interpretation may always form quite a long chain
linking the user and the maker of art, and although there will always be
more or less competent interpreters, artists should nevertheless consider
for themselves *why* rather than merely *how* art functions. It would be
wrong to think of the writings collected here as literature "about" art.
Kosuth the artist is as present in his writings as he is in the works he
exhibits in galleries and museums. His commitment is to a practice that
aims to grasp and unravel the conceptual web of art as a whole. For him,
artists deal with content rather than with forms alone; only by taking
responsibility for the meaning of their art can they hope to bridge the gap
that severs the work of art from the social fabrication of its content.
Accordingly, throughout his own career (which began publicly in 1967),

he has chosen not simply to be an art maker but to create and promote a critical understanding of art making. Insofar as he considers art as the whole rather than the sum of its parts, both his writings and his visual installations stem from the assumption that conceptual art's goal is to show that art begins where mere physicality ends.[1]

Growing up in a context created by, among others, Marcel Duchamp, Ad Reinhardt, and Donald Judd, Kosuth has continued to challenge the tradition of the authority of form, beginning with that tradition's dichotomy between painting and sculpture. At the same time, he has superseded the limitations implied by the modern system of the "arts" as isolated objects originating with and intended for isolated subjects (namely, the gap between art and art criticism). In seeking to identify the notion of artistic work with the conceptual activity of the artist, Kosuth has not only aligned art with language and culture but has helped to reduce its status as an isolated, independent discipline. This view has enabled him to draw new relations among previously unconnected cultural activities and, in turn, encourages the reader-viewer to perceive art as a global process that makes these relations possible. In fact, articulating an increasingly wide range of interests (philosophy of language, anthropology, Marxism, and Freudian psychoanalysis are a few), Kosuth seems interested less in linking specialized fields than in discovering the common principles that inform them within a practice that always moves to and from art. This book, then, extends the range of a singular *modus operandi*. What fascinates Kosuth and dominates this book is the possibility that the riddle of the creative process itself may be eventually solved by the artist. Here, as in galleries and museums, Kosuth vindicates not only artists' right to self-reflection, but also their freedom to investigate the *nature* of art without waiting for the mediation of critics.[2]

In 1965, having attended the Toledo School of Design and the Cleveland Art Institute and traveled for a year in Europe, the twenty-year-old Kosuth moved to New York. A student at the School of Visual Arts upon his arrival, he was invited to become a member of the faculty in 1968, where he is still teaching. During his early years in New York, the young artist fully immersed himself in the cultural life of the city. While meeting and exchanging ideas with other artists such as On Kawara, Roy Lichtenstein, and Claes Oldenburg, as well as joining Donald Judd in regularly writing reviews for *Arts* magazine, Kosuth also organized discussions with various artists about their work—including Judd, Reinhardt, Sol LeWitt, and Robert Smithson—holding these sessions in the basement of the School of Visual Arts. In 1967, with the aid of Christine Kozlov and Michael Rinaldi, he founded an alternative space, the Lannis Gallery, which soon had its name changed to The Museum of Normal Art. Here, revealing his affinities at the time, the artist organized the *Opening Exhibition of Normal*

Art, which included works by Carl Andre, Mel Bochner, Hanne Darboven, Walter De Maria, On Kawara, Christine Kozlov, Sol LeWitt, Robert Ryman, and Kosuth himself. In a significant tribute to the recently deceased Reinhardt, Kosuth began to subtitle his work "Art as Idea as Idea," while a label quoting Reinhardt's well-known dictum "Art as Art" was affixed to the entrance wall of the gallery.[3] The following year, presenting what the artist sees as his first "secret" solo exhibition in New York, the Lannis Gallery featured *15 People Present Their Favorite Book.* The show delivered precisely what its title promised: Kosuth simply asked other artists to contribute their favorite books to a presentation in the gallery. It was in late 1968 that Kosuth began to gain public recognition as a leading—and highly controversial—figure in the emerging movement of conceptual art. It was around this time that Seth Siegelaub, later to become the pioneering dealer in conceptual art, took an interest in the work of Kosuth, eventually showing it, along with projects by Robert Barry, Douglas Huebler, and Lawrence Weiner, in a series of group exhibitions that included the now legendary show-catalogue *5–31 January, 1969.* By the end of this crucial year in his career, Kosuth not only had his first solo exhibition at the Leo Castelli Gallery but also published his first major text, an article entitled "Art after Philosophy," in the widely read *Studio International.* Since 1969, Kosuth has been exhibiting, publishing, teaching, and lecturing in America and Europe. In marked contrast to the steady appreciation of his work in Europe, however, his reputation in America has undergone several fluctuations. During the past twenty years, the artist has been a target for critics keen on maintaining the value of painting and sculpture and, secondly but no less importantly, the status of their own discipline, which seems to be threatened by an art that includes self-reflection and criticism.[4] In 1970, Peter Schjeldahl was already rallying against the "moral crusade" of conceptualism, characterizing Kosuth in the *New York Times* as its "Savonarola"; yet, more recently, Roberta Smith, clearly receptive to the current reevaluation of conceptual art begun by younger artists and critics, would not hesitate to define Kosuth (also for the readers of the *New York Times*) as "the *eminence grise* of conceptual art while remaining its *enfant terrible.*"[5]

Although an exhaustive study of Kosuth's activities as art maker, writer, curator, and teacher is obviously needed at this point, I will refrain from providing one, limiting myself to a consideration of his writings. Throughout these, there is a constant and almost obsessive purpose that renders them particularly suggestive. Kosuth's questioning of the nature of art, his call for clarity and understanding in the artistic practice, together with his increasing preoccupation with contemporary art's loss of credibility (concurrent with its increased market value), are all clues pointing to a number of recurrent questions in his work. Is it possible to assign to the

artist the status of critic, the role of autonomous maker of meaning? Can art be given an intellectual place in our society at least equal to that held by other cultural activities (philosophy, anthropology)? These questions have led Kosuth to a series of provocative if partial conclusions about art and the artist. Discussing them, I have decided to focus first on two crucial moments in his thinking, roughly corresponding to the writings "Art after Philosophy" (1969) and "The Artist as Anthropologist" (1975). Then, after exploring the reasons underlying Kosuth's synthesis of other cultural activities, I intend to comment on some of his more recent essays, drawing from them a reconfirmation of what seems to be consistently implied in his writings since "Art after Philosophy," namely a belief in the agency of the artist as the primary actor who makes both the critique and maintenance of art in our society possible. While it is evident that many of Kosuth's ideas have undergone significant evolutions, it is equally clear that, since the 1960s, the image of the artist he envisions has been a constant one, tending to absorb in turn the roles of analyst of language, anthropologist, and philosopher. What interests me in Kosuth's ongoing conceptualization of his practice is not only the explicit attempt to define a responsible role for the artist, but also the notion that the *agency* of the artist is indeed as important an element of art as works of art themselves.

IS THERE A WAY OF BEING NEITHER A PAINTER NOR A SCULPTOR BUT AN ARTIST?

This question, which clearly crossed the minds of several artists during the sixties and is indeed still with us, no doubt led Kosuth to write "Art after Philosophy" in 1969. With this text, he developed a strong analogy between the status of the work of art and that of the analytical proposition. He also set for himself the goal of simultaneously breaking away from the institutionalized forms of painting and sculpture while placing art above philosophy and defining the task of the artist as a thorough questioning of both the function and the use of the language of art. Hoping thereby to bridge the gap between the artist's idea and whatever materials are employed in its realization, and between the presentation of the art work and its public institutionalization, Kosuth defined conceptual art in terms of its special capacity to provide information about the nature of art. His well-known thesis that the twentieth century could be seen as marking "the end of philosophy and the beginning of art" stemmed from his close identification with a line of thinking that, following the collapse of idealism at the turn of the century, had become so influential in the English-speaking world (Ayer and Wittgenstein were often called on in "Art after Philosophy," along with some of their American interpreters) as to begin to affect the language of art criticism during the aftermath of

minimalism in 1965.[6] On the other hand, Kosuth's arguments in favor of art eclipsing philosophy were equally significantly founded upon the manifest recognition of those ideational aspects already prominent in the work of some of his immediate predecessors (Johns, LeWitt, Morris, Rauschenberg, and, most notably, Judd)[7] and earlier artists (Duchamp, Reinhardt). To the extent that it helped to produce the mental fabric through which "Art after Philosophy" was woven, the interplay of references to artists and philosophers of language allowed Kosuth to look forward and draw what must have seemed a natural conclusion. In short, as he argued, since Duchamp and the recent reappearance of avant-garde modes of artistic production, it had become increasingly clear that a work of art is dependent upon both its artistic context and its nomination as art by the artist. Its status or *raison d'être* is thus wholly abstracted from any material implication (perceptive or referential) and may be finally equated with that of a linguistic tautology. The trap implied by such an equation (as Kosuth would later acknowledge when lamenting that his earlier example of tautology had been quintessentially "modern") consisted in venturing to challenge the circularity inherited by modernism while continuing to use those very analytical and antihistorical tools modernism provided.

Despite its ambivalence, "Art after Philosophy" represents an attempt to determine the agency of the artist by means of transferring the notion of authorship from the "auratic" and visible aspects of the work to those mental and invisible processes that finally rendered it more or less influential within the history of our idea of art. As Kosuth suggested in reference to his *Sixth Investigation: Proposition 14* (see "Context Text," 1971), the artist, not unlike a scientist for whom there is no distinction between working in the laboratory and writing a thesis, has now "to cultivate the conceptual implications of his art propositions, and argue their explication." Understandably, then, a main goal in "Art after Philosophy" was to separate art from aesthetics. Aesthetic evaluations did not simply mislead the artist concerned with conceptual investigations, but were basically extraneous to art—dealing with opinions on perception of the world in general, they precluded the much sought-after understanding of the function and *raison d'être* of the art object:

When objects are presented within the context of art . . . they are as eligible for aesthetic consideration as are any objects in the world, and an aesthetic consideration of an object existing in the realm of art means that the object's existence or functioning in an art context is irrelevant to the aesthetic judgement.

This, of course, was not completely unprecedented. In 1961, returning to his by then increasingly popular "readymades," Duchamp had made it clear that the choice of these objects was never dictated by aesthetic delectation, but rather based on visual indifference and their complete

absence of either good or bad taste.[8] Kosuth fully acknowledged Duchamp's influence, crediting him for being the first artist to have raised the question of the function of art. With the unassisted readymade, he wrote, "art changed its focus from the form of the language to what was being said." For Kosuth, such a shift from appearance to conception marked the beginning of modern and "conceptual" art insofar as it eclipsed the morphology of art and highlighted both the artist's process of intentional designation and the contextual value of the work.[9]

Whereas Duchamp, recasting the role of the artist from simply a tickler of aesthetic sensibilities into that of an intellectual operating on multiple levels, had grounded the emancipation of the artists in modern society upon their capacity to select information,[10] for Kosuth in 1969 the artist was nothing if not the analyst questioning the language of art as a whole. Such a comprehensive view of art existing prior to any given form of language brings us to the core of Kosuth's circular thinking in "Art after Philosophy," and moreover indicates a clear link with the respective views of Donald Judd and Ad Reinhardt who, along with Duchamp, were especially important for the young artist during these formative years. Characteristic of Kosuth at the time is the notion that, since the validity of a work of art can no longer be ascertained solely on the basis of its materials, artists should recognize the conceptual structure determining what they designate as art. Accordingly, they should perceive the "art" condition of whatever object is presented in the context of art as a condition analogous to that of an analytic proposition. Kosuth is explicit:

Works of art are analytic propositions. That is, if viewed within their context—as art—they provide no information what-so-ever about any matter of fact. A work of art is a tautology in that it is a presentation of the artist's intention, that is, he is saying that a particular work of art *is* art, which means, is a *definition* of art. Thus, that it is art is true *a priori* (which is what Judd means when he states that "if someone calls it art, it's art").

Here, various sources that I should like to distinguish were brought together in order to reconcile intentional designation and conceptual schematism. On the one hand, the neo-Kantianism of A. J. Ayer's philosophy (his distinction between analytic and synthetic proposition introduces Kosuth's passage) apparently reinforced what the artist had learned from Reinhardt. Reinhardt's paintings and writings already presented not only a call for a definitive tabula rasa in art, but also the idea that one cannot discuss art without appreciating its tautological character. As Reinhardt had argued in 1962, "The one subject of a hundred years of modern art is that awareness of art of itself, of art preoccupied with its own process and means, with its own identity and distinction, art concerned with its own

unique statement."[11] To the extent that Reinhardt had been preoccupied with making the last painting that anyone can make, there was room for Kosuth to speak for a renewed self-reflective practice, this time exclusively concerned with the definition of art as idea. On the other hand, parallel to Kosuth's identification of art and logic via their common tautological condition is the intentionalist reading of Duchamp's readymade found in the oft-quoted statement by Judd. Both positions support the claim of "Art after Philosophy" that art is always prior to its materialization and is ultimately rooted in the agency of the artist. This best explains why, according to Kosuth, art could only free itself from morphological constrictions by becoming aware of its functioning as a kind of logic, and thus, absorbing the function once relegated to criticism, could most effectively aid the artist in the transfer of ideas. Rather than relying on critics, it would be the artist's conceptual responsibility to guarantee at this point the contact between the artist and the audience, between the work of art and its public institutionalization.

Kosuth's image of the artist as an analyst questioning the language of art contains certain broader social implications that cannot, I think, be fully grasped unless we return to Reinhardt. Reinhardt possessed a highly developed sense of the artist's moral commitment; often asserting that art cannot exist without being constantly questioned, he poignantly linked what he saw as the current corruption pervading the art world with "the idea of the artist making believe he doesn't know what he is doing."[12] In other words, for him there was something wrong with the artist's current lack of control over the interpretation of his work and the subsequent manipulation of it by the media and market. He was evidently alarmed, for instance, by the fact that Still, De Kooning, and Rothko had permitted *Life* magazine to treat their work in terms of "flames, girders, grasses, and sunsets."[13] It is thus natural to suggest that the young Kosuth was exposed to these issues, because he sought, in his own turn, to envisage a condition in which artists "knew" what they were doing. Whereas Reinhardt had hoped to preserve the integrity of art, contemplating a future mission for the academy and the museum, Kosuth's different but equally utopian impulse revealed itself in the attempt of "Art after Philosophy" to found a sort of community of communication that, abolishing any superfluous form of mediation, aimed to link artists and non-artists directly. As he would point out in his "Introductory Note" (1970), this questioning of the nature of art renders conceptual art an activity as informative and serious as philosophy, the audience for which, since it cannot take a position outside the discipline, consists of participants who are more or less informed. Accordingly, in 1970, when asked by Jeanne Siegel what he had meant in saying that an artist is someone who questions the nature of

art, Kosuth vehemently replied by disclosing the broader social implications of his definition of the artist:

I think to be an artist now means to question the nature of art—that's what being 'creative' means to me because that includes the whole responsibility of the artist as a person as well as the cultural implications of his or her activity. To say that the artist only makes high-brow craft for a cottage industry's specialized market might satisfy the needs of this society . . . but it's an insult to the valued remains of an 'avant garde' tradition . . . unless artists reconceptualize their activity to include responsibility for re-thinking art itself, than all that is of value in art will be subsumed by the market, because then we will have lost the moral tool to keep art from just becoming another high-class business.

In retrospect there is little doubt that while rallying against the tradition of painting and sculpture, Kosuth nevertheless perpetuated, in "Art after Philosophy," the modernist belief (invoked throughout the text) that art exists only for its own sake. Paradoxically, the ideology of scientism acting upon modern art and culture (an ideology that the artist would later attack in his writings) could not have found a more significant endorsement at the time. To employ Wittgenstein and other philosophers of language in order to advocate the replacement of continental metaphysics by art as a form of a priori knowledge, the structure of which coincided with that of logic and mathematics, represented a significant attempt to reorient art through an act of linguistic self-understanding. Yet this endeavor was heavily undermined by the implicit adoption of a paradigm too abstract to enable Kosuth to question art as a whole. His much-sought control over the conceptual processes ruling the artist's practice, promoting as it did a formal analysis restricted to the linguistic implications of all the aspects of the concept of art, had at the same time edited out those human and historical elements that shape both the work and the intention of the artist.[14] A few years later, in fact, Kosuth would resist the positivistic remains of modernism (now clearly seen as a cultural counterpart to the ideology of scientism), objecting in particular to scientism's systematic denial of self-conception to the human subject within the construction of art and science. This proceeded from the admission that, notwithstanding its capacity to reveal aspects of the artistic activity that had always been either internalized or simply left unknown, his earlier conceptual program had been gradually upset by the antihistorical and positivistic character of the scientistic methodology invoked in "Art after Philosophy." Thus the statement accompanying Kosuth's *Tenth Investigation* of 1975 reads:

This, *The Tenth Investigation*, is my last. The point . . . is not that I intend to stop working, but that it has become extremely difficult for me to support the epistemological implications and cultural ramifications of the uncritical analytic scientific paradigm which the structure of this work (regardless of my own attempts to subvert it) inescapably implies.

Despite the text's ambivalent stance and Kosuth's later distance from it, "Art after Philosophy" can still be read, twenty years after its publication, as a radical attempt to launch a project of change in art, one that soon turned out to be far more difficult to articulate than the artist had perhaps suspected in 1969. A retrospective reading of the article allows an understanding of Kosuth's major preoccupations in his activity to date. The attempt to posit art above philosophy evinces his ongoing fascination with seeing art as a global model for language and culture. It also foreshadows subsequent attempts to equate art with anthropology, as well as to improve and refine conceptual art's capacity for engaging the reader-viewer in a rational reconstruction of art itself. Secondly, from 1969 onward, Duchamp's exemplary readymades, along with the influence of Judd and Reinhardt, reinforced in Kosuth the image of the artist as an intellectual who, conscious of being neither painter nor sculptor, identifies the making of art with a knowledge of those dynamics that make art possible.

THE ARTIST AS ANTHROPOLOGIST

In "The Artist as Anthropologist" (1975), the mosaic of citations that constitutes the first part of the text suggests a model of art enriched by the possibilities of understanding art within its sociohistorical context. This serves as a prelude to Kosuth's criticism of the ideology of scientism and his warning that conceptual art should dismiss its pretenses of autonomy in the world at large:

Art must internalize and *use* its social awareness. The fallacy of Modernism is that it has come to stand for the culture of Scientism. It is art outside of man, art with a life of its own. It stands and fails as an attempt to be objective.

This call for social awareness in art derived from Kosuth's growing realization that conceptualism was by this time embedded in contradictions. These were made clearer by the general revival of political commitment in the New York art world. In contrast to the wave of antiwar political activism that had shaken that world during the 1960s, and as a delayed reaction to it, political ferment around 1975 assumed a more theoretical, notably Marxist character. Many artists in Soho were now arguing and writing at least as much as they were making art. Theoretical discussion groups, panel presentations, papers, and publications constituted a political forum for them to criticize the pervasive commodification of the art object and to analyze the role of the artist in capitalist society. In this milieu marked by disenchantment with institutions and hopes for imminent radical change, a new magazine, *The Fox*, despite its short life, played

a role in shaping the debate about art and politics that would soon lead to the creation of those Sunday night open gatherings known as "Artists Meeting for Cultural Change" (AMCC).[15] *The Fox* provided a context for discussing, among other issues, the "failure" of conceptual art in the face of the voracious international art market, which, successfully assimilating conceptualism as a mere "stylistic" rupture, had visibly undermined the movement's capacity to equate art with information in its attempt to challenge the art industry. Although working from different agendas, Sarah Charlesworth and Kosuth undertook the delicate job of learning from this failure. The two artists contributed to a redefinition of conceptualism within a renewed and, as Kosuth put it, "anthropological" perspective. According to Charlesworth, earlier "theoretical" or "analytical" art had valued the art object in terms of its ideational rather than physical attributes and was to be credited with having shifted attention toward those conceptual tenets underpinning contemporary artistic practice. Yet, as she pointed out in "A Declaration of Dependence," an essay published in the same issue of *The Fox* in which "The Artist as Anthropologist" appeared, "To the extent that conceptual art is dependent upon the very same mechanisms for presentation, dissemination, and interpretation of art works, it *functions in society* in a manner not unlike previously more morphologically oriented works."[16] Thus, once confronted with a mechanism that severed the intentional aspects of the artist's practice, artists had to begin to deal with the problems caused by their own alienation by making these very problems part of the content of their activity. In this respect, she concluded, the apparent failure of conceptual art could serve as both a warning and a point of departure for new generations of artists because

while such activities now appear naive and unsuccessful on the one hand . . . they *do* signify a positive and potentially liberating capacity; that is, the will to change, to re-examine, and, more importantly, to "call to arms" the tools that make radical and contextual critique conceivable. Suppose we imagine this capacity as a medium, a methodology, and not an end in itself. We can *learn* as much, in a sense, through the "failure" of concept art as we do through its partial success; while being critical of the (self) presumptive and reductionist aspects of formalist tradition, we exist as its inevitable heir.[17]

At the same time, Kosuth in his "The Artist as Anthropologist" objected to taking responsibility for an art bound to fail because of its isolation. Thinking over his former fascination with an analytic model of art, he acknowledged its limits as well as its capacities to mark the beginning of a true critique of modernism:

Our earlier conceptual art, while still being a 'naive' Modernist art based on the scientific paradigm, externalized features of the art activity which

had always been internalized—making them explicit and capable of being examined. It is this work which initiated our break with the Modernist art continuum.

However, in disassociating himself from attempts to continue conceptualism in terms of a stylistic alternative to modernism and recasting his previous concerns with the function and social destination of art, Kosuth did not abandon the crucial notion of art as intentional designation in favor of a mere contextual critique. Instead, he sought to understand the dynamics ruling the construction of the subjectivity of the artist within the artistic apparatus and the larger sociohistorical framework. From our vantage point, therefore, "The Artist as Anthropologist" is of interest not only because it proposes a socially committed art, but because it continues to discern a distinctive role for the artist in a world that Kosuth now perceived from a para-Marxist and postmodern perspective. What is at stake in this text, in fact, is a sense of the conditions under which artists exist within the world and make purposive interventions in the artistic apparatus.

Though different from the characterization of the artist as analyst of the language of art, that of the artist as anthropologist partially incorporated the former image. Conceived as an anthropologist, the artist need not dismiss the tools of analysis entirely, but rather must amend their pretense of objectivity, combining them within a vision of art, culture, and history as intrinsically dialectical realities that can be understood and criticized precisely because they are humanly made. Taking up what had been left perhaps too implicit in the writing of "Art after Philosophy"— the notion that the conceptual character of art is inseparable from its use and from the willing concurrence of artist and public—Kosuth now recycled and refounded this idea of communicative interplay upon the experience of the hermeneutic circle of interpretation. A hermeneutic understanding of both art and culture, while binding the language of art together with the world of experience, has the power to expose those intentional subjective patterns that a "non-naive," anthropologized art should finally make wholly visible. Accordingly, "The Artist as Anthropologist" assigned to the artist the responsibilities of a social commitment that would not limit itself to an external critique of art as an institution, but rather seek an exit altogether from the impasse into which conceptualism had fallen. This exit would be taken via construction and exposure of the agency of the artist within a practice so much a part of culture and history as to end up remodeling art within its totality. As Kosuth argued:

When one talks of the artist as an anthropologist one is talking of acquiring the kinds of tools that the anthropologist has acquired—insofar as the anthropologist is concerned with trying to obtain fluency in another culture. But the artist attempts to obtain fluency in his own culture. For the

artist, obtaining cultural fluency is a dialectical process which, simply put, consists of attempting to affect the culture while he is simultaneously learning from (and seeking the acceptance of) that same culture which is affecting him.

As a parallel to the mission of the anthropologist, the artist would eliminate the risk of perpetuating an activity unable to question the circularity of its human foundations. This idea reinforces the supposition that artists are able to accomplish what orthodox anthropologists often fail to achieve: a dynamic linguistic depiction of art and culture. Within this framework, Kosuth echoed and reelaborated the arguments of "engaged" anthropologists such as Stanley Diamond and Bob Scholte.[18] Their innovative definition of the anthropologist corresponded well with the image of the artist Kosuth was at this time sketching. While maintaining a continuity between experience and reality, Diamond and Scholte had firmly criticized the physicalist model as it had been applied so far in the domain of the human sciences. As Scholte had pointed out in a paragraph quoted in "The Artist as Anthropologist,"

if we assume a continuity between experience and reality, that is, if we assume that an anthropological understanding of others is conditioned by our capacity to open ourselves to those others . . . we cannot and should not avoid the 'hermeneutic circle' . . . but must explicate, as part of our activities, the intentional processes of constitutive reasoning which make both encounter and understanding possible.

Indifferent as it was to the historicity of scientific praxis, faith in the physicalist model applied to the human sciences had prevented anthropologists from interacting with the culture they were getting ready to study, encouraging in them an attitude of detachment that resulted in a naive attempt to establish and verify formal laws and the definition of timeless truths (an attempt that, in a quite similar vein, had been evidently pursued throughout "Art after Philosophy"). Thus, learning from his reading in radical anthropology, Kosuth acknowledged in 1975 that questioning the nature of art could no longer be carried out through an analytical practice that unavoidably retained the ideology of scientism and its logic of neutrality. The artist as anthropologist should therefore try to gain fluency within his or her own culture; in fact, since they were already both users and makers of signs within a given cultural context, artists could rightly be seen as the best representatives of the "engaged" anthropology theorized by Diamond and Scholte. Kosuth, suggesting the kind of agency necessary to the functioning of a model of art within the world, put it this way:

The artist-as-anthropologist, as a student of culture, has as his job to articulate a model of art, the purpose of which is to understand culture by making its implicit nature explicit—internalize its 'explicitness' (mak-

ing it, again, 'implicit') and so on. Yet this is not simply circular because the agents are continually interacting and socio-historically located. It is a non-static, in-the-world model.

The attractiveness of a text such as "The Artist as Anthropologist" lies in its assumptions that contextual critique and intentional designation are two basically complementary notions, and that only through a subjective internalization of culture does the individual artist learn to become a critic and influential actor within the context of art and the world of life at large. Kosuth's marked insistence upon individual responsibilities in art, as well as the politics that inspires such an insistence, can be better grasped if viewed against the background of a still widely accepted tenet that, overlooking the agencies of individual artists, identifies political commitment in art with denouncing both the production and the reception of art as a social institution. Most notably formulated by P. Bürger in his influential study of the theory of the avant-garde (1974),[19] this strict identification of art and politics, which undermines the category of "artist" as a bourgeois myth in order to posit and denounce the existence of an overall artistic apparatus (art as a social institution), all in all leads artists to run the even more pernicious risk of mythologizing the category of "institution" to such an extent as to be unable to see its concrete human side. Obviously, in theory as well as in artistic practice, to posit and unmask the overall artistic apparatus is safer (since it avoids conceptualizing the problematic place of individual artists active within the institutional context) than positing and unmasking both the apparatus and the internal dynamics that make such an apparatus possible. Rather than being mere abstractions, however, it is reasonable to argue that these dynamics (cultural, economic, political) determine the outcome of individual performances that, ultimately, affect the interplay among artists, art as an institution, and the world precisely because they are fueled, reformed, and upset by concrete human agents. Thus, in open contrast to an acceptance of contextual critique, which despite its visible attempt to subvert would in fact mainly continue to reify the artistic apparatus, Kosuth's characterization of the artist as anthropologist chiefly sought to expose and conceptualize art's human foundations, beginning with a self-reflective understanding of the role played by the artists. The politics that inspired "The Artist as Anthropologist," as well as the course undertaken by Kosuth in the following years, could be summarized at this point by referring to a text from 1977. Here, the survival of art in institutional societies, grounded upon the dialectical principle that "the ability to create consciousness is an integral part of the actual ability to create the social world," is ultimately guaranteed by art's power to remain the place where "making meaning" is possible.

EXPOSING PROTEUS

Both "Art after Philosophy" and "The Artist as Anthropologist" clearly evince a will to assign credibility to art and the artist. Whether considered above philosophy or equated with the very process of gaining fluency within culture, art is in both texts imagined as a conceptual domain constructed in relation to a complex network of information received, revolved, and ultimately recycled within a practice rooted in the agency of the artist. The artist, whether analyst of the language of art or anthropologist, is in any case perceived as a responsible maker of meaning whose critical self-reflection is an activity intimately involved with, and every bit as important as, the physical realization of the work. It seems that, insofar as it aims to question the nature of art and to shape an audience of relatively informed participants, conceptual art is compelled to expose the reasoning of its maker. The dialectics between the exposure of the artist and conceptualism's ambition to understand and reorient the function of art in the world is particularly evident when turning to "Within the Context: Modernism and Critical Practice" (1977). Here, Kosuth declares that

'consciousness' in the function of self-reflexivity should be operating within the elements of the work (proposition) of art itself. In this way the *subject* of the maker is present and 'humanifies' the work. The proposal is for work which understands itself as a context which mediates (as it is mediated by and is part of) the social context. The purpose of this is to eliminate the duality of subject and object which permeates the 'objectivity' of bourgeois thought. Our work must bring together, then, the work and its maker in the process of locating both in society and history.

In this way, presenting the subjectivity of the maker who "humanifies" the work of art, Kosuth wished to tackle a dilemma that has plagued many of his contemporaries as well, namely, the striking evidence that the communicative intentions of the artist are often contradicted by the lack of a dialogical interplay between the work and its context. Producing work for people whose lives, beliefs, and needs might be completely unknown to them, who might either appreciate or ignore the work for reasons beyond their control, contemporary artists make art that may appear distant and arbitrary in relation to the very context for which it provides, and from which it receives, meaning. Never before the advent of modern institutional societies has there been so wide a gap between the public and the meaning of art, the work and the artist. Nor has it seemed so problematic to acknowledge that meaning is produced by humans and for humans. Yet, as Kosuth has so often insisted in his writings since 1975, it is this "making of meaning" that defines what we mean by the word "human":

Where is our work? Wherever we find ourselves. Meaning is made by humans, and it is this 'making of meaning' which connects us in a real way to each other and to the world. . . . But 'making meaning', that is, culture, is not the collected sum of numerous fragmented forms, but the process through which they come into being. Everyone's work is part of that process; indeed, in a large part it defines what we mean by human.

These remarks from "Within the Context," removed as they are from the culture that inspired "Art after Philosophy," nevertheless indicate a similar preoccupation with redeeming the artists' lack of control over the interpretation of the work of art. This time, however, the gaps between the artist and the work and the work and its public institutionalization are bridged by highlighting human agency as well as art's deeply human and historical base. For Kosuth, writing in 1977, art remains one of the less alienating activities in institutional societies insofar as it seeks to remain conscious of its intentional modes of communication. For the artist as well as for the reader-viewer, the contact with art has to have the power of turning into a dynamic praxis—a praxis leading to a dialogical correlation among artist, work, and audience. Despite the shifts of focus in his writings since 1969, Kosuth maintains that conceptual art aims for an understanding (corrective and demystifying) of the web of relations underlying the communication among artists and non-artists. What constitutes a crucial feature of this program, the very attempt to identify the notion of artistic work with the conceptual activity of the artist, is nonetheless an enterprise that may raise more questions than it resolves. For instance, given the possibility of reshaping rather than wholly dismissing the notion of authorship, to what extent is it legitimate to trust notions such as inwardness and self-conception in art while exposing the agency of the artist? And, furthermore, given that conceptual art seeks to internalize the function once relegated to criticism, are there any distinctions still to be made between a work of art and a text talking about art? These two questions, which I want to discuss before bringing my considerations to a close, are also the best introduction to some aspects of Kosuth's most recent writings.

Concerning inwardness and self-conception in art, we may explore Kosuth's recent interest in Freud; in particular, his "Notes on Cathexis" (1982), which were significantly introduced by a quotation from Freud:

. . . thought proceeds in systems so far remote from the original perceptual residues that they have no longer retained anything of the qualities of those residues, and in order to become conscious, need to be re-inforced by new qualities.

As Kosuth implies throughout his "Notes," the series of works entitled *Cathexis* suggest the prospect of a general overview of past and present interpretative aims in art analogous to that presented by Freud. These

aims could eventually be conceptualized only via a renewed investment of meaning by the artist as well as by the reader-viewer of the work.[20]

Kosuth's references to Freud are visible in a body of works produced from 1982 onward: *Cathexis* (1980–81); *Hypercathexis* (1982); *Fort! Da!* (1985); *Intentio (Project)* (1985); *Zero & Not* (1985–89); *It Was It* (1986); *Modus Operandi* (1987–89); *Q&A/F!D! (to I.K. and G.F.)* (1987). These Freudian allusions are not based upon any specific school of thinking, nor are they primarily involved in any particular application of psychoanalysis, but rather reflect on Freudian theory itself. Freudian theory, in other words, represents a culturally internalized system of beliefs that has to be taken into account by an artist who is willing to recognize those structures and relations of meanings affecting art and culture.[21] Freud also seems to offer Kosuth a new opportunity to enlarge the scope of self-conception in art, and to define intentional designation as a principle of signification. Rather than deriving from the existence of a unique "self" prior to art making, this intentionality is experienced as a process locating the agency of the artist within the very construction of its object of conceptual apprehension. While Freud had thought of cathexis as an "interest" and as an "intention" toward a goal belonging to the realm of psychical phenomena, Kosuth aimed with his *Cathexis* to render this mental event somewhat tangible, linking its occurrence to those dynamics sustaining both the making and the remaking of meaning in art. "*Cathexis*," he wrote, "attempts to understand the *conditions* of content, with, finally, the process of understanding those conditions becoming the content of the work." What seems therefore to be at stake is a true identification of the artist with the Freudian analyst, insofar as they are both concerned with a construction that is at the same time an exposure of the conditions that lead the subject of the language to a form of self-conception. Not unlike Freud, who in his "Construction of the Analysis" (1937) saw psychoanalysis as a sort of archaeology of the subject, Kosuth in 1982 seems to draw an implicit parallel between archaeology and conceptual art, given that the latter sees that "patterns of meanings and forms are arbitrarily related" and does not fail to recognize the fragmented texture of its social context. By virtue of uncovering those agencies and dynamics affecting the process of signification, this conceptual seeing may well serve the purpose of preserving "all that is human in the idea of tradition" since, as Kosuth argues, "an understanding of the mechanism(s) of art—how meaning is made—suggests both a liberating act as well as a description of the infinite possibilities of human meaning."

As to the distinction between conceptual art and the discursive text, it is worth returning to the notion of audience in Kosuth's writings, a notion that has changed noticeably since "Art after Philosophy" and his "Introductory Note" (1970). During these years, while his commitment to estab-

lishing a community among artists and non-artists has remained unchanged, it has become increasingly evident that the audience of conceptual art cannot be limited to a closed and almost exclusive circle of more or less informed participants. This realization, which may be correctly described as a shift toward more dialectical and open forms of art, surfaced in Kosuth's writings around 1975, but its origin may be traced back to the "Introduction to *Function*" (1970) and to the introduction to the *Sixth Investigation: Proposition 14* ("Context Text," 1971). In the 1970 text, for instance, he clearly indicated that "*art* only exists as a context" and that "the final and ultimate context is unknown." Evidently, because of the contextual character of the activity, the artist's attempt to question and define the nature of art does not necessarily rule out forms of "external" participation, but rather seeks to shape them as a part of the conceptual investigation. Kosuth has continued to reflect upon the relationship between art and its public institutionalization, moving from the concept of an audience receptive to the sole analytical definition of art as idea to the image of a reader-viewer who completes the artistic process with his or her cooperative interpretation (see "Seven Remarks," 1978–79, but also "Notes on *Cathexis*").[22] It is significant that, in this continuous refining of conceptual art's capacity to engage its audience in a rational reconstruction of art, Kosuth has gone so far as to acknowledge criticism as an activity parallel to art, maintaining, however, that there is an ontological difference that separates criticism in general from the "critical" activity of the artist. This difference, observed Kosuth very recently, can be seen in terms of "primary" and "secondary" theory:

No matter what actual form the activity of art takes, its history gives it a concrete presence. Framed by such a presence then, this theory is engaged as part of a practice. Such theory I'll call primary. Secondary theory may be no less useful (in many cases *more* useful) but the point I'm stressing is that it has a different ontology. Primary theory is no more interesting than the practice, *in toto*, is. However, theory not linked to an art practice is an unconcretized (or *unfertilized*) conversation after (or before) the fact. . . . Behind every text about art rests the *possibility* of an art work, if not the presence of one.

And, as he continues:

Texts *about* artworks are experienced differently than texts that *are* artworks. It is abundantly clear by now, that we do not need to have an object to have an artwork, but we must have a difference manifested in order to have it seen. That *difference* which separates an artwork from a conversation also separates, fundamentally, primary theory from secondary theory.

These passages are from a text written to introduce the exhibition *The Play of the Unsayable: Ludwig Wittgenstein and the Art of the Twentieth Century*, which Kosuth curated in the fall of 1989 in Vienna and Brussels.

The thesis underlying both the exhibition and the text somewhat reinterprets and carries further the theses of "Art after Philosophy." This time Kosuth draws an analogy between the conceptual tendencies in the art of the century and the aims of Wittgenstein who, especially in his *Philosophical Investigations* (1953), sought to review and order the several applications of the concept of meaning and the wide range of conceptual conjunctions between meaning and other notions. "The work of art," writes Kosuth, "is essentially a *play* within the meaning system of art." But whereas primary theory is always part of this play, secondary theory stands outside, unavoidably biased by its status as "objective science." Thus what allows artists, knowing where they are and what "meanings" are to them, to play, is an "event context" that produces and locates their subjectivity within a practice. As Kosuth has it:

Talking about art is a parallel activity to making art, but without *feet*—it is providing meaning without an *event context* that socially commits subjective responsibility for consciousness produced (making a world).

This distinction, which is obviously not meant to discredit criticism but rather to articulate the difference between a work of art that is criticism and a text about art, also poignantly discloses once again how and why conceptual art's communicative powers are ultimately founded upon an exposure of the agency of the artist, identified by his or her "subjective responsibility." Such an exposure is in the end quite consistent with Kosuth's efforts to make obsolete an artistic apparatus according to which art, rather than being equated with information, depends almost exclusively upon an aesthetic and economic appreciation of mere objects. Exposing the artist, in fact, may have the emancipatory effect of renewing the interplay among artists, art as a social institution, and the world at large, while leaving us face to face with what we are perhaps far too casually avoiding—the consideration that artists are not necessarily passive, unconscious mediums of culture and history, imaginary entities whose aims, choices, and motivations cannot be scrutinized.

For Kosuth, art does not have a true object, an isolated form or work. A work of art is not a given object, but rather represents the result of mental choices that are intentionally pursued at the time of both its production and reception, an "object of thought." Nor can there be in art a pure meaning, an abstract definitive content. Throughout these pages, what often appears most clearly circumscribed in the triangle of artist, work, and audience turns out to be the most obscure. The work of art is an abstraction for Kosuth; it is, however, an abstraction clearly willed into being. The readers of this book (as well as the public who attend Kosuth's exhibitions) are thus invited to experience art as an "event context" intelligible to those who live it. Within this rational reconstruc-

tion of art itself, the agents are no longer isolated subjects in the production or reception of isolated objects. The artist first, and the public thereafter, construct and locate their subjectivity, inseparable from signs, while employing and perceiving the signs as the effective course of human action. Conceptual art implies choice and will: creating the work, concerning oneself with it, means to determine a pattern of intentions. For Kosuth, true propositions of meaning are recognizable in art. These propositions design relations of relations that, once perceived, reveal the object as a means through which the very process of making meaning is finally realized by its agents. A reading of this book, therefore, offers ample evidence for the belief that "who we are, both as individuals and as a people, is inseparable from what our art means to us" ("Necrophilia Mon Amour," 1982). What might become increasingly clear following Kosuth is that art's innermost capacity to function as a form of shared consciousness, together with its power to guarantee a certain sense of our place in history, will be seriously threatened unless we recognize by whom and for whom art exists.

Notes

Works cited by author, month, and year appear in part 2 of the bibliography at the end of the volume (periodical and newspaper articles, arranged chronologically). Works cited by author and year appear in part 3 of the bibliography (books, arranged alphabetically).

1. The term "conceptual art" has been around since the early 1960s, often meant to stress a conceptual side of paintings seen as not sufficiently expressionistic. Dore Ashton, for instance, referred to the paintings of Larry Poons as "conceptual." Fluxus, a movement seen as anathema by pure conceptualists like Kosuth, found its own early advocate of a "Concept art" in Henry Flynt. Flynt's text of 1961 (published in La Monte Young, ed., *An Anthology* [New York, 1963]) apparently gained currency after, if not because of, the later movement associated with Robert Barry, Douglas Huebler, Kosuth, and Lawrence Weiner in America and the group Art & Language in England. According to Roberta Smith (1981), on the other hand, it was Edward Kienholz who coined the term "conceptual art" in the early 1960s, but, as she goes on to indicate, the term received its first theoretical exegesis in 1967 with Sol LeWitt's "Paragraphs on Conceptual Art" (*Artforum* 5, no. 10, Summer 1967, pp. 79–83). This text was published the same year as the catalogue *Non-Anthropomorphic Art*, in which the then unknown Kosuth also proposed an art made of "conceptual rather than found material" in notes dated 1966.

2. This shift from the making of mere objects to an investigation of all the implications of the concept of art characterized conceptual art at its inception in the 1960s. At that time, critics spoke of a true conflation of the separate realms of art and art criticism as well as of a restoration of art to the artists. For a discussion of this point, see L. R. Lippard and J. Chandler (February 1968); S. Siegelaub and C. Harrison (December 1969); J. Burnham (February 1970); and U. Meyer (1972, especially Introduction). Kosuth and the British group Art & Language (whose founders in 1968 were Terry Atkinson, David

Bainbridge, Michael Baldwin, and Harold Hurrell) were also resolute in claiming for the conceptual artist the right to internalize the former functions of art criticism and theory. In the editorial to the first issue of the journal *Art-Language* (Coventry, May 1968), while discussing the recent outcome of conceptualism in Britain and America, the group advanced that their very editorial, "in itself an attempt to evince some outliners as to what 'conceptual art' is," could be "held out as a 'conceptual art' work."

3. Kosuth's admiration for Reinhardt dates back to their first encounter in 1964, when Reinhardt was a visiting artist at the Cleveland Art Institute and Kosuth a student. Here Reinhardt gave a lecture that, while it found the public indifferent and hostile, apparently highly impressed the young Kosuth. Once in New York, Kosuth visited Reinhardt's studio on several occasions and the two became better acquainted, often taking walks around Union Square and Washington Square Park and having lunch together. In May 1966, Kosuth and Christine Kozlov wrote a term paper at the School of Visual Arts entitled "Ad Reinhardt: Evolution into Darkness—the Art of an Informal Formalist; Negativity, Purity, and the Clearness of Ambiguity."

4. For the reputation of Robert Barry, Douglas Huebler, Kosuth, and Lawrence Weiner in America, see G. Guercio (1989). As to the European reception of Kosuth and other conceptualists, see a forthcoming issue of *Figure* (Rome).

5. Cf. P. Schjeldahl (August 1970); R. Smith (September 1988). For a review of the criticism that reevaluated conceptual art during the mid-eighties, among others, see: R. Morgan (December 1981; January 1988; February 1989); A. Trimarco (January 1983); C. Le Vine (June–August 1985); M. A. Staniszewski (November–December 1988).

6. Prior to Kosuth's text of 1969, the references to analytical philosophy of language most notably helped writers to discuss minimalism's concern with reduction in terms of immanence, concrete thereness, and serial character of the art object. See, among others, B. Rose, "ABC Art," *Art in America* 53, no. 5 (October–November 1965), pp. 57–69; J. Perrault, "Union-Made, Report on a Phenomenon, A Minimal Future?," *Arts Magazine* 41, no. 5 (March 1967), pp. 26–35; M. Bochner, "Serial Art Systems: Solipsism," *Arts Magazine* 41, no. 8 (Summer 1967), pp. 39–42; and M. Bochner, "The Serial Attitude," *Artforum* 6, no. 4 (December 1967), pp. 28–33.

7. In Judd's works and writings during the 1960s there was not only a clear attempt to come up with "forms" that are neither painting nor sculpture but also the will to grasp art as a "whole." As the artist argued in "Specific Objects" of 1965: "The thing as a whole, its quality as a whole, is what is interesting" (here quoted from D. Judd, *Complete Writings 1959–1975* [Halifax: Nova Scotia College of Art and Design, 1975], p. 187). Another link between Judd and Kosuth can be found, for instance, in the former's discontent toward C. Greenberg and M. Fried (cf. "Complaints," *Studio International* 177, no. 910, April 1969, pp. 182–184) and the attack perpetuated in "Art after Philosophy" against a formalist aesthetic, mainly individuated in the works of Greenberg and Fried.

8. In the numerous interviews and talks given during the 1960s, Duchamp often stressed aesthetic indifference. In the well-known "Apropos of Readymades" of 1961 (a talk delivered by Duchamp at the "Art of Assemblage" symposium at the Museum of Modern Art, New York, 19 October 1961, and later published in *Art and Artists* 1, no. 4 [July 1966, p. 47]), the artist maintained that the choice of the "readymades" was founded upon "a reaction of visual indifference . . . in fact a complete anesthesia." More emphatic still was the 1962 letter from Duchamp to Hans Richter, quoted in Richter's book *Dada Art and Anti-Art* (New York: Abrams, 1965), pp. 207–208: "When I discov-

ered ready-mades I thought to discourage aesthetics. In Neo-Dada they have taken my ready-mades and found aesthetic beauty in them. I threw the bottle-rack and the urinal into their faces as a challenge and now they admire them for their aesthetic beauty."

9. A great deal has been written about Duchamp's readymades, and no doubt fascinating researches into their significance are continuing. Kosuth seems to emphasize their ideational aspect as well as their capacity to expose art's functional and contextual value, thus apparently combining two lines of interpretation more or less current at that time. The former, stressing intentional designation, and probably dating back to a 1934 issue of *Minotaure* in which A. Breton defined the readymades as manufactured objects promoted to the dignity of art through the sole choice of the artist, had found eminent advocates in the writings of H. and S. Janis, R. Lebel, G. H. Hamilton, and the group Art & Language. The latter line of interpretation, instead, only originated in the late 1960s; foregrounding the readymade's virtue of denouncing art as a social institution, it rendered Duchamp a key figure in the development of the "institutional theory"—a notion that would take various shapes throughout the writings of A. C. Danto, G. Dickie, and P. Bürger (for Bürger's definition of "institutional critique," see below, note 19).

10. See for instance M. Duchamp, "L'Artist doit-il aller a l'université?," speech delivered at Hofstra University, 13 May 1960. Reprinted in M. Duchamp, *Duchamp du Signe* (Paris: Flammarion, 1975), pp. 236–239.

11. Ad Reinhardt, "Art-as-Art," *Art International* (December 1962). Here quoted from B. Rose, ed., *Art-as-Art: The Selected Writings of Ad Reinhardt* (New York: Viking, 1975), p. 53.

12. Ad Reinhardt, "What Is Corruption?," excerpts from a panel discussion with Milton Resnick, first published in *Scrap* (New York), January 20, 1961. Here quoted from B. Rose, ed., *Art-as-Art*, p. 153: "What would corruption be in art? . . . My answer would be in the art that's too available, too loose, too open, too poetic. I would say it permits too many people to project their own ideas in it, and I don't like to see art that open, so that at some point almost anything goes, almost anyone could do it."

13. Ibid., p. 155: "Not only the artist's art becomes a manipulated symbol, the artist himself becomes a manipulated symbol, and in this climate the idea of what the artist is and what his work is ought to be questioned. For example, the latest *Life* article about avant-garde art that I saw was involved with Still, DeKooning, and Rothko, and they permitted their work to be treated as flames, girders, grasses, and sunsets. Now does the art permit this? If the art permits *Life* magazine making anything they want of it, this may make for a corrupt situation, too. A kind of art, perhaps, that seems to excite or entertain, perhaps. That way it seems to be accessible and maybe it's involved in quickly exhausted values, in a kind of built-in obsolescence."

14. Moreover, as L. Aloisio and F. Menna demonstrated in a lecture of 1972 (published 1973), Kosuth's equation between art and tautology in 1969 presented problems analogous to those faced some years earlier by modern logicians (chiefly Tarski and Gödel), who had to acknowledge the limits of any program of self-reference as well as the impossibility of reaching an exhaustive linguistic formalization of concepts.

15. *The Fox* initiated from conversations between Sarah Charlesworth and Kosuth in Italy in the summer of 1974. The name of the magazine was chosen with reference to Isaiah Berlin's book *The Hedgehog and The Fox*; its first issue, published by the Art & Language Foundation, appeared in 1975. The editorial board was composed of Kosuth

and Charlesworth as well as by disaffected members of the New York Art & Language group: Ian Burn, Michael Corris, Preston Heller, Andrew Menard, and Mel Ramsden. For a detailed review of the climate of those years, see N. Marmer's article (July–August 1977), from which I have largely drawn. As she remarks with regard to *The Fox*'s short life, "In late spring 1976 . . . a majority of the Foundation's members decided to adopt more orthodox Marxist-Leninist positions and to collectivize their group. . . . Since most of the Art and Language people already worked and tended to exhibit together, it was Kosuth . . . who was conspicuously singled out by the decision. Refusing to submit to the new orthodoxy, he and Charlesworth withdrew, effectively dissolving the Foundation and ending the life of *The Fox*" (p. 66).

16. S. Charlesworth, "A Declaration of Dependence," *The Fox* 1, no. 1 (1975), p. 5.

17. Ibid., pp. 5–6.

18. In 1973–74, Kosuth studied cultural anthropology at the Graduate Faculty for Social Research of the New School with Stanley Diamond and Bob Scholte. For Diamond and Scholte's definitions of the "engaged" anthropologist, see their papers in D. Hymes, ed., *Reinventing Anthropology* (New York: Random House, 1969).

19. Cf. P. Bürger, *Theorie der Avantgarde* (Frankfurt: Suhrkamp, 1974); English trans. of the second German ed. (1980) by M. Shaw, with foreword by J. Schulte-Sasse, *Theory of the Avant-Garde* (Minneapolis: University of Minnesota Press, 1984). Arguing that the existence of a true avant-garde became possible at all only at the beginning of our century and lasted for a limited time, Bürger identifies the notion of avant-garde with a thorough critique of art as a social institution. Since it "no longer criticizes schools that preceded it, but criticizes art as an institution, and the course its development took in bourgeois society" (1984, p. 22), Dadaism represents for the writer the most radical movement within the European avant-garde. Unfortunately Bürger's refusal to consider individual agencies in the history and theory of the avant-garde somewhat undermines the decisive definition of institutional critique he so poignantly develops out of the emancipatory project envisaged in the historical avant-garde. Such a dismissal of the artist, in fact, not only flies in the face of all the historical evidence that, from Courbet to Duchamp (whose readymades he extensively discusses), avant-garde artists either considered themselves or were described as "individuals" formed through a deliberate act of resistance to art as an institution; it moreover frustrates any call for concrete human responsibilities, editing out the possibility of advancing self-criticism (what Bürger rightly takes as one of the most preeminent features of avant-garde art) to an understanding of those dynamics internal to the artistic apparatus.

20. Though seen in a different perspective, the series *Cathexis* has been interestingly analyzed by C. Le Vine (June–August 1985).

21. For Kosuth's views on Freud, see R. Morgan (January 1988), A. Trimarco (1982; 1990), and especially this writer's interview with the artist (1985) now translated into English by K. Richter and C. Le Vine and reprinted in *Joseph Kosuth: Interviews*, preface by C. Le Vine.

22. G. Inboden (1981), evincing the presence of these shifts of focus in Kosuth's thinking, has analyzed the artist's growing interest in the critical role of the viewer. E. Migliorini (1972) and L. Aloisio and F. Menna (1973) seem to agree in observing that, as early as 1970, Kosuth clearly began to lose faith in an exhaustive definition of art as tautology and took greater interest in the notion of art as a "context."

TEXT

NOTES ON CONCEPTUAL ART AND MODELS

I will omit, but I will not distort.
—Cleveland Amory

Art objects or structures that are facts in themselves, whose entities exist self-realized actually in this world (although by their uselessness often separate from it) are not illusions. Because they are art they need no feelings, history, or future. Art is art, nothing more, nothing less. If real art is not interesting, find a more humanistic game.

The implications of recent art are obvious. Painting is both a noun and a verb. How things were made was once important. The final object is now important.

Hope, the inability to accept things as they are, was once an aspect of art. It no longer is. Objects that are art are excluded from the qualities man judges man by.

My art objects are total, complete, and disinterested. They are made of non-organic, non-polar, completely synthetic, completely unnatural, yet of conceptual rather than found materials.

JUNE, 1966

It is not by mere chance that all of the work done by me included in this exhibit is labeled 'model'. All I make are models. The actual works of art are ideas. Rather than 'ideals' the models are a visual approximation of a particular art object I have in mind. It does not matter who actually makes the model, nor where the model ends up. The models are real and actual

First published as "Statement" in *Non-Anthropomorphic Art by Four Young Artists* [ex. cat.] (New York: Lannis Gallery [Museum of Normal Art], 1967).

and are beautiful in more or less proportion to other models and who they are being viewed by. In so far as they are, as models, objects concerned with art—they are art objects.

FEBRUARY, 1967

If a growth seems to exist to those familiar with my comparatively short history as a maker of art objects, it is an illusion. Each art object exists as an isolated event, without reference to time. When each art object was made I had a particular interest. If there is a continuum it exists in the similarity of my interests.

When I say that "Each art object exists as an isolated event, without reference to time," I could add as well, "or meaning." Yet, I do not intend to deny or reject its philosophical implications. Its uselessness, on another level, leaves little but that as a quality. An art object concerned totally with art (in as much as it is concerned with nothing else) must take the properties of an order, a logic of one kind or another to keep from taking the shape of other things which cannot be controlled, as well as to eliminate an association with elements embodying their own particular qualities.

SEPTEMBER, 1966

Several artists in process today are over-using mathematics, in one way or another in their work. This is unfortunate. There is no sense in glorifying mathematics. Math is merely a tool. Artists use tools. Math is either math or it is not math, but it is not art. Mathematics does make it possible for a structure or object to have an order not associated with natural or useful objects. But orders can have their limitations. Particular artists not very interested in art get 'hung-up' in the order. Art *is* boring.

This plight of order-over-art is unfortunate for various reasons. What is most unfortunate is that it, I do not think, is in the particular interests of these artists for it to occur. This is somewhat fixed, because the term artist implies a primary interest in art.

Order, when used by particular artists, becomes a 'hidden motive' and a secret inside.

NOVEMBER, 1966

Basically, theoretical subjects such as science and philosophy arrive at an epistemological level directly or indirectly through the perception of the physical or tangible. The accuracy in which we perceive the world directly corresponds to the perceptivity of our apparatus; thus, the entire base of our knowledge exists entirely on a projection, empirically based on a general idea we have acquired through experience of what seems to be and what seems not to be. All thought or knowledge or 'truth' is man-made.

Numbers exist only within the realm of mathematics because mathematics is itself man-made. Other pursuits such as science and philosophy are dealt with as both theory and as a truth or as reality. An acceptance of one aspect (such as theory) diminishes your belief in the other (as real or true). One can understand both of these aspects, but to deal with it one must in one manner or another 'pretend' that it is real or true. If, however, one believes that it is (without doubt) true or real it is then to him *a priori* in nature. If it is *a priori* (like a religious belief) it is then an actual part of his reality and world; in a sense he is connected to it, and could not disassociate himself from it.

In the past man has considered the picture of the world which was given to him by his vision as being totally true or real and absolute. The mathematical perspective invented by renaissance scientists gave the artists an opportunity to make 'real' works of art. Modern scientists have realized the limitations of our vision. Technological 'aids' to vision, such as the advanced microscope or telescope, show us how much we don't see. If man's natural vision could see molecules or distant planets, surely his consideration of reality would be much different. The level of our perception of the world around us is arbitrarily arrived at by our vision. Just as we would not consider the world of a man blind since birth as absolute and real, neither should we consider our own.

Art that implies this absolute view of reality is an art of another age. 'Realistic' art can be only considered real by projecting oneself into the fictive reality of the art work. This anthropomorphic projecting is neither intelligent nor artistic.

Art seems to be the man-made theory or idea made perceptible, yet useless. The idea of beauty in art has simply expanded to mean the enjoyment-appreciation-interest in *something* transmitted to our consciousness that has importance in itself without any direct or implied usefulness as something else. By its uselessness it is beautiful; there we have its importance. Absolutes can only exist in art theory, because art doesn't 'exist' in that it is without tangible transcending value. The use or tangible transcending value of such pursuits as science and philosophy is replaced by beauty. Beauty in the sense of art is tautological for the idea of *pure or total existence*. Thus, we understand why it must be useless. We can consider the philosophy of art theoretical theory. Love of artistic beauty is dehumanized or non-anthropomorphic love; this is probably what Apollinaire meant when he said that the modern school of painting ". . . wants to visualize beauty disengaged from whatever charm man has for man."

JULY, 1966

EDITORIAL IN 27 PARTS

1. "Intelligence . . . is the faculty of manufacturing artificial objects, especially tools to make tools."

Henri Bergson

2. "He can't play the game anymore. But nobody can get around the paintings anymore either. If you don't know what they're about you don't know what painting is about."

Frank Stella (on Ad Reinhardt's death)

3. "Why could not Mallarmé, after an interval of time, have simply got up from his chair and produced the blank sheet of paper as the poem which he sat down to write?"

Richard Wollheim

4. "Advertisement contains the only truths to be relied on in a newspaper."

Thomas Jefferson

5. "My rackets are run on strictly American lines and they're going to stay that way."

Al Capone

6. "To my mind, to kill in war is not a whit better than to commit ordinary murder."

Albert Einstein

First published in *Straight* 1 (April 1968). *Straight* was edited by Kosuth and published by the School of Visual Arts, New York. Its first issue appeared in April 1968.

7. "People's lack of detachment about themselves surprises me."
Claes Oldenburg

8. "I am proud of the fact that I never invented weapons to kill."
Thomas Edison

9. "Electric light is just another instrument."
Dan Flavin

10. "Opinion says hot and cold, but the reality is atoms and empty space."
Democritus

11. "A painting by Newman is finally no simpler than one by Cézanne."
Donald Judd

12. "Owing to fatigue and constipation I had to give up going to the studio."
Paul Cézanne

13. "The Frenchman has so much tradition he can easily say anything, except what he wants to."
Harold Rosenberg

14. "Some people wanted champagne and caviar when they should have beer and hot dogs."
Dwight D. Eisenhower

15. "We all know temperamental, irrational scientists and abstract, cold-blooded artists."
Harold Taylor

16. "A definition of sculpture: something you bump into when you back up to look at a painting."
Ad Reinhardt

17. "Objective truth must be something non-utilitarian, haughty, refined, remote, august, exalted."
William James

18. "The essence of belief is the establishment of a habit."
Charles S. Peirce

19. "Knowledge consists in understanding the evidence that establishes the fact, not in the belief that it is a fact."
Charles T. Sprading

20. "Anyone who sees and paints a sky green and pastures blue ought to be sterilized."

Adolf Hitler

21. President Coolidge, while riding through Detroit, is credited with the following dialogue with an aide:

Aide: "I see they've painted the street cars in Detroit."

President Coolidge: "Yes. At least on one side."

22. "It is only the shallow people who do not judge by appearances. The mystery of the world is the visible, not the invisible."

Oscar Wilde

23. ". . . in 1922 I ordered by telephone from a sign factory five paints in porcelain enamel. I had the factory's colour chart before me and I sketched my paintings on graph-paper. At the other end of the telephone the factory Superintendent had the same kind of paper divided into squares. He took down the dictated shapes in the correct position."

Moholy-Nagy

24. "When the State is corrupt then the laws are most multiplied."

Tacitus

25. "Discontent is the first step in the progress of a man or a nation."

Oscar Wilde

26. "The artist who wants to develop art beyond its painting possibilities is forced to theory and logic."

Kasimir Malevich

27. "All that is not thought is pure nothingness."

Henri Poincaré

NOTES ON SPECIFIC AND GENERAL

What makes earlier art seem incredible is the air of generality which is connected to a specific object. It *is* a specific, real thing. It's right there in front of you. What it *means* to you beyond its specific physicalness is another issue, an issue related to language. An object always "stands for" the artist's ideas because its value rests outside of the object; i.e. that its reason to exist is connected to an art context. A box in an art context is experienced differently from one out of it. Objects have a tendency to be experienced as an aspect of their 'use' context, and art objects are 'used' for art.

In effect, Judd's work becomes specific characterizations of his general ideas on an experiential level and, paradoxically, are also general characterizations of his specific ideas on a conceptual level.

I have attempted to have my work exist on a general level in as many aspects as possible. Although, of course, in some works the predicate, copula, and the apparent 'subject' of the work are specific as a way of constructing a context for that work, (or as I prefer to call them, 'investigation'.) In the final analysis the work reads as general—and in the more recent work—non-iconic.

Unpublished notes written in 1968.

ART AFTER PHILOSOPHY

PART I

The fact that it has recently become fashionable for physicists themselves to be sympathetic towards religion . . . marks the physicists' own lack of confidence in the validity of their hypotheses, which is a reaction on their part from the anti-religious dogmatism of nineteenth-century scientists, and a natural outcome of the crisis through which physics has just passed.

A. J. Ayer

. . . Once one has understood the Tractatus *there will be no temptation to concern oneself any more with philosophy, which is neither empirical like science nor tautological like mathematics; one will, like Wittgenstein in 1918, abandon philosophy, which, as traditionally understood, is rooted in confusion.*

J. O. Urmson

Traditional philosophy, almost by definition, has concerned itself with the *unsaid.* The nearly exclusive focus on the *said* by twentieth-century analytical linguistic philosophers is the shared contention that the *unsaid* is *unsaid* because it is *unsayable.* Hegelian philosophy made sense in the nineteenth century and must have been soothing to a century that was barely getting over Hume, the Enlightenment, and Kant.[1] Hegel's philosophy was also capable of giving cover for a defense of religious beliefs, supplying an alternative to Newtonian mechanics, and fitting in with the growth of history as a discipline, as well as accepting Darwinian biology.[2]

First published in *Studio International* (London) 178, no. 915 (October 1969), pp. 134–137; no. 916 (November 1969), pp. 160–161; no. 917 (December 1969), pp. 212–213.

He appeared to give an acceptable resolution to the conflict between theology and science, as well.

The result of Hegel's influence has been that a great majority of contemporary philosophers are really little more than *historians* of philosophy, Librarians of the Truth, so to speak. One begins to get the impression that there "is nothing more to be said." And certainly if one realizes the implications of Wittgenstein's thinking, and the thinking influenced by him and after him, 'Continental' philosophy need not seriously be considered here.[3]

Is there a reason for the 'unreality' of philosophy in our time? Perhaps this can be answered by looking into the difference between our time and the centuries preceding us. In the past, man's conclusions about the world were based on the information he had about it—if not specifically like the Empiricists, then generally like the Rationalists. Often, the closeness between science and philosophy was so great that scientists and philosophers were one and the same person. In fact, from the time of Thales, Epicurus, Heraclitus, and Aristotle to Descartes and Leibniz, "the great names in philosophy were often great names in science as well."[4]

That the world as perceived by twentieth-century science is vastly more different than the one of its preceding century, need not be proved here. Is it possible, then, that in effect man has learned so much, as his 'intelligence' is such, that he cannot *believe* the reasoning of traditional philosophy? That perhaps he knows too much about the world to make those *kinds* of conclusions? As Sir James Jeans has stated:

. . . When philosophy has availed itself of the results of science, it has not been by borrowing the abstract mathematical description of the pattern of events, but by borrowing the then current pictorial description of this pattern; thus it has not appropriated certain knowledge but conjectures. These conjectures were often good enough for the man-sized world, but not, as we now know, for those ultimate processes of nature which control the happenings of the man-sized world, and bring us nearest to the true nature of reality.[5]

He continues:

One consequence of this is that the standard philosophical discussions of many problems, such as those of causality and freewill or of materialism or mentalism, are based on an interpretation of the pattern of events which is no longer tenable. The scientific basis of these older discussions has been washed away, and with their disappearance have gone all the arguments . . .[6]

The twentieth century brought in a time which could be called "the end of philosophy and the beginning of art." I do not mean this, of course, strictly speaking, but rather as the 'tendency' of the situation. Certainly linguistic philosophy can be considered the heir to empiricism, but it's a

philosophy in one gear.[7] And there is certainly an 'art condition' to art preceding Duchamp, but its other functions or reasons-to-be are so pronounced that its ability to function clearly as art limits its art condition so drastically that it's only minimally art.[8] In no mechanistic sense is there a connection between philosophy's 'ending' and art's 'beginning', but I don't find this occurrence entirely coincidental. Though the same reasons may be responsible for both occurrences, the connection is made by me. I bring this all up to analyze art's function and subsequently its viability. And I do so to enable others to understand the reasoning of my art and, by extension, other artists', as well as to provide a clearer understanding of the term 'Conceptual art'.[9]

THE FUNCTION OF ART

The main qualifications to the lesser position of painting is that advances in art are certainly not always formal ones.

Donald Judd (1963)

Half or more of the best new work in the last few years has been neither painting nor sculpture.

Donald Judd (1965)

Everything sculpture has, my work doesn't.

Donald Judd (1967)

The idea becomes a machine that makes the art.

Sol LeWitt (1967)

The one thing to say about art is that it is one thing. Art is art-as-art and everything else is everything else. Art as art is nothing but art. Art is not what is not art.

Ad Reinhardt (1963)

The meaning is the use.

Wittgenstein

A more functional approach to the study of concepts has tended to replace the method of introspection. Instead of attempting to grasp or describe concepts bare, so to speak, the psychologist investigates the way in which they function as ingredients in beliefs and in judgements.

Irving M. Copi

Meaning is always a presupposition of function.

T. Segerstedt

. . . the subject-matter of conceptual investigations is the meaning of certain words and expressions—and not the things and states of affairs

themselves about which we talk, when using those words and expressions.

G. H. Von Wright

Thinking is radically metaphoric. Linkage by analogy is its constituent law or principle, its causal nexus, since meaning only arises through the causal contexts *by which a sign stands for (takes the place of) an instance of a sort. To think of anything is to take it* as *of a sort (as a such and such) and that 'as' brings in (openly or in disguise) the analogy, the parallel, the metaphoric grapple or ground or grasp or draw by which alone the mind takes hold. It takes no hold if there is nothing for it to haul from, for its thinking is the haul, the attraction of likes.*

I. A. Richards

In this section I will discuss the separation between aesthetics and art; consider briefly Formalist art (because it is a leading proponent of the idea of aesthetics as art), and assert that art is analogous to an analytic proposition, and that it is art's existence as a tautology which enables art to remain 'aloof' from philosophical presumptions.

It is necessary to separate aesthetics from art because aesthetics deals with opinions on perception of the world in general. In the past one of the two prongs of art's function was its value as decoration. So any branch of philosophy which dealt with 'beauty' and thus, taste, was inevitably duty bound to discuss art as well. Out of this 'habit' grew the notion that there was a conceptual connection between art and aesthetics, which is not true. This idea never drastically conflicted with artistic considerations before recent times, not only because the morphological characteristics of art perpetuated the continuity of this error, but also because the apparent other 'functions' of art (depiction of religious themes, portraiture of aristocrats, detailing of architecture, etc.) used art to cover up art.

When objects are presented within the context of art (and until recently objects always have been used) they are as eligible for aesthetic consideration as are any objects in the world, and an aesthetic consideration of an object existing in the realm of art means that the object's existence or functioning in an art context is irrelevant to the aesthetic judgement.

The relation of aesthetics to art is not unlike that of aesthetics to architecture, in that architecture has a very specific *function* and how 'good' its design is is *primarily* related to how well it performs its function. Thus, judgements on what it looks like correspond to taste, and we can see that throughout history different examples of architecture are praised at different times depending on the aesthetics of particular epochs. Aesthetic thinking has even gone so far as to make examples of architecture not related to 'art' at all, works of art in themselves (e.g. the pyramids of Egypt).

Aesthetic considerations are indeed *always* extraneous to an object's function or 'reason to be'. Unless of course, the object's 'reason to be' is strictly aesthetic. An example of a purely aesthetic object is a decorative object, for decoration's primary function is "to add something to so as to make more attractive; adorn; ornament,"[10] and this relates directly to taste. And this leads us directly to 'Formalist' art and criticism.[11] Formalist art (painting and sculpture) is the vanguard of decoration, and, strictly speaking, one could reasonably assert that its art condition is so minimal that for all functional purposes it is not art at all, but pure exercises in aesthetics. Above all things Clement Greenberg is the critic of taste. Behind every one of his decisions there is an aesthetic judgement, with those judgements reflecting his taste. And what does his taste reflect? The period he grew up in as a critic, the period 'real' for him: the fifties.[12] Given his theories (if they have any logic to them at all) how else can one account for his disinterest in Frank Stella, Ad Reinhardt, and others applicable to his historical scheme? Is it because he is ". . . basically unsympathetic on personally experiential grounds"?[13] Or, in other words, their work doesn't suit his taste?

But in the philosophic *tabula rasa* of art, "if someone calls it art," as Don Judd has said, "it's art." Given this, formalist painting and sculpture activity can be granted an 'art condition', but only by virtue of its presentation in terms of its art idea (e.g. a rectangularly-shaped canvas stretched over wooden supports and stained with such and such colors, using such and such forms, giving such and such a visual experience, etc.). Looking at contemporary art in this light, one realizes the minimal creative effort taken on the part of formalist artists specifically, and all painters and sculptors (working as such today) generally.

This brings us to the realization that formalist art and criticism accept as a definition of art one which exists solely on morphological grounds. While a vast quantity of similarly looking objects or images (or visually related objects or images) may seem to be related (or connected) because of a similarity of visual/experiential 'readings', one cannot claim from this an artistic or conceptual relationship.

It is obvious then that formalist criticism's reliance on morphology leads necessarily with a bias toward the morphology of traditional art. And in this sense such criticism is not related to a 'scientific method' or any sort of empiricism (as Michael Fried, with his detailed descriptions of paintings and other 'scholarly' paraphernalia would want us to believe). Formalist criticism is no more than an analysis of the physical attributes of particular objects which happen to exist in a morphological context. But this doesn't add any knowledge (or facts) to our understanding of the nature or function of art. Nor does it comment on whether or not the objects analyzed are even works of art, since formalist critics always by-

pass the conceptual element in works of art. Exactly why they don't comment on the conceptual element in works of art is precisely because formalist art becomes art only by virtue of its resemblance to earlier works of art. It's a mindless art. Or, as Lucy Lippard so succinctly described Jules Olitski's paintings: "they're visual *Muzak.*"[14]

Formalist critics and artists alike do not question the nature of art, but as I have said elsewhere: "Being an artist now means to question the nature of art. If one is questioning the nature of painting, one cannot be questioning the nature of art. If an artist accepts painting (or sculpture) he is accepting the tradition that goes with it. That's because the word art is general and the word painting is specific. Painting is a *kind* of art. If you make paintings you are already accepting (not questioning) the nature of art. One is then accepting the nature of art to be the European tradition of a painting-sculpture dichotomy."[15]

The strongest objection one can raise against a morphological justification for traditional art is that morphological notions of art embody an implied *a priori* concept of art's possibilities. But such an *a priori* concept of the nature of art (as separate from analytically framed art propositions or 'work' which I will discuss later) makes it, indeed, *a priori:* impossible to question the nature of art. And this questioning of the nature of art is a very important concept in understanding the function of art.

The function of art, as a question, was first raised by Marcel Duchamp. In fact it is Marcel Duchamp whom we can credit with giving art its own identity. (One can certainly see a tendency toward this self-identification of art beginning with Manet and Cézanne through to Cubism,[16] but their works are timid and ambiguous by comparison with Duchamp's.) 'Modern' art and the work before seemed connected by virtue of their morphology. Another way of putting it would be that art's 'language' remained the same, but it was saying new things. The event that made conceivable the realization that it was possible to 'speak another language' and still make sense in art was Marcel Duchamp's first unassisted readymade. With the unassisted readymade, art changed its focus from the form of the language to what was being said. Which means that it changed the nature of art from a question of morphology to a question of function. This change—one from 'appearance' to 'conception'—was the beginning of 'modern' art and the beginning of 'conceptual' art. All art (after Duchamp) is conceptual (in nature) because art only exists conceptually.

The 'value' of particular artists after Duchamp can be weighed according to how much they questioned the nature of art; which is another way of saying "what they *added* to the conception of art" or what wasn't there before they started. Artists question the nature of art by presenting new propositions as to art's nature. And to do this one cannot concern oneself with the handed-down 'language' of traditional art, since this activity is

based on the assumption that there is only one way of framing art propositions. But the very stuff of art is indeed greatly related to 'creating' new propositions.

The case is often made—particularly in reference to Duchamp—that objects of art (such as the readymades, of course, but all art is implied in this) are judged as *objets d'art* in later years and the artists' *intentions* become irrelevant. Such an argument is the case of a preconceived notion of art ordering together not necessarily related facts. The point is this: aesthetics, as we have pointed out, are conceptually irrelevant to art. Thus, any physical thing can become *objet d'art*, that is to say, can be considered tasteful, aesthetically pleasing, etc. But this has no bearing on the object's application to an art context; that is, its *functioning* in an art context. (E.g. if a collector takes a painting, attaches legs, and uses it as a dining-table it's an act unrelated to art or the artist because, *as art*, that wasn't the artist's *intention*.)

And what holds true for Duchamp's work applies as well to most of the art after him. In other words, the value of Cubism is its idea in the realm of art, not the physical or visual qualities seen in a specific painting, or the particularization of certain colors or shapes. For these colors and shapes are the art's 'language', not its meaning conceptually as art. To look upon a Cubist 'masterwork' *now* as art is nonsensical, conceptually speaking, as far as art is concerned. (That visual information which was unique in Cubism's language has now been generally absorbed and has a lot to do with the way in which one deals with painting 'linguistically'. [E.g. what a Cubist painting meant experimentally and conceptually to, say, Gertrude Stein, is beyond our speculation because the same painting then 'meant' something different than it does now.]) The 'value' now of an original Cubist painting is not unlike, in most respects, an original manuscript by Lord Byron, or *The Spirit of St. Louis* as it is seen in the Smithsonian Institution. (Indeed, museums fill the very same function as the Smithsonian Institution—why else would the *Jeu de Paume* wing of the Louvre exhibit Cezanne's and Van Gogh's palettes as proudly as they do their paintings?) Actual works of art are little more than historical curiosities. As far as *art* is concerned Van Gogh's paintings aren't worth any more than his palette is. They are both 'collector's items'.[17]

Art 'lives' through influencing other art, not by existing as the physical residue of an artist's ideas. The reason why different artists from the past are 'brought alive' again is because some aspect of their work becomes 'usable' by living artists. That there is no 'truth' as to what art is seems quite unrealized.

What is the function of art, or the nature of art? If we continue our analogy of the forms art takes as being art's *language* one can realize then that a work of art is a kind of *proposition* presented within the context

of art as a comment on art. We can then go further and analyze the types of 'propositions'.

A. J. Ayer's evaluation of Kant's distinction between analytic and synthetic is useful to us here: "A proposition is analytic when its validity depends solely on the definitions of the symbols it contains, and synthetic when its validity is determined by the facts of experience."[18] The analogy I will attempt to make is one between the art condition and the condition of the analytic proposition. In that they don't appear to be believable as anything else, nor about anything (other than art) the forms of art most clearly finally referable only to art have been forms closest to analytical propositions.

Works of art are analytic propositions. That is, if viewed within their context—as art—they provide no information what-so-ever about any matter of fact. A work of art is a tautology in that it is a presentation of the artist's intention, that is, he is saying that a particular work of art *is* art, which means, is a *definition* of art. Thus, that it is art is true *a priori* (which is what Judd means when he states that "if someone calls it art, it's art").

Indeed, it is nearly impossible to discuss art in general terms without talking in tautologies—for to attempt to 'grasp' art by any other 'handle' is to merely focus on another aspect or quality of the proposition which is usually irrelevant to the art work's 'art condition'. One begins to realize that art's 'art condition' is a conceptual state. That the language forms which the artist frames his propositions in are often 'private' codes or languages is an inevitable outcome of art's freedom from morphological constrictions; and it follows from this that one has to be familiar with contemporary art to appreciate it and understand it. Likewise one understands why the 'man on the street' is intolerant to artistic art and always demands art in a traditional 'language'. (And one understands why formalist art 'sells like hot cakes'.) Only in painting and sculpture did the artists all speak the same language. What is called 'Novelty Art' by the formalists is often the attempt to find new languages, although a new language doesn't necessarily mean the framing of new propositions: e.g. most kinetic and electronic art.

Another way of stating in relation to art what Ayer asserted about the analytic method in the context of language would be the following: The validity of artistic propositions is not dependent on any empirical, much less any aesthetic, presupposition about the nature of things. For the artist, as an analyst, is not directly concerned with the physical properties of things. He is concerned only with the way (1) in which art is capable of conceptual growth and (2) how his propositions are capable of logically following that growth.[19] In other words, the propositions of art are not

factual, but linguistic in *character*—that is, they do not describe the behaviour of physical, or even mental objects; they express definitions of art, or the formal consequences of definitions of art. Accordingly, we can say that art operates on a logic. For we shall see that the characteristic mark of a purely logical enquiry is that it is concerned with the formal consequences of our definitions (of art) and not with questions of empirical fact.[20]

To repeat, what art has in common with logic and mathematics is that it is a tautology; i.e., the 'art idea' (or 'work') and art are the same and can be appreciated as art without going outside the context of art for verification.

On the other hand, let us consider why art cannot be (or has difficulty when it attempts to be) a synthetic proposition. Or, that is to say, when the truth or falsity of its assertion is verifiable on empirical grounds. Ayer states:

> . . . The criterion by which we determine the validity of an *a priori* or analytical proposition is not sufficient to determine the validity of an empirical or synthetic proposition. For it is characteristic of empirical propositions that their validity is not purely formal. To say that a geometrical proposition, or a system of geometrical propositions, is false, is to say that it is self-contradictory. But an empirical proposition, or a system of empirical propositions, may be free from contradiction, and still be false. It is said to be false, not because it is formally defective, but because it fails to satisfy some material criterion.[21]

The unreality of 'realistic' art is due to its framing as an art proposition in synthetic terms: one is always tempted to 'verify' the proposition empirically. Realism's synthetic state does not bring one to a circular swing back into a dialogue with the larger framework of questions about the nature of *art* (as does the work of Malevich, Mondrian, Pollock, Reinhardt, early Rauschenberg, Johns, Lichtenstein, Warhol, Andre, Judd, Flavin, LeWitt, Morris, and others), but rather, one is flung out of art's 'orbit' into the 'infinite space' of the human condition.

Pure Expressionism, continuing with Ayer's terms, could be considered as such: "A sentence which consisted of demonstrative symbols would not express a genuine proposition. It would be a mere ejaculation, in no way characterizing that to which it was supposed to refer." Expressionist works are usually such 'ejaculations' presented in the morphological language of traditional art. If Pollock is important it is because he painted on loose canvas horizontally to the floor. What *isn't* important is that he later put those drippings over stretchers and hung them parallel to the wall. (In other words, what is important in art is what one *brings* to it, not one's adoption of what was previously existing.) What is even less

important to art is Pollock's notions of 'self-expression' because those *kinds* of subjective meanings are useless to anyone other than those involved with him personally. And their 'specific' quality puts them outside of art's context.

"I do not make art," Richard Serra says, "I am engaged in an activity; if someone wants to call it art, that's his business, but it's not up to me to decide that. That's all figured out later." Serra, then, is very much aware of the implications of his work. If Serra is indeed just "figuring out what lead does" (gravitationally, molecularly, etc.) why should *anyone* think of it as art? If he doesn't take the responsibility of it being art, who can, or should? His work certainly appears to be empirically verifiable: lead can do and be used for many physical activities. In itself this does anything but lead us into a dialogue about the nature of art. In a sense then he is a primitive. He has no idea about art. How is it then that we know about 'his activity'? Because he has told us it is art by his actions *after* 'his activity' has taken place. That is, by the fact he is with several galleries, puts the physical residue of his activity in museums (and sells them to art collectors—but as we have pointed out, collectors are irrelevant to the 'condition of art' of a work). That he denies his work is art but plays the artist is more than just a paradox. Serra secretly feels that 'arthood' is arrived at empirically. Thus, as Ayer has stated: "There are no absolutely certain empirical propositions. It is only tautologies that are certain. Empirical questions are one and all hypotheses, which may be confirmed or discredited in actual sense-experience. And the propositions in which we record the observations that verify these hypotheses are themselves hypotheses which are subject to the test of further sense-experience. Thus there is no final proposition."[22]

What one finds all throughout the writings of Ad Reinhardt is this very similar thesis of 'art-as-art', and that "art is always dead, and a 'living' art is a deception."[23] Reinhardt had a very clear idea about the nature of art, and his importance is far from being recognized.

Forms of art that can be considered synthetic propositions are verifiable by the world, that is to say, to understand these propositions one must leave the tautological-like framework of art and consider 'outside' information. But to consider it as art it is necessary to ignore this same outside information, because outside information (experiential qualities, to note) has its own intrinsic worth. And to comprehend this worth one does not need a state of 'art condition'.

From this it is easy to realize that art's viability is not connected to the presentation of visual (or other) kinds of experience. That this may have been one of art's extraneous functions in the preceding centuries is not unlikely. After all, man in even the nineteenth-century lived in a fairly

standardized visual environment. That is, it was ordinarily predictable as to what he would be coming into contact with day after day. His visual environment in the part of the world in which he lived was fairly consistent. In our time we have an experientially drastically richer environment. One can fly all over the earth in a matter of hours and days, not months. We have the cinema, and color television, as well as the man-made spectacle of the lights of Las Vegas or the skyscrapers of New York City. The whole world is there to be seen, and the whole world can watch man walk on the moon from their living rooms. Certainly art or objects of painting and sculpture cannot be expected to compete experientially with this?

The notion of 'use' is relevant to art and its 'language'. Recently the box or cube form has been used a great deal within the context of art. (Take for instance its use by Judd, Morris, LeWitt, Bladen, Smith, Bell, and McCracken—not to mention the quantity of boxes and cubes that came after.) The difference between all the various uses of the box or cube form is directly related to the differences in the intentions of the artists. Further, as is particularly seen in Judd's work, the use of the box or cube form illustrates very well our earlier claim that an object is only art when placed in the context of art.

A few examples will point this out. One could say that if one of Judd's box forms was seen filled with debris, seen placed in an industrial setting, or even merely seen sitting on a street corner, it would not be identified with art. It follows then that understanding and consideration of it as an art work is necessary *a priori* to viewing it in order to 'see' it as a work of art. Advance information about the concept of art and about an artist's concepts is necessary to the appreciation and understanding of contemporary art. Any and all of the physical attributes (qualities) of contemporary works if considered separately and/or specifically are irrelevant to the art concept. The art concept (as Judd said, though he didn't mean it this way) must be considered in its whole. To consider a concept's parts is invariably to consider aspects that are irrelevant to its art condition— or like reading *parts* of a definition.

It comes as no surprise that the art with the least fixed morphology is the example from which we decipher the nature of the general term 'art'. For where there is a context existing separately of its morphology and consisting of its function one is more likely to find results less conforming and predictable. It is in modern art's possession of a 'language' with the shortest history that the plausibility of the abandonment of that 'language' becomes most possible. It is understandable then that the art that came out of Western painting and sculpture is the most energetic, questioning (of its nature), and the least assuming of all the general 'art' concerns. In

the final analysis, however, all of the arts have but (in Wittgenstein's terms) a 'family' resemblance.

Yet the various qualities relatable to an 'art condition' possessed by poetry, the novel, the cinema, the theatre, and various forms of music, etc., is that aspect of them most reliable to the function of art as asserted here.

Is not the decline of poetry relatable to the implied metaphysics from poetry's use of 'common' language as an art language?[24] In New York the last decadent stages of poetry can be seen in the move by 'Concrete' poets recently toward the use of actual objects and theatre.[25] Can it be that they feel the unreality of their art form?

We see now that the axioms of a geometry are simply definitions, and that the theorems of a geometry are simply the logical consequences of these definitions. A geometry is not in itself about physical space; in itself it cannot be said to be 'about' anything. But we can use a geometry to reason about physical space. That is to say, once we have given the axioms a physical interpretation, we can proceed to apply the theorems to the objects which satisfy the axioms. Whether a geometry can be applied to the actual physical world or not, is an empirical question which falls outside the scope of geometry itself. There is no sense, therefore, in asking which of the various geometries known to us are false and which are true. In so far as they are all free from contradiction, they are all true. The proposition which states that a certain application of a geometry is possible is not itself a proposition of that geometry. All that the geometry itself tells us is that if anything can be brought under the definitions, it will also satisfy the theorems. It is therefore a purely logical system, and its propositions are purely analytic propositions.

A. J. Ayer[26]

Here then I propose rests the viability of art. In an age when traditional philosophy is unreal because of its assumptions, art's ability to exist will depend not only on its *not* performing a service—as entertainment, visual (or other) experience, or decoration—which is something easily replaced by kitsch culture and technology, but rather, it will remain viable by *not* assuming a philosophical stance; for in art's unique character is the capacity to remain aloof from philosophical judgements. It is in this context that art shares similarities with logic, mathematics and, as well, science. But whereas the other endeavors are useful, art is not. Art indeed exists for its own sake.

In this period of man, after philosophy and religion, art may possibly be one endeavor that fulfills what another age might have called 'man's spiritual needs'. Or, another way of putting it might be that art deals analogously with the state of things 'beyond physics' where philosophy had to make assertions. And art's strength is that even the preceding sentence is an assertion, and cannot be verified by art. Art's only claim is for art. Art is the definition of art.

PART II
'CONCEPTUAL ART' AND RECENT ART

*The disinterest in painting and sculpture is a disinterest in doing it again,
not in it as it is being done by those who developed the last advanced
versions. New work always involves objections to the old. They are part
of it. If the earlier work is first rate it is complete.*

Donald Judd (1965)

*Abstract art or non-pictorial art is as old as this century, and though
more specialized than previous art, is clearer and more complete, and
like all modern thought and knowledge, more demanding in its grasp of
relations.*

Ad Reinhardt (1948)

*In France there is an old saying, 'stupid like a painter'. The painter was
considered stupid, but the poet and writer very intelligent. I wanted to
be intelligent. I had to have the idea of inventing. It is nothing to do
what your father did. It is nothing to be another Cézanne. In my visual
period there is a little of that stupidity of the painter. All my work in the
period before the Nude was visual painting. Then I came to the idea. I
thought the ideatic formulation a way to get away from influences.*

Marcel Duchamp

*For each work of art that becomes physical there are many variations
that do not.*

Sol LeWitt

*The main virtue of geometric shapes is that they aren't organic, as all art
otherwise is. A form that's neither geometric or organic would be a great
discovery.*

Donald Judd (1967)

*The one thing to say about art is its breathlessness, lifelessness, death-
lessness, contentlessness, formlessness, spacelessness, and timelessness.
This is always the end of art.*

Ad Reinhardt (1962)

Note: The discussion in the previous part does more than merely 'justify'
the recent art called 'conceptual'. It points out, I feel, some of the confused
thinking which has gone on in regards to past—but particularly—present
activity in art. This article is not intended to give evidence of a 'move-
ment'. But as an early advocate (through works of art and conversation)
of a particular kind of art best described as 'Conceptual' I have become
increasingly concerned by the nearly arbitrary application of this term to
an assortment of art interests—many of which I would never want to be
connected with, and logically shouldn't be.

The 'purest' definition of conceptual art would be that it is inquiry into
the foundations of the concept 'art', as it has come to mean. Like most

terms with fairly specific meanings generally applied, 'Conceptual Art' is often considered as a *tendency*. In one sense it is a tendency of course because the 'definition' of 'Conceptual Art' is very close to the meanings of art itself.

But the reasoning behind the notion of such a tendency, I am afraid, is still connected to the fallacy of morphological characteristics as a connective between what are really disparate activities. In this case it is an attempt to detect stylehood. In assuming a primary cause-effect relationship to 'final outcomes', such criticism by-passes a particular artist's intents (concepts) to deal exclusively with his 'final outcome'. Indeed most criticism has dealt with only one very superficial aspect of this 'final outcome', and that is the apparent 'immateriality' or 'anti-object' similarity amongst most 'conceptual' works of art. But this can only be important if one assumes that objects are necessary to art—or to phrase it better, that they have a definitive relation to art. And in this case such criticism would be focusing on a negative aspect of the art.

If one has followed my thinking (in part one) one can understand my assertion that objects are conceptually irrelevant to the condition of art. This is not to say that a particular 'art investigation' may or may not employ objects, material substances, etc. within the confines of its investigation. Certainly the investigations carried out by Bainbridge and Hurrell are excellent examples of such a use.[27] Although I have proposed that all art is finally conceptual, some recent work is clearly conceptual in intent whereas other examples of recent art are only related to conceptual art in a superficial manner. And although this work is in most cases an advance over Formalist or 'Anti-Formalist' (Morris, Serra, Sonnier, Hesse, and others) tendencies, it should not be considered 'Conceptual Art' in the *purer* sense of the term.

Three artists often associated with me (through Seth Siegelaub's projects)—Douglas Huebler, Robert Barry, and Lawrence Weiner—are not concerned with, I do not think, 'Conceptual Art' as it was previously stated. Douglas Huebler, who was in the *Primary Structures* show at the Jewish Museum (New York), uses a non-morphologically art-like form of presentation (photographs, maps, mailings) to answer iconic, structural sculpture issues directly related to his formica sculpture (which he was making as late as 1968). This is pointed out by the artist in the opening sentence of the catalogue of his 'one-man show' (which was organized by Seth Siegelaub and existed only as a catalogue of documentation): "The existence of each sculpture is documented by its documentation." It is not my intention to point out a *negative* aspect of the work, but only to show that Huebler—who is in his mid-forties and much older than most of the artists discussed here—has not as much in common with the aims in the *purer* versions of 'Conceptual Art' as it would superficially seem.

The other men—Robert Barry and Lawrence Weiner—have watched their work take on a 'Conceptual Art' association almost by accident. Barry, whose painting was seen in the *Systemic Painting* show at the Guggenheim Museum, has in common with Weiner the fact that the 'path' to conceptual art came via decisions related to choices of art materials and processes. Barry's post-Newman/Reinhardt paintings 'reduced' (in physical material, not 'meaning') along a path from two-inch square paintings, to single lines of wire between architectural points, to radio-wave beams, to inert gases, and finally to 'brain energy'. His work then seems to exist conceptually only because the material is invisible. But his art does have a physical state, which is different than work which only exists conceptually.

Lawrence Weiner, who gave up painting in the spring of 1968, changed his notion of 'place' (in an Andrean sense) from the context of the canvas (which could only be specific) to a context which was 'general', yet all the while continuing his concern with specific materials and processes. It became obvious to him that if one is not concerned with 'appearance' (which he wasn't, and in this regard he preceded most of the 'Anti-Form' artists) there was not only no need for the fabrication (such as in his studio) of his work, but—more important—such fabrication would again invariably give his work's 'place' a specific context. Thus, by the summer of 1968, he decided to have his work exist only as a proposal in his notebook—that is, until a 'reason' (museum, gallery, or collector) or as he called them, a 'receiver' necessitated his work to be made. It was in the late fall of that same year that Weiner went one step further in deciding that it didn't matter whether it was made or not. In that sense his private notebooks became public.[28]

Purely conceptual art is first seen concurrently in the work of Terry Atkinson and Michael Baldwin in Coventry, England; and with my own work done in New York City, all generally around 1966.[29] On Kawara, a Japanese artist who has been continuously travelling around the world since 1959, has been doing a highly conceptualized kind of art since 1964.

On Kawara, who began with paintings lettered with one simple word, went to 'questions' and 'codes', and paintings such as the listing of a spot on the Sahara Desert in terms of its longitude and latitude, is most well known for his 'date' paintings. The 'date' paintings consist of the lettering (in paint on canvas) of that day's date on which the painting is executed. If a painting is not 'finished' on the day that it is started (that is, by 12:00 midnight) it is destroyed. Although he still does the date paintings (he spent last year travelling to every country in South America) he has begun doing other projects as well in the past couple of years. These include a *One-hundred year calendar*, a daily listing of everyone he meets each day

(*I met*) which is kept in notebooks, as is *I went* which is a calendar of maps of the cities he is in with the marked streets where he travelled. He also mails daily postcards giving the time he woke up that morning. On Kawara's reasons for his art are extremely private, and he has consciously stayed away from any publicity or public art-world exposure. His continued use of 'painting' as a medium is, I think, a pun on the morphological characteristics of traditional art, rather than an interest in painting 'proper'.

Terry Atkinson and Michael Baldwin's work, presented as a collaboration, began in 1966 consisting of projects such as: a rectangle with linear depictions of the states of Kentucky and Iowa, titled *Map to not include: Canada, James Bay, Ontario, Quebec, St. Lawrence River, New Brunswick . . .* and so on; conceptual drawings based on various serial and conceptual schemes; a map of a 36-square-mile area of the Pacific Ocean, west of Oahu, scale 3 inches to the mile (an empty square). Works from 1967 were the *Air conditioning show* and the *Air show.* The *Air show* as described by Terry Atkinson was, "A series of assertions concerning a theoretical usage of a column of air comprising a base of one square mile and of unspecified distance in the vertical dimension."[30]

No particular square mile of the earth's surface was specified. The concept did not entail any such particular location. Also such works as *Frameworks, Hot-cold,* and *22 sentences: the French army* are examples of their more recent collaborations.[31] Atkinson and Baldwin in the past year have formed, along with David Bainbridge and Harold Hurrell, the Art & Language Press. From this press is published *Art-Language,* (a journal of conceptual art),[32] as well as other publications related to this enquiry.

Christine Kozlov has been working along conceptual lines as well since late 1966. Some of her work has consisted of a 'conceptual' film, using clear Leder tape; *Compositions for audio structures*—a coding system for sound; a stack of several hundred blank sheets of paper—one for each day on which a concept is rejected; *Figurative work* which is a listing of everything she ate for a period of six months; and a study of crime as an art activity.

The Canadian Iain Baxter has been doing a 'conceptual' sort of work since late 1967. As have the Americans James Byars and Frederic Barthelme; and the French and German artists Bernar Venet and Hanne Darboven. And certainly the books of Edward Ruscha since around that time are relevant too. As are *some* of Bruce Nauman's, Barry Flanagan's, Bruce McLean's, and Richard Long's works. Steven Kaltenbach *Time capsules* from 1968, and much of his work since is relatable. And Ian Wilson's post-Kaprow *Conversations* are conceptually presented.

The German artist Franz E. Walther in his work since 1965 has treated objects in a much different way than they are usually treated in an art context.

Within the past year other artists, though some only related peripherally, have begun a more 'conceptual' form of work. Mel Bochner gave up work heavily influenced by 'Minimal' art and began such work. And certainly some of the work by Jan Dibbets, Eric Orr, Allen Ruppersberg, and Dennis Oppenheim could be considered within a conceptual framework. Donald Burgy's work in the past year as well uses a conceptual format. One can also see a development in a *purer* form of 'conceptual' art in the recent beginnings of work by younger artists such as Saul Ostrow, Adrian Piper, and Perpetua Butler. Interesting work in this 'purer' sense is being done, as well, by a group consisting of an Australian and two Englishmen (all living in New York): Ian Burn, Mel Ramsden, and Roger Cutforth. (Although the amusing pop paintings of John Baldessari allude to this sort of work by being 'conceptual' cartoons of actual conceptual art, they are not really relevant to this discussion.)

Terry Atkinson has suggested, and I agree with him, that Sol LeWitt is notably responsible for creating an environment which made our art acceptable, if not conceivable. (I would hastily add to that, however, that I was certainly much more influenced by Ad Reinhardt, Duchamp via Johns and Morris, and by Donald Judd than I ever was specifically by LeWitt.) Perhaps added to conceptual art's history would be certainly early works by Robert Morris, particularly the *Card File* (1962). Much of Rauschenberg's early work such as his *Portrait of Iris Clert* and his *Erased DeKooning Drawing* are some important examples of a conceptual kind of art. And the Europeans Klein and Manzoni fit into this history somewhere, too. And in Jasper Johns' work—such as his *Target* and *Flag* paintings and his ale cans—one has a particularly good example of art existing as an analytical proposition. Johns and Reinhardt are probably the last two painters that were legitimate *artists* as well.[33] Robert Smithson, *had* he recognized his articles in magazines as being his work (as he could have, and should have) and his 'work' serving as illustrations for them, his influence would be more relevant.[34]

Andre, Flavin, and Judd have exerted tremendous influence on recent art, though probably more as examples of high standards and clear thinking than in any specific way. Pollock and Judd are, I feel, the beginning and end of American dominance in art; partly due to the ability of many of the younger artists in Europe to 'purge' themselves of their traditions, but most likely due to the fact that nationalism is as out of place in art as it is in any other field. Seth Siegelaub, a former art dealer who now functions as a curator-at-large and was the first exhibition organizer to 'specialize' in this area of recent art, has had many group exhibitions that

existed no *place* (other than in the catalogue). As Siegelaub has stated: "I am very interested in conveying the idea that the artist can live where he wants to—not necessarily in New York or London or Paris as he has had to in the past—but *anywhere* and still make important art."

<div align="center">PART III</div>

I suppose my first 'conceptual' work was the *Leaning Glass* from 1965. It consists of any five foot square sheet of glass to be leaned against any wall. It was shortly after this that I got interested in water because of its formless, colorless quality. I used water in every way I could imagine— blocks of ice, radiator steam, maps with areas of water used in a system, picture postcard collections of bodies of water, and so on until *1966* when I had a photostat made of the dictionary definition of the word water, which for me at that time was a way of just presenting the *idea* of water. I used a dictionary definition once before that, in late 1965, in a piece which consisted of a chair, a slightly smaller photographic blow-up of the chair—which I mounted to the wall next to the chair, and a definition of the word chair, which I mounted to the wall next to that. About the same time I did a series of works which were concerned with the relationship between words and objects (concepts and what they refer to). And as well a series of works which only existed as 'models': simple shapes—such as a five-foot square—with information that it should be thought of as a one-foot square; and other simple attempts to 'de-objectify' the object.

With the aid of Christine Kozlov and a couple of others I founded The Museum of Normal Art in 1967. It was an 'exhibition' area run for and by artists. It only lasted a few months. One of the exhibitions there was my only 'one-man show' in New York and I presented it as a secret, titled *15 People Present Their Favorite Book*. And the show was exactly what its title states. Some of the 'contributors' included Morris, Reinhardt, Smithson, LeWitt, as well as myself. Also related to this 'show' I did a series which consisted of quotations by artists, about their work, or art in general; these 'statements' were done in 1968.

I have subtitled all of my work beginning with the first 'water' definition, *Art as Idea as Idea*. I always considered the photostat the work's form of presentation (or media); but I never wanted anyone to think that I was presenting a photostat as a work of art—that's why I made that separation and subtitled them as I did. The dictionary works went from abstractions of particulars (like *Water*) to abstractions of abstractions (like *Meaning*). I stopped the dictionary series in 1968. The only 'exhibition' I ever had of them was last year in Los Angeles at Gallery 669 (now defunct). The show consisted of the word 'nothing' from a dozen different dictionaries. In the beginning the photostats were obviously photostats, but as

time went on they became confused for paintings, so the 'endless series' stopped. The idea with the photostat was that they could be thrown away and then re-made—if need be—as part of an irrelevant procedure connected with the form of presentation, but not with the 'art'. Since the dictionary series stopped I began one series (or 'investigations', as I prefer to call them) using the categories from the *Thesaurus*, presenting the information through general advertising media. (This makes clearer in my work the separation of the art from its form of presentation.) Currently I am working on a new investigation which deals with 'games'.

Notes

1. Morton White, *The Age of Analysis* (New York: Mentor Books, 1955), p. 14.

2. Ibid., p. 15.

3. I mean by this Existentialism and Phenomenology. Even Merleau-Ponty, with his middle-of-the-road position between Empiricism and Rationalism, cannot express his philosophy without the use of words (thus using concepts); and following this, how can one discuss experience without sharp distinctions between ourselves and the world?

4. Sir James Jeans, *Physics and Philosophy* (New York: Macmillan, 1946), p. 17.

5. Ibid., p. 190.

6. Ibid., p. 190.

7. The task such philosophy has taken upon itself is the only 'function' it could perform without making philosophic assertions.

8. This is dealt with in the following section.

9. I would like to make it clear, however, that I intend to speak for no one else. I arrived at these conclusions alone, and indeed, it is from this thinking that my art since 1966 (if not before) evolved. Only recently did I realize after meeting Terry Atkinson that he and Michael Baldwin share similar, though certainly not identical, opinions to mine.

10. *Webster's New World Dictionary of the American Language* (1962), s.v. "decoration."

11. The conceptual level of the work of Kenneth Noland, Jules Olitski, Morris Louis, Ron Davis, Anthony Caro, John Hoyland, Dan Christensen *et al.* is so dismally low, that any that is there is supplied by the critics promoting it. This is seen later.

12. Michael Fried's reasons for using Greenberg's rationale reflect his background (and most of the other formalist critics) as a 'scholar', but more of it is due to his desire, I suspect, to bring his scholarly studies into the modern world. One can easily sympathize with his desire to connect, say, Tiepolo with Jules Olitski. One should never forget, however, that an historian loves history more than anything, even art.

13. Lucy Lippard uses this quotation in *Ad Reinhardt: Paintings* [ex. cat.] (New York: Jewish Museum, 1966), p. 28.

14. Lucy Lippard again, in "Constellation by Harsh Daylight: The Whitney Annual" [review], *Hudson Review* 21, no. 1 (Spring 1968), p. 180.

15. Arthur R. Rose, "Four Interviews," *Arts Magazine* 43, no. 4 (February 1969), p. 23.

16. As Terry Atkinson pointed out in his introduction to *Art-Language* 1, no. 1, the Cubists never questioned *if* art had morphological characteristics, but *which* ones in *painting* were acceptable.

17. When someone 'buys' a Flavin he isn't buying a light show, for if he was he could just go to a hardware store and get the goods for considerably less. He isn't 'buying' anything. He is subsidizing Flavin's activity as an artist.

18. A. J. Ayer, *Language, Truth, and Logic* (New York: Dover, 1946), p. 78.

19. Ibid., p. 57.

20. Ibid., p. 57.

21. Ibid., p. 90.

22. Ibid., p. 94.

23. *Ad Reinhardt: Paintings*, p. 12.

24. It is poetry's use of common language to attempt to *say the unsayable* which is problematic, not any inherent problem in the use of language within the context of art.

25. Ironically, many of them call themselves 'Conceptual Poets'. Much of this work is very similar to Walter de Maria's work and this is not coincidental; de Maria's work functions as a kind of 'object' poetry, and his intentions are very poetic: he really wants his work to change men's lives.

26. Ayer, p. 82.

27. *Art-Language*, 1, no. 1.

28. I did not (and still do not) understand this last decision. Since I first met Weiner, he defended his position (quite alien to mine) of being a 'Materialist'. I always found this last direction (e.g. *Statements*) sensical in *my* terms, but I never understood how it was in his.

29. I began dating my work with the *Art as Idea as Idea* series.

30. Atkinson, pp. 5–6.

31. All obtainable from Art & Language Press, 84 Jubilee Crescent, Coventry, England.

32. (Of which the author is the American editor).

33. And Stella, too, of course. But Stella's work, which was greatly weakened by being painting, was made obsolete very quickly by Judd and others.

34. Smithson of course did spearhead the Earthwork activity—but his only disciple, Michael Heizer, is a 'one idea' artist who hasn't contributed much. If you have thirty men digging holes and nothing develops out of that idea you haven't got much, have you? A very large ditch, maybe.

STATEMENT FOR WHITNEY ANNUAL EXHIBITION, 1969

While my work is in an area which could be considered the heir to Western painting and sculpture, I do not consider it either 'painting' or 'sculpture' but rather an 'art investigation'. There are two reasons for this. One is that the word art denotes the general context of my activity, while the word 'painting' and 'sculpture' ascribe particular qualities to the materials used within my art investigation in such a way as to imply a relationship between my art and earlier art on morphological grounds. Secondly, one of the further disadvantages of specific terms such as painting and sculpture is their 'defining' character, and the subsequent limitation of the area of consideration. This limiting would seem to me to be contrary to the nature of art in our time.

First published as "Statement" in *1969 Annual Exhibition* [ex. cat.] (New York: Whitney Museum of American Art, 1969).

FOOTNOTE TO POETRY

Concrete poetry was a formalization of the poet's material. And when the poets become materialistic, the state is in trouble.

Poetry is bankrupt for the same reasons painting and sculpture is bankrupt. They all come out of the same age, and it's over. Aesthetic categorical gerry-mandering won't save an artist from himself. And last year's concrete poets (who for the most part make up—directly or indirectly—this year's conceptual poets) merely hailed the death of poetry. Poetry, painting, and sculpture died (and this is the way it goes) because it was no longer real for the living. The Western fear of death has always desired to expand meanings for old words rather than find new ones, or even new realizations to previously unrelated words.

To say something is dead isn't to say that it's not around. Andrew Wyeth and Kenneth Noland still make paintings, Anthony Caro and Chaim Gross still make sculpture. Robert Lowell and Ogden Nash still write poetry.

At this time art (and simply that) is still meaningful and a usable word. It's general (not connected to an action or a material like the words painting and sculpture are). And yet specific (separate, in its *raison d'être*, from science, politics, or entertainment).

It's generally known that I've taken the precarious position of predicting that art will replace philosophy (if it hasn't already) because, simply stated, we know too much about the world to make the assumptions that traditional philosophy demands. Philosophy and religion collapsed together because science pushed man past a credibility gap. Art will take that

Unpublished notes written in 1969.

intellectual area because it is only one endeavor left that is both theoretical and open. Art's evolution will have to leave visual experience as its basis out of its *raison d'être*. Man before our century didn't travel as much and had a fairly regularized visual environment. Painting and sculpture could add to that and present a rich visual experience (added to an unchanging, 'timeless' quality found nearly nowhere else). In our time, of course, the artist cannot compete with flying to the moon by rocket, or by jet to Los Angeles, nor with the lights of Las Vegas or even Times Square, or even colored television or movies. The visual experiences of the modern day man make paintings impotent and pathetic trophies to forgotten aristocracies.

INTRODUCTORY NOTE TO *ART-LANGUAGE*
BY THE AMERICAN EDITOR

Current American art activity can be considered having three areas of endeavor. For discussion purposes I call them: aesthetic, 'reactive', and conceptual. Aesthetic or 'formalist' art and criticism is directly associated with a group of writers and artists working on the east coast of the United States (with followers in England). It is however, far from limited to these men, and is still the general notion of art as held by most of the lay public. That notion is that, as stated by Clement Greenberg: "Aesthetic judgements are given and contained in the immediate experience of art. They coincide with it; they are not arrived at afterwards through reflection or thought. Aesthetic judgements are also involuntary: you can no more choose whether or not to like a work of art than you can choose to have sugar taste sweet or lemons sour."

In terms of *art* then this work (the painting or the sculpture) is merely the 'dumb' subject-matter (or cue) to critial discourse. The artist's role is not unlike that of the valet's assistance to his marksman master: pitching into the air of clay plates for targets. This follows in that aesthetics deals with considerations of opinions or perception, and since experience is immediate, art becomes merely a human ordered base for perceptual kicks, thus paralleling (and 'competing' with) natural sources of visual (and other) experiences. The artist is omitted from the 'art activity' in that he is merely the carpenter of the predicate, and does not take part in the

First published as "Introductory Note by the American Editor" in *Art-Language* (Coventry) 1, no. 2 (February 1970), pp. 1–4. Kosuth became the American editor of the British journal *Art-Language* in 1969. This was his introduction to the second issue, and the formal beginning of his association with the Art & Language group.

conceptual engagement (such as the critic functions in his traditional role) of the 'construction' of the art proposition. If aesthetics is concerned with the discussion of perception, and the artist is only engaged in the construction of the stimulant; he is within the concept 'aesthetics as art' and thus not participating in the concept formation. Insofar as visual experiences, indeed aesthetic experiences, are capable of existence separate from art, the condition of art in aesthetic or formalist art is exactly that discussion or consideration of concepts as examined in the functioning of a particular predicate in an art proposition. To re-state: the only possible functioning as art aesthetic painting and sculpture is capable of, is the engagement or inquiry around its presentation within an art proposition. Without the discussion it is 'experience' pure and simple. It only becomes 'art' when it is brought within the realm of an art context (like any other material used within art).[1]

A discussion of what I call 'reactive' art will be necessarily brief and simplistic. For the most part 'reactive' art is the scrap-heap of 20th century art ideas—cross-referenced, 'evolutionary', pseudo-historical, 'cult of personality', and so-forth; much of which can be easily described as an angst-ridden series of blind actions.[2]

This can be explained partially via what I refer to as the artist's 'how' and 'why' procedure. The 'why' refers to art ideas, and the 'how' refers to the formal (often material) elements used in the art proposition (or as I call it in my own work 'the form of presentation'!). Many disinterested in and often incapable of conceiving of art ideas (which is to say: their *own* inquiry into the nature of art) have used notions such as 'self-expression' and 'visual experience' to give a 'why' ambient to work which is basically 'how' inspired.

But work that focuses on the 'how' aspect of art is simply taking a superficial and necessarily gestural reaction to only one chosen 'formal' consequence—out of several possible ones. As well, such a denial (or ignorance) of art's conceptual (or 'why') nature follows always to a primitive or anthropocentric conclusion about artistic priorities.[3]

The 'how' artist is one that relates art to craft, and subsequently considers artistic activity 'how' construction. The framework in which he works is an externally provided historical one, which takes only into account the morphological characteristics of preceding artistic activity. This reactionary impetus has left us with a kind of involuted artistic inflation.

Thus the only real difference between the formalists and the 'reactive' artists is that the formalists believe that artistic activity consists in closely following the 'how' construction tradition; whereas the 'reactive' artists believe that artistic activity consists in an 'open' interpretation (and subsequent reaction to) not as much of the 'how' construction of 'long range'

(or traditional) 'how' construction, but of the 'short range' or directly preceding 'how' construction. But both readings of 'how' construction still—in a more or less sophisticated form—are concerned with the morphological characteristics, rather than the functional aspects, of artistic propositions.

Art propositions referred to by journalists as 'anti-form', 'earthworks', 'process art', etc., comprise greatly what I refer to here as 'reactive' art. What this art attempts is to refer to a traditional notion of art while still being 'avant-garde'. One support is securely placed in the material (sculpture) and/or visual (painting) arena, enough to maintain the historical continuum[4] while the other is left to roam about for new 'moves' to make and further 'breakthroughs' to accomplish. One of the main reasons that such art seeks connections on some level to the traditional morphology of art is the art market. Cash support demands 'goods'. This always ends in a neutralization of the art proposition's independence from tradition.

In the final analysis such art propositions become equivocated with either painting or sculpture. Many artists working outside (deserts, forests, etc.) are now bringing to the gallery and museum super blown-up color photographs (painting) or bags of grain, piles of earth and even in one instance a whole uprooted tree (sculpture). It muddles the art proposition into invisibility.[5]

At its most strict and radical extreme the art I call conceptual is such because it is based on an inquiry into the nature of art. Thus, it is not just the activity of constructing art propositions, but a working out, a thinking out, of all the implications of all aspects of the concept 'art'. Because of the implied duality of perception and conception in earlier art a middle-man (critic) appeared useful. This art both annexes the functions of the critic, and makes a middleman unnecessary. The other system: artist-critic-audience existed because the visual elements of the 'how' construction gave art an aspect of entertainment, thus it had an audience. The audience of conceptual art is composed primarily of artists—which is to say that an audience separate from the participants doesn't exist. In a sense then art becomes as 'serious' as science or philosophy, which don't have 'audiences' either. It is interesting or it isn't, just as one is informed or isn't. Previously, the artist's 'special' status merely relegated him into being a high priest (or witch doctor) of show business.[6]

This conceptual art then, is an inquiry by artists that understand that artistic activity is not solely limited to the framing of art propositions, but further, the investigation of the function, meaning, and use of any and all (art) propositions, and their consideration within the concept of the general term 'art'. And as well, that an artist's dependence on the critic or writer on art to cultivate the conceptual implications of his art prop-

ositions, and argue their explication, is either intellectual irresponsibility or the naivest kind of mysticism.

Fundamental to this idea of art is the understanding of the linguistic nature of all art propositions, be they past or present, and regardless of the elements used in their construction.[7]

This concept of American 'conceptual' art is, I admit, here defined by my own characterization, and understandably, is one that is related to my own work of the past few years. Yet it is here at the 'strict and radical extreme' where agreement is reached between American and British conceptual artists—at least in the most general aspects of our art investigations—as diverse as the 'choice of tools' or methodology or art propositions may be.

There is a considerable amount of art activity between the 'strict and radical extreme' and what I call 'reactive' art earlier. My contributions by artists working on the American continent will be relatable—whenever possible—to the former, though unfortunately the quantity of such activity makes the sole consideration of such contributions impossible.

Notes

1. One begins to understand the popularity among critics of such mindless movements as expressionism, and the general disdain toward 'intellectual' artists such as Duchamp, Reinhardt, Judd, or Morris.

2. Artists in America have a tendency to cloak their investigations in such a way as to enable extra-art justification for their activities. I suspect this has a great deal to do with America's basic anti-intellectualism. As John Sloan says in *The Gist of Art* (New York: American Artists Group, Inc., 1939), "Artists, in a frontier society like ours, are like cockroaches in kitchens—not wanted, not encouraged, but nevertheless they remain."

3. In recent years artists have realised that the 'how' is often purchasable and that purchasability of the 'how' (and the subsequent 'de-personalization' of 'how' construction) is *negatively* impersonal only when the 'how' is functioning for a 'personal touch' 'why' construct.

4. And give the art economists and politicians something to 'invest' in.

5. Unfortunately many of these artists want to reform the system enough to make their ideas acceptable, but not so much as to ruin their chances for 'success' in the grand old manner.

6. An aspect of this problem is that which was fundamental to our earlier discussion of formalist and 'reactive' art. That has to do with the supervisory, even 'parental' role critics have taken in the 20th century toward artists; the institutionalized condescension engaged in by museum and gallery personnel; and the peculiar ability artists themselves have to romanticize intellectual bankruptcy and opportunism.

7. Without this understanding a 'conceptual' form of presentation is little more than a manufactured stylehood, and such art we have with increasing abundance.

INTRODUCTION TO *FUNCTION*

INTRODUCTION 1

Function refers to 'art context'.

Art only exists as a context, that is its nature—it has no other qualities.

My primary interest excludes both the subject matter and the structure(s) used.

The final and ultimate (without reference to time) context is not limited as an ascribed quality (i.e. as propositions not one-to-one).

With the functioning of sets within sets, boundaries are temporary and arbitrary and wholly dependent on a sense of 'purpose'.

Function as presented in this (body of) proposition(s) operates in an 'internal' and 'external' manner.

Because of the nature of the subject the final and ultimate context is unknown (except in personal terms) and cannot exist in any manner relatable to a gestalt or any such implied iconic entity.

The *art* is related only to the following (directly and implied) in its relation to an investigation and not in any sense to any (implied or otherwise) 'mental object'.

INTRODUCTION 2

This book is actually only segment one (specific), and segment two (general) is necessarily supplied by the reader.

First published in *Function Funzione Funcion Fonction Funktion* (Turin: Sperone, 1970).

The complete proposition (art) is limited by both the information of the reader (at the time of publication) and the inconsistent 'meaning' of the information (in regard to the future). It is impossible for me to speculate on either. This applies to not only the propositions (unitary and 'art') but to the entire series of investigations as well.

An analysis of my 'subtitle' will give an insight into the procedure used. Subtitle: "Art as Idea as Idea."

"Art as Idea / As (An) Idea"

Or, the presentation of the *concept* of 'Conceptual art' as an art idea— as (separate from) the presentation (solely) of a particular 'conceptual' work of art.

Thus, my 'works' can be considered unitary propositions as well as 'art' propositions; each unit has no more inherent value or meaning anywhere along the line than does another, since the boundaries are temporary 'givens' and function within a 'game-like' arena, with changing *use* and *meaning.*

A SHORT NOTE: ART, EDUCATION
AND LINGUISTIC CHANGE

Human beings do not live in the objective world alone, nor alone in the world of social activity as ordinarily understood, but are very much at the mercy of the particular language which has become the medium of expression for their society. It is quite an illusion to imagine that one adjusts to reality essentially without the use of language and that language is merely an incidental means of solving specific problems of communication or reflection. The fact of the matter is that the 'real world' is to a large extent unconsciously built up on the language habits of the group . . . we see and hear and otherwise experience very largely as we do because the language habits of our community predispose certain choices of interpretation.

Edward Sapir

In art the 'means of expression' is also not unlike language. Even accepting the common view that art's history goes back hundreds of years,[1] it is possible to see that the 'language' of the art of the west has been painting and sculpture for some time. Up until the very recent past it has been assumed that if one wanted to speak as an artist he had to speak in the 'correct' language. That's how we knew he was an artist and what he made was art or meant to be art. Whatever was done, it had to be done *within* that language. One reason for this was the notion that art was defined by its morphological characteristics. This means that the arena of artistic activity was arbitrarily arrived at by the demands of primarily *non*-art functions. That is, to put it simply, by the decorative needs of architecture. A further confusion in this regard was the prevalent notion

First published in *The Utterer* (April 1970). This journal was published by the School of Visual Arts, New York.

that there was a conceptual connection between art and decoration and taste.

In art before the 'modern' period the language form was the carrier of "the depiction of religious themes, portraiture of aristocrats, detailing of architecture" and so on. The modern period brought an end to art's invisibility and first painters, then sculptors began to focus on art's language—not as a means, but as an end. While art was still being conveyed by the use of the same language form (painting and sculpture) it was vastly different from earlier 'art' because the 'art condition' became singularly identified with the language form itself. Up until ten years ago the modern period was about really only this one thing: the myriad uses of art's language *as* art. Focusing on art's language was the one immediate way to make art and only art *without* the confusion of subject matter or a new language form which might be interesting in their own right.

In the past few years artists have realized that their traditional language is exhausted and unreal. Whether it is because its roots go too far back to a world so completely different from our own that the old language, as art, isn't believable or real anymore, or whether it is because all of the 'limits' have been reached, is difficult to know. We do now realize that *anything* can be art. That is, any material or element in any sense can be made to function within an art context. And that in our time quality is associated with the artist's thinking, not as a ghost within the object.

Ideally, in the new art each artist creates his own language.[2] This was necessary for art to become a kind of 'pure science' of creativity—the new artist must not only construct new propositions, but attempt to create a whole new idea of art. And only if he manages to do this has he really made any individual contribution.

What effect will this change in art have on the educational needs of the artist? The change is of course a radical one. Previously, when all artists used the same language, it was possible to predict what tools he would be using in the fashioning of that language. Since everyone seemed to know, if not what art was, at least the forms it would take, it was possible to set up a fairly rigid learning situation that all of the students would be subjected to equally. And it was assumed that the best students were the ones who acquired the necessary information the fastest. In retrospect, we can now see that the best students didn't turn out that way in the modern period. Even within the confines of the old language, the work of the modern masters upon early exposure was usually 'ugly', usually 'didn't look like art', and was also usually subjected to a great deal of ridicule—with intimations that it was either a fraud or a joke.[3]

Nonetheless, most present day art schools are still based on the assumptions inherited from the 19th century, and most art educators are either uneasy about or openly hostile to students disinterested in the grammar

lessons of the old language. Even in those schools that allow experimentation in the advanced years, the tone set for learning about the traditional modes of art in the earlier years is a moralistic one—implying that for one to be a *true* artist technical knowledge of painting and sculpture is mandatory. In reality, however, painting and sculpture courses are like laboratory art history studies. Actually studying painting and sculpture is not unlike learning Latin. Latin is useful for information (particularly to historians) but separate from the reality the young art student lives and thinks in.

But if the 'real world' is one of complete freedom, one where the artist not only plays the game alone, but makes up his own rules as well, is it even feasible to attempt to maintain an institution of learning for the artist? I believe it is. But only if the art educator can separate the 'art' from the 'art history' in every possible sense. The most important role, if not the *only* role, now of the art school is to consider (metaphorically) the courses as 'books', and run the school as a 'library'. The students are old enough to explore the 'books' and 'read' at their own pace. Technicians should be available for those students that need that sort of specific information, but the role of the art instructor is to enable the student to connect his particular way of seeing with what is possible. He can't tell a student what art is because that will be up to the student to decide. He can help the student to keep from closing doors and making assumptions, and help him eliminate wasted time by informing him of known facts about his *particular* arena of activity.

It is only this kind of individual attention that will separate the art school from the normal university. Most kinds of information can be presented to groups of students in the usual university fashion but the capacity of the art school to consider art students as individual thinkers, is its sole viability.

Notes

1. I don't. Even given some notable exceptions, I feel the general term 'art' begins with the modern period (i.e. approximately Manet).

2. Or, in the case of lesser artists, accept as his own one recently formed.

3. This is of course because often the elements used in an art proposition *are* nonsensical if separated from an art ambience. The art is what vies with the elements' 'sense'.

ART AS IDEA AS IDEA: AN INTERVIEW
WITH JEANNE SIEGEL

Jeanne Siegel: "Art as Idea As Idea" is a subtitle that you have been giving your work since your first started photostating definitions from the dictionary. Joseph, what do you mean by "art as idea as idea"?

Joseph Kosuth: Well, obviously, first one would question the necessity for the repetition, why not just 'art as idea'? The 'device' of the phrase is a reference to Ad Reinhardt, an early hero of mine. But the point is very much mine. Like every one else I inherited the idea of art as a set of *formal* problems. So when I began to re-think my ideas of art, I had to re-think that thinking process, and it begins with the making process. So what happened was a shift within what I understood was the context of the work. 'Art as idea' was obvious; ideas or concepts as the work itself. But this is a reification—it's using the idea as an object, to function within the prevailing formalist ideology of art. The addition of the second part—'Art as Idea *as Idea*'—intended to suggest that the real creative process, and the radical shift, was in changing the idea of art itself. In other words, my idea of doing that was the real creative context. And the value and meaning of individual works was contingent on that larger meaning, because without that larger meaning art was reduced to decorative, formalist stuff.

It's interesting to see, on the level of practice, how work works. The works of mine that are more well known, to use an example, are the definitions from the *First Investigations*. The early photostats were of

This interview was broadcast on WBAI-FM on April 7, 1970. Thereafter published as "Joseph Kosuth: Art as Idea as Idea" in Jeanne Siegel, *Artwords: Discourse on the 60s and 70s* (Ann Arbor, Michigan: UMI Research Press, 1985), pp. 221–231.

definitions of materials I had been working with earlier, such as water, because of their indeterminate formal properties. I was trying to escape formalism, but I was trying to do it within its own terms, unfortunately. Earlier I had used definitions in a different kind of work using objects. It was a bit of a tangent effected by philosophy I had been reading, but very useful in opening up my idea of art. I realized then I could use the definitions alone in solving my dilemma about formless forms—in other words, by just presenting the *idea* of water—'art as idea'. But meaning doesn't function in a linear direction, it's more *multi*-directional. Using a text as art raised questions, using a photograph as art raised questions, the artifact of a dictionary definition raised questions. This was about the time I started reading a lot of language philosophy as well and this paved the way for me to start thinking about art in relation to language. It became clearer to me that the material of the work was these series of contexts or levels. It seems to me that when work works that's how it works.

If "Art as Idea as Idea" is the subtitle, then what's the title?

On the photostats I titled them all the same. It was titled already within the work, so I just titled the title.

Which depends on it being an abstraction?

That's what it was about. It was my way of dealing with abstraction. Art is always abstract. When you think about it, who is more abstract: Duchamp, Magritte, or Pollock? As I was saying a minute ago, besides all the art of this century which is evidence to the contrary, we inherited a philosophy of art that has a strong decorative, formalist bias. So as art students we are handed a set of presumptions: palettes, brushes, canvases, and a philosophy to go with them. Of course often our limitations present themselves as choices—such as the one between geometric and organic forms. I remember feeling very much that they had *both* been used up, but then where was I? If such forms—which together include all forms— had become invisible through overuse it had to mean that they are loaded with too much meaning—traditional meaning. But even if you can't invent new forms you can invent new meanings. I think that's really what an artist does. So I felt that all art was abstract in relation to cultural meaning, in the way that the noises we utter called words are meaningful only in relation to a linguistic system, not in relation to the world. That seemed to me a more interesting idea, more open and challenging, than the Cubist idea of abstraction we inherited, which is a formalist one of abstracting *from* . . . from 'nature'. Like in art school where you abstract a leaf to its 'essence' until you can't see that it's a leaf anymore.

What was the progression toward your form of abstraction?

After I stopped doing paintings in the traditional sense, the first piece I did was one using glass because it was clear and there were obviously no compositional problems as far as choice or location or color. (I agree with Judd when he says that composition is old world philosophy. I think it presumes as it constructs an interior, magical space, which ultimately refers back to painting's earlier religious use.) Also, I found that according to color psychology there was more of a transcultural response to achromatic color—black, white, and gray—than to the chromatic scale, which had a much more marked difference among specific individuals as well as between cultures. So my last paintings were achromatic. It's interesting how the serious early work of most artists tends to be achromatic—early Warhol and Lichtenstein, Rauschenberg, Flavin, Stella, Cubism. *Broadway Boogie-Woogie* could only be late Mondrian . . . when you're trying to make a statement there is no place for color.

So I liked glass because it had no color to speak of, except for the color it reflected from its environment. There was always the problem of form, though. So I tried presenting it in different conditions—smashed, ground, stacked, and this led me in another direction. The first use of language began with this work. With the first glass piece it was the label which took on a great importance. That piece was just a five-foot sheet of glass which leaned against the wall, and next to it was a label with the title: *Any Five Foot Sheet of Glass To Lean Against Any Wall.* (A former friend of mine is making a whole career out of this piece, I guess that's flattery.)*
I succeeded in avoiding composition, and I had succeeded in making a work of art which was neither a sculpture (on the floor) nor a painting (on the wall). I wasn't certain how 'abstract' it was, but it was certainly ambiguous. From the work with glass I began working with water, for most of the same reasons. Water had the advantage of being 'formless' as well as 'colorless'. Even now this seems too much like the simplistic meanderings of an art student, which I was, but it seemed like very heavy stuff at the time.

Then you made the transition to working with words?

Yes, both the use of words in my work and my interest in language in general began at that time—1965. In the glass piece I just mentioned and in other glass works, the use of words became increasingly important. One solution to the problem of form at the time was to make a division between 'abstract' and 'concrete' within the work itself, such as the work with three glass boxes I referred to a minute ago—one was filled with

*Kosuth is referring to Lawrence Weiner.

smashed glass, one with ground glass, and the other had stacked glass. And on each of these boxes the word 'Glass' was lettered. This way, by reducing the concrete formal properties to the one abstraction 'glass', the work arrived at a kind of formless, colorless state as a physical 'device' (not unlike language) within that art system which was that work. So you had the abstraction 'glass'. Language began to be seen by me as a legitimate material to use. Part of its attraction too was that by being so contrary to the art one was seeing at that time it seemed very personal to me. I felt I had arrived at it as a personal solution to personal art problems. So then I used photostats of dictionary definitions in a whole series of pieces. I used common, functional objects—such as a chair—and to the left of the object would be a full-scale photograph of it and to the right of the object would be a photostat of a definition of the object from the dictionary. Everything you saw when you looked at the object had to be the same that you saw in the photograph, so each time the work was exhibited the new installation necessitated a new photograph. I liked that the work itself was something other than simply what you saw. By changing the location, the object, the photograph and still having it remain the same work was *very* interesting. It meant you could have an art work which was that *idea* of an art work, and its formal components weren't important. I felt I had found a way to make art without formal components being confused for an expressionist composition. The expression was in the idea, not the form—the forms were only a device in the service of the idea.

So, you were working mainly with language?

Increasingly, yes. It was the system of language itself which I felt held great implications when considered in relation to art which interested me. I've been very wary of using words as objects—concrete poetry and that sort of thing. It's been thinking about language as a cultural system parallel to art which makes it useful, both in theory and in practice. So the works I talk about now, which interest me the most now, are the ones which I learned something from, and have led me to do the work I'm doing now. I've been working on games, and other meaning-generating systems. Even the most abstract work has a kind of concrete level, which is the fact that the functional part of it must be contextually contingent. So instead of working with the relations between objects, or forms, like most art, I'm trying to do work with the relations between relations. The work with common objects was a simple start, but those works are static. I want this work to be more dynamic—less of an illustration and more of a test.

How have you presented the games?

The earlier work was photographically 'blown-up', which was just reproducing habits from painting, I suppose, but there was enough going on in the work to sever it from tradition anyway, and if you cut all the connections then no connection is made. But one thing did bother me eventually, which was this *group* experience to works of art, which is necessary for the sort of heroics and monumentality that traditional art feeds on. So the work since the *Second Investigation* has insisted on a kind of individual contemplative state. Usually they're small. Sometimes in notebooks. Or, for example, like the work in the Whitney Biennial, where although I have a whole wall, the parts of the work are typed on normal-sized labels where only one person at a time can read them.

Is it meant to be preserved as a permanent piece?

I have no interest in that. Those labels are thrown away or whatever. It's just the information. And the art really doesn't exist in terms of its reunification.

There it is up on the wall. What do you expect the viewer to do with it?

They are supposed to read it, that's all. I think culture is a kind of intersubjective space. So art connects in a way which is more than simple, visual pleasure. If I pander to the viewer in a kind of show-biz way I compromise those uncomfortable ruptures of the supposed 'normal' way things are expected to go. I don't want to risk doing that. That de-politicizes art, cancels it out. The so-called 'avant-garde' is a political history if it is anything. I couldn't imagine a more banal activity than simply providing visual kicks to the public. Of course that's how a lot of artists see their role. But let's face it: there's a lot more dumb people out there than there are smart ones, so if your goal in life is to be popular, and/or rich, the choice isn't a difficult one.

Is the viewer supposed to solve the riddle itself?

That's part of the riddle, my riddle.

I gather you see little connection of your art to poetry?

Absolutely no relationship at all. It's simply one of things superficially resembling one another. A poet wants to say the unsayable. That's the reason the concrete poets have begun doing 'street work' projects because of the fact that they don't feel in many ways that language is adequate to make the kind of statements they want to make. And so they've been doing a lot of performance pieces as well. But the typical concrete poem

makes the worst sort of superficial connections to work like mine because it's a kind of formalism of typography—it's cute with words, but dumb about language. It's becoming a simplistic and pseudo-avant-garde gimmick, like a new kind of paint.

What do you see as the relationship between your use of words and Wittgenstein's linguistic theories?

That's a long discussion, and a difficult one. On one level there is an obvious, too obvious relationship, which shouldn't be said; and there is another, more complex, less apparently conscious one, which can't be said—at least outside of the work itself. In any case I see no advantage in connecting my work to philosophy any more than it already is. The thing to remember is that such a discussion would be a discussion about art, not philosophy; the point being that artists use things. Art is itself philosophy made concrete. So the academic exercise of what is called Philosophy isn't particularly relevant, and too easily misunderstood.

There was really only one point in my work when it had a particular relevance, which is that earlier period (1965) we've been discussing. Actually, for quite a while I never really connected the philosophy I was reading with the art I was making. Mostly, I suppose, because like everyone else I'm a product of this system that tends to keep things disconnected (and in their neat categories) rather than connected, with a larger more holistic view. It is very easy to make some kind of superficial relationship with someone like Wittgenstein. But even then, if that were clear, there is early Wittgenstein and late Wittgenstein, with the latter repudiating the former, and even then in a particular way. I would guess that whatever connections there are between his work and my work is also true for all art, it's just that my art makes that connection more visible.

There are aspects to work which preceded mine—people like Andre or Flavin—which have a bearing on the kinds of discussion about art which I've tried to help generate. If you can make your point with work which is somewhat more acceptable as art than your own, then your heuristic task is a couple of notches closer, one hopes. Anyway, issues of function having to do with meaning being contingent on use are particularly relevant to someone like Flavin. The value of his work is the power of his art as an idea—I don't think one can seriously argue that it is due to craft, composition, or the aura of the traces of his hand. Anyone can have a 'Flavin' by going into a hardware store, but you needed Flavin's initial 'proposal' for it to be art.

That's a similarity between philosophy and art. I suspect that at this moment in time, your work would be subject to misunderstandings. Many people might look at it and say, "Well, this is philosophy, not art."

I call it art and it came out of art. I have had a traditional, even classical, art education—it's perhaps because of that I've been able to work through certain ideas of tradition that others find necessary to appeal to. As for philosophy, serious thought about any endeavor takes on a philosophical character; as for Philosophy (capital P), it's an academic subject with no real social life and little cultural effect. It seems we are in a kind of post-philosophical period; as the power of philosophy atrophied beginning with this century, the philosophical thrust of art increased and I don't think that is a coincidence. As science replaced religion, philosophy also lost its social base and became a subject for universities only. Because we are in this long-term transition, art's actual role is ambiguous—in many ways it is a manifested form of the very cultural mechanism itself—but the role it is forming for itself is not unrelated to the gaps forming by these shifts.

There seem to be certain premises that you have accepted as absolute bases for your work. One of them is the Duchampian-based idea that "if someone calls it art it's art."

What else could be the case? If one says otherwise it means you are suggesting that the work itself must tell you. This, of course, suggests the most reactionary kind of theory of art, one based on morphological characteristics as the sole definition of art. The culture—greatly thanks to Duchamp—has already been forced to accept a larger concept of art.

That appears to be another premise—the fact that your definition of what art is, is what separates you from all of the other art before. Can you state what your idea of art is?

That's no single simple statement. What my idea of art is comes out in both my propositions—that is to say, the specific work I show—and my activities in the production of any meaning in relation to art: such as articles I write, lectures at universities, my teaching at the School of Visual Arts, or conversations such as this one. (In fact, you could say this interview is the answer to your question.) An example I always use for my students is Ad Reinhardt—what makes him an artist isn't just that he painted black paintings. What those paintings mean is a product of his total signifying activity: lectures, panel discussions, *The Rules For A New Academy*, cartoons, and so forth. Our experience, and the meaning of that experience, is framed by language, by information. Seeing is not as simple as looking.

Let's just take one idea, for instance, the idea that an artist is now one who questions the nature of art.

I think to be an artist now means to question the nature of art—that's what being 'creative' means to me because that includes the whole responsibility of the artist as a person: the social and political as well as the cultural implications of his or her activity. To say that the artist only makes high-brow craft for a cottage industry's specialized market might satisfy the needs of this society from the point of view of some people, but it's an insult to the valued remains of an 'avant-garde' tradition, and a denial to artists of their historical role. And unless artists re-conceptualize their activity to include responsibility for re-thinking art itself, then all that is of value in art will be subsumed by the market, because then we will have lost the moral tool to keep art from just becoming another high-class business. In any case, what is more 'creative' than creating a new idea of what art is? And hasn't the best art of this century been concerned with just this task? The best art when it was new seldom 'looked like art' and was never beautiful—to most of the public it was ugly and boring.

In contrast, a lot of the stuff that at the time becomes fashionable and people are interested in because it's exciting often fades away because it is really glamour, a high-brow version of show business. There is still so much of that.

If you feel that the artist is now stating the intentions, what do you feel will be the role of the critic, if any?

I don't know. It's hard for me to imagine. There are people who write and it seems like a lot of science, but it's really a kind of journalism. I guess it can be more obviously journalism. Instead of magazines like *Artforum* or *ARTnews*—it will all probably be written about in *Newsweek* and *Time* and *New York* magazines, God forbid the thought! But critics today really seldom get into the nitty-gritty of what the works of art are.

Perhaps this is just what separates the good from the bad critics.

Yes, the better ones, I suppose, are closer to artists, in a sense. But my argument is with artists who feel that they can fashion an object in some sense and put it out in the world and not say a word about it and let all the thinking about it be done by others. The artist has just become a sort of a prop man, a dummy, and the critics do all the thinking and order the way in which you see it, and any sort of thinking around the work is presented by them and not by the artist. So that they really become makers of the readymade, for the critic. That's what I object to.

How do you see your relationship to the other conceptual artists at this moment?

Pretty hostile at this point. There are only a few that I'm interested in. Some of the hostility is patricidal, frankly; in other cases I have to take some of the responsibility because they don't like things I've said about them (or didn't say about them) in articles or interviews or their treatment in exhibitions that I have input into . . . things like that. I don't think my influence in this area is inappropriate, of course. My work, as well as my activity in promulgating this point of view precedes others by at least a couple of years. I feel many of them 'arrived' after most of the hard work was done and it was a fashionable 'art movement'. I suppose they know I feel this way and understandably resent it. Many of my American friends also don't understand my support of Art & Language in England. They are important to me because I can talk to them about art from a perspective, theoretically, that my American friends can't or won't.* Whether it is simplistic to attribute it to England's rich linguistic/literary tradition I don't know, but philosophically my exchange with them is good As far as their actual art practice is concerned it is much less strong, they seem to be embarrassed by their own subjectivity, maybe that's an English tradition, too. With American artists it is the reverse. Their ideas of art are much more traditional—much of it is really a kind of Minimal art using words—but they at least have the strength of conviction to actually make it. So straddled as I am between the two, I seem to be in a good position to make the points I need to.

What do you consider to be the influence of Duchamp?

I don't find it pervasive in the way it's usually thought of; if that were the case work like mine would have occurred much sooner. He may very well turn out to be the most important artist in the first half of this century (thanks, of course, to what we are planning in *this* half!) . . . an outrageous thought to the rabid protectors of institutionalized modernism. Poor Picasso, poor Matisse. The uncomfortable truth is that an artist like Picasso provides the dirt in which an artist like Duchamp grows. And Matisse? That's the fertilizer.

Seriously, though, Duchamp maintained the radical alternative all the while modernism was gaining respectability; it is almost as though art had to reach a point of maturation before Duchamp could really be usable. This is, of course, all terribly unhistorical, but it's not simply sentimental.

*Among his American friends Kosuth is referring to Robert Barry, Lawrence Weiner, and Douglas Huebler. The leading Art & Language people were Charles Harrison, Terry Atkinson, and Michael Baldwin.

The implications of Duchamp's work are vastly more profound than any artist I can think of. Certain aspects of his work have been slowly internalized, certainly, but I can't imagine how one could proceed with a radical re-thinking of the art of this century without Marcel Duchamp providing a source for the tools which could make that possible. Duchamp has been there for others as a source, in various ways and for some time. Certainly Johns and later Morris and others kept his ideas alive, but that was because they used and got certain things from that work, while perhaps I'm getting other things from it.

Like what, for example?

Well, for one thing, in the idea of the unassisted readymades, there is a shift in our conception of art from one of "What does it look like?" to a question of function, or "How does an object work as art?" which brings into question the whole framing device of context. . . .

I'm sorry but I'm afraid I'm going to have to interrupt you in the middle of Marcel Duchamp because we're running out of time.

I'm sure he wouldn't have minded anyway.

INFORMATION 2

Art should raise questions.

Bruce Nauman

In ecological terms what has transpired in recent art is a shift from "primary" homesite to the alternate or "secondary" homesite. With the fall of galleries, artists have sensed a similar sensation as do organisms when curtailed by disturbances of environmental conditions. This results in extension or abandonment of homesite. The loft organism stifled by the rigidity of his habitat works on not recognizing his out-put waning to the contemplation of new ways to work within old bounds.

The more successful work from the minimal syndrome rejected itself, allowing the viewer a one-to-one confrontation with pure limit or bounds. This displacement of sensory pressures from object to place will prove to be the major contribution of minimalist art. However, when one's energy can be absorbed so wantonly by the "place you put your thing" . . . it's time to consider a more deserving location.

Dennis Oppenheim

Every art expression has an effect.

Stephen Kaltenbach

I start by thinking I'm going to make use of all possibilities without troubling any longer about problems when something starts to be art. I don't make the ETERNAL work of ART, I only give visual information.

First published in *Conceptual Art and Conceptual Aspects* [ex. cat.] (New York: New York Cultural Center, 1970), pp. 29–59.

I'm more involved with the process than the finished work of art. The part of my object is untranslated. I think objects are the most usual part of my work. I'm not really interested any longer to make an object.

Jan Dibbets

The essential quality of existence concerns where one is at any instant in time: that locates everything else. Location, as a phenomenon of space and time, has been transposed by most art forms into manifestations of visual equivalence: that is, as an experience located at the ends of the eyeballs. I am interested in transposing location directly into "present" time by eliminating things, the appearance of things, and appearance itself. The documents carry out that role using language, photographs and systems in time and location.

Douglas Huebler

Magazine reproductions are part of today's landscape.

Iain Baxter

I'm not only questioning the limits of our perception, but the actual nature of perception. These forms certainly do exist, they are controlled and have their own characteristic. They are made of various kinds of energy which exist outside the narrow arbitrary limits of our own senses. I use various devices to produce the energy, detect it, measure it, and define its form.

Robert Barry

The working premise is to think in terms of systems; the production of systems, the interference with and the exposure of existing systems.

 Such an approach is concerned with the operational structure of organizations, in which transfer of information, energy and/or material occurs. Systems can be physical, biological or social, they can be man-made, naturally existing or a combination of any of the above. In all cases verifiable processes are referred to.

Hans Haacke

Every effect is a causative force producing another effect.
The chain of influence can diminish in power.
The power of the chain can increase.

Stephen Kaltenbach

The perspective we are beginning to have, thanks to these past four years, allows a few considerations on the direct and indirect implications for the very conception of art. This apparent break (no research, nor any formal evolution for four years) offers a platform that we shall situate at zero level, when the observations both internal (conceptual transformation as regards the action/praxis of a similar form) and external (work/production

presented by others) are numerous and rendered all the easier as they are not invested in the various surrounding movements, but are rather derived from their absence.

Daniel Buren

My work is a manifesto against sensibility, against the expression of the personality of the individual. In my work, the final manifestation of my personality, my last choice will have been to opt for OBJECTIVITY.

Bernar Venet

I present oral communication as an object, . . . all art is information and communication. I've chosen to speak rather than sculpt. I've freed art from a specific place. It's now possible for everyone. I'm diametrically opposed to the precious object. My art is not visual, but visualized.

Ian Wilson

I suppose some work has to do in part with some of the things that Dadaists and Surrealists did. I like to give the pieces elaborate titles the way they did, although I've only been titling them recently. That all came from not trying to figure out why I make those things. I got so I just couldn't do anything. So like making the impressions of knees in a wax block [*A Wax Mold of the Knees of Five Famous Artists*] was a way of having a large rectangular solid with marks in it. I didn't want just to make marks in it so I had to make this other kind of reasoning. It also had to do with trying to make a less important thing to look at.

Bruce Nauman

The documents prove nothing. They make the piece exist and I am interested in having that existence occur in as simple a way as possible. Where a thing is located involves everything else and I like that idea much more than how I "feel" about it or what it looks like.

Douglas Huebler

A work of art by its existence is a fabricated reality. As an object which is man made (or chosen), and also part of the inanimate world but not natural and also not utilitarian, it has an ambiguous existence. Phenomena are impenetrable by thought and exist nonambiguously as they exist preceding definition. But a work of art is the product of thought which precedes the actual work. Now that art has freed itself from both referential and abstract burdens artists face a new paradox. Is ambiguity inherent in the thing or is it created by ambiguous elements?

Mel Bochner

I do not owe anything to the Dadaist tradition.

Saul Ostrow

. . . the new series of my works are traces of what an artist does. Somehow the shit residue of art history made me make paintings and sculptures. But now I feel no contact with or relevance or need of a place in art history.

Lawrence Weiner

Twenty-six gasoline stations, various small fires, some Los Angeles apartments, every building on the Sunset Strip, thirty-four parking lots, Royal road test, business cards, nine swimming pools, crackers.

Ed Ruscha

The techniques of recording are appropriate to the kind of information presented and include visual, verbal, and mathematical data.

Donald Burgy

What's the difference between asking and telling?

James Lee Byars

Sensory consciousness is of essentially undifferentiated sensory information. The primary ordering of sensory information is into space and time continuums. The secondary ordering further differentiates it into segments along the continuums: specific space and time conditions The resulting consciousness is of an indeterminate number of points or instants at which the space and time continuum intersect. Any combination of space and time conditions on the continuum may intersect to form one or a series of points or instants.

Adrian Piper

The true artist helps the world by revealing mystic truths.

Bruce Nauman

Painting and selling have become cliches of fine arts. I search consciously for a form of art which is not tied by tradition and in which an oeuvre is less important than the research. There are so many different situations in which to look at something, that standing right before the painting or walking around a sculpture could well be the most simple kind.

Jan Dibbets

The existence of each sculpture is documented by its documentation.

Douglas Huebler

Altitude lines on contour maps serve to translate measurement of existing topography to a two dimensional surface. With my piece, I create contours

which oppose the reality of the existing land, and impose their measurements onto the actual size, thus creating a kind of conceptual mountainous structure on a swamp grid.

Dennis Oppenheim

Canvas, which should be left for the tent and awning makers, is returning in my work in the form of tents and awnings.

Iain Baxter

There are many other possibilities which I intend to explore—and I'm sure there are a lot of things we don't yet know about which exist in the space around us, and although we don't see them or feel them, we somehow know they are out there.

Robert Barry

Art is the form which it takes. The form must unceasingly renew itself to ensure the development of what we call new art. A change of form has so often led us to speak of a new art that one might think that inner meaning and form are linked together in the mind of the majority—artists and critics. Now, if we start from the assumption that new, i.e. "other," art is in fact never more than the same thing in a new guise, the heart of the problem is exposed. To abandon the search for a new form at any price means trying to abandon the history of art as we know it: It means passing from the *Mythical* to the *Historical,* from the *Illusion* to the *Real.*

Daniel Buren

The chain can branch at every link.
The chain and its branches can develop in any direction.
The direction and strength of the chain may be determined at every link by an artist who has the desire to do so.

Stephen Kaltenbach

I'm not a poet and I'm considering oral communication as a sculpture. Because, as I said, if you take a cube, someone has said you imagine the other side because it's so simple. And you can take the idea further by saying you can imagine the whole thing without its physical presence. So now immediately you've transcended the idea of an object that was a cube into a word, without a physical presence. And you still have the essential features of the object at your disposal. So now, if you just advance a little, you end up where you can take a word like time and you have the specific features of the word "time." You're just moving this idea of taking a primary structure and focusing attention on it.

Ian Wilson

. . . this is Genet's existentialism, not Sartre's or Camus's.

Lawrence Weiner

. . . and since I am not interested in problems of forms, color and material, it goes without saying that my evolution could not be esthetic. It may be that simply making a work signed 1970 will be more interesting than another signed 1967 (treating the same subject) because of new informations and additional precisions that will have enlarged the subject.

Bernar Venet

The recent shift to terrain has evaporated the importance of discrete objects and rejects what could be called "media distance," a force of indirect energy, compounded by allowing mobility, and permanence a major position in scribing aesthetic boundaries. The artist, relieved of dogmas which covet this indirect energy distribution, now responds directly to the terrestrial eco-system. Rather than the objectification of aesthetic impetus through physical media, the actual exterior framework which delivers stimulus will house and project the art. This allows the sculptor to work within the media. There is no deliberate transporting of materials for pre-arranged viewing or the isolation of individual components for contemplation. The aesthetic transaction is a constant force operating between polarities that affect major or minor change—the sculptor is now occupied by his material.

Dennis Oppenheim

I use the unknown because it's the occasion for possibilities, and because it's more real than anything else. Some of my works consist of forgotten thoughts, or things in my unconscious. I also use things which are not communicable, are unknowable or are not yet known. The pieces are actual but not concrete

Robert Barry

A reproduction in a top art magazine is worth two one-man shows.

Iain Baxter

Vertically striped sheets of paper, the bands of which are 8–7 cms wide, alternate white and coloured, are stuck over internal and external surfaces: walls, fences, display windows, etc.; and/or cloth/canvas support, vertical stripes, white and coloured bands each 8–7 cms, the two ends covered with dull white paint.

Daniel Buren

Desire often results from an understanding of the process.
Understanding may be gained through observation of existing chains.

The critical opinion expressed as a result of this show provides opportunity for observation of a secondary link.

Stephen Kaltenbach

I use the camera as a "dumb" copying device that only serves to document whatever phenomena appear before it through the conditions set by a system. No "esthetic" choices are possible. Other people often make the photographs. It makes no difference. What may be documented that has appearance in the world actually is returned to itself as only that and as nothing that has to do with the piece.

Douglas Huebler

N.E. Thing Co. is anything.

Iain Baxter

Condensation—forcing out space between a series of steps—is like eradicating time intervals between notes. The result is a single sound unbroken by silence. The museum walls echo the solidified vibrations of exterior distance.

Dennis Oppenheim

Materialist implies a primary involvement in materials, but I am primarily concerned with art. One could say the subject matter is materials, but its reason to be goes way beyond materials to something else, that something else being art.

Lawrence Weiner

Every impossible thing I can think of is possible, everything I think already exists. Everything exists in any possibility.

James Lee Byars

You can fly over something, you can walk along something, drive (by car or train), sail, etc. You can "disorientate" the spectator in space, integrate him, you can make him smaller and bigger, you can force upon him space and again deprive him of it.

Jan Dibbets

Every act is political and, whether one is conscious of it or not, the presentation of one's work is no exception. Any production, any work of art is social, has a political significance. We are obliged to pass over the sociological aspect of the proposition before us due to lack of space and considerations of priority among the questions to be analysed.

Daniel Buren

I feel I am the New Hudson River School traditionalist, using water, air, sky, land, clouds, and boats. My friend, Friel, uses fire. We could be called the fire and water boys.

Iain Baxter

The proposed projects do not differ from the other pieces as idea, but do differ to the extent of their material substance.

Douglas Huebler

As with any art, an interested person reacts in a personal way based on his own experience and imagination. Obviously, I can't control that.

Robert Barry

The terrestrial studio cannot accept the stringencies of a minimalistic influence. Reductionists' needs no longer have their source—this art should not pay heed to vibrations returning from the mimicry of compositional superstitions. The vestiges of a loft micro-environment will not find rapport with the new sensibility.

Dennis Oppenheim

The forms of art are always preformed and premeditated. The creative process is always an academic routine and sacred procedure. Everything is prescribed and proscribed. Only in this way is there no grasping or clinging to anything. Only a standard form can be imageless, only a stereotyped image can be formless, only a formularized art can be formulaless.

Ad Reinhardt

In France there is an old saying, "stupid like a painter." The painter was considered stupid, but the poet and writer very intelligent. I wanted to be intelligent. I had to have the idea of inventing. It is nothing to do what your father did. It is nothing to be another Cézanne. In my visual period there is a little of that stupidity of the painter. All my work in the period before the *Nude* was visual painting. Then I came to the idea. I thought the ideatic formulation a way to get away from influences.

Marcel Duchamp

The basis of an aesthetic act is the pure idea. But the pure idea is, of necessity, an aesthetic act. Here then is the epistemological paradox that is the artist's problem. Not space cutting nor space building, not construction nor fauvist destruction, not the pure line, straight and narrow, nor the tortured line, distorted and humiliating; not the accurate eye, all fingers, nor the wild eye of dream, winking; but the idea-complex that makes contact with mystery—of life, of men, of nature, of the hard, black

chaos that is death, or the grayer, softer chaos that is tragedy. Everything else has everything else.

Barnett Newman

I will refer to the kind of art in which I am involved as conceptual art. In conceptual art the idea or concept is the most important aspect of the work. When an artist uses a conceptual form of art, it means that all of the planning and decisions are made beforehand and the execution is a perfunctory affair. The idea becomes a machine that makes the art. This kind of art is not theoretical or illustrative of theories; it is intuitive, it is involved with all types of mental processes and it is purposeless. It is usually free from the dependence on the skill of the artist as a craftsman. It is the objective of the artist who is concerned with conceptual art to make his work mentally interesting to the spectator, and therefore usually he would want it to become emotionally dry. There is no reason to suppose, however, that the conceptual artist is out to bore the viewer. It is only the expectation of an emotional kick, to which one conditioned to expressionist art is accustomed, that would deter the viewer from perceiving this art.

Sol LeWitt

"Non-art," "anti-art," "non-art art" and "anti-art art" are useless. If someone says his work is art, it's art.

Don Judd

In a broad sense art has always been an object, static and final, even though structurally it may have been a depiction or existed as a fragment. What is being attacked, however, is something more than art as icon. Under attack is the rationalistic notion that art is a form of work that results in a finished product. Duchamp, of course, attacked the Marxist notion that labor was an index of value, but readymades are traditionally iconic art objects. What art now has in its hand is mutable stuff which need not arrive at the point of being finalized with respect to either time or space. The notion that work is an irreversible process ending in a static icon-object no longer has much relevance.

Robert Morris

In time the whole electrical system will pass into inactive history. My lamps will no longer be operative; but it must be remembered that they once gave light.

Dan Flavin

Focus. Include one's looking. Include one's seeing. Include one's using. It and its use and its action. As it is, was, might be (each as a single tense, all as one). A = B. A is B. A represents B (do what I do, do what I say).

Jasper Johns

. . . The thing that I find in commercial art—in the new world outside largely formed by industrialism or by advertising—is the energy and the impact that it has and the directness and a kind of aggression and hostility that come through it It has a lot to do with the conceptualization of art rather than the visual. Conceptualization in a way means oversimplification and I'm very much concerned with apparent oversimplification It doesn't mean that the art is oversimplified; but it's a kind of stylistic development

Roy Lichtenstein

The disinterest in painting and sculpture is a disinterest in doing it again, not in it as it is being done by those who developed the last advanced versions. New work always involves objections to the old, but these objections are really relevant only to the new. They are part of it. If the earlier work is first-rate it is complete

Don Judd

I think both art and life are a matter of life and death.

Walter De Maria

But having gotten used to its absence, one notices the new presence derived from and created by its physical sojourn; a kind of presence—presence, autonomous and different from all other phenomenal states in this work from which the painting is absent.

It's a question, really, of a creation of art, pure, true art. And no longer of suggestion, of picturesque this and that, crystallisation of desires, or of a psychological state, etc., etc. . . .

Yves Klein

It is not surprising that some of the new sculpture which avoids varying parts, polychrome, etc., has been called negative, boring, nihilistic. These judgments arise from confronting the work with expectations structured by a Cubist esthetic in which what is to be had from the work is located strictly within the specific object. The situation is now more complex and expanded.

Robert Morris

For too long the artist has been estranged from his own "time." Critics, by focusing on the "art object," deprive the artist of any existence in the world of both mind and matter. The mental process of the artist which

takes *place* in time is disowned, so that a commodity value can be maintained by a system independent of the artist. Art, in this sense, is considered "timeless" or a product of "no time at all"; this becomes a convenient way to exploit the artist out of his rightful claim to his temporal processes. The arguments for the contention that time is unreal is a fiction of language, and not of the material of time or art. Criticism, dependent on rational illusions, appeals to a society that values only commodity type art separated from the artist's mind.

Robert Smithson

Every possible buyer of an immaterial pictorial sensitivity zone must realize that the fact that he accepts a receipt for the price which he has paid takes away all authentic immaterial value from the work, although it is in his possession.

Yves Klein

I'm just making the last paintings which anyone can make.

Ad Reinhardt

One of the important things in any art is its degree of generality and specificity and another is how each of these occurs. The extent and the occurrence have to be credible. I'd like my work to be somewhat more specific than art has been and also specific and general in a different way. This is also the intention of a few other artists. Although I admire the work of some of the older artists, I can't altogether believe its generality. Earlier art is less credible. Of course, finally, I only believe in my own work. It is necessary to make general statements, but it is impossible and not even desirable to believe most generalizations. No one has the knowledge to form a comprehensive group of reliable generalizations. It is silly to have opinions about many things that you're supposed to have opinions on. About others, where it seems necessary, the necessity and the opinion are mostly guess. Some of my generalizations, like these verbal ones, are about this situation. Other generalizations and much of the specificity are assertions of my own interests and those that have settled in the public domain.

Don Judd

A diagram is not a painting; it is as simple as that. I can make a painting from a diagram, but can you; can the public; it can just remain a diagram if that is all I do, or if it is a verbalization it can just remain a verbalization. Clement Greenberg talked about the ideas or possibilities of painting in, I think, the "After Abstract Expressionism" article, and he allows a blank canvas to be an idea for a painting. It might not be a *good* idea, but it is

certainly valid. Yves Klein did the empty gallery. He sold air, and that was conceptualized art, I guess.

Frank Stella

Abstract art or non-pictorial art is as old as this century, and though more specialized than previous art, is clearer and more complete, and like all modern thought and knowledge, more demanding in its grasp of relations.

Ad Reinhardt

The detachment of art's energy from the craft of tedious object production has further implications. This reclamation of process refocuses art as an energy driving to change perception. (From such a point of view the concern with "quality" in art can only be another form of consumer research—a conservative concern involved with comparisons between static, similar objects within closed sets.) The attention given to both matter and its inseparableness from the process of change is not an emphasis on the phenomenon of means. What is revealed is that art itself is an activity of change, of disorientation and shift, of violent discontinuity and mutability, of the willingness for confusion even in the service of discovering new perceptual modes.

Robert Morris

Somewhat new work is usually described with the words that have been used to describe old work. These words have to be discarded as too particular to the earlier work or they have to be given new definitions. Occasionally new terms have to be invented.

Don Judd

If the artist carries through his idea and makes it into visible form, then all the steps in the process are of importance. The idea itself, even if not made visual is as much a work of art as any finished product. All intervening steps—scribbles, sketches, drawings, failed work, models, studies, thoughts, conversations—are of interest. Those that show the thought process of the artist are sometimes more interesting than the final product.

Sol LeWitt

The difference between the new, non-objective ("useless") art and the art of the past lies in the fact that the full artistic value of the latter comes to light (becomes recognized) only after life, in search of some new expedient, has forsaken it, whereas the unapplied artistic element of the new art outstrips life and shuts the door on "practical utility."

Kasimir Malevich

It can be argued that we are not really dealing with alternatives. If almost all modern art is developmental, consciously or not, with a family tree of

commentaries, quotations and extensions, then the very notions of experimentation and brinkmanship are themselves heritage of the last hundred years. Admittedly so, but the crucial difference here involves a separation of cultural *attitudes* from cultural *acts:* attitudes which are to be applied to a zone, still unmarked, between what has been called art and ordinary life. Metaphorically, the displacement is almost a manufactured schizophrenia, and in the shift, a unique mentality may take over.

Allan Kaprow

I wanted work that didn't involve incredible assumptions about everything. I couldn't begin to think about the order of the universe, or the nature of American society. I didn't want work that was general or universal in the usual sense. I didn't want it to claim too much . . .

Don Judd

An Eskimo lady who couldn't speak or understand a word of English was once offered free transportation to the United States plus $500 providing she would accompany a corpse that was being sent back to America for burial. She accepted. On her arrival she looked about and noticed that people who went into the railroad station left the city and she never saw them again. Apparently they traveled some place else. She also noticed that before leaving they went to the ticket window, said something to the salesman, and got a ticket. She stood in line, listened very carefully to what the person in front of her said to the ticket salesman, repeated what that person said, and then traveled wherever he traveled. In this way she moved about the country from one city to another. After some time, her money was running out and she decided to settle down in the next city she came to, to find employment, and to live there the rest of her life. But when she came to this decision she was in a small town in Wisconsin from which no one that day was traveling. However, in the course of moving about she had picked up a bit of English. So finally she went to the ticket window and said to the man there, "Where would you go if you were going?" He named a small town in Ohio where she lives to this day.

John Cage

Fine art can only be defined as exclusive, negative, absolute, and timeless.

Ad Reinhardt

At first, he didn't like the notion much, but he understood, and after a while he agreed. He took out a portfolio of his drawings and began thumbing through it. He pulled out one drawing, looked at it, and said, "No, I'm not going to make it easy for you. It has to be something I'd miss." Then he took out another portfolio and looked through that, and finally he gave me a drawing, and I took it home. It wasn't easy, by any means.

The drawing was done with a hard line, and it was greasy too, so I had to work very hard on it, using every sort of eraser. But in the end it really worked. I *liked* the result. I felt it was a legitimate work of art, created by the technique of erasing. So the problem was solved, and I didn't have to do it again.

Robert Rauschenberg

In order that art may be really abstract, in other words, that it should not represent relations with the natural aspect of things, the law of the *de-naturalization of matter* is of fundamental importance.

Piet Mondrian

What the work of art looks like isn't too important. It has to look like something if it has physical form. No matter what form it may finally have it must begin with an idea. It is the process of conception and realization with which the artist is concerned. Once given physical reality by the artist the work is open to the perception of all, including the artist. (I use the word "perception" to mean the apprehension of the sense data, the objective understanding of the idea and simultaneously a subjective interpretation of both.) The work of art can only be perceived after it is completed.

Sol LeWitt

Art no longer cares to serve the state and religion, it no longer wishes to illustrate the history of manners, it wants to have nothing further to do with the object, as such, and believes that it can exist, in and for itself, without things.

Kasimir Malevich

Art is what we do. Culture is what is done to us.

Carl Andre

We saw that pictures these days are only imitations and substitutes of real things and therefore not "high" art. If you think that a picture of a sunset or a nude is real, then you don't have much fun, do you; . . . We saw that both light and time is space, that you yourself are a space, that a painting is a flat space. We saw that an abstract painting is not a window-frame-peep-show-hole-in-the-wall but a new object or image hung on the wall and an organization of real space relations. . . . A modern painter's worst enemy is the picture maker who somehow creates in people the illusion that one need not know anything about art or art history to understand it. But looking isn't as simple as it looks.

Ad Reinhardt

. . . in 1922 I ordered by telephone from a sign factory five paintings in porcelain enamel. I had the factory's colour chart before me and I sketched my paintings on graph-paper. At the other end of the telephone the factory superintendent had the same kind of paper divided into squares. He took down the dictated shapes in the correct position.

Laszlo Moholy-Nagy

I'm believing painting to be language.

Jasper Johns

I know of no occupation in American life so meaningless and unproductive as that of art critic.

Dan Flavin

The artist who wants to develop art beyond its painting possibilities is forced to theory and logic.

Kasimir Malevich

Conceptual art doesn't really have much to do with mathematics, philosophy or any other mental discipline. The mathematics used by most artists is simple arithmetic or simple number systems. The philosophy of the work is implicit in the work and is not an illustration of any system of philosophy.

Sol LeWitt

Whatever happened to the art object?

Carl Andre

One's proposal challenges what one thinks art might become (even its existence).

Dan Flavin

The main virtue of geometric shapes is that they aren't organic as all art otherwise is. A form that's neither geometric or organic would be a great discovery.

Don Judd

The one standard in art is oneness and fineness, rightness and purity, abstractness and evanescence. The one thing to say about art is its breathlessness, lifelessness, deathlessness, contentlessness, formlessness, spacelessness and timelessness. This is always the end of art.

Ad Reinhardt

STATEMENT FROM *INFORMATION*

At its most strict and radical extreme the art I call conceptual is such because it is based on an inquiry into the nature of art. Thus, it is not just the activity of constructing art propositions, but a working out, a thinking out, of all the implications of all aspects of the concept 'art'. Because of the implied duality of perception and conception in earlier art a middle-man (critic) appeared useful. This art both annexes the functions of the critic, and makes a middleman unnecessary. The other system: artist-critic-audience existed because the visual elements of the 'how' construction gave art an aspect of entertainment, thus it had an audience. The audience of conceptual art is composed primarily of artists—which is to say that an audience separate from the participants doesn't exist. In a sense then art becomes as 'serious' as science or philosophy, which don't have 'audiences' either. It is interesting or it isn't just as one is informed or isn't. Previously, the artist's 'special' status merely relegated him into being a high priest (or witch doctor) of show business.

This conceptual art, then, is an inquiry by artists that understand that artistic activity is not solely limited to the framing of art propositions, but further, the investigation of the function, meaning, and use of any and all (art) propositions, and their consideration within the concept of the general term 'art'. And as well, that an artist's dependence on the critic or writer on art to cultivate the conceptual implications of his art prop-

First published in *Information* [ex. cat.] (New York: Museum of Modern Art, 1970). The first three paragraphs had appeared in Kosuth's "Introductory Note to *Art-Language* by the American Editor."

ositions, and argue their explication, is either intellectual irresponsibility or the naivest kind of mysticism.

Fundamental to this idea of art is the understanding of the linguistic nature of all art propositions, be they past or present, and regardless of the elements used in their construction.

This concept of American 'conceptual' art is, I admit, here defined by my own characterization, and understandably, is one that is related to my own work of the past few years.

My activity as an artist should be considered as one which is separate from the 'construction' of significant individual 'works'. My activities, since 1965, have consisted of a series of investigations which are comprised of propositions on/about/of 'art'. 'Masterpieces' imply 'heroes' and I believe in neither.

Every unit of an (art) proposition is only that which is *functioning* with a larger framework (the proposition) and every proposition is only a unit which is *functioning* within a larger framework (the investigation) and every investigation is only a unit which is *functioning* within a larger framework (my art) and my art is only a unit which is functioning within a larger framework (the concept 'art') and the concept art is a concept which has a particular meaning at a particular time but which exists only as an idea used by living artists and which ultimately exists only as information.

To attempt an 'iconic' grasp of only a part or unit of the above paragraph (which means to consider one action a potential 'masterpiece') is to separate the art's 'language' from its 'meaning' or 'use'. The art is the 'whole' not 'part'. And the 'whole' only exists conceptually.

STATEMENT FROM *SOFTWARE*

While certainly some of the elements I use in my investigations are of more importance than others, it is not possible to construct a mental image or 'icon' from the elements used—as you could in my work of a couple of years ago. The elements I use in my propositions consist of information. The groups of information types exist often as 'sets' with these sets coupling out in such a manner that an iconic grasp is very difficult, if not impossible. Yet the *structure* of this set coupling is not the 'art'. The art consists of my action of placing this activity (investigation) in an art context (i.e. art as idea *as idea*).

The specific quality of the items used in a form of presentation and in a museum presentation installation are of a temporal nature directly related to taste. In other words, it is necessary for me to choose a particular way *at this time* which is neither 'important' in its own right, nor deliberately 'unimportant' in an *arty* manner. This problem exists because of the still prevalent belief that there is a conceptual connection between art and aesthetics—thus it becomes assumed that there is *artistic* relevance to my choices based on taste. Fifty years from now if my idea of art is extant it will be so only through the activities of living artists, and the taste I showed in my choices of the installation for this show will be dated and irrelevant.

First published in *Software* [ex. cat.] (New York: The Jewish Museum, 1970)

NOTES ON *CRANE*

Conceptually what made the crane a work of art in its *art* state? I'm afraid one can only answer: "The total context, particularly including the possibility of it not being art." One realizes that if *Crane* had been constructed under the exact same situations and conditions, excepting not having been the work of an artist of conceptual persuasion, the work's complete *raison d'être* would have been "a functional crane to serve as a recreational plaything in one of the council's play parks" and nothing more. The 'fine artist' that made the work would have merely used his ability as a craftsman (the ability being a 'tool' acquired, we assume, for use in the making of 'useless' fine art: sculpture). Thus, one must underscore the role of the (an) artist's *intentions* in art, i.e. the importance of the postulate.

(The inherent weakness of Expressionism, of course, is that the postulate is completely unclear, particularly to the artist. Is he expressing himself, making an aesthetic object, or depicting an emotional world?)

It's my particular thesis that art *only* exists conceptually, because (perhaps) *man* only exists conceptually. That is to say if a totally objective being were to view earth it is most likely he would see only just so much matter. This sounds unsound, I'm sure, but one begins to realize the only difference between 'works of art' and other objects is that someone (usually an artist) has taken upon himself to include the object into a concep-

Unpublished notes written in 1970. Kosuth refers to the work *Crane* which had been realized by David Bainbridge in 1966. *Crane* gave Bainbridge and Terry Atkinson an opportunity to discuss issues of intentional designation in art. See "Introduction," *Art-Language* 1, no. 1 (May 1969), p. 8.

tual context in accordance with some postulate; thus ordering our experience with it and the value placed on it. (i.e. gold isn't *really* worth any more than lead.)

But there must be a postulate, and indeed, there always is one. Often it is different from what the artist thinks it is. (Here is how we differentiate between a 'good' artist and a 'bad' one: if one considers the particular 'work of art' a theorem, it is possible to consider the theorems as formal consequences of the postulates. A 'bad' artist is one that (a) either has no postulates to speak of—"of his own" let us say (i.e. he is a craftsman expressionist, or some such) or (b) his 'theorem' is so influenced by popular notions of what 'formal consequences' should be like that his own postulate gets lost; or (c), and this is the most common: like in students the work is a hybrid of either other's postulates, theorems (as just mentioned) or both.) When one says that a young artist or student is 'promising' what one is actually saying is that he has original postulates but yet has not been able to develop original theorems. On the other hand, for me, someone with 'talent' has always meant someone with popular postulates and original theorems.

A postulate, then, is the conceptual context in which a work of art exists. How it gets there is fairly irrelevant (as Duchamp pointed out, all of the painter's tools—his pigments, brushes, canvas, are all 'readymades') depending, if at all, on local values.

To be 'original' or 'creative' one must invent new postulates. This means that it is necessary to create—in the final analysis—a new notion of what art is, or can be. One certainly finds elements of this in various 20th century artists: Picasso (if we attribute cubism to him), Mondrian, Pollock, Warhol, Judd, Reinhardt, others.

Because the world changes and likewise the meaning of things changes, the conceptual and experiential aspect of a work of art changes. The physical residue of the work of art in time (the painting etc.) is less reliable than the sum total of its critical evaluation by contemporaries. At any rate, art only 'lives' through influencing art after it. This is the only way for it to continue existing conceptually. Once that particular artist's reality has gone, the reality of that particular work of art is gone as well, so its physical residue is little clue to the 'meaning' of the work of art.

INFLUENCES: THE DIFFERENCE BETWEEN
'HOW' AND 'WHY'

Artists that (often in retrospect) appear to make quality art, or, better stated—artists that seem to make valid work, are artists with a clear, or at least steady, notion of the 'why' of their work. 'Why' is about art, and 'how' is about presentation. Morris' 'why' has always been solid, yet his recent flagrant 'borrowing' of younger artists' 'hows' has resulted in a lot of criticism. Embarrassingly weak artists like Michael Steiner, Peter Hutchenson, Richard Van Buren (and most of the Bykert Gallery), are weak because they are mostly 'how' with little 'why' and that's the reason their work changes from art season to art season. One's 'why' *usually* demands that one's 'how' at one time connects with one's 'how' at another time, on some level. A student is an embryonic artist who is studying 'hows' until the 'why' develops or occurs.

A recent occurrence is the killing of a young artist's 'why' in its early forming stages by the international art market. Good examples of this are Michael Heizer, William Bollinger, and Dan Christensen. Bollinger is the greatest loss because he was the most developed. His last show (at Bykert) and his pieces in the Kunsthalle, the Stedelijk, in Lucy Lippard's Paula Cooper show, and at the Whitney are all about "what's happening in art." Before, he was slow, steady, clear; and, although I am sure "what's happening now" has a great deal to do with his artistic world-view, his choice of 'how' is fashionable whereas before, his 'how' was clearly his own, although it was obvious he was searching.

To my knowledge Heizer was one of the first (if not *the* first) to go to the desert and dig, within an art context. I knew him at that time (although

Unpublished notes written in 1970.

not well) and he was a peaceful yet intense, serious very romantic Rimbaud-like character. Sort of an existential cowboy. He thought the art world was perverse, perverted and corrupting. He wanted nothing to do with it. He would talk about the holes he dug and consider the implications. He had a few notes and sketches around the studio, not much more. He would admit he didn't know what it all meant, and didn't really know what he was doing, except that he enjoyed what he did; it was about him, and he didn't want to do something else. Before that had a chance to develop, the 'Earth Movement' avalanche occurred. The result has become standard. His work can be seen via slick, super-color, self-operating slide machines and/or wall size blow-ups (an approximated visual experience?). The artist is now violently anti-intellectual—not because of cowboy turned artist masculinity problems, but due probably to self doubt/disgust from never having had the chance to develop his few beginning attempts: defensiveness is bound to follow.

Often an artist radically changes his 'how' while clearly continuing his 'why'. Lawrence Weiner and Douglas Huebler are good examples in explaining this process. Weiner's paintings (which he was actively involved in when I met him in the late spring of 1968) were quite unlike most, done in what was then the familiar 'systemic' mode—they were very non-composed, and the color could be chosen by any arbitrary method. They all had a notch removed and slanted lines (sometimes slanted fields of color) because, he said, he wanted to kill its 'picture' quality, although I always felt that was quite unresolved. Weiner was also doing some 'sculpture' as he called it. They were pieces consisting of the binding together (by glues, etc.) of two pieces of some material. They were as interesting and less arty. By the beginning of that Summer his 'how' drastically changed (I persuaded him to give up the traditional painting format) and he presented his ideas directly without the 'art' (canvas and stretchers) format. He did some pieces which consisted of the paint sprayed directly on the floor of his studio, paint thrown out the window of this studio to the wall outside, paint poured into a hole dug in the backyard of his studio and so on. This was long before Richard Serra and all that followed, and the paint sprayed on the floor pieces was even reproduced in *Arts* later that fall (still, by the way, long before anyone else had done that, save, possibly Jackson Pollock and Gary Kuehn—both doing it for different reasons).

Just preceding that 'breakthrough,' as art historians like to say, the American Federation of Arts were organizing a travelling show titled "The Square in Painting" and I was asked to suggest some younger artists for the show. I asked Weiner if he were interested and he was. What followed though was a discussion about doing work *for* a context—a show, a commission, etc. He began relating this to his procedure in making paintings

(the collector could choose the color, which side the notch would be on, the size—width or height; and, in effect, all Weiner could be left to choose was the time element—how long he would aim the sprayer at the canvas). And, although nothing particular came out of this discussion, he was later to remember it and make it an important aspect of his work. And he mentioned it to me a couple of times after that. (Once, in April 1968, I remember when I was trading one of my *Art as Idea as Idea* pieces with him for a painting he was doing especially for me—a black painting, one of the last and one of the best he did), he mentioned how he always worked best when doing it for a specific reason—when he worked on his own, he said, the work wasn't as exciting for him to make nor were the results as good. I remembered it because I was slightly offended by the idea; with me it was the exact opposite, the 'how' should serve the 'why' process.

When Weiner gave up the painting format, it soon became clear to him that—owing to the smallness of his studio—he would have little area in which to work. And so that summer he began to write down proposals for pieces in his notebook. A visitor to his studio could look on the floor and out the window then sit down at his desk and leaf through his note book. It was entirely pragmatic. If a collector wanted a piece he could just pick it out of the notebook and Weiner would do it for him at his choice of place. It wasn't until late fall of 1968 that Weiner decided that the *statement* could be art unmade. (I never fully understood this in *his* terms because he had always claimed to be interested in the materials, and it seemed to me that for *him* he was giving up a lot to perfect the presentation issue.)

I never really liked *Statements** because it seems to hide the beauty of Weiner's thinking in a presentation form that is too obviously influenced by me. I had been dividing my work between 'general' and 'specific' since late 1965, and the divisions which were titled the same in *Statements* seemed to be superflous and often incorrectly labeled. I suppose his desire to lean toward conceptualization and lean away from materialization had in part to do with his failure to get the recognition he deserved for the 'process' or 'anti-form' pieces. (Robert Morris has since told me that Weiner wasn't included in those shows because he felt Weiner's work was "too pretentious and gestural"; although I took Morris to Weiner's studio as early as November of 1968, and Richard Serra's liquid lead pieces came out of Morris' transfer of the information.)

Weiner's 'why' was always about materials—not how they looked, not the process, but merely an interest in materials for their own sake. And

*Kosuth refers to the book *Statements*, which Weiner realized in 1968.

he had previously developed a 'how' which dealt with his 'why' in a direct way.

Perhaps only because it's been this way for me, it seems that the strongest artists have their 'why' before they have their 'how'. It certainly was that way for Pollock, for Reinhardt, for Judd, for Flavin. It's about having one's 'why' and realizing that everyone else's 'how' won't do; and the continuing search for a personal 'how' that directly answers and relates to his 'why'.

CONTEXT TEXT

A. On the idea of 'Conceptual Art':

My original reasons for using the term 'conceptual' in reference to my art was to underscore my *motives* and to clarify the sense in which I was using particular materials at that time. My first published use of the term was in a catalogue for an exhibition titled *Non-Anthropomorphic Art* at the now defunct Lannis Gallery in New York. I used the term in reference to a lesser known group of works exhibited there which I called *Double Sized Models.* They consisted of clear square sheets of glass or plexiglass which lay directly on the floor. Each work had a label which would ask the viewer to consider the size to be another, such as, a five foot square of glass was marked to be considered a one foot square sheet of glass, and so on. I did this group shortly before I began the *Art as Idea as Idea* series, and concurrently with investigations using the various physical states of water.

My reasons for beginning to call my *activities* 'Conceptual Art' was a very well developed sense I had that the art 'meanings' that materials used within an art context took on were extremely transitory and almost totally dependent on support information. Obviously then the 'art' wasn't *in* the materials used no more than the *meaning* is *in* the phoneme in a spoken sentence. It is only a naive view that art is craftsmanship which supports such thinking, and by extension, allows painters to continue to paint. Once one realizes this it becomes obvious that *all* art is conceptual, particularly when we refer to modernist art. Art before the modern period

Introduction to *The Sixth Investigation 1969, Proposition 14* (Cologne: Gerd de Vries, 1971).

is as much art as neanderthal man is man. It is for this reason that around the same time I replaced the term 'work' for *art proposition.* Because a conceptual *work* of art, in the traditional sense, is a contradiction in terms. The term 'Conceptual Art' then means that the artist is involved in a (conceptual) investigation or method of inquiry into the nature of art. The term 'art' used here then refers to *activity,* not the physical residue of the end result. It is only the capitalist-marxist economic obsessions which have blown out of proportion this so called 'new phenomenon' of artists that don't make objects. Artists such as Gilbert and George, Robert Barry, Ian Wilson, Lawrence Weiner, and Daniel Buren may appear 'radical' in the *social* history of art but since they have contributed so little to the *conceptual* development of art their only present viability is as poetic-mystic enigmas. And by that I don't mean to say they aren't serious men, it's just that they have used information developed by others for their own ultimately basically expressionist pursuits without *adding* anything to our fund of knowledge about art.

What makes an artist, or any other thinker, important is what he has contributed to the history of ideas. The issue itself isn't radicality, since that's only a value judgement, but it is how much one has enlarged the scope of our understanding of the area of endeavor—that is what a contribution consists of. There is nothing wrong *per se* with using objects in art—if they *as tools* can cope with the continuing enlargement of the complexity of issues in art. And it is for this reason, at this time, that *texts* are the necessary result of 'Conceptual Art' activities. When objects are used—by myself or by Bainbridge or Hurrell, for instance—they are usually used as a kind of 'formal' language for which a support language is necessary to clearly understand the terms involved.

My use of 'Conceptual Investigations' is obviously from philosophy. In other words the subject-matter of conceptual investigations is the *meaning* of elements or propositions in an art context, and not our subjective opinions of our perception of them as entities in the world. So, to put it simply, 'Conceptual Art' merely means *a conceptual investigation of art.*

B. On art and aesthetics:

One of the reasons why there has been so much contradictory discussion concerning art in our time is due to the inability of modern thinkers to fully understand the terms they employ in their consideration of some of their primary *a priori* assumptions about art. The difference between art and aesthetics is perhaps the most important. It is necessary to separate aesthetics from art because aesthetics deals with opinions on perception of the world in general. One of the two aspects of art's function in the past was its value as decoration. Thus, any branch of philosophy which dealt with 'beauty' and likewise, taste, was inevitably duty bound to

discuss art as well. From this grew the notion that there was a conceptual connection between art and aesthetics, which is not true. Art was never obviously at odds with this assumption until recently.

Aesthetics is about *subjective* opinions on perception. In a way one could say that experience is how profoundly we react to our perceptions, that is, to all the various kinds of information we receive from our senses. Aesthetics then has to do with what as individuals we perceive in terms of experience. Those subjective preferences we usually call 'taste'. Thus, one can have an aesthetic reaction to *any* information which our senses give us: what we put in our mouths, touch with our hands, smell with our noses, or see with our eyes. In other words, we can deal aesthetically with *anything* that is in the world that our senses can respond to. While a sunset, a flower, an ocean, or any man-made structure or thing can be aesthetically considered or experienced, this doesn't constitute their existence as art. So, when objects are presented within the context of art (and until recently objects have consistently been used) they are as eligible for aesthetic consideration as are any objects in the world, and an aesthetic consideration of an object existing in the realm of art means that the object's existence or functioning in an art context is irrelevant to the aesthetic judgement.

As Wittgenstein said, "The meaning is the use." Any consideration of a man-made object in aesthetic terms is separate from its use (and thus, 'meaning'). Unless, of course, that use is solely and primarily aesthetic. Such an object would be a decorative one, for instance. Many areas of endeavor previously considered 'lesser' artistic activities should be re-evaluated and considered as legitimate enterprises in their own context, that is, as aesthetic field, overt notions of 'self-expression' are relevant in aesthetic considerations because choices of taste, i.e., choices of experience, are important personal statements. Whereas in *art* notions of 'self-expression' are no more relevant than they are in science, philosophy or any other field. The specialized, subtle, technical, and intricate nature of art issues—in other words that which makes art art and not some other activity—makes the demands on artists in our time such that the inherent solipsistic nature of expressionism rules out both comprehension and contribution.

C. On art and language:

There is a kind of interdependent two-fold aspect to procedural considerations of art's relationship to language. Art can be dealt with as a language on its own internal terms. And it can also be analyzed in a parallel study of linguistics and linguistic philosophy. At best one must simultaneously consider both without confusing the two activities.

If art exists for non-aesthetic reasons, what are those reasons and how does an art proposition 'work' within those reasons vis-a-vis the world? If one considers that the forms art takes as being art's *language* one can realize then that a work of art is a kind of proposition presented within the context of art as a comment on art. An analysis of proposition types shows art 'works' as analytic propositions. Works of art that try to tell us something about the world are bound to fail. Even the disciplines that are there to attempt, have a difficult enough time of it. The absence of reality in art is exactly art's reality. And only if, and only when, artists' activities function solely within that art 'reality' can a conception be drawn later about that 'structure' and the implied 'picture' of human reality shown by it. The failure of philosophy, even so-called 'ordinary language' philosophy, is the underlying ultimate goal of some kind of comprehension of reality. Whereas at best all one can ever hope for is an accurate 'picture' of man's reality.

The issues that have to do specifically with the relationship of art and language and art to language are, of course, primarily what my activity as an artist is about. The issues are extremely complex to discuss conversationally because of the extreme relativism implicit in the contextural nature of the elements in my investigations. In other words it's better to go to my work, half of which includes texts, than to have me synopsize it here.

D. On the investigation as a working process; the unit of an art proposition:

Often it becomes very apparent that general social notions of what constitutes a profession or an activity can be a strong cultural deterrent to change, enlargement, even 'progress' (if you accept such notions). This certainly is the case with art. The general public's romantic notions concerning what activities a man must participate in to be considered an 'artist' has certainly turned away from art many fertile, intelligent minds, and let in an abundance of intellectually irresponsible and lazy, as well as pretentious, ego-centrics.

If you consider, for instance, a scientist. A scientist is a scientist both when he is working in his laboratory, as well as when he is working on his thesis papers. *Both* activities constitute being a scientist. Yet in art the artist has limited his activities to *just* the work in the laboratory, and has depended on the critic to do the other work—that is—to cultivate the conceptual implications of his art propositions, and argue their explication. We're far enough along in this century to realize it just isn't enough to make an artistic gesture—to present a blank painting, to say your life is your art, 'oral communication' or whatever. It's just *too* easy. This kind of 'rough' work was done long ago. If an artist hasn't given art something

that wasn't there before, if he hasn't enlarged or articulated the concept of it, then he hasn't contributed anything and his unexplained, mystical gesture is meaningless—in art, and probably in life as well.

My first use of the term 'proposition' for my work was when I began my *Art as Idea as Idea* series in 1966. The photostatic blow-ups weren't supposed to be considered paintings, or sculpture or even 'works' in the usual sense—with the point being that it was art as *idea.* So I referred to the physical material of the blow-up as the works' 'form of presentation', and referred to the art entity as a *proposition*—a term I borrowed from linguistic philosophy. At about the same time I began thinking in terms of art propositions while considering the—at that time—*analogy* between language and art. So that in my mind I began to equate linguistic propositions with artistic propositions.

The first *Art as Idea as Idea* series—the blow-ups of dictionary definitions—began to disturb me in their iconic nature, not in a visual sense because I had successfully resolved that, but in the sense of a single, isolated iconic 'idea', with amplified boundaries, and a beginning and an ending. At first this was a positive aspect of the work for me—I liked the idea of taking a concept which everyone has and *re*-presenting it to them in an art context. Believe it or not that, in one sense anyway, came out of my earlier use of materials like glass, water, air—materials with a neutral, low information excitation yield.

So later I tried to neutralize this 'iconic' quality. I first began this in the second investigation, *The Synopsis of Categories*, which was in 1968. In this work I used as a form of presentation whatever was the normal information or advertising media for that society—such as newspaper, magazine, subway, bus and billboard advertising, or handbills, or television, and so on. It was anonymous of course, so that *meaning* was dependent on, first, certain situations we could refer to as 'cultural functions' and, secondly, an understanding (whenever it comes) of the conceptual nature of art. One could say that what some later presented as 'physics' I originally used as 'engineering'.

Later in the subsequent investigations I was able to get away from the wholesale 'readymade' use. That way the parallel was more of a 'word—sentence—paragraph—text' function than an 'element in time and space' function, even implied. As I have stated before, it works something like this: every unit of an (art) proposition is only that which is *functioning* within a larger framework (my art) and my art is only a unit which is *functioning* within a larger framework (the concept of 'art') and the concept 'art' is a concept which has a particular meaning at a particular time, but which exists only as an idea used by living artists and which exists

ultimately only as (cultural) information. To attempt an 'iconic' grasp of only a part or unit of the preceding (which would mean to consider one part more important than another) is to separate the art's 'language' from its 'meaning' or 'use'. The art is the 'whole' not 'part'. And the 'whole' only exists conceptually.

PAINTING VERSUS ART VERSUS CULTURE
(OR, WHY YOU CAN PAINT IF YOU WANT TO, BUT IT
PROBABLY WON'T MATTER)

The history of painting is the history of fabricating 'other worlds', be they
of social orders, historical myths, religious dreams, or personal inner
voyages. Long before Manet and through to abstract expressionists, the
painting has been a magic rectangle: a window to another world. Believing
in painting has meant that to be able to see a painting you have had to
see the paint-on-the-painting and the paint-on-the-wall as being different
in quite a special way, and we have. In this sense painting has been the
language of art in modern times; the concept of art only meant something
when concretized as painting or sculpture. (And sculpture has been con-
ceptually dependent on painting; sculpture has tried to create the same
fictive arena spatially that painting does on the surface of a canvas.) As
with any language, the physicality of the language of art *had* to be trans-
parent. For instance, if I began speaking to you in Hungarian right now
most of you would hear noises—you wouldn't enter the Hungarian lin-
guistic reality. When language loses its transparency and becomes opaque,
and you only see or hear its physical properties it means you are outside
of that belief system and its organization of reality. Abstract expressionism
attempted to push the physical stuff of its language to the edge; as though
the whole semantic infrastructure was straining, trapped. In the early
sixties the language of painting collapsed. (I say that meaning within the
context of a particular history, but all written history is particular—it is
written *for*, not of.) One thinks of the flag paintings of Jasper Johns (is
that a painting of a flag within the magical fictive world of painted reality,

Unpublished lecture delivered to art students in 1971 at the University of Chile, Santiago;
Cleveland Art Institute; and Coventry College of Art, Coventry, England.

or is it a flag in *this* world, in the room I am in?) Or the early paintings of Stella, which became to the viewer painted canvas objects occupying space in the same room you were in . . . and then, it was asked, why make objects with materials limited and culturally loaded? Why not *choose* the materials and forms for your particular work? There no longer seemed to be a need to validate one's work with the traditional frame of painting; the art context itself was frame enough. The work of Judd, Flavin, Morris, LeWitt, Andre, and so forth continued to articulate the possibilities.

Rather than presenting an inward-turning world, as painting had, I saw this new work doing quite the opposite: it began the process of looking *outward*, making the *context* important. I began to realize that the issue for art was to examine its context, and in the process one would be investigating meaning, and ultimately, reality. An important point then, about so-called 'minimal art', was that it was neither painting nor sculpture, but simply art. This last stop on the formalist trajectory gave us nowhere to look but out: first the physical, then the social, philosophical, cultural, institutional and political contexts—they all would by necessity become the focus of our work.

The belief system of the old language of painting had collapsed, and coinciding with it collapsed our ability to believe in the social, cultural, economic and political order of which it had been part. When this institution of painting and sculpture collapsed, something much more important than a style of art-making was altered—it meant that the *meaning* of art was in a crisis. This certainly doesn't mean everyone simultaneously put down their brushes—painting in some form will undoubtedly continue, painting's rich tradition will continue to be powerful for some time to come. Post-vanguard painting (as one might call it, since painting is no longer 'avant-garde' having itself been eclipsed) has counted on the art market's need for stability in the form of quality commodities.

The marketing by nature must go roughshod over the complex matrix of intention, social context, and cultural momentum which are more central to art-making than the residue which finds its place in the market. 'Tradition' if even a spurious and inflated one, provides investors with the promise of art 'securities'.

The 'collapse' we have been talking about has meant a shift in one of the major belief-systems of our culture. The belief in the magical space of the canvas surface has had an enormous effect on how we see the world. When artists became capable of thinking of *art-making* in terms of a larger conception of art, painting and sculpture became physical/formal possibilities *within* that arena of work rather than constituting the whole of our conception of art. In this way, as a language, it lost its transparency and role as a belief system, and increasingly began to be seen by artists

since the sixties as formal/physical possibilities loaded and limited by their references to tradition. Being an artist began to mean that one had to question the nature of art, using one's work as part of the questioning process. To paint or sculpt meant that one *wasn't* engaged in that questioning process. The act of painting or sculpting—and that means seeing your activity as part of that tradition—was philosophical, indeed, ideological: it meant you were saying *that* was still the nature of art, and that you didn't doubt it. It seemed to some of us that working on new forms within the picture frame begged the larger question of the function, and the meaning, of the frame itself.

What we are discussing is the relationship between art-*making* and *meaning*, and the interdependence between the two. The point is that the creative work of the artist in art-making is not in making another object in a commodified world full of objects, but in having an effect *as a maker*, on the meaning of art. The role of the artist can be seen as inherently political, since our social reality is mediated by our cultural assumptions. This is *not* the same as saying that one's art will necessarily initiate change; indeed most American art today rationalizes the existing social order and its cultural and political institutions. The politics of one's art, implicit or explicit, can work either for change or against it.

Painting has become a 'naive' art form because it can no longer include 'self-consciousness' (theoretically as well as that of historical location) in its program. Such a self-consciousness necessitates that the prevailing 'language of art', like any language, must be transparent to be believed.

With conceptual art emerged (out of what was only implicit in 'minimalism') a competitive paradigm or model of artistic activity. Sixties 'minimalism' *appealed* to the innate structure of 'logic' of Western civilization, more recent work has increasingly consisted of *revealing*, through praxis, that 'logic'. The older scientistic analytic model was passive (relied on institutions for meaning); whereas the dynamic of the new work must, in part, consist of revealing the contradictions, and as such has as its task the dismantling of the mythic structure of art as posited in the present day cultural institutions. But to do this our work must be *methodologically* creative; as artists we must continually question the conventions of our activity—and indeed, this paper has its assumptions and its conventions. My history and my experience position me. If my work has value, it is because of its use to younger artists, not because of its exchange value on the art market.

I chose language for the 'material' of my work because it seemed to be the only possibility with the potential for being a neutral non-material; considering the transparency of language meant its use in art would, in a sense, allow us to 'see' art, while still focusing on the social/cultural context it's dependent upon for meaning. It would, it seemed to me,

necessitate an art that would tell us something *about* our art by *being* our art, which is not the same thing as being art for its own sake. An art about form is an art for its own sake because it is dependent entirely on its tradition for meaning, it can speak for itself only because it can only mean something in relation to its former self.

The potential revolutionary nature of conceptual art has been that while focusing on the social/cultural context it wasn't focusing on its own formal development, but rather became a spiralling *method*, a reflexive critical practice perpetually overviewing and recontextualizing its own history; methodological choice that joined art practice with theory. Increasingly, conceptual art methodology is concerned with looking at that larger cultural, social and political context that art is dependent upon for meaning; that we are concerned with trying to do that effectively has meant in many instances that conceptual art has had to leave the proper category of art, and simply function on the level of culture.

Being anti-formalistic and, in some sense, consciously radical, necessitates the 'methodology' to transcend categorical niceties such as 'high art'. Only a low culture like ours would need to invent 'high art'. The sad fact that the market determines the meaning of our work has meant that artists are continually under pressure to make work with the consumer in mind. This had demeaned the experience of art-making for both 'art stars' and non-stars alike. The artist's experience of making has been trivialized and emptied while the priority has been put on the product. The value of the art-making experience—its human dimension—does not separate 'stars' from non-stars—only the need for 'quality' commodities does that. Thus the system of competitive individualism ends with either the artists media heroes (seldom heroines) and their styles trade marks, or one is banished to inauthentic non-history. Generalized, institutionalized 'individualism' is the ideology used to divide us. Social and cultural change, like any meaningful work, can only be the product of collaboration and collective activity. Histories that tell another story are written to teach, and what they teach is to *live* that history.

STATEMENT FOR THE CONGRESS OF CONCEPTUAL ART

A person behaves toward things in a manner that is similar to the manner in which he talks about the things that he behaves towards.

V. Steffire

An anthropologist's description of a culture is like a myth in that it is a narrative that organizes data for some purpose.

P. Bohannon

If earlier artists were merely 'carpenters' and others (critics, historians, etc.) dealt with the 'philosophical-like implications' it allowed for a condition where no one took the *responsibility* for the cultural action (art). It was still a state of naive culture, however extremely 'advanced' naive culture. (It is only such a 'naive' culture that anthropologists can comfortably deal with.) They can successfully be outside of the context because primitive societies, by their own nature, don't include anthropology. ('Responsibility' is important in that it may be the only existing 'law' in these matters that still successfully operates in relation to and regardless of the various notions of relativism subscribed to currently.)

Insofar as our 'carpentry' has been replaced by (or in some cases consists of) questioning the nature of 'questioning the nature of' 'the philosophical-like implications' of primarily a 20th century cultural action (art), one realizes 'our sense of "responsibility" ' is merely the final form of a 'non-naive' art (cultural action). (One thinks of the joke: "What is the difference

First published as "Statement," in *Congress of Conceptual Art* (Deurle, Belgium: Galerie MTL, 1973).

between a dog and a man?" answer: "A dog 'knows', but a man 'knows that he knows.' ")

Thus, an 'Anthropologized Art' such as the one I am discussing is forced to analyze contexts (that is the overview which makes our situation different) before contexts can be 'developed'.

By making the 'philosophy' explicit (consciously describing art so as to not be accused of trying to describe the world) rather than implicit (consciously describing the world so as to not be accused of trying to describe art) are we not just allowing for 'conversation' but also attempting 'myth-making'?

Are we assuming that if we can construct a 'myth' (i.e. Art & Language, Theoretical Art, Analytical Art, Conceptual Art, etc.) and it is believed (which in this case means that the former 'myth' is no longer believed) the 'philosophy' will remain 'explicit'? Is this a safe assumption? Would a distinct Anthropological overview hold to this assumption? Would such an overview treat the 'acts' of our actions (philosophical methodology, sociology, linguistic analysis, or whatever) significantly different than it does earlier forms of 'art'? Considering my notion of an 'Anthropologized Art' is such an art only possible in a sphere of 'no-philosophy'? Does *any* 'meaningless' and 'useless' cultural action, insofar as it is *only* a cultural action, imply 'philosophy' (or world-view) from the viewpoint of Anthropology?

(NOTES) ON AN 'ANTHROPOLOGIZED' ART

1. Mary Douglas: "Sets of rules are metaphorically connected with one another; allow meaning to leak from one context to another along the formal similarities that they show. The barriers between finite provinces of meaning are always sapped either by the violent flooding through of social concerns or by the subtle economy which uses the same rule structure in each province. Since this is so, separate conversations will not go on for long without returning inevitably to their shared origins. In the end the puzzles that are insoluble within a particular discipline's means will be solved by downing the fences, recognizing the common pictorial form in which the problems are posed, and restating them in the wider socio-logical perspective. The time has come to treat everyday knowledge and scientific knowledge as a single field in sociology."

2. The test of art is its believability as art. The culture (in this case 'specialists') known as the 'art public' has a grasp (or 'picture') of different aspects of the inferentially logical operations of art (in terms of its 'growth' or change capacities). Very few have a total, complete or accurate 'picture' because, for one reason, it is always changing; with a comprehension (absorption) level which is in a lag behind the most current additions. Nonetheless these opinions have a powerful force. If a work is accepted or influential it is because the basic tenets of this work respond to this 'collective picture'. This is the grounds for its believability. It is also this 'collective picture' as it were, which allows for the eventual acceptance

First published in *Kunst bleibt Kunst: Projekt '74* [ex. cat.] (Cologne: Kunsthalle, 1974), pp. 234–237.

of work which was initially unacceptable to a reigning aesthetic. By a 'reigning aesthetic' one would be referring to the more salient features of this 'collective picture' at any given time. However the salient features (formal language) can only have a perceived relevancy of a limited duration due to the temporal/contextual format of experience.

3. The difference between the internal participation in art questions (artist) and a relation with art which is external (audience, historian, critic) can be compared (yet again) with the participants in a game. That sense of 'lived time' (experience) which is understood by measured judgements within explicit or implicit constructs give the participants an 'inner space' (reality) terrain. Like with any game the ability of the audience to maintain interest in the game is dependent on the capacity of the audience to project itself (believe) into the game (play through the players).

4. (2, 3) There is a nature to games which is separate from the particular consciousness of the playing participants. The game itself is also the construct of a group consciousness (culture) of which those players are members. Further the game of art (its internal rules) consists precisely of 'rule-formation'. The game is making the game. Artists 'make the game' and society plays, in the following way: the playing of the game consists of the art (the new rules being added to the existing ones) becoming believable. Proof (or the consequence) of believability rests in the society's providing of more 'players' in the game (artists). The more pervasive a new rule becomes (thus significantly altering the game—which means altering the basis for the acceptance of additional rules), the higher a particular player is valued. The lessening of application of particular rules is a result of the society providing players which are playing (adding to and thereby strengthening and making more important) other rules. There are certainly many factors responsible for the strengthening of some rules and the atrophy of others, but ultimately it rests on the society's sense of what constitutes 'believability'.

5. Obviously this (4) picture is too neat. Since the players are not equal and rule adding not only differs in strength but is multidirectional, there is a lot of contextual 'clustering' of rules. Less significant contributions (usually antecedent) are absorbed by similar yet stronger contributions, and so on, to the extent that they take on the properties of the former. If one can follow it, this description is of a unitary rule (or 'law') which can be viewed as being on another, perhaps broader, level.

6. (One unnecessary comment is probably necessary. This description/ conversation (2, 3, 4, 5) [insofar as it would be taken as having any internal sense] is intended more as bad anthropology than as bad philosophy—as

far as the kind of operational 'depiction' model I have tried to construct is concerned. Insofar as it is a mapping it is also an artifice.)

7. Marx Wartofsky: "A model may . . . represent a theoretical picture, and not simply a mechanical one. But what marks it distinctively as different from a law in this regard is that the law *in itself* serves only as a framework for interpretation, and does not carry its interpretation with it. It may be hard to separate the statement of a law from its interpretation, because we tend automatically to associate a law with the current or common interpretations which it is given. It is in this sense that the 'entities' which a law includes, in its interpretation, are transparent. But these are transparent *because* we assume we understand them. We allege, in effect, that 'it goes without saying.' "

8. Obviously, growth (2) can go in a variety of directions and still be consistent with the 'collective picture or belief'. It is not deterministic, of course. Some work has a normative strength that other work lacks— though one could probably make a case that such work is simply 'clearer' (and more readily available) as an alternate conceptual model (of the 'collective picture'?). A model, as it functions in other fields, is intended to explain (in a way consistent with the theory of the work) the 'laws (or rules)' of art. These laws must be viewed in relation to a test of their 'believability' in the culture. If the essential character of the model can be retained under such testing then it is 'real' as art.

9. Any participation in any culture expresses implicitly held aspects of that 'world-view'. If so then, can one see that a participation in 'culture' (even though it may be 'non-naive', 'extra-art' or 'anthropologized') is an attempt to deal in a meaningful way with fictional-like (man-made) structures which seem by their existence to imply a separation from (the possibility of) 'objective reality'. These structures seem to continually collapse, however, even while attempting to focus on what one might want to call the 'nature' of the culture. (Even if one could make the attempt, could one attempt to 'reveal everything' and still operate within the bounds of Anthropology? Or the bounds of *an* Anthropology? Furthermore, the more apparently 'non-naive' the cultural action is, the more that aspect of the action which *is* naive is pertinent to an understanding of the world-view of the members of that culture.)

10. Edmund Leach: "Now let us imagine the situation of an individual A who is trying to get a message to a friend B who is almost out of earshot, and let us suppose that communication is further hampered by various kinds of interference—noise from wind, passing cars, and so on. What will A do? If he is sensible he will not be satisfied with shouting his message just once; he will shout it several times, and give a different wording to

the message each time, supplementing his words with visual signals. At the receiving end B may very likely get the meaning of each of the individual messages slightly wrong, but when he puts them together the redundancies and the mutual consistencies and inconsistencies will make it quite clear what is 'really' being said."

11. Otto Hintze: "Whenever interests are vigorously pursued, an ideology tends to be developed also to give meaning, reinforcement and justification to these interests. And this 'ideology' is as real as the real interests themselves, for ideology is an indispensable part of the life process which is expressed in action. And conversely: wherever ideas are to conquer the world; they require the leverage of real interests, although frequently ideas will more or less detract these interests from their original aim."

12. (4, 7, 8, 9, 11) A major understanding and significant character of Art & Language has been a realization that any cultural action should not be assumed 'profound' in itself. That is, if the texture of the activity has philosophical implications (about the world, not art) then the *whole* of the activity (as artists *in the world*) is meaningless. Particular to art is the capacity to 'speak' (in the sense of saying the unsayable) in a vacuum. The texture (conversation) is deliberately meaningless so that the larger cultural context ([an 'anthropologized'] art) can attempt to be unravelled (10), and potentially (but perhaps only potentially) have meaning. Art is a 'de-philosophizing' system for cultural action. Nearly all activity in contemporary art outside of Art & Language work would have to be seen simply as esoteric and rather mad if artists were incapable of maintaining that implication of profundity. Art & Language work has attempted to replace 'profundity' with 'self-consciousness'. This allows for (demands?) self-doubt, tentativeness and the outright necessity of failure. Working in the sphere of an *a priori* profundity necessitates the 'texture of the activity' as *meaningful.* But in order to have such meaning it would have to address itself to the world (existence) in a way in which it cannot. The activity *is* meaningless outside the context of art. A search for meaning in art can only address itself to art, though that need not be as simplistic as it seems (and has been).

13. (12) Art in this century (modernism) previously allowed for this assumption of profundity because in the face of a notion of 'Western Civilization' modernism was itself *one* construction with specific works and actions, the internalizations of a collective cultural entity. The conscious or non-naive consisted of an understanding of and relationship with a community in which these internalizations were taken as real and believable. With the subsequent 'opacity' of the traditional language of art (painting and sculpture) in the sixties, the objects (paintings or sculp-

tures) themselves began to lose 'believability' (the language was losing its transparency). One was always in a position of being 'outside' the work and never 'inside'. With that began, through the sixties, an increased shift of focus from the 'unbelievable' object to what was believable and real: the context. Objects or forms employed became more articulations of context than simply and dumbly objects of perception in themselves.

14. To return to our notion of a game (3, 4, 5): previously (13) I mentioned how the conception of the game as 'painting and/or sculpture' folded, one could say, into the conception of the *larger* game (context) 'art'. The conception of the game as 'art' would seem to be the outer parameters of the field of endeavor. The only possible overview of art (overview would mean to alter what is 'opaque'—insofar as one is 'outside' and from that point of view 'sees' it) is to see the game in the context of a culture; that is, as an Anthropologist. Is this the same as saying one is *outside* of the game (not an artist)? Obviously not, because the players are still 'playing' as far as any impartial understanding of the history of the game is concerned. But more importantly (to put it better) if a substantial facet of the 'collective picture' can allow for it (consider it 'believable') in conjunction with the extra-art activities occurring in the parent society then it will be absorbed and be influential (internally and externally).

15. Would one want to go that one step further and state that a capacity for art is the proof of a 'naive' society? Probably not, because there is no available position from which one can state with some sort of 'universal conviction' what a non-naive society might be like (how can you tell one when you see it?).

16. (12, 13, 14) In a typically Kuhnian schema Art & Language work (by implication) (12) is an *alternative.* Nonetheless within the Art & Language *Group* there has been consistently and increasingly a variety of conflicts concerning a program of action in relation to the art world. While on one hand many members have complained bitterly that Art & Language has been viewed simply in terms of a 'stylistic' alternative within a ('Conceptual') art movement, on the other hand the same individuals have clung to the more obvious stylistic distinction between Art & Language working and the rest of the art world as though the absence of these distinctions would precipitate an identity crisis of disastrous proportions. The most salient example is collaboration. It seems as though individual responsibility is seen as 'disruptive' in a society whose identity is dependent upon an *apparent* separation (an actual one would only be opting for total meaninglessness) from the (art) world at large. In a certain sense it is a manifestation of a tacit recognition that most (art/cultural) actions in the art world are ultimately (art) socio-politically coded in stylistic terms as

was the reception of early Art & Language work (Atkinson, Baldwin, this writer) and its viewing as part of the general 'de-materializing' art scene—simply as stylistic possibilities. With the growth of Art & Language to include two groups (England and New York) and perhaps as many as twenty members (membership being dependent on who's filling out the list), collaboration has come to mean (in England) working for Michael Baldwin or (in New York) working for Mel Ramsden. This is not said simply as a disparaging remark to either the foremen *or* the crew (for some it's an honor and in any case it is an oversimplification) but I am trying to construct a context of understanding for my own particular membership in Art & Language these past six years. That I could maintain membership from (nearly) the beginning of Art & Language as a non-collaborator is not without significance. Perhaps one aspect of my role in Art & Language has been to articulate that the group does have an identity which exists independent of collaboration. Otherwise, the Art & Language ideology is simply the credo of an artist's labor union: part of the public relations necessary to keep bread on the table. The public, popular notion of collaboration as central to Art & Language is in error—though it is true that this depiction has gained Art & Language acceptance in some circles as a traditional 'art group'. It is the kind of acceptance Art & Language can do without.

17. (16) Collaboration has been a confused formalism. Rather than accepting that the ideological thrust of individual efforts were capable of 'weaving' the (Art & Language) society's framework, the desire (with collaboration) was to formally articulate an ideological exo-skeleton. Instead, however, the result has been to construct, reinforce, and perpetuate a cultural ghetto. The most familiar form that this takes is the participation of Art & Language in most exhibitions—*such as this one*—as a single 'identity' (equivalent say, to one photo-realist) whereas in fact many of the 'individuals' in these exhibitions could be more comfortably grouped than the members of Art & Language. Art & Language as a ghetto has had its capacity for growth and the accumulation of (cultural) power drastically contained (which is usually the purpose of a ghetto to the larger society in its attempt to maintain the status quo). Perhaps the most major risk envisaged at this time for Art & Language is a general climate of timidity within the group. A result of which (if it itself is not the cause) is that careerism in Art & Language, unfortunately, has taken on a bureaucratic style (Ian Burn). This comes, quite unproductively, out of having one's identity *only* as a 'Company Man'. I view collaboration—'consensus constructivism' as one might call it—as a pseudo-issue. Its existence could be defended only as a form of the ideological insecurity which has been basic to Art & Language (and a strength) (12).

18. I should make it as clear as possible that when I am discussing collaboration I am discussing specifically the *public* manifestation of Art & Language work. Primarily, that would be the published articles and the 'display' situations in galleries, museums, etc. (It is the public manifestation where issues of the sociology of Art & Language take form sufficiently to evaluate in a disinterested manner—if decision-making can be taken seriously at all.) There is another (perhaps *the* other) sense of the group as being 'collaborative' which has to do with the group as a *conversational* ('intersubjective') one; that is (and, from here on, anything said is both controversial as well as participatorily descriptive) the realm in which the collective weight of our shared beliefs (and influences) *necessarily* separates us from the rest of the (art) world (10). It is in this realm that I have maintained membership, and it is in this realm that I will continue to maintain membership. Any other basis for membership in Art & Language is simply a kind of 'belief feature' eligible for consideration as part of the general (and *international*) Art & Language landscape.

19. (4, 8, 9, 10, 12, 13) Lévi-Strauss: "Mythical thought . . . is imprisoned in the events and experiences which it never tires of ordering and re-ordering in its search to find them a meaning. But it also acts as a liberator by its protest against the idea that anything can be meaningless with which science at first resigned itself to a compromise."

20. (12, 13, 14, 15, 16, 17) Barry Barnes: "In (Robert) Horton's opinion the preliterate actor meets anomaly with essentially conservative responses such as taboo and avoidance because he cannot contemplate the breakdown of his category system as anything other than the creation of chaos. The scientist is not in this position; he is aware of the existence of belief-systems alternative to his own, which diminishes the hold of his own beliefs upon him and enables him to make radical responses to anomaly, involving the abandonment of his current beliefs."

21. (2, 3, 8, 9, 12, 16, 17) William Morris: "Men fight and lose that battle, and the thing they fought for comes about in spite of their defeat, and when it comes, turns out to be not what they meant, and other men have to fight for what they meant under another name."

A NOTICE TO THE PUBLIC

1. a.) Worlds of discourse set up in a dialectically staged ('model') construct concerned with an apparent sphere of information and/or theory. Each of these 'worlds' are in turn divided into four sections which (as a psychological space) maintain the features of a specific reality (operationally read: nature). Each world faces a map (or depiction) of itself and in relation to the other 'worlds'. b.) At the point at which one conceives of the location of one 'world' in relation to the others by way of these maps (read: culture) one is inhabiting a 'reality' not unlike the sectional one, yet the 'psychological space' is arrived at categorically (and contextually). The divisions "A, B, C, D" and "1, 2, 3, 4," demarcate two contextual stratas which, while maintaining the features of their internal sectional distinctions (solid lines) as well as a relational mapping to each other (dotted lines), also correspond to a grid implied (necessitated) but not visible. c.) The notions of 'nature/culture' are arbitrarily taxonomic and supplied (operational). One of the later overviews (in a logical attempt to approach an 'ultimate' one) consists of a cognizance of all eight 'worlds' as constructing two and then one world—that is, as a heuristic yet tautologically structured model of art. (Though by necessity a partial one.) The intention is to have an analytic model function as a 'situated activity'. (One might think of a tautology as a logical attempt to make the implicit explicit.) d.) One is then led into a consideration of this model (or proposition) in relation to the other models/propositions within *The Tenth*

First published as a flyer, "Plan (for Proposition 4) and A Notice to the Public," *The Tenth Investigation, Proposition 4* (New York: Leo Castelli Gallery, 1975).

Investigation, and a consideration (critique) in relation to the preceding Investigations, etc. Further, it leads to a conservation between various 'models', propositions, works, theory or any other activist posits (all art praxis) socio-culturally and historically located and e.) available to the same or similar sets of inquiry one confronts in the 'reality' referred to in "a.)" above.

2. This, *The Tenth Investigation,* is my last. The point of my saying this is not that I intend to stop working, but that it has become extremely difficult for me to support the epistemological implications and cultural ramifications of the uncritical analytic scientific paradigm which the structure of this work (regardless of my own attempts to subvert it) inescapably implies. My study of Anthropology in the past few years was initiated out of a desire to acquire tools which might make possible the overview of art and culture that my earlier work finally necessitated. This, at least in part, has led me to the following conclusions: 1. That history is, indeed, man-made and therefore more understandable than nature; and that an understanding of this is more a part of my work than the isolation of this exhibition would imply; 2. That our historiography is our mythology and the art we experience is, at best, an extension of it; 3. That ideology, be it expressed, acted or observed is always subjective; that meaning is dependent upon a community's intersubjectivity and this society fails to provide one; 4. That Art, Anthropology, and History share at least two things in common: they are both creative and constitutive.

The work in this exhibition is (as well as the other things I claim it to be) flawed by my attempts to overcome my own historical baggage—while at the same time, of course, the attempt adds to it. The Wittgensteinian and scientist aspect of Investigations, Propositions, and the necessarily complex display installations constitute a structural outgrowth from an earlier period of faithful ethnocentricity which can no longer accommodate my view of my activity. The ideological package has become inappropriate. That the work was viable eight or nine years ago within that structure is no justification for cultural self-perpetuation *ad infinitum.* Our war at that time against Formalism's mindless aestheticism was 'won' at the expense of our being responsible (after proliferation has begot proliferation) for a replacement which is functionally decorative and potentially even more 'mindless' because of its inability to be self-reflexive in spite of its claims. The Revolution didn't even simply end, it continues as a style. I don't like the work I see being done around me, and to the extent that

I am a co-participant (even if as an antithesis) I must somehow alter my course.

William Morris: "Men fight and lose that battle, and the thing they fought for comes about in spite of their defeat, and when it comes, turns out to be not what they meant, and other men have to fight for what they meant under another name."

THE ARTIST AS ANTHROPOLOGIST

The reflective assimilation of a tradition is something else than the unreflected continuity of tradition.
Rolf Ahlers

PART I
A FRAGMENTED AND DIDACTIC ETHNOLOGY
OF SCIENCE AS RELIGION AND IDEOLOGY

Consider the following mosaic:

1. Albert Einstein: ". . . whoever has undergone the intense experience of successful advances made in this domain is moved by profound reverence for the rationality made manifest in existence. By way of this understanding he achieves a far-reaching emancipation from the shackles of personal hopes and desires, and thereby attains that humble attitude of mind towards the grandeur of reason incarnate in existence, and which, in its profoundest depths, is inaccessible to man. This attitude . . . appears to me to be religious, in the highest sense of the word."

2. Michael Polanyi: ". . . if we decided to examine the universe objectively in the sense of paying equal attention to portions of equal mass, this would result in a lifelong preoccupation with interstellar dust, relieved only at brief intervals by a survey of incandescent masses of hydrogen—not in a thousand million lifetimes would the turn come to give man even a second's notice . . . Our vision of reality . . . must suggest to us

First published in *The Fox* (New York) 1, no. 1 (1975), pp. 18–30.

the kind of questions that it should be reasonable and interesting to explore."

3. Martin Jay: "Hobbes and later Enlightenment thinkers had assimilated man to nature in a manner that made man into an object, just as nature had been objectified in the new science. In their eyes, both man and nature were no more than machines. As a result, the assumption that nature repeated itself eternally was projected onto man, whose historical capacity for development, so closely bound to his subjectivity, was denied. For all its progressive intentions, this 'scientific' view of man implied the eternal return of the present."

4. Max Weber: "All the analysis of infinite reality which the finite human mind can conduct rests on the tacit assumption that only a finite portion of this reality constitutes the object of scientific investigation, and that only it is 'important' in the sense of being 'worthy of being known'.
"Only a small portion of existing concrete reality is colored by our value-conditioned interest and it alone is significant to us. It is significant because it reveals relationships which are important to us due to their connection with our values . . . We cannot discover . . . what is meaningful to us by means of a 'presuppositionless' investigation of empirical data. Rather perception of its meaningfulness to us is the presupposition of its becoming an *object* of investigation."

5. William Leiss: "So long as Christianity remained a vital social force in Western civilization, the notion of man as lord of the earth was interpreted in the context of a wider ethical framework. Religion's declining fortunes, however, led to the gradual secularization of this notion in imperceptible stages, and in contemporary usage it reveals few traces of its Judaeo-Christian background. The identification of mastery over nature with the results of scientific and technological progress, in connection with the cultural antagonism of science and religion in the eighteenth and nineteenth centuries, dissolved the traditional framework. For Francis Bacon there was no apparent contradiction between his religion and his hopes for science—in fact the image of man as the lord of nature clearly helped him to unite the two; but the Baconian synthesis, so characteristic of the seventeenth century, has not endured. The purely secular version of this image retains the various associations derived from the political analogy discussed above while shedding the ethical covering that both sustained and inhibited it. In its latter-day guise, mastery over nature loses the element of tension resulting from the opposing poles of domination and subordination in the religiously based version and adopts a unidimensional character—the extension of human 'power' in the world."

6. Stanley Diamond: "Just as, in the nineteenth century, the social orga-
nization and techniques of modern industrial capitalism emerge as a world
force, so the idea of inevitable progress in the name of science becomes a
fixed ideology. The revolutions having succeeded and then, quite
obviously, having failed in their social promise, it appears as if all the
frustrated passion was mobilized behind the idea of a regnant science."

7. Bob Scholte: "If the emancipatory and normative interests of 'scien-
tism', especially as practiced in applied domains, are contradictory and
illusory, if no position can ever hope to be entirely value-free and trans-
cultural, and if its naive, uncritical application may either simply hide
ideological presuppositions or unwittingly generate reactionary political
consequences, does not the self-corrective, self-critical, and progressive
nature of scientific activity eventually ensure consistency, transparency,
and viability? I would argue—following Radnitzky and others—that this
would be possible only if 'scientism' were to embark on a self-reflexive
and self-critical course, that is, one which would emancipate it from its
own paradigmatic stance. This, of course, is highly unlikely, since the
paradigm's own assumptions, procedures, and aims mitigate against a
radical and contextual critique. The basic reason for this lack of self-
reference lies in the widely held assumption that there is, and should be,
a discontinuity between experience and reality, between the investigator
and the object investigated. If we accept this assumption (which, ironi-
cally, is no longer tenable or practical, even from a strict scientific point
of view) the scientist can afford to remain largely indifferent to his own
existential, sociological, historical, and philosophical environment . . .

"While 'scientism' may express a peripheral interest in the intentional
consciousness of scientific investigation, it does so only to use or to purge
existential circumstances for the sake of scientific objectivity and repli-
cability. Though it may utilize and contribute to the 'ethnomethodologies'
available at any given time and may study, manipulate, or implement a
culture's norms and values, its professed and ultimate aim lies in tran-
scending the sociocultural settings and particular time periods in which
scientific activities are located and developed. Similarly, if progress
demands at least some awareness of history, 'scientism' nevertheless
remains largely indifferent to the historicity of scientific praxis as a whole.

"If 'scientism' also considers itself empirical and problem-oriented, it
usually assumes that facts are facts, that objective methods simply select
relevant data without further affecting them, and that these 'units of
analysis' can be processed to yield lawful predictions and functional
norms. Its overriding interest in logical clarity and technical precision,
realizable within the 'manageable' boundaries of 'piecemeal' research,
further assures only a marginal concern with the ontological grounds and

epistemological preconditions which science's own activities nevertheless presuppose or simply take for granted. Finally, when 'scientism' is raised to the encompassing status of a philosophical system, its ultimate purpose becomes the rational explanation of a determinable reality in accord with universal principles and objective techniques. Its transcendental aim is to establish and to verify formal laws and eternal verities. Any relativizing or perspectivistic alternatives to scientific dogma are simply considered irrational, impractical, or—worst of all—metaphysical."

8. Alvin Gouldner: ". . . objectivity is not neutrality, but alienation from self and society; it is an alienation from a society experienced as a hurtful and unlovable thing. Objectivity is the way one comes to terms and makes peace with a world one does not like but will not oppose; it arises when one is detached from the status quo but reluctant to be identified with its critics, detached from the dominant map of social reality as well as from meaningful alternative maps. 'Objectivity' transforms the nowhere of exile into a positive and valued social location; it transforms the weakness of the internal 'refuge' into the superiority of principled aloofness. Objectivity is the ideology of those who are alienated and politically homeless.

"In suggesting that objectivity is the ideology of those who reject both the conventional and the alternative mappings of the social order, I do not, however mean to suggest that they are equally distant from both; commonly, these 'objective' men, even if politically homeless, are middle class and operate within the boundaries of the social status quo. In some part they tolerate it because they fear conflict and want peace and security, and know they would be allowed considerably less of both if they did not tolerate it."

9. William Leiss: ". . . the 'mastery of inner nature' is a logical correlate of the mastery of external nature; in other words, the domination of the world that is to be carried out by subjective reason presupposes a condition under which man's reason is already master in its own house, that is, in the domain of human nature. The prototype of this connection can be found in Cartesian philosophy, where the ego appears as dominating internal nature (the passions) in order to prevent the emotions from interfering with the judgements that form the basis of scientific knowledge. The culmination of the development of the transcendental subjectivity inaugurated by Descartes is to be found in Fichte, in whose early works 'the relationship between the ego and nature is one of tyranny', and for whom the 'entire universe becomes a tool of the ego, although the ego has no substance or meaning except in its own boundless activity.'

"In the social context of competition and cooperation the abstract possibilities for an increase in the domination of nature are transformed into actual technological progress. But in the ongoing struggle for existence

the desired goal (security) continues to elude the individual's grasp, and the technical mastery of nature expands as if by virtue of its own independent necessity, with the result that what was once clearly seen as a means gradually becomes an end in itself . . .

"On the empirical level the mastery of inner nature appears as the modern form of individual self-denial and instinctual renunciation required by the social process of production. For the minority there is the voluntary, calculating self-denial of the entrepreneur; for the majority, it is the involuntary renunciation enforced by the struggle for the necessities of life.

"The crucial question is: what is the historical dynamic that spurs on the mastery of internal and external nature in the modern period? Two factors shape the answer. One is that the domination of nature is conceived in terms of an intensive exploitation of nature's resources, and the other is that a level of control over the natural environment which would be sufficient (given a peaceful social order) to assure the material well-being of men has already been attained. But external nature continues to be viewed primarily as an object of potentially increased mastery, despite the fact that the level of mastery has risen dramatically. The instinctual renunciation—the persistent mastery and denial of internal nature—which is required to support the project for the mastery of external nature (through the continuation of the traditional work-process for the sake of the seemingly endless productive applications of technological innovations) appears as more and more irrational in view of the already attained possibilities for the satisfaction of needs . . .

"The persistent struggle for existence, which manifests itself as social conflict both within particular societies and also among societies on a global scale, is the motor which drives the mastery of nature (internal and external) to even greater heights and which precludes the setting of any *a priori* limit on this objective in its present form. Under these pressures the *power* of the whole society over the individual steadily mounts and is exercised through techniques uncovered in the course of the increasing mastery of nature. Externally, this means the ability to control, alter, and destroy larger and larger segments of the natural environment. Internally, terroristic and nonterroristic measures for manipulating consciousness and for internalizing heteronomous needs (where the individual exercises little or no independent reflective judgement) extend the sway of society over the inner life of the person. In both respects the possibilities and the actuality of domination over men have been magnified enormously . . .

"The more actively is the pursuit of the domination of nature undertaken, the more passive is the individual rendered; the greater the attained power over nature, the weaker the individual vis-a-vis the overwhelming presence of society. . . .

"So long as the material basis of human life remains fixed at a relatively low level and bound to premechanized agricultural production, the intensity of the struggle for existence fluctuates between fairly determinate limits. The material interdependence of men and women in different areas under such conditions is minimal, and the lack of any appreciable control over the natural environment also constricts efforts to extend the hegemony of particular groups permanently beyond their local borders. Political domination within and among societies is everywhere at work, to be sure, but it is also severely limited in scope. Slowness of communications and transportation hampers the exercise of centralized authority, which outside the area of its immediate presence is restricted to intermittent displays of its might; the daily struggle for the requirements of life normally occurs on a local basis. As mentioned earlier, in all forms of society characterized by class divisions the natural environment surrounding the individual in everyday life appears as actually or potentially in another's domain. The fear of being denied access to the means of survival is a determining aspect of the relationship between man and external nature in the evolution of society. But in the premechanized agricultural economy both ruler and ruled are subject to the parsimonious regime of nature: the comparatively low productivity of labor, the paucity of the economic surplus, and the small accumulated reserves of commodities generally check the designs of empire or at least render both domestic and imperial authority highly unstable.

"The link between the struggle for existence and control of the natural environment is illustrated best by the fact that the intensity of the possible exploitation of human labor is directly dependent upon the attained degree of mastery over external nature. Here the decisive step has been the coming of industrial society: the machine and the factory system have expanded enormously the productivity of labor and consequently the possible margin of its exploitation. Thus the heightened mastery of external nature reveals its social utility in the mounting productivity of labor resulting from the technological applications of scientific knowledge in the industrial system. But why does there also occur a qualitative leap in the intensity of social conflict? In the first place, the economic surplus, which in class-divided societies is appropriated as private property, becomes so much larger and opens new opportunities for the development and satisfaction of needs, both material and cultural; consequently disposition over this surplus becomes the focus of greater contention. Second, certain types of natural resources (for example, coal and oil), available only in specific areas, become essential ingredients for the productive process. An adequate supply of these resources must be assured, and so the commercial tentacles of the productive unit must expand, until in some instances it draws upon supplies extracted from every corner of the

planet. Inasmuch as every productive unit becomes dependent upon its source of raw materials, every actual or potential denial of access to them represents a threat to the maintenance of that unit and to the well-being of its beneficiaries. Since obviously no equitable distribution of the world's natural resources has been agreed upon, the effect of that widened dependency is to magnify the scope of conflict.

"The imbalance among existing societies in the attained level of mastery over the external environment acts as a further abrasive influence. The staggering growth in the destructiveness of weapons and in the capabilities of the 'delivery systems' for them aggravates the fears and tensions in the day-to-day encounters among nations, whether or not those weapons are ever actually employed. The most favored nations in this regard may wreak havoc anywhere on the globe, and those less fortunate must either hope for parity or expect to suffer repeated ignominy. The fact that every social order must fear the depredations not only of its immediate neighbors but potentially of every remote country—a condition arising out of increased mastery of nature accomplished in the context of persistent social conflict—alters the stakes in the dangerous game of human rivalry.

"A fourth contributory factor may also be mentioned, namely, the extension of the struggle to the realm of the spirit through intensive propaganda (both domestic and foreign) and the manipulation of consciousness. . . . Finally, the rising material expectations of populations grown accustomed to an endless proliferation of technological marvels have a decisive impact. In this respect, mastery of nature without apparent limit becomes the servant of insatiable demands made upon the resources of the natural environment, that is, demands for the transformation of those resources into a vast realm of commodities. Perhaps they can be met—even on a universal scale, for all men. Yet if every level of gratification for material wants merely serves to elicit a more elaborate set of desires, the competitiveness and isolation among individuals that underlies the psychology of consumer behavior will continue to feed the sources of conflict.

"Through the attempted conquest of nature, therefore, the focus of the ongoing struggle of men with the natural environment and with each other for the satisfaction of their needs tends to shift from the local areas to a global setting. For the first time in history the human race as a whole begins to experience particular clashes as instances of a general worldwide confrontation; apparently minor events in places far removed from the centers of power are interpreted in the light of their probable effect on the planetary balance of interests. The earth appears as the stage-setting for a titanic self-encounter of the human species which throws into the fray its impressive command over the forces of nature, seemingly deter

mined to confirm the truth of Hegel's dictum that history is a slaughter-bench. The idea of man as a universal being, one of the great achievements of philosophical and religious thought, is refracted through the prism of universal conflict and realized in a thoroughly distorted form.

"The cunning of unreason takes it revenge: in the process of globalized competition men become the servants of the very instruments fashioned for their own mastery over nature, for the tempo of technological innovation can no longer be controlled even by the most advanced societies, but rather responds to the shifting interplay of worldwide forces. Entire peoples and their fragile social institutions, designed for far different days, are precipitously sucked into the maelstrom."

10. Stanley Diamond: ". . . investment in the notion of progress in the nineteenth century was the beneficent aspect of a morbid process, which can be epitomized as the conquest of nature—including human nature. Imperialism was a political manifestation of the struggle against nature and man, associated with the notion of the inevitable superiority of Western civilization; the means at hand for conquering primitive and archaic peoples helped rationalize the scientific perspective in which they were viewed as inferior. Coincidentally, the spirit of reason, the scientific utopianism of the eighteenth century, was transformed into functional, or, better, reductive rationality, evident, ideally, in the mechanisms of the market, and embedded in the apparatus of industrial capitalism. The arena for rationalization becomes the whole of human existence; as reason is reduced to rationality, the aesthetic and sensuous aspects of the person are repressed, that is, they are brutalized or sentimentalized. The 'performance principle' develops in antagonism to human nature or, rather, constricts the definition of human possibilities."

11. Max Horkheimer: "As the principle of the self endeavoring to win in the fight against nature in general, against other people in particular, and against its own impulses, the ego is felt to be related to the functions of domination, command, and organization . . . Its dominance is patent in the patriarchal epoch . . . The history of Western civilization could be written in terms of the growth of the ego as the underling subliminates, that is, internalizes, the commands of his master who has preceded him in self-discipline . . . At no time has the notion of the ego shed the blemishes of its origin, in the system of social domination."

12. William Leiss: "The objective of transforming all of nature (including consciousness) into the material of production becomes compulsive, blindly repetitive, and finally self-destructive. The apparatus of production expands infinitely—steady growth is its Nicene Creed—while all rational criteria for judging the human value of its fruits are subverted. The final

stage is reached when the only rationale for production that can be offered is that many persons can be induced to believe that they really want and need the newest offering of commodities in the marketplace. At this stage domination over nature and men, directed by the ruling social class, becomes internalized in the psychic processes of individuals; and it is self-destructive because the compulsive character of consumption and behavior destroys personal autonomy and negates the long and difficult effort to win liberation from that experience of external compulsion which marked the original relationship between humanity and nature."

13. Martin Jay: "Critical Theory . . . refused to fetishize knowledge as something apart from and superior to action. In addition, it recognized that disinterested scientific research was impossible in a society in which men were themselves not yet autonomous; the researcher, Horkheimer argued, was always part of the social object he was attempting to study. And because the society he investigated was still not the creation of free, rational human choice, the scientist could not avoid partaking of that heteronomy. His perception was necessarily mediated through social categories above which he could not rise."

14. Stanley Diamond: "The fear of excommunication from the kinship unit, from the personal nexus that joins man, society, and nature in an endless round of growth, in short, the sense of being isolated and depersonalized and, therefore, at the mercy of demonic forces—a punishment and a fear widespread among primitive peoples—may be taken as an indication of how they would react to the technically alienating processes of civilization if they were to understand them. That is, by comprehending the attitude of primitive people about excommunication from the web of social and natural kinship we can, by analogy, understand their repugnance and fear of civilization.

"Primitive society may be regarded as a system in equilibrium, spinning kaleidoscopically on its axis, but at a relatively fixed point. Civilization may be regarded as a system in internal disequilibrium; technology or ideology or social organization are always out of joint with each other— that is what propels the system along a given track. Our sense of movement, of incompleteness, contributes to the idea of progress. Hence, the idea of progress is generic to civilization. And our idea of primitive society as existing in a state of dynamic equilibrium and as expressive of human and natural rhythms is a logical projection of civilized societies, in opposition to the latter's actual state. But it also coincides with the real historical condition of primitive societies. The longing for a primitive mode of existence is no mere fantasy or sentimental whim; it is consonant with fundamental human needs, the fulfillment of which (although in different form) is, as we have discovered in the milieus of civilization, a

precondition for our more elaborate lives. Even the skeptical and civilized Samuel Johnson, who derided Boswell for his intellectual affair with Rousseau, had written:

when man began to desire private property then entered violence, and fraud, and theft, and rapine. Soon after, pride and envy broke out in the world and brought with them a new standard of wealth, for man, who till then, thought themselves rich, when they wanted nothing, now rated their demands, not by the calls of nature, but by the plenty of others; and began to consider themselves poor, when they beheld their own possessions exceeded by those of their neighbors."

15. Edward Sapir: ". . . a genuine culture refuses to consider the individual as a mere cog, as an entity whose sole *raison d'être* lies in his subservience to a collective purpose that he is not conscious of or that has only a remote relevancy to his interests and strivings. The major activities of the individual must directly satisfy his own creative and emotional impulses, must always be something more than means to an end. The great cultural fallacy of industrialism, as developed up to the present time, is that in harnessing machines to our uses it has not known how to avoid the harnessing of the majority of mankind to its machines. The telephone girl who lends her capacities, during the greater part of the living day, to the manipulation of a technical routine that has an eventually high efficiency value but that answers to no spiritual needs of her own is an appalling sacrifice to civilization. As a solution of the problem of culture she is a failure—the more dismal the greater her natural endowment. As with the telephone girl, so, it is to be feared, with the great majority of us, slave-stokers to fires that burn for demons we would destroy, were it not that they appear in the guise of our benefactors. The American Indian who solves the economic problem with salmon-spear and rabbit-snare operates on a relatively low level of civilization, but he represents an incomparably higher solution than our telephone girl of the questions that culture has to ask of economics. There is here no question of the immediate utility, of the effective directness, of economic effort, nor of any sentimentalizing regrets as to the passing of the 'natural man'. The Indian's salmon-spearing is a culturally higher type of activity than that of the telephone girl or mill hand simply because there is normally no sense of spiritual frustration during its prosecution, no feeling of subservience to tyrannous yet largely inchoate demands, because it works in naturally with all the rest of the Indian's activities instead of standing out as a desert patch of merely economic effort in the whole of life."

16. Meredith Tax: "In most cultures prior to that of industrial capitalism, artists have had a well-defined and clearly understood relation to some part of their society, some group of consumers. In a primitive tribe or collective, art is the expression of the whole tribe—later, some people

may be specially good at it, or hereditarily trained to it, and take on the production of artifacts as their work, but they work surrounded by the community, and work for the community's immediate and obvious benefit. In other periods of history, the artist has produced for a court, for a personal patron, for a religious sect, or for a political party. It is only with the dominance of the capitalist system that the artist has been put in the position of producing for a *market*, for strangers far away, whose life styles and beliefs and needs are completely unknown to him, and who will either buy his works or ignore them for reasons that are equally inscrutable and out of his control."

PART II
THEORY AS PRAXIS: A ROLE FOR AN
'ANTHROPOLOGIZED ART'

The highest wisdom would be to understand that every fact is already a theory.

Goethe

1. The artist perpetuates his culture by maintaining certain features of it by 'using' them. The artist is a model of the anthropologist *engaged*. It is the implosion Mel Ramsden speaks of, an implosion of a reconstituted socio-culturally mediated overview.[1] In the sense that it is a theory, it is an overview; yet because it is not a detached overview but rather a socially mediating activity, it is engaged, and it is praxis. It is in this sense that one speaks of the artist-as-anthropologist's *theory* as praxis. There obviously are structural similarities between an 'anthropologized art' and philosophy in their relationship with society (they both depict it—making the social reality conceivable) yet art is manifested in praxis; it 'depicts' *while* it alters society.[2] And its growth as a cultural reality is necessitated by a dialectical relationship with the activity's historicity (cultural memory) and the social fabric of present-day reality.

2. Art in our time is an extension by implication into another world which consists of a social reality, in the sense that it is a believable system. It is this holding up what is often said to be a 'mirror' to the social reality which attempts to be believable and real. Yet the mirror is a *reference* which we take as being real. To the extent that we take it as being real, it is real. It is the manifestations of internalizations which connect an 'anthropologized art' to earlier 'naive' forms of art activity. Our 'non-naiveness' means we are aware of our activity as constituting a basis for self-enlightenment, self-reflexivity—rather than a scientistic attempt at presenting objectivity, which is what a pictorial way of working implies. Pictorial art is an attempt to depict objectivity. It implies objectivity by

its 'other world' quality. The implication of an 'anthropologized art', on the other hand, is that art must internalize and *use* its social awareness. The fallacy of Modernism is that it has come to stand for the culture of Scientism. It is art outside of man, art with a life of its own. It stands and fails as an attempt to be objective. Modernism seems to offer two roads—one might be called the 'high' road and the other the 'low' road. The high road allowing for an impersonalized other—worldly 'objectivity', and the lower road, for an idiosyncratic subjectivity reified 'objective' in stylistic terms on the art-historical marketplace. The choice Modernism seems to offer is one between the personal 'other world' or the objective 'other world', with both being 'alienated and politically homeless'.

3. Thus, the crisis Modernist abstract painting finds itself in is that it can neither provide an experientially rich fictive reality, the kind of quasi-religious 'other world' believability which the traditional form of painting was still capable of maintaining earlier on in the Modernist period *nor*, by virtue of its morphological constriction and traditional semantic form has it been able to contribute *in any way* to the emerging post-Modern debates of the late sixties and early seventies. Modernist abstract painting now finds itself as a collapsed and empty category, perpetuated out of nostalgia that parades as a self-parody, due to the necessities of bankrupt mythic historical continuums, but ultimately settling for its meaning in the marketplace.

4. There is perhaps no better example of how crazed and alienated our culture has become than the popularity of photo-realism. Photo-realism has totally internalized pop irony. Its cold sober acceptance of American society iconizes consumer trivia. Perhaps what the camera sees is the desired scientific/technological view of the 'objective' world. More likely though, a camera is a mechanical approximation of how a committee sees the world: it is the perfect bureaucratic vision of 'objectivity'. The hand-painted mechanized 'objectivity' of photo-realism ends in an unproblem-atical fraud, of course, when one realizes that the selected pastiches of glimpsed reality are *glorifications*. Two of photo-realism's major practi-tioners have steadfastly maintained that they were 'abstractionists'. One of them even paints the paintings upside down just to prove it. They probably *are* 'abstract' in terms of their meaninglessness and alienation. To be engaged in an activity which consists of mimicking a machine in order to perfectly depict depictions of stoned silent vignettes of industrial or commercial artifacts, to sell on an impersonal art market, and to think of it as anything other than 'abstract' would be to invite terror.

5. Our earlier conceptual art, while still being a 'naive' Modernist art based on the scientific paradigm, externalized features of the art activity

which had always been internalized—making them explicit and capable of being examined. It is this work which initiated our break with the Modernist art continuum and it is this work which constitutes perhaps the *legitimate* history of 'conceptual art'. This schism in 'conceptualism' which occurred between conceptual *theorists* and conceptual *stylists* (artists of the 'naive' Modernist variety who consider 'conceptualism' a stylistic alternative, within Modernism, to painting and sculpture) was a logical result of the dominant popular art-media learning situation. The work of the *original* conceptualists (which in fact consists almost exclusively of the theorists)[3] as regurgitated and reified in the art press and presented within the art institutions, only accentuated and preserved those features of the activity which complemented and reinforced the Modernist view of art and culture. All but the style was edited out.

6. Bob Scholte: "What seems to me to be urgently required is a genuinely dialectical position, one in which 'analytical procedures (and descriptive devices are chosen and) determined by reflection on the nature of the encountered phenomena and on the nature of that encounter' (Fabian, 1971, p. 25). This would mean that every procedural step in the constitution of anthropological knowledge is accompanied by radical reflection and epistemological exposition. In other words, if we assume a continuity between experience and reality, that is, if we assume that an anthropological understanding of others is conditioned by our capacity to open ourselves to those others (cf. Huch, 1970, p. 30), we cannot and should not avoid the 'hermeneutic circle' (cf. Ricoeur, 1971), but must explicate, as part of our activities, the intentional processes of constitutive reasoning which make both encounter and understanding possible. Indeed, 'the question is not . . . how to avoid it, but . . . how to get properly into it.' (cf. Radnitzky, 1968, p. 23)"[4]

7. Because the anthropologist is outside of the culture which he studies he is not a part of the community. This means whatever effect he has on the people he is studying is similar to the effect of an act of nature. He is not part of the social matrix. Whereas the artist, as anthropologist, is operating within the same socio-cultural context from which he evolved. He is totally immersed, and has a social impact. His activities embody the culture. Now one might ask, why not have the anthropologist, as a professional, 'anthropologize' his own society? Precisely because he *is* an anthropologist. Anthropology, as it is popularly conceived, is a science. The scientist, as a professional, is *dis*-engaged.[5] Thus it is the nature of anthropology that makes anthropologizing one's own society difficult and probably impossible in terms of the task I am suggesting here. The role I am suggesting for art in this context is based on the difference between the very basis of the two activities—what they mean as human activities.

It is the pervasiveness of 'artistic-like' activity in human society—past or present, primitive or modern, which forces us to consider closely the nature of art.

8. Stanley Diamond: "The authentic historian may thus be said to have attained, by training and talent, a very high pitch of speciational consciousness. He approaches other societies in other times with the confidence that his humanity is equal to the task of registering *differences.* And that, though not the only element, is the *critical* one in all human communication.

"The anthropologist must be such a historian. In conceptualizing a primitive society, he interprets signs and symbols by exchanging places with the actors in the system under study. The mere cataloguing or even systematic linking of institutions and artifacts is meaningless unless the effort to reproduce the social consciousness, the cultural being of the people who live and produce in their modality, is made. Every technique available must, of course, be used in these efforts, but the techniques may not become ends in themselves. If we detach the social forms and tools from persons and arrange and rearrange them typologically in the service of this or that method or as abstract, deductive models, we lose touch with concrete social reality, with the imprecisions of human behavior, and with its actual meaning at a particular time."[6]

9. Artistic activity consists of cultural fluency. When one talks of the artist as an anthropologist one is talking of acquiring the kinds of tools that the anthropologist has acquired—insofar as the anthropologist is concerned with trying to obtain fluency in another culture. But the artist attempts to obtain fluency in his *own* culture. For the artist, obtaining cultural fluency is a dialectical process which, simply put, consists of attempting to affect the culture while he is simultaneously learning from (and seeking the acceptance of) that same culture which is affecting him. The artist's success is understood in terms of his praxis. Art *means* praxis, so any art activity, including 'theoretical art' activity, is praxiological. The reason why one has traditionally not considered the art historian or critic as artist is that because of Modernism (Scientism) the critic and art historian have always maintained a position outside of praxis (the attempt to find objectivity has necessitated that) but in so doing they made culture *nature.* This is one reason why artists have always felt alienated from art historians and critics. Anthropologists have always attempted to discuss other cultures (that is, become fluent in other cultures) and translate that understanding into sensical forms which are understandable to the culture in which they are located (the 'ethnic' problem). As we said, the anthropologist has always had the problem of being outside of the culture which he is studying. Now what may be interesting about the artist-as-anthro-

pologist is that the artist's activity is not *outside,* but a mapping of an internalizing cultural activity in his *own* society. The artist-as-anthropologist may be able to accomplish what the anthropologist has always failed at. A non-static 'depiction' of art's (and thereby culture's) operational infrastructure is the aim of an anthropologized art. The hope for this understanding of the human condition is not in the search for a religio-scientific 'truth', but rather to utilize the state of our constituted interaction.

10. There is a highly complex operational structure to art which one could describe as a kind of cultural 'black hole' which semantically implodes (internalizes) functioning elements which are reconstituted simultaneously as both the most specific feature and the most general consciousness.

11. Stanley Diamond: "The study of cultural apparatus finds its basic meaning in the attempt to understand the social consciousness that it both reflects and creates. Otherwise the study of man is not the study of man but the study of social, ideological, economic, or technical forms, a sort of cultural physics."[7]

12. Johannes Fabian: "In anthropological investigation, objectivity lies neither in the logical consistency of a theory, nor in the givenness of the data, but in the foundation . . . of human *intersubjectivity.*"[8]

PART III
EPILOGUE

The savage has his life within himself; civilized man, in the opinions of others.

Jean-Jacques Rousseau

1. The Marxist critique *as well as* the evolving theory and praxis of art of which I speak in this paper are features of a modern world. The model of art has evolved into a viable and workable model based on certain tenets of the same Western civilization from which Marx began his work. In the face of the conspicuous absence of any sophisticated (that is, real in terms of its complexity) alternative Marxist model, we must use as a given the model of art as it has come to us in this Post-Modern period. We cannot do so uncritically, but in terms of an 'anthropologized art' such a critique is (along with the study of primitive culture) basic to the activity.

2. It is almost truistic to point out that the 'non-naive' artist-as-anthropologist is forced to become politically aware. This should not be confused with art which uses political subject-matter or which aestheticizes the

necessity of political action. 'Protest art' is not artistically radical (it is oblivious to the philosophical self-reflective historical relationship between the artist and the concept of art in this society) but is more likely an *ad hoc* expressionistic ad media appeal to liberalism.

3. The life-world of abstracted experience of which I speak would be total and all-embracing if not for the fact that we are all involved within the context of a culture, which means that insofar as the culture consists of a generalization of experience which we have grown up in (and have been mediated by) then that generalization of experience becomes an aspect of us. It orders and forces our experiential world to correlate to and exemplify the generalized experience.

4. The cultural change and growth, rather than being dependent upon natural events and qualitative decisions within the context of a life which is textually integrated with nature is, in our civilization, dependent upon cultural events alone. Science, obviously through an empiricist illusion, presents our analysis of nature as a meaningful relationship with it. Science is a religious-like motor which is perhaps primarily responsible for the abstraction of our natural world. Culture is dependent upon the language of abstraction. Culture means consensus. Direct experiences are always compared with the generalized experience. By 'compared with' we mean 'try to give meaning to'.

5. Perhaps art consists of experiencing abstractions of experience. Abstraction means a generalization of our experiential world. This super-structural connective is what constitutes culture. Culture consists of an abstraction of experience. That's what brings in the significance of language and the direct relationship between language and culture. Why art is culture is that it is an abstraction of culture in the sense that it is a depiction—a linguistic-like depiction of culture. A considerable part of our world consists of experiencing abstractions of experience. This is what civilization has come to be. It is in this sense that one can speak of our civilization as being out of control, having a will of its own, being an automated system. Our culture has been self-perpetuating, and the more abstract it gets, the more its capacity for self-perpetuation increases—primarily due to the life-world of this civilization which flows on independent, if not oblivious to, the arbitrary forces of the natural world. A self-replicating culture indifferent to nature is quite unlike the world of the so-called primitive whose every experiential moment is mediated by their relationship with this natural environment. It is this relationship with nature which maintains the pace of a life and gives meaning to it. We, on the other hand, live in a totally enculturated world which is

running out of control precisely because it does operate independent of nature.

6. Maurice Stein: "The combination of artist and philosopher in the role of the primitive thinker as distinct from the man of action is not as removed from civilized actuality as many would contend . . . But the conception that these activities must be interrelated is alien to our specialized civilization. And even more alien is the relation between primitive thinkers and men of action which rests upon the thinker's ability to sense crises of the community and cope with resulting strains by symbolic and ceremonial acts. While men of action live in a 'blaze of reality', there are strains in their relation to their impulses, to the community and to the external world. Thinkers who perform properly feel these strains first and express them symbolically. Religious men, shamans and priests, cooperate in this endeavor and indeed are occasionally themselves the artist-philosophers of the tribe. Radin's complex interpretation of primitive religion denies the theories of 'mystical participation' without denying that the bulk of primitives who are non-religious still have their experience illuminated by their relation to the authentic religious men of the tribe. Actually there is always a possibility that the tribal intellectuals will become exploitative, but prior to state development the larger context of tribal status should keep this tendency within limits.

"In terms of a perspective on the modern community, the distinctions between men of action and thinkers or between religious and non-religious men must be seen as entailing important points of contact and even fusion between the distinctive groups. Primitive artist-philosophers articulate the symbolic-ceremonial web of the tribe, while religious men authenticate this web by inspiration and the evidence of their 'seizures'. Both are more sensitive to strains and tensions than ordinary members of the community and in their different ways both react to these strains in order to cushion their impacts on the less introspective members. But all remain tied to each other in the larger network of kin statuses and the experiences are shared insofar as they can by symbolically communicated. The revelations of the shaman are the property of the tribe . . .

"But the modern artist, mystic, or philosopher rarely breaks through to community experience, nor does he help to authenticate communal symbols. Modern men of thought are segregated from the everyday world and the people who live in it by barriers of sensibility and language. Our artists are therefore forced to record their private responses to the strains of civilization without any assurance that the meaning of their expression will carry much beyond a small circle of similarly inclined creators and critics."[1]

7. Perhaps the locale of 'praxis' is just here at the vectors of where the historically located and philosophically aware anthropologist joins the agents of lived cultural reflexivity (artist) . . . Art is an activity which, to (scientific) 'objectivity' is more a complex paradox than a profound one—but in lieu of such an objectivity they are simply two over-lapping yet perpendicular 'myths'.

8. The artist-as-anthropologist, as a student of culture, has as his job to articulate a model of art, the purpose of which is to understand culture by making its implicit nature explicit—internalize its 'explicitness' (making it, again, 'implicit') and so on. Yet this is not simply circular because the agents are continually interacting and socio-historically located. It is a non-static, in-the-world model. The implication of this, as a cultural heuristic, is its epistemological non-specificity, but more importantly—it is *non-teleological.* One could describe primitive art as culture made implicit. The Modernist paradigm of art is culture made explicit and timeless—*objective.* In this Post-Modern, para-Marxist situation that the artist-as-anthropologist finds him or herself in, is a world where one realizes that *objective* explicit art means (in Sapir's sense) a spurious culture. Implicit art is an art of lived subjectivity, but at this point unreal and culturally lost in our technological era.[2]

9. Meyer Fortes: "Primitive people express the elementary emotions we describe by terms like fear and anger, love and hate, joy and grief in words and acts that are easily recognizable by us. Some anthropologists say that many non-European peoples are sensitive to the feeling of shame but not to guilt feelings. I doubt this. One of the most important functions of ritual in all societies is to provide a legitimate means of attributing guilt for one's sins and crimes to other persons or outside powers. In many primitive societies this function of ritual customs is prominent and it leads to the impression that individuals have a feeble sense of guilt, by comparison with Europeans. The truth is that our social system throws a hard and perhaps excessive burden of moral decision on the individual who has no such outlets for guilt feelings as are found in simpler societies. This is correlated with the fragmentation of social relations, and the division of allegiances and affectations in our society. I am sure it has a great deal to do with the terrifying toll of mental disease and psychoneurosis in modern industrial countries. We know very little about mental diseases in primitive communities. What evidence there is suggests that those regarded by many authorities as of constitutional origin occur in the same forms as with us. But disturbances of personality and character similar to those that cause mental conflict and social maladjustment in our society seem to be rare. I do not mean to imply that everybody is always happy, contented, and free of care in a primitive society. On the

contrary, there is plenty of evidence that among them, as with us, affability may conceal hatred and jealousy, friendliness and devotion enjoined by law and morals may mask enmity, exemplary citizenship may be a way of compensating for frustration and fears. The important thing is that in primitive societies there are customary methods of dealing with these common human problems of emotional adjustment by which they are externalized, publicly accepted, and given treatment in terms of ritual beliefs; society takes over the burden which, with us, falls entirely on the individual. Restored to the esteem of his fellows he is able to take up with ease the routine of existence which was thrown temporarily off its course by an emotional upheaval. Behavior that would be the maddest of fantasies in the individual, or even the worst of vices, becomes tolerable and sane, in his society, if it is transformed into custom and woven into the outward and visible fabric of a community's social life. This is easy in primitive societies where the boundary between the inner world of the self and the outer world of the community marks their line of fusion rather than of separation. Lest this may sound like a metaphysical lapse I want to remind you that it springs from a very tangible and characteristic feature of primitive social structure, the widely extended network of kinship. The individual's identification with his immediate family is thus extended outward into the greater society, not broken off at the threshold of his home."[3]

10. Stanley Diamond: "Linton proposes that the decay of the local group in contemporary society, that is, of the sense and reality of community, is the fundamental problem of modern man—since it is through the local group that people learn to realize their humanity. This is a critical anthropological concept, and it is drawn from experience in the primitive locality, composed of reciprocating persons, growing from within, as opposed to the imposed, technically estranging, modern collective."[4]

Notes

I would like to dedicate this section to Terry Atkinson, whose ability to internalize borrowed material and write papers untainted by appeals to any authority other than his own has necessitated the use of this literary device.

PART I

1. Albert Einstein, quoted in Robert W. Friedrichs, *A Sociology of Sociology* (New York: The Free Press, 1970), p. 105.

2. Michael Polanyi, quoted in Friedrichs, p. 138.

3. Martin Jay, *The Dialectical Imagination* (Boston: Little, Brown and Co., 1973), p. 257.

4. Max Weber, quoted in Friedrichs, p. 139.

5. William Leiss, *The Domination of Nature* (New York: George Braziller, 1972), p. 35.

6. Stanley Diamond, "Anthropology in Question" in *Reinventing Anthropology*, ed. Dell Hymes (New York: Random House, 1969), p. 410.

7. Bob Scholte, "Towards a Reflexive and Critical Anthropology" in Hymes, pp. 435–436.

8. Alvin Gouldner, *The Coming Crisis in Western Sociology* (New York: Basic Books, 1970), p. 103.

9. Leiss, pp. 152–158.

10. Diamond, pp. 413–414.

11. Jay, p. 271.

12. Leiss, p. 136.

13. Jay, p. 81.

14. Stanley Diamond, "The Search for the Primitive" in *Man's Image in Medicine and Anthropology*, ed. Iago Galdston (New York: International Universities Press, 1963).

15. Edward Sapir, "Culture, Genuine and Spurious," in *Selected Writings of Edward Sapir*, ed. David G. Mandelbaum (Berkeley: University of California Press, 1949), pp. 316–317.

16. Meredith Tax, "Introductory: Culture is Not Neutral, Whom Does it Serve?" in *Radical Perspectives in the Arts*, ed. Lee Baxandall (Baltimore: Penguin Books, 1972), p. 22.

PART II

1. The term "implosion" was originally introduced into our conversation by Michael Baldwin. I refer here to its use by Mel Ramsden in "On Practice", this issue.˙

2. This notion of an "anthropologized art" is one that I began working on over three years ago—a point at which I had been studying anthropology for only a year, and my model of an anthropologist was a fairly academic one. That model has continually changed, but not as much as it has in the past year through my studies with Bob Scholte and Stanley Diamond (at the Graduate Faculty of the New School for Social Research). While their influence is strongly felt, I obviously take full responsibility for the use (or misuse) of their material within my discussion here (see note 5).

3. Granted, this is self-serving though I don't feel it is inaccurate. I refer here to the work of Atkinson, Baldwin, and myself. By now it is quite clear that most of the work which followed (outside of the Art & Language community) consisted of stylistic morphological experimentation, the meaning of which rested (and still rests) on the epistemological underpinnings of the early work. Sadly, "conceptualism" became synonymous with "avant-garde" to the extent that the launching of art careers for traditional modernist painters (such as Bochner) first had to go through a "legitimization"

˙See Mel Ramsden, "On Practice," in *The Fox* 1, no. 1 (New York, 1975), pp. 66–83.

period of "conceptualism" first. The idea seems to be: first get everyone's attention, then please the market with goods they are familiar with.

4. Bob Scholte, in Hymes, pp. 441–442.

5. To be fair, I must point out here that the Marxist anthropology of Diamond and Scholte is not included in this generalization. Indeed, due to the alternative anthropological tradition in which they see themselves, their role as anthropologists *necessitates* that they be "engaged." It is a consideration of their work, and what it has to say about the *limits* of anthropology (and the study of culture) which has allowed me a further elucidation of my notion of the "artist-as-anthropologist."

6. Stanley Diamond, ed., *Primitive Views of the World* (New York: Columbia University Press, 1960), pp. xiv–xv.

7. Ibid., p. xv.

8. Johannes Fabian, "Language, History, and Anthropology," in *Journal for the Philosophy of the Social Sciences* 1, no. 1 (1971), p. 25.

PART III

1. Meyer Fortes, quoted in Maurice Stein, "Anthropological Perspectives on the Modern Community," in Diamond, p. 207.

2. The following is a public statement posted during my last exhibition (January, 1975) at Leo Castelli Gallery, New York:* "This, *The Tenth Investigation,* is my last. The point of my saying this is not that I intend to stop working, but that it has become extremely difficult for me to support the epistemological implications and cultural ramifications of the uncritical analytic scientific paradigm which the structure of this work (regardless of my own attempts to subvert it) inescapably implies. My study of Anthropology in the past few years was initiated out of a desire to acquire tools which might make possible the overview of art and culture that my earlier work finally necessitated. This at least in part, has led me to the following conclusions: 1. That history is, indeed, man-made and therefore more understandable than nature; and that an understanding of this is more a part of my work than the isolation of this exhibition would imply; 2. That our historiography is our mythology and the art we experience is, at best, an extension of it; 3. That ideology, be it expressed, acted or observed is always subjective; that meaning is dependent upon a community's intersubjectivity and this society fails to provide one; 4. That Art, Anthropology, and History share at least two things in common: they are both creative and constitutive.

"The work in this exhibition is (as well as the other things I claim it to be) flawed by my attempts to overcome my own historical baggage—while at the same time, of course, the attempt adds to it. The Wittgensteinian and scientific aspect of Investigations, Propositions, and the necessarily complex display installations constitute a structural outgrowth from an earlier period of faithful ethnocentricity which can no longer accommodate my view of my activity. The ideological package has become inappropriate. That the work was viable eight or nine years ago within that structure is no justification for cultural self-perpetuation *ad infinitum.* Our war at that time against Formalism's mindless aestheticism was 'won' at the expense of our being responsible (after proliferation has begot proliferation) for a replacement which is functionally

*See "A Notice to the Public" in this collection, p. 104.

decorative and potentially even more 'mindless' because of its inability to be self-reflexive in spite of its claims. The Revolution didn't even simply end, it continues as a style. I don't like the work I see being done around me, and to the extent that I am co-participant (even if as an antithesis) I must somehow alter my course."

3. Diamond, pp. 202–203.

1975

1

*Art changes only through strong convictions, convictions strong enough
to change society at the same time.*

Theophile Thoré, 1855[1]

*Bolshevism, and later Nazism, offered avant-garde art the alternative of
supporting a revolutionary regime through aesthetic conformity—(that
is, through ceasing to exist) or attempting to revolutionize itself without
any prospect of changing life, in view of the superior force of the 'profes-
sional revolutionists'.*

*Either of these choices could only lead to the end of avant-gardism.
Without its political shadow, the defiance of accepted social or moral
norms becomes a game in which the old threats are turned into an
insider's joke. Today, revolts restricted to the aesthetic are welcomed by
the middle class as a solace; they revive the aroma of the exciting times
when hostility and misunderstanding between artists and the public were
considered dangerous.*

*With the door to politics closed by totalitarianism art has to an increas-
ing degree affirmed its dissociation from political and social purpose. In
the ideologies of recent art movements art-historical reasoning has been
offered as a substitute for consciousness of history. In this parody of
vanguardism, which revives the academic idea of art as a separate
'realm', art can make revolutionary strides without causing a ripple in
the streets or in the mind of a collector.*

Harold Rosenberg[2]

The last *Fox* poster advertised ". . . the failure of Conceptual Art" as part
of the content of Number 1. The nature of that 'failure' was only alluded

First published in *The Fox* (New York) 1, no. 2 (1975), pp. 87–96.

to in various articles, and was left at that. But, in fact, I have reservations as to whether 'failure' accurately describes the rather complex history of its diverse currents of artistic intent. Certainly the activities of the mass of practitioners within what is now an (art) institution is a betrayal of the impetus of its original aims. Stylistic conceptual art (hereafter SCA) is to my view superstructure begetting superstructure: a formalistic hypostatization of cultural sleepwalking; as dependent on and as expressive of the institutions of the prevailing dominating socio-political-economic ideology as is the current practice of the more traditional modes of art-making (painting and sculpture). In this article I hope to underscore an alternative reading of the past, present, (and possibly future) history of an art-practice one might call, with certain discomfort, theoretical conceptual art (hereafter TCA).

This article is not intended to constitute some sort of 'last word'. Given its author such a discussion can be inescapably self-serving. (I will leave it up to the reader to decide on the relative usefulness of an article of this sort as opposed to the objectively cloaked creative work done by our colleagues, those 'neutered' artists, the professional critics and art historians.) No, quite the contrary: as this journal is the expression of a moment in the intersubjective space of those of us involved with it, so this article is a conversational cross-section of my learning and thinking. It is also a response to the experience of finding myself in the world in which I do— and realizing the vulnerability of my past context dependent work to 'mean' what to so many it appears to. My thoughts about the future are unsure; certainly more unsure than this article implies. And this is compounded by the fact that in many ways I feel responsible—at least in part—for some of the current malaise in art-practice. My role, and the role of others, in disassembling the art-making opiate—as it is in its traditional mode—will only be appreciated if it is counter-balanced with a larger explanation of the historical necessity of our doing so.

Typical of most recent art 'movements', conceptual art has had a relatively brief life. Had we known that its death would have come from acceptance, perhaps many of us would have appreciated (for as long as it continued) that the hostility and extreme defensiveness that marked its art public greeting was paradoxically its life-support system: the reaction from the vanguard establishment was itself a tacit understanding of its potential threat. The subsequent deterioration of the movement into a popular SCA pointed, at least on the surface, to an ultimate victory by the establishment. The form the victory takes is that of annexation. On a personal level for the practitioners what occurs is that the sense of authentic existence obtainable through a kind of struggle is replaced by an impersonal participatory role in cultural power brokerage and subse-

quent defense of that generalized cultural status quo of which, henceforth, your movement is part. The political implications of such a generalization is the identification of what you 'mean' or intend with those institutions of society upon which your work is dependent.

The scientistic structure upon which I based my older work was intended to provide an arena in which work *on* art could *be* art yet leave behind the aura of profound personal moments reified and vying for recognition as 'masterpieces'. The *activity* was art, not the residue. But what can this society do with *activity*? Activity must mean labor. And labor must give you a service or a product. Only as a *product* could what I spent my time doing be meaningful in this society. But what it meant to *me*, and to anyone really interested in art had nothing at all to do with its existence as a product. The more recent work needed galleries and museums to provide the necessary context—and this is where the problems, artistic and political, begin. On one hand, one can rightly ask: where else is the audience for this activity? Certainly the museums, galleries, and art magazines provide the stage for the interested public to make contact with the 'activity'. Then, on the other hand, one realizes that the museums, galleries, and art magazines transform, edit, alter and obscure the very basis of one's art.[3] Just like the other institutions in America, these institutions in *our* world are bent on maintaining the cultural *status quo*.

In the late sixties and early seventies in New York there was somewhat of a 'junta' atmosphere in the art world. The Greenberg gang was attempting with great success to initiate an Official History gestalt, and there wasn't much generosity toward us 'novelty' artists that didn't happen to fit into the prescribed historical continuum. Fortunately, there were very few younger artists that *did* fit into his historical continuum, which is what collapsed the movement—in spite of the tremendous appeal of Greenberg's brand of formalism to academics and other upper middle-class professionals. Exponents of the 'party line' had saturated all aspects of the art establishment. There was Lawrence Rubin selling it in his gallery, and William Rubin curating it at the MOMA; Greenbergers were on the grant-giving panels, and were published relentlessly in the magazines—from *The Hudson Review* to *Artforum*. At *Artforum*, under Phil Leider, they decided that if they would just ignore us maybe we would go away—their hegemony being what it was at the time. We didn't. If one did get reviewed you could be sure it would be a hatchet job. The token coverage of 'novelty' art was usually reserved for the weakest possible examples within any tendency deemed threatening enough to Official History to deserve coverage. Anything positive generally consisted of trying to reveal the 'classic' lurking within the misfit—most of the 'anti-form' artists were seduced, and their work affected, by such annexation.

This annexing finally was forced on the formalists insofar as they were now forced to be formalists *theoretically*, but had to liberalize their practice since there were too few non-'novelty' painters or sculptors of any merit around to keep them all working. Perhaps it was that or perish. So the art critical establishment began to consider the work of younger artists (Serra, Heizer, Sonnier, Nauman, Hesse, etc.) which could be embraced in some fashion by formalist criticism—regardless of the artists' intentions. With the exception of two articles by Jack Burnham, Conceptual art was by and large ignored during this period. The recent appearance of articles such as "Artists as Writers" by Lawrence Alloway (*Artforum*, March 1974) in which TCA was totally omitted, increasingly made it clear the omissions were still (small p) political. My work has seemed to be particularly useful as a negative example, so much so that it began to get humorous in its predictability.[4] (Finally, I suppose to avoid admitting past errors, when 'Conceptual Art' could no longer be ignored *Artforum* came up with their *own* 'Conceptual Artists'. Sort of how the Russians came up with Husak to 'lead' Czechoslovakia. They've pretty much still continued to ignore the work which has been around for years and constituted most of the early and even not-so-early conceptual art exhibitions here and abroad.)[5] So much for provincial bitching.

With little exception the work which gets attention (SCA) has been made 'cute' and palatable. The use of language is seen as 'a new kind of paint'. Most of the objections have been laid out years ago in *Art-Language*.* What has been important about TCA has been that it has a theoretical force that recent movements have not had. It has allowed for the possibility of new work on a *collective* basis (with that 'collectivity' being the product of ideological self-awareness), and not simply on the traditional stylistic tract of individual histories. What has emerged from an understanding of TCA's infrastructure (and obviously by extension art's) has been the necessity for an *alternative supporting social structure*. What began in the mid-sixties as an analysis of the context of specific objects (or propositions) and correspondingly the questions of *function*, has forced us now, ten years later, to focus our attentions on the society and/or culture in which that specific object operated. Our 'radicalization' has, rather cold-bloodedly, evolved from our work. Such a recognition increasingly forces us to confront the high problematicity of participation with the establishment avant-garde in our work. As the Rosenberg quote above points out, the relationship between the present avant-garde and the historical role of the revolutionary artist is similar to the relationship

*Kosuth seems to be referring to his own "Introductory Note" and Terry Atkinson's "From an Art & Language Point of View," which appeared in *Art-Language* 1, no. 2 (February 1970), pp. 25–60.

between the forthcoming Bicentennial Celebration and what it meant to be an American and fighting in Concord in 1775.

To turn to the case of my own work, any description must appreciate its formalization through a stratification of 'overviews', with these overviews operating as models of art. The initial study of anthropology was for me a way of viewing art itself as a context: though I found the lack of self-reflexivity in academic cultural anthropology seriously undermining its capacity to provide a model which wasn't *itself* an artifact. The 'objective' reality of the scientistic, architectonic model is, by construction, incapable of the sort of reflexivity mandatory of a real model of art. It is in this way that one can possibly see an evolution toward a more marxian and critical overview of American art and culture.

To the extent that one speaks of art in this century one understands modernism to have been authentic to it. I don't think that is controversial. The self-consciousness of modernist art-practice was a 'motor' for the complex unconscious mediation of social reality with human action as 'meaning' *internally*; beyond which—as a symbolic language—the *external* societal structure could support the contradictions; thus taking us to the present crisis. I think it is no accident that the art which I am describing in this article (TCA), as the first to address itself to a conscious self-reflexive dialectic with society/culture, is the one and the same that was so radically concerned with the internal or infrastructural mechanism of art. Whether *any* such concern would follow that direction is at best unclear, but what is clearly of paramount importance to such a trajectory is the particularities (methodological and otherwise) of a significantly altered conception of art-practice priorities.

2

. . . A language is at the same time the product and the instrument of speech: their relationship is therefore a genuinely dialectical one.
Roland Barthes

'Formalism' was at issue in Conceptual Art (CA) in more ways than the apparent ones. With Greenbergian formalism what is at issue is a belief that artistic activity consists of *superstructural* analysis (prominent traditional modes of art are taken as 'givens' and the issue is to attempt to understand the nature of art qua technical praxis of those traditional modes). CA, which might be described as a formalism of another sort, has as its basis *infrastructural* analysis, and it is in this context that one understands the endeavor to 'question the nature of art'. It is necessary to such an infrastructural analysis to locate one's activity in artistic endeavor since Abstract Expressionism, after which work began to appeal to *the*

logic of modernism for art status rather than appealing to the tradition of western painting for art status.

In my past few articles I have tried to explain my activities, and the activities of Art & Language, in terms of my notion of an 'anthropologized art'.[6] An 'anthropologized art', in keeping with my previous discussion of it, must concern itself with exposing institutional contradictions and thereby obliterating art ideologies which presuppose the autonomy of art. The understanding is that such art is dependent on an even more embracing ideology which presupposes institutions of equally autonomous value. An 'anthropologized art' is an art which is not 'naive' towards its own ethno*logic,* and which has as its practice the construction of a model which, though tautological in the particularities of its own structure nevertheless functions dialectically *in situ*—that is, culture *qua* art. That it meets the demands of the ethno*logic* and alters existing norms of art is a demonstration of its dialectical functioning. *Its* alteration by the institutional supports of those 'norms of art' (galleries, museums, and magazines) is as well a demonstration. An 'anthropologized art' must therefore accelerate the dynamic to such a degree that this larger (operational) dialectical model exposes and isolates those institutional supports on one hand, and thereby simultaneously articulates with clarity that dimension of western civilization's ethnologic we call art, on the other.

Painting has become a 'naive' art form because it can no longer include 'self-consciousness' (theoretically *as well as* that of historical location) in its program. Such a self-consciousness necessitates that the prevailing 'language of art', like any language, must be transparent to be believed. Sixties art was the dissolution of the language of art as painting and sculpture into opacity. With CA emerged (out of what was only implicit in 'minimalism') a *competitive* paradigm or model of artistic activity. The work closest in time to 'minimalism' *appealed* to the innate structure or 'logic' of western civilization, more recent work (TCA) has increasingly consisted of *revealing,* through praxis (action on the superstructural level), that 'logic'. The older scientistic, analytic model was *passive (relied* on institutions for meaning); whereas the dynamic of the new work must, in part, consist of *revealing* the contradictions, and as such has as its task the dismantling of the mythic structure of art as posited in the present day cultural institutions.

The motor of art is that it is engaged. That is, the notion of art coming out of art speaks exactly of this. Art's existence is on a level of praxis, and as such it is a continuous working model of culture. But our art, even if it is to be a model of culture, is not static, but an operating, continually changing, model. One of our tasks is to re-establish an equilibrium between its internality and its externality. It must be *in the world.* By not being *in the world* it is culturally naive.

In some respects CA was a tacit recognition that visual iconography was 'used up' for surface structural purposes. What then became the surface structure in TCA was *methodological choice* in the description of whether what was being described *was* art—which is in keeping with the understanding that this was not appealing to the traditions of art-making procedure (painting and sculpture) but to the deepest structure of the 'logic' of western civilization: that is, to *culture* itself. What was felt, I think, was the need for a radical surgery—a tracheotomy to bypass the blockage of meaninglessness that this society by way of its institutions (of which painting is one) had come to represent.[7]

(New) art begins with a reference to tradition (or culture, or *'langue'*). That is, it appeals to tradition for 'believability'; it then proceeds to exist in terms of being a *representative itself* of tradition—taking its meaning *from* while it simultaneously gives meaning *to* 'tradition'. Yet the dependency of perception on theory forces the work of art into a state of continuous change in meaning. In this way it functions as a cultural road map, appearing to exist isomorphically to human consciousness as a memory of it (with the experience of art more like the experience of memory than of an actual event); speaking of itself as 'tradition' it speaks of the institutions of society—the social reality—with such a specific static embodiment of 'reality' as to imply the possibility of transcendent 'conversations' on a cosmic level (contemplation) if only for a moment—while the *promise* of such conversations floats on as an ideology.

3

Mythic variants and their contents may be progressively engendered by the logic of myth itself. In all cases, however, they remain comparative and relational, either within the specific confines of their respective ethnographic settings or in those relatively autonomous instances when myths 'reflect upon themselves and their interrelation'.

Bob Scholte

No doubt everything in the folk tale originates with the individual, just as all sound changes must; but this necessary fact of invention in the first place is somehow the least essential characteristic of folk literature. For the tale does not really become a folk tale, given the oral diffusion of this literature, with its obvious dependence on word of mouth circulation, until the moment when it has been accepted by the listeners who retain it and pass it on. Thus the crucial moment for the folk tale is not that of the parole, *that of its invention or creation (as in middle class art), but that of the* langue; *and we may say that no matter how individualistic may be its origin, it is always anonymous or collective in essence; in Jakobsonian terminology, the individuality of the folk-tale is a redundant feature, its anonymity a distinctive one.*

Fredric Jameson

It might be useful to consider certain aspects of my past work within this discussion of an 'anthropologized art'. Central to much of my work has been a somewhat special use of the notion of tautology. This notion of a tautology as a formal (art) model can only be understood *operationally* as an hermeneutic. The formal 'map description' of it forces us to call it a tautology, but an understanding of it as a dynamic (dialectic) sees it as an hermeneutic. By hermeneutic here I am thinking of Scholte's notion of an hermeneutic approach as one which "considers a tie between historical consciousness and ethnological understanding—between experience and reality—to be fundamental to any textual interpretation. . . ." Its own paradigmatic foundations are reconstituted throughout the model in such a way as to offer (systemically include) an autocritique implicit in its own self-reflexivity.

The convenience of structuring models of art along the lines of a tautology have to do with the specific needs of a 'non-naive' art-practice. If the 'artist-anthropologist' has as his/her task the construction of models which 'expose' our ethnologic while simultaneously being 'accepted' by it and thereby mediating each other into a totality, an understanding of Modernism (in which the ethnologic of this civilization *qua* art has been most exposed) returns us in fact (though one might want to describe it differently) to my argument of artistic functioning—naive as it is—in "Art after Philosophy."[8]

Both the usefulness and the inappropriateness of tautology as a description can be made more clear in the attempt to map out the functioning of my past *Investigations.* Consider the following: we first have the need to formally construct the model so that, even if only perceptually (operationally), it can be grasped as a whole. Previous art did this literally in a visual way. Comprehension can be understood as 'holistic'. In my models 'operationality' was pervasive. The smallest operational unit in each proposition was designed to function (operate 'meaningfully') in unison with other units. These units or stratifications of meaning were all totally dependent on each other. Shifts of meaning from unit to proposition to investigation to all ten *Investigations* to contemporary art to Modernism to western civilization, etc. were structured to force *meaning* to be dependent on context *at every level,* and from the outside. And on the inside, the units (as well as the other ways they functioned) consisted of textual material, usually 'theory' but not always. These were self-referential in order to be self-reflexive of the model (and art) itself. Its space consisted of 'psychological space' at a unitary level (comprehension of the text) yet the construction from adding all the parts (units) to make a 'whole' had no iconic meaning; the model's physicality was not rarified and made magical. Outside of the personal meaning of entering its 'psychological space' no specific proposition could be 'seen' any more or less than any

Investigation could be 'seen'. Indeed, its interdependency from unit to proposition to Investigation meant that the act of 'seeing' my work meant 'seeing' art.[9] In this way there was a direct operational relationship between the particular (a unit) and the general (art and culture).

While I always considered my writing on art a part of my role as an artist—interdependent with the models—I nevertheless have maintained that to quasi-gesturally profess one's functioning *as a writer* (this being the praxiological in-the-world agent) as continually the 'model' (from the point of view of praxis) of art *qua* artist sets up too clear and in fact an inappropriate distinction between the meaning of the *activity* and the import of the content of what was being written. Further, in Art & Language, there has been the problem of mystification which follows writing so special as to be too inaccessible to be 'influential' on generally applied conceptions of art-practice; thus furthering the notion that the artistic significance of the group is the generalizable 'script-making activity' rather than what is actually being said.

Language when used within the context of a 'model' of art cannot be considered operationally similar to its use in explicated 'art theory'. 'Modelistic' use of language is not the voluntary and full conscious literal content-communication which it is often mistaken to be. Certainly there is a level of specific meaning to what is stated. But its significance as a model of art is *relational*, not literal; though those relations cannot be understood independent of specific meaning, it is understood only when it is understood *in its totality*.

Throughout my work there has been a realization that 'model' must *clearly* exist as such, as internalizations and capable of a contrast to *external* art criticism or aesthetics. (What separates the critic and art historian from the artist is his/her demand to have an *external* relationship to art-practice; the myth of scientific 'objectivity' has demanded this—in some ways one can define the artist as one who tries to affect change from the *inside,* and the historian/critic as one who tries to affect it from the *outside.* There can be little doubt as to why the historian/critic is increasingly viewed as a 'cultural policeman'.) *Theory as praxis* to be more fully understood must withstand transformation in being reversed: praxis as theory—meaning what contextually (semantically) functioned *as art* was *a theory* of art.

The historically evolving unconscious rules of language were understood to have a homologous relationship to what I have called the 'logic' of culture. Thus, the attempt to formalistically disassociate our work from our society's iconographic surface structure (and attempt to arrive at some kind of 'non-style') partially explains the reasoning behind (in Saussure's terms) the attempted use of the *signifier* as the *signified*—what else could more clearly focus our attention on the *system of art itself*?

A TCA praxis which doesn't include a distinction between implicit theory ('models') and explicit theory (articles) is incapable of clearly establishing the interdependence between the two. Insofar as art-practice itself can only be historically understood as *model construction* then explicit theory itself becomes the model (with its meaning understood to be implicit—that is, as not being what is *actually* said in the texts themselves). The point perhaps being that unless one sets up the models as part of a conscious and controlled (relative to the endeavor) program inclusive of a self-reflexive and self-critical dynamic, formalistically functioning *explicitly*, then alternatively what emerges uncritically is a model arrived at via (social) practice. Thus one can begin to see that what has been Art & Language's weakness according to one mapping is its potential strength according to another.

Art & Language's role as an (art) model builder in the past is then subject to interpretation. What does make Art & Language extremely important is the implicit social critique in its methodology. I don't refer here to 'collaboration'—this was in no way unique to Art & Language, and the unevenness of participation in practice makes "collaboration" a misnomer in signifying what's special about the group. As Mel Ramsden recently put it:[10]

I still insist on the social roots of the problem. 'The group' forced to compete in an individualistic antagonistic self-interested (Adam Smith you Scottish Bastard) world. For example: 'having a show' is a one or two man endeavor. You need impact and gestalt. The whole thing is epistemologically individualistic. That's that. One reason for the collapse of A&L was that it moved from the journal (which was a 'group effort') to gallery shows which suddenly meant 15 or 14 out of the 16 people were standing around pretending they knew what was going on. There's nothing wrong with leaders, it's just when others see them leading and you following that we get screwed up. Again, these problems are *social*, not 'merely psychological'.[11]

The importance of Art & Language remains as an ideological (art) collective. I say 'collective' and not community, but one could say the collective consists of two communities—one in England and the other in New York. The recent collapse of the spirit of Art & Language as *one* community has come about through work by the New York group which concerns itself with issues anchored in the specificity of their New York lives and the larger artists' community here. *The Fox* is obviously one expression of this work. It has forced us into the real world, or to put it better, it has shown us that Art & Language spans *two* real worlds: and that the gulf between the two communities is, indeed, as wide as the Atlantic.

How can we make the transition from a praxiological life-world in which our work *along with us* is commodified (i.e. money and fame) to one in which 'payment' takes the form of an acknowledgment by the

community in which one lives implicitly by the act of adaptation. That means seeing how one's work effects the world in which one lives, and learning *along with others* from its effect, and appreciating that effect not as simply an extension of oneself (power) but as a part of a larger historical complexity which connects the location of your life with that of others. Perhaps it is here where one begins to understand the import of the (artistic) ideological collective of which Art & Language is a proto-type and emerging model.

4

. . . with the events of recent years Marxism has definitely entered a new phase of its history, in which it can inspire and orient analyses and retain a real heuristic value, but is certainly no longer true in the sense it was believed to be true.

Maurice Merleau-Ponty

The shift from the individual craftsman to the 'ideological community' has as its pivotal base an understanding of a changed sense of *responsibility*. It is one result of the *generalizing* aspect of theoretical work, paramount as it has been to Conceptual art. Initially, as Harold Rosenberg suggests, CA was self-consciously historical. Particularly among the early Conceptual artists, we were united not by a shared involvement in the technical issues of painting, for instance, but rather by a collective sense of a historical location: a view of art *overlooking* the flatlands of painting and sculpture. In thinking of artist's groups as a human community, one thinks of how painters are forced to underscore their *differences* from other painters; the struggles being how to maintain one's own identity within the generalization of painting. In CA what was felt, in the beginning at least, was not a sense of solidarity among technicians—that was wide open with everyone trying to stay out of everyone else's way—but rather a sense of solidarity in our sameness, what we shared: being members of the first generation to be young enough to be capable of breaking our ties with modernism. The myth of modernism, which includes painting and sculpture, collapsing at our heels, left only its shock waves: the sense of a more direct relationship with the cultural bias of western civilization, left for us to try to express in some historical way. It is impossible to understand this without understanding the sixties, and appreciate CA for what it was: the art of the Vietnam war era. Perhaps there is some interwoven nature to the myth of America and the myth of modernism, and when both have been sufficiently unwoven the autonomy of art may be seen for what it is: one colored strand and part of a larger fabric.

The particularities of art have, before modernism, made such a comprehensible depiction (if only a partial one) of the infrastructure of art apart from the traditional modes of superstructural art-making unthinkable. Those 'particularities' of the mythic structure of art have in this century constituted a continuous and profound, even if indirect, critique of Marxism. The lack of an accommodation of one to the other might in fact be characteristic, on a level of *post*-revolutionary societal fracturing, of Marxism's *own* programs (as separated from its critique of Capitalism) as ultimately unworkable in profoundly human terms.

As far as any real politics are concerned I have no hope for the Soviet Union and her 'satellites'.[12] Like America, they have forgotten what their revolutions meant. A country that must look to its past for honor is not a happy place in which to live. I must simply refuse to accept, as well, the scenario which only allows for 'bourgeois' thought or Marxist thought. I think the *use* of Marxism is instructive, and Marxism in general must be taken into account. The conspicuous inability of Anglo-American intellectual enterprise to do so is singularly significant and perhaps its major weakness. Yet any anthropology, 'marxian' or otherwise, cannot avoid the realization that Marxism and Capitalism both are representative of the 19th century life-world, and both present day Russia and America exist as monuments to the unreality and unworkability of both as systems at this point at the three-quarter mark of the 20th century. Our task is now clear: our generation must assemble its knowledge from any and all available sources and *find a viable alternative* to Capitalism and Communism. *The failure of our generation continues to be its inability to do so.*

Our youth was spent in an environment clouded over by the prospect of a nuclear holocaust: our children face an equally grisly, and more likely, prospect: life under the merged bureaucracies of multi-national corporations and Communist state capitalism—the 'peaceful' world of which Kissinger's 'detente' speaks. Such an arrangement is simply an accommodation among rulers to facilitate themselves *remaining* rulers. What is the *alternative* to this encroaching space-age feudalism? I wish I knew.

Eventually, of course, I must return this conversation to art. It is my 'location' and in many ways how I organize my understanding of the world. (Perhaps that's what 'work' of any kind is all about). My attacks over the years on tradition must be understood as attacks on particular (and popular) *conceptions* of tradition. Art is a description of reality by way of an interpretation of tradition. It is in the interpretation that one judges the value of the activity—as a real depiction of the social reality. In this sense 'real' work is an historical fusion of an individual's (or individuals') lived reality with the constituted 'optimism' inherent in a civilization's ethnologic. One can begin to see the struggle of the earlier stage—the relationship of the active agent *in* history *to* history. The fight,

too, is for the status of existence (meaning) that young art and the young artist in his/her role as mediators between a 'past' and a 'future' understand as the confrontation with civilization. Here, at this stage, the artist-philosopher meets momentarily the artist-shaman and contacts the inherently revolutionary nature of art-praxis—until again, that parent Society seduces with a further re-description of reality.

I have said that the artist 'depicts' reality by a description of tradition in terms unique for his/her historical location. My reading of art history tells me that I now find myself capable of seeing for art (out of art) a tradition independent of and unmolested by a social coloration (meaningfully mediated) which describes *and re-enforces* the presently unacceptable social status-quo. In this sense the Marxists are correct when they claim that art cannot be apolitical. When I realize this I must ask myself: if art is necessarily political (though not necessarily *about* politics) is it not necessary to make one's politics explicit? If art is *context* dependent (as I've always maintained) then it cannot escape a sociopolitical context of meaning (ignoring this issue only means that one's art drifts into one). For this it is necessary to make one's politics explicit (in some way) and work toward constructing a socio-political context of one's own in which (cultural) actions are anchored for meaning. It is in this sense that *The Fox* is a 'political' journal. The desire is to consider art, and the lives of artists, in relation to (a) social philosophy. One begins to understand, increasingly, how the notion of a 'category' of politics is at best a temporary device and at worst a naive relationship vis-a-vis the world. And further, an understanding of art is forced by a realization that a 'political' reading of art (as I outline here) is an integral aspect of the internalizing feature (of artistic activity) towards a rich and comprehensive (though 'located') understanding of the nature of art. Such an understanding is necessary if we find that there is something in art of importance to mankind/womankind which must be preserved. A defense of art in terms of its current formalization is necessarily prescriptive, and politically repugnant.

Notes

1. Théophile Thoré, quoted in Linda Nochlin, "The Invention of the Avant-Garde: France, 1830–80," in *Avant-Garde Art*, ed. T. B. Hess and J. Ashbery (New York: Collier Books, 1968), p. 3.

2. Here quoted from Harold Rosenberg, "Collective, Ideological, Combative," in Hess and Ashbery, pp. 90–91.

3. I count curators, dealers, and historian/critics among my friends, but I think non-artist art "professionals" are in an extremely problematic situation vis-a-vis the system. Particular individual efforts are noteworthy, occasionally even heroic, but a re-thinking of one's role in society is in order for *everyone*.

4. One of *Artforum's* more dismal chapters has been the James Collins episode. Collins' overnight conversion from an Art & Language sycophant to an *Artforum* sycophant (and useful anti-CA hatchet man) attests to both *Artforum's* power and sense of expediency. Collins ended a response to Rosetta Brooks saying that discourse ". . . between the covers of magazines like *Artforum* seems like a proper location to me. There, unlike self-edited Conceptual Art magazines, the Editor can always say 'No.' " Of course at *Art-Language* we said "No" too—to *him*, several times. Hence the fanaticism of a sour grapes convert. His naive belief in the absolute and legitimate authority of non-artist art magazine editors, by the way, is pathetic coming from someone whose opportunism has propelled him on to yet another career as an artist. This time around, though, "theory" has been replaced by sex appeal.

5. It's very instructive for artists to see which work the critics find most usable for *their* craft. Take a look at old *ArtNews'* and *Artforums*. Since such magazines are usually in the hands of the prevailing art establishment the critics tend to act as lawyers for the maintenance of the status quo. The practice seems to be to use the *weakest* examples of any threatening new development to argue against, thereby facilitating a put-down of the whole movement. You can't expect these more malleable artists to object to the sudden windfall that's come their way, given the set-up of the art world, but by now artists at least should realize the myth of 'objective' criticism/history to be understood for what it is: creative work *competitive* with the artist's, yet repressive and tenaciously self-serving in its role as 'administrator' for the artist's community.

6. "The Artist as Anthropologist" [this collection, pp. 107–127]; "(Notes) on an 'Anthropologized' Art" [pp. 95–101]; Statement for the Congress of Conceptual Art [pp. 93–94].

7. The current re-interest in painting—perhaps best exemplified by Brice Marden and Robert Ryman—is a result, ironically, of the 'success' (taken as historically 'right') of CA in Europe. Several intelligent dealers, supporters of CA, but dealers none-the-less, accepted the demise of painting sufficiently to pose the question: "So, then who are the last young painters?" Art market momentum, being as it is oblivious to 'content', and fueled by a basic bourgeois preference of an art of decoration to that of an art of complexity, is rolling on of its own accord. Painting, which asks no questions—even about the nature of art—has its cultural neutrality at the service of the dominant ideology.

8. There are of course many, many problems with "Art after Philosophy." One of the ones that comes to my mind at this moment is that while objecting to the romantic paradigm of the artist—being as it is a device for rendering artists powerless in any meaningful social sense—I seemed to swallow whole the scientistic ideology which by necessity must relegate the artist to such a position in the first place. It is the same ideology that we see, when described economically or politically, as culturally eclipsing our lives of their meaning. Of course one *can* write alternate historical schemas to Greenberg's (or anyone else's) aesthetic historical continuums. We *shouldn't* because we end up, unavoidably, as formalist bedpartners. While obviously I still do not hold to the scientistic, positivistic epistemology that is exhibited in "Art after Philosophy," there is an aspect to my discussion of artistic functioning which, at least in spirit, I feel is useful—though limited as it is to our understanding at the time. The overall, somewhat propagandistic, purpose of that article was to provide an understanding of the theoretical basis for a great deal of art-making activity eliminated from the art historical schema of Greenbergian formalism. Those that have criticized my theory as

a "continuation of the 'art for art's sake' doctrine, resuscitated by Ad Reinhardt in the 60's" unhappily miss the complexity of the argument, and rely too heavily on my acknowledged (and for that matter continuing) respect for Reinhardt. It's also pretty ignorant, come to think of it, of the significance of Reinhardt's work. Rosetta Brooks, as quoted above, has her own axe to grind. She and John Stezaker—the artist whose mission she identifies as her own—go to great lengths to dismiss "Art after Philosophy" for rather transparent reasons which might best be described as 'Oedipal' (read Stezaker).

9. Or seeing *nothing at all* in the form of tables, chairs, and my 'summer reading'.

10. In a letter I received this summer.

11. The journal Mel Ramsden refers to, *Art-Language,* allowed for individual effort as part of a collective ideological front which it constituted as the 'party organ'. The *Art-Language* which has re-appeared more recently has been victimized to some extent by the 'social problems' similarly manifested in as well as acerbated by the group's participation in the gallery and museum system. My own relationship with Art & Language has been both a part of the problem, and (as I contend) a part of the solution.

12. Not that work isn't continuously being done to improve the Marxist model, nor for that matter that there aren't perhaps better working models than the Soviet Union (Yugoslavia, China, or Cuba). One can only look longingly, and momentarily, at anarchism or utopian socialism.

WORK

PART I

. . . Schleiermacher had in mind the circular process of understanding itself, in which we read the parts in the light of the whole, but cannot presumably know the whole at all until we have read all the parts; in which we understand the individual words against the background of a projected sentence which will, however, not be complete until we have finished reading each of the words one by one. The same circle (or spiral) holds, it seems to me, for our comprehension of the past. No doubt, the degree to which we can have a vivid sense of the great struggles of the past, and of the social conflict from which the greatest works have emerged, is directly proportionate to our own personal experience of just such conflicts in the present. So the political struggles of the last decade have renewed our understanding of the past as well, and caused us to see in a new light many of these masterpieces of the past which for an apolitical generation had been felt as mere art objects or formal constructions . . . [1]

The desire to place history among the sciences sprang, Croce believes, from two false beliefs; that all knowledge had to be scientific knowledge and that art was not a mode of cognition but merely a stimulant to the senses or, conversely, a narcotic. To straighten out the matter, it was necessary only to show that art was nonconceptual knowledge of the world, *knowledge of the world in its particularity and its concreteness, to point to the fact that history was a similar kind of knowledge of the world, and then to distinguish history from art in general on the basis of* the content *of their representations.* [2]

First published in *The Fox* (New York) 1, no. 3 (1976). 116–120.

If we are ever to transform our present social and cultural reality we will do so through a process of mediation *from* our present arena of work/life, and conscious struggle toward another. Only through artistic critical *practice* in the working out of the premises of our present art can we, beginning as artists, consider the meaning of our work in terms of (1) a mystification and fetishization of institutionalized symbols, to (2) understanding such symbols as commodity objects that rationalize present day reality by rarifying and glorifying—and thereby serving—the existing power structure (whose existence stands between us and the possibility of a society in which our work would mean something), to (3) through the process of forming cultural conceptualizations make explicit our implicit ethnologic: the making culturally concrete of 'philosophic' belief languages and seeing them, as art, as actual pivots of mediation. Art must constitute a critique in order to avoid annexation by a day to day language which must make a process a product in order to give it 'meaning'. Our understanding sees the mechanisms of art-making as a sub-structural continual human historiography which transcends the capitalist scientism of 'Official History' and its subsequent organization of reality—a reality for which the 'best' of our work, by being so, reveals more than we wish to know of our age. How can we begin *here*, without reverting to mimicking work which was concrete and real for *another* time? Creative work now demands 'self-predictive' cultural criticism historically anchored to a radical understanding of artistic functioning in the form of models made culturally concrete. The road to social and cultural reintegration begins with the attempt to practice positive work within the scope (and that means daily life) of one's own specific historical location. For the living, the *means* is a perpetual 'end'. That means is the process of mediating reality through work, and it is in artistic practice that the language of the belief-system can function as both homology and reality itself—though it is the role of the radical artist to push cultural consciousness by making reality 'visible' through homology rather than participating in evolving homologies that *constitute* reality, which led to and is typified by modernism. Such a direction, which Walter Benjamin suggests is the aesthetizing of reality (as under Fascism) is understandable for a civilization whose religious motor is scientific progressivism in the form of consumptive capitalism. It is dependent on an abstract and artificial world where culture isn't concretized experience (and under the control of all those specific humans having the experience) but rather is technological theater: mass hypnosis under which behavior is controlled and pockets are picked.

The perspective of one's unique historical situation is organized from the location of one's work—that is how in a *healthy* society one is connected meaningfully with other humans. 'Political' activity unconcretized

is thus idealist dilettantism, regardless of the force or piousness of the 'activist'. Work can respond to and mediate the ethnologic of this civilization in ways which do not reinforce and perpetuate the socio-cultural status quo. This is an understanding necessary for new work. Another is that in modernist art, unlike science, an illustration has also always been a 'test' because it was operationally capable of being 'meaningful' within the belief system of art *a priori*. The present state of contradiction has come about because our cultural/social world is no longer anchored to the concrete reality of the time and space of our lives, but rather our lives are indexed (for meaning) to an overly encultured, technologically fabricated media life-world. Thus, our world has become a 'theater', and like any theater it is produced and directed. Works of art are now stage props and no longer real. 'Creative work' in art—a continuation of the questioning of the *nature* of art—consists of attempting to make this transparent 'theater' (taken as neutral and natural) opaque and visible. This theater calls such work 'political'. 'Successful' work is no longer creative because it isn't questioning this reality, but accepting and refining it. Work must be that which is intended to 'fail' and in its failing resists being 'meaningful' to bourgeois society (*within that consciousness*) while still creatively articulating and making explicit the ethnologic of this civilization, a structure which by necessity must be exposed, for only with such an exposure can a truly new society culturally (and socially) evolve.

Making our ethnologic explicit in art will begin with an understanding that form is content, though certainly not in the usual sense in which this is meant. The conscious and temporal aspects of artistic choice can be considered 'form', the unconscious and cultural rationale of the work its 'content'. But when the formalization of 'content' occurs from unconscious adaptation and 'analysis' it constitutes an exposed dimension of our 'ethnologic'; though only momentarily: the spiralling nature of the social dynamic is such that 'understanding' re-establishes that 'content' as 'form'—and on and on the process goes. A market-dependent and oriented culture invests in static conceptualizations (at any given moment the 'formalism' of art) since the generalization we call culture is only accessible to the market as a frozen moment rather than as a dynamic human process uncontrollable and open to everyone. We no longer make art, we make culture directly. The result of the commodification of culture in capitalist society is that the false consciousness of the 'market reality' has converted this 'symbolic crust' of historically imbedded social relations into a dead and artificial mechanism susceptible to control. Art is thereby separated from its deeply human historical base. In 'primitive' society, by contrast, history is 'lived' through human (and natural) interconnectedness, not simply printed and politically commodified. A program for future activist cultural work would seem to be two-fold: (1) the

making opaque of such transparent mechanisms as well as (2) a self-reflexive analysis of the epistemic base ('the making explicit of the implicit ethnologic') implied by the practice of the former, while at the same time that former practice must constitute a 'self-reflexive analysis' of the latter. Both are 'practice' and both are 'theory'; and their fusion could in part constitute the kind of motor necessary for a radical evolution out of capitalist cultural consciousness.

PART II

Someone who does not care about real change betrays both art and change. But he who gives up art as something supposedly bourgeois falls into a bad state of affairs, that is: he is reactionary in the real sense of the word.

Herbert Marcuse[3]

To have an interest in art, and an interest in the people interested in art, doesn't itself necessarily condemn one as a 'bourgeois reactionary'. And one must question the motivations of anyone that maintains so. A consciousness of one's social section and the desire to transform it isn't the same as glorifying the *status quo*, though it must be imbedded in the work. Wholesale dismissals of a social activity simply because of its current bourgeois formalization is usually the position of those whose relationship to the social dimension (if not *all* dimensions) of the activity is either highly problematical or non-existent. (To suggest this that might be the case regardless of *what* society they found themselves in, would be unhistorical and non-dialectical, as tempted as one is to suggest it.)

In many ways the history of *The Fox* is a public travelogue of the re-education of a group of artists, their evolution out of a consciousness another consciousness calls 'bourgeois', and, at this point, their arrival at a juncture where the basis of their socializing activity—'going on'—is split and sub-divided.[4]

Some have made a 'choice'. They see the Marxist-Leninist path as the 'correct' one and see the history of libertarian socialism and what some of us consider the need of *our* establishing a revolutionary *and* evolutionary methodology for social and cultural transformation as a 'diversion'. They see the aims of the feminist movement in terms eclipsed by their programs; they don't understand the necessity of embracing Marx's goals and avoiding Lenin's practice. They haven't learned that the attempt at applying the *theory* of practice from the classics to 'our situation' is a poor substitute for seizing the opportunities for change as they exist already *within* our situation, and feminism is a case in point. The issues of feminism are profoundly transformatory, they're here now, and they're

having an increased effect. Only a religious mind rejects such 'opportunism'.

Those that have made a 'choice' want others to make the *same* choice—thereby facilitating the auspices of the group as an ideological tool. The form that consolidation of power takes is always similar, regardless of the ideological justifications used. Experience tells us that 'means' *does* become the lived reality; but I'm willing to let others learn from their mistakes as well. 'Going on' is *still* the question, and our confusion is seen by some as a demand for 'organization'. The question is seen as *simply* political, thereby necessitating direct political activity with the working class. This categorical fetishization, for it is that—'politics' (*and* the 'working class') being as easily a candidate as art—sees everything else as a shadow. Perhaps I will deserve being criticized for saying so, but the recent gushing pace of 'radicalization' is in part due to the fact that it is only an intellectualization, 'in the air' as position-taking, and not brought down to a real level: the radical re-evaluation of the basis of work. Instead, old habits continue. Group (and an arbitrary one at that) momentum is seen as a priority over the establishment of a living, working and learning situation that could have a *real* effect by being *community oriented*. The alternative has meant a return to the isolated pious and elitist club, with a social style and force virtually indistinguishable from the group's early seventies position, regardless of the fact that Wittgenstein has been replaced by Lenin. One of the surface changes has meant a shift from 'bourgeois artists' to 'revolutionaries', but the forms it takes (in terms of psychological need) reveals it as *art* historical, avant-gardist thinking. What we're stuck with now is hard-lining as a new kind of paint.

One problem arising from the ideological desert of American education in the reawakening that is part of the process of a genuine study of the social, political, and cultural processes that have formed us, is that everyone—working class and middle—is susceptible to being blinded by the sheer power of the clarity and sense of purpose of revolutionaries such as Marx, Lenin, and Mao. For those located in the emptiness of American Society without an historical embeddedness and sense of purpose of their own, nor the capacity to overcome the tremendous difficulties in creating such a space, the tendency all too often is to feel that one has found the 'answer'. How typical of our western (and that means scientific and messianic) mentality to stop the process of education and 'choose'. The point isn't to *choose* (and we must remain suspicious of programs which insist on simplistic choices); it is to *learn*, and attempt to apply what one has learned to *one's own historical situation*. Many Marxist-Leninists in America are so preoccupied with making Holy Writ relevant to our situation (and as one might imagine it's a full-time job) that they have lost touch with what 'our situation' is. Isolated from the day-to-day reality of

socially connected work, the professional revolutionary instead enters another psychological space which consists of internecine position-taking on Holy Writ interpretations, fueled by revolutionary careerism and greased with romance. Unless one sees social transformation occurring in *this* world by introducing it into one's work and by extension one's social relations, it is academic by any standard—even if accompanied by the usual 19th century assumptions about revolution, which in 'our situation' comes off as macho provocation. In some sense Leninism has *served capitalism* in its role as an ideological 'boogeyman' thereby thwarting real social and cultural *transformation.* As the military-industrial complexes on both sides of 'detente' show us: we are fighting a mentality as much as anything else. We need to begin to realize that the 'left-right' mapping of the political spectrum hasn't set out for all time and encompassed for all people what must be done to make this world livable. If change comes, and I believe it must, it won't be in the male fantasy characterization (cops n' robbers, cowboys n' indians) or 'revolutionary science'; unless one sees countries like the Soviet Union as a 'change'. The 'ends' of Leninism have been its *means:* authoritarianism. What you see in that country, and in other countries, is the direct result of Leninist method-ology. In our fight against capitalism, a fight which is historically just and absolutely necessary for the preservation of humanity, we might fight with *equal* vigor against the anti-humanism that capitalism has bred on the left.

Our reality is located in our work, whatever our work is, and conver-sations which begin with other priorities and schemas seem ultimately to be abstract, procrastinating and safe. Given the multiplicity of revolu-tionary 'game plans' (and the uncompromising formalistic methodology of most of them) at what point does one begin to see the professional revolutionary's insistence that his or her way is the *only* way for social change, as being an impediment to *real* change?[5] The activity of the former, insofar as it isn't anchored within the fabric of society, can be self-justificatory, amoral, and 'group solipsistic'—as anyone that has had contact with those 'possessed' (politically or religiously) will attest. Rev-olution as a professional niche which isn't mediated through a meaningful anchoring within the social reality (work) becomes idealistic, elitist, mes-sianic, and finally *unreal.* Constructions such as a 'Vanguard party' are perhaps attempts to legitimize the niche with the aura of quasi-work. (Unfortunately, idealist pragmatizing and work are not the same.) Political issues must be contextualized within the historically human social con-tinuity of work, and this begins *for us* by asking questions, such as: if I like neither the way nor the meaning of my work, why is this and what can I do about it?

Notes

1. Fredric Jameson, Introduction to *Marxist Aesthetics* by Henri Arvon (Ithaca: Cornell University Press, 1973).

2. Hayden White, *Metahistory* (Baltimore and London: The Johns Hopkins University Press, 1973).

3. Herbert Marcuse at a symposium, Cologne, 1972.

4. This issue of *The Fox* is a collaborative effort by *at least* two groups. It contains material I can in no way support—and I know that of course I'm not alone, probably *no one* supports everything that is between these covers. One justification for the publishing of some of it might be the 'educational' role of *The Fox*, allowing for negative as well as positive examples to learn from.

5. This isn't intended as an indictment against all 'professional revolutionaries', certain historical situations demand them, to be sure. The question I'm raising is what will bring about social and cultural transformation in *our situation* in a way which is radical, because it is real; and as artists, what is our role in that transformation?

WITHIN THE CONTEXT: MODERNISM AND CRITICAL PRACTICE

So our campaign slogan must be: reform of consciousness, not through dogma, but through the analysis of that mystical consciousness which has not yet become clear to itself. It will then turn out that the world has long dreamt of that which it had only to have a clear idea to possess it really. It will turn out that it is not a question of any conceptual rupture between past and future, but rather of the completion *of the thoughts of the past.*

Marx, Letter to Ruge (1843)[1]

1

Some eight years ago, in an article entitled "Art After Philosophy" I attempted to develop an analogy between the art condition and analytic propositions. The attempt was to describe the modernist model of art as being tautological. "That is, if viewed within their context—as art—they provide no information whatsoever about any matter of fact. A work of art is a tautology in that it is a presentation of the artist's intention, that is, he is saying that that particular work of art is art, which means, is a *definition* of art." And again, art "can be appreciated as art without going outside the context of art for verification." Or, "If we continue our analogy of the forms art takes as being art's *language* one can realize then that a work of art is a kind of proposition presented within the context of art as a comment on art." And so on. Without commenting on whatever other useful or problematical aspects surround this article, I would like to consider for a moment this model. These explications, as argument, simul-

First published Ghent: Coupure, 1977.

taneously depend on and take for granted 'within their context', 'without going outside the context', and, again, 'within the context'. There are several reasons why I point to these phrases. One is to point out the paradox of realizing the context dependency of art on one hand, while on the other, take for granted the *location* of that context: the abstract, ahistorical space of modernism. Such space is the 'objective' realm of science culture, and, of course, the language of logical positivism was aptly suited, 'expressive' for the task. I understood the appropriateness of using the language of science to convey a conception of art which attempted to seize some essential character of modernism. Modernism, as I mean it, is the cultural ideology of industrial capitalism. As a process it forms both 'modern' science and 'modern' art. Both are distinctive by their "ahistorical, metaphysical way of viewing human life in the world." The similarities between the detached description which Lukács finds in modern literature, and its counterpart in the methods of modern science, is as Fredric Jameson has pointed out,

a symptom of some deeper underlying mode of apprehension . . . That is, a purely static contemplative way of looking at life and experience which is the equivalent in literature to the attitude of bourgeois objectivity in philosophical thought . . . Thus description begins when external things are felt to be alienated from human activity, come to be viewed as static things-in-themselves; but it is fulfilled when even the human beings who inhabit these lifeless settings become themselves dehumanized, become lifeless tokens, mere objects in motion to be rendered from the outside.[2]

Habermas has discussed how, since the Nineteenth Century,

the theory of knowledge has made way for a theory of science. By theory of science I mean a methodology in which the sciences are scientivistically understood; and by scientivism, I mean science's faith in itself, the conviction that science must no longer be regarded as one form of possible cognition, but that cognition must be identified with science.

Until quite recently 'scientivism' was considered an internal academic matter. Increasingly, however, in advanced industrial countries, the social role of science and technology has become such that it is the 'motor' of economic growth and cultural forces. Accordingly, many things about science have acquired a direct political significance, and, "There are as many political consequences flowing from the scientivistic interpretation of science as from its critique."[3] As Stanley Diamond has noted, "Just as, in the nineteenth century, the social organization and techniques of modern industrial capitalism emerge as a world force, so the idea of inevitable progress in the name of science becomes a fixed ideology. The revolutions having succeeded and then, quite obviously, having failed in their social promise, it appears as if all the frustrated passion was mobilized behind the idea of a regnant science."[4]

Modernism, then, as a consciousness organizing identity of science, projects and fulfills a reality, a belief-system of 'rationality'. "Individuals," Marcuse has written, "are stripped of their individuality, not by external compulsion, but by the very rationality under which they live . . . The point is that today the apparatus to which the individual is to adjust and adapt himself is so rational that protest and liberation appear not only as hopeless but as utterly irrational. The system of life created by modern industry is one of the highest expediency, convenience and efficiency. Reason, once defined in these terms, becomes equivalent to an activity which perpetuates this world. Rational behavior becomes identical with a matter-of-factness which teaches reasonable submissiveness and thus guarantees getting along in the prevailing order."[5] Science, in its 'objectivity', not only maintains that it is describing reality, but that its *methods* are themselves part of that reality described. In this way, the 'objective' methods of science are not seen as made by humans in history—particular humans with motives—but rather, are seen as part of the *mystery* of the still-not-yet-completely-analyzed 'objective' world, *out there*. Thus, in its circularity it defies criticism. Modernism, the cultural counterpart to the philosophic ideology of scientism, depends on a circularity of another sort, but towards the same end: eliminating the human subject from its self conception. Whether a 'value free' science or autonomous art, the goal is power. In seeing our cultural processes as self-regulating and 'natural' as we are taught, we are less inclined to demand some say in making our world. The present crisis in our culture is a result of the acceleration of the process by which it must teach us to identify the 'progress' of science with the needs of capitalism. Its control is increasingly asserted through the process of institutionalization. This assault on our most basic human need for the freedom to make meaning is not an external threat: it is internal, being introduced as part of the cultural process itself. If the threat is to be countered, we must first know what we mean by culture; for our conception of culture, and art as a particular part of it, is itself that discourse which forms it—and connects us to it.

What modernist circularity points to, in art or science, is that, be it within their theoretical interstices or in social fact, it represents a closed system. In this sense, my example of the tautology was quintessentially modern. Indeed, there is a sense in which my comments in this paper can also be seen as 'modern' as well. That is my intention, not that I could avoid it; which brings me to my next point. One initiates change by first clarifying and articulating, that is, raising one's consciousness of the *present* in its particularity as the arena of one's cultural engagement. It is with this understanding that one begins work, and critical work is impossible without it. Work engaged without such a consciousness perpetuates and

reifies both its forms and its meanings. Yet all work initiates from the same present, and to this extent a *complete* break from the modernist bourgeois tradition is impossible.

The frame of discourse is always provided, but not necessarily known. However knowledge, within art, is always contingent on the circle of the activity which is continually describing itself. Artists 'make meaning' to the extent that they can articulate that same context that provides, and limits, meaning. The artist, as situated actor, articulates and makes opaque that 'frame of discourse' in the process of making meaning. But being 'situated' provides the dynamic by which the frame of discourse expands, contracts, shifts. The system is closed, insofar as it is a tautological circularity when seen, and interpreted, as a formalistic static moment. The point I will try to make in this paper is that those 'static' moments in art, be they in the form of art historical 'facts' or quality commodities on the market—or more theoretically understood as the high art of the modernist period—still, nonetheless, can be seen to function as models of art which must be understood if we are to hope for an alternative practice. That static tautological circle seen by scientist modernism when historically and critically engaged is no longer static, but dynamic: the circularity becomes that of a spiral, culturally located, seeing itself as part of the dynamic of an historical understanding which approaches totalization with the same tools which make such totalization impossible. Here lies the understanding which is both its critique and project; the project now for art can be seen as both sides of the hermeneutic circle: demystification and restoration of meaning.

2

Understanding is a basically referential operation; we understand something by comparing it to something we already know. What we understand forms itself into systematic unities, or circles made up of parts. The circle as a whole defines the individual part, and the parts together form the circle. A whole sentence, for instance, is a unity. We understand the meaning of an individual word by seeing it in reference to the whole of the sentence; and reciprocally, the sentence's meaning as a whole is dependent on the meaning of individual words. By extension, an individual concept derives its meaning from a context or horizon within which it stands; yet the horizon is made up of the very elements to which it gives meaning. By dialectical interaction between the whole and part, each gives the other meaning; understanding is circular, then. Because within this 'circle' the meaning comes to stand, we call this the 'hermeneutical circle'.

Richard E. Palmer[6]

The meaning of the whole is a 'sense' derived from the meaning of individual parts. An event or experience can so alter our lives that what

was formerly meaningful becomes meaningless and an apparently unimportant past experience may take on meaning in retrospect. The sense of the whole determines the function and meaning of the parts. And meaning is something historical; it is a relationship of whole to parts seen by us from a given standpoint, at a given time, for a given combination of parts. It is not something above or outside history but a part of a hermeneutical circle always historically defined.

Richard E. Palmer[7]

Hermeneutics and (concrete reflection) are here correlative and reciprocal: on the one hand, self-understanding provided a round-about way of understanding the cultural signs in which the self contemplates himself and forms himself; on the other hand, the understanding of a text is not an end in itself and for itself; it mediates the relation to himself of a subject who, in the short circuit of immediate reflection, would not find the meaning of his own life. Thus it is necessary to say just as strongly that reflection is nothing without mediation by means of signs and cultural works and that explanation is nothing if it is not incorporated, as an intermediary stage, in the process of self-understanding. In short, in hermeneutical reflection—or in reflective hermeneutics—the constitution of self *and that of meaning are contemporaneous.*

David M. Rasmussen[8]

My use of material such as hermeneutics, and indeed all theoretical and philosophical material, is particular: it is *bound* to the practice and process of art and its making. The use of the material is understood as particular and partial. I see the reference to or use of philosophical or theoretical systems—be they arguments in or partial aspects of, as a part of the language which forms the art while it marks the perimeters of the frames of discourse in which its own generation can occur. Such material is a kind of syntax operating on another level; it's a dimension of the contextualized (historical and cultural) location of a (in this case, my) perceiving consciousness. To be sure, it is part of the consciousness-formed-in-ideology. Insofar as I see 'epistemology' as contingent, it has been a 'lens' through which I discuss art; all its discourse comes with the language. Such language would want to say that art is the epistemological tool by which aspects of the human condition usually treated by philosophy are discussed; nonetheless, my point is that such language does not speak for me. Philosophical (theoretical) language is (momentarily) a *parole* within the *langue* of art. Such an understanding, however, tells us at the same moment that the *langue* of art is itself a *parole* within that larger world of significance: the discourse which is both social and historical. The circularity of which one speaks is the circularity of language, a language, culture. Its organized perception of itself orders its own generation within the material and historical aspects of its own location, which in their turn give meaning as they take it. That dynamic, in art, as an 'order' is the

interface where 'form' and 'content' are one; that is to say, its 'structure'. Structure here is seen as not a transcendent ahistorical category, but dynamic and formed from the particularity of its location. Tradition now is the continuity of *methodic* conceptualizations of such structure, which by necessity perpetuates and replicates, over and over again, continuity within the particularity of its explicit expression, while internally the movement of history has forced an implicit understanding of tradition's 'other', its absence. In this way, modernist traditions are historicist and vulnerable to manipulation; all traditions in our era are bound to collapse as formalisms.

Nonetheless, understanding tradition is crucial to understand art. The spiralling circularity of art, then, sees art to be both learning and teaching; it is both *langue* and *parole.* In this sense art, as a language system, art shows by making the *langue* of art momentarily a *parole* within the *langue* of culture both the nature and limitations of knowledge. I say momentarily because the multivalent nature of the structures of which we speak are such that there is no hierarchy of form and meaning, contrary to what science preaches. Thus, the structure of art, and culture, contains its opposite. Structures which posit 'progress' are ideological, are directed. In such a state one is no longer looking at structures, but forms or content; as such, as intent they are self-negations. Such work simultaneously voids the approach to the structure of art as it denies its own intent, for in attempting to be *langue* without *parole* (form) or *parole* without *langue* (content) such work denies both its historicity and its essential materiality. Work which emphasizes *either* is equally conservative: both from the point of view of the activity itself *and* politically (if such a separation were possible). Work which chooses between form or content implicitly and uncritically accepts the existing dominant structure. In thinking that they are only 'teaching' they in fact are only 'learning'. Central to an understanding of art-making as dialectical is that the nature of the practice is such that it demands a questioning of its 'theory', and it does so in the process of its mediation by its social and historical context. It is for this reason that formalist or 'art for art's sake' conceptions of art are one-sided: in omitting from the practice a consciousness of such mediation the 'practice' perpetuates the 'theory' (and vice versa). On the other hand, the attempt to use art to 'speak directly' contains its own paradox; one is always saying *something else,* that else being the prevailing structure of art, uncritically being replicated. In art one must speak in a circular fashion; that is, through the attempt of understanding the language system itself: in the process of that circularity the art process shows and is affected by its collective character, its historicity, its actual location. It is only here, as *parole and langue,* that understanding permits a critical practice.

The negative connotes those historical forces which are incompatible with a certain form of social life and which act upon it destructively: but forces which nonetheless arise inevitably out of the particular social structure which they negate and surpass. Human rationality has a history which consists in the criticism in life and in thought of the constraints imposed by each of its specific historical forms. Hence this understanding of critique implies a particular narrative structure in which the potentialities for development of a given mode of thought or a given social condition are latent within the very structure of the initial terms.

Paul Connerton[9]

In an article called "Why More Philosophy?" Jürgen Habermas notes the end of "great philosophy," which, from its beginnings through to Hegel, was "an interpretive system covering both nature and the human world." Like myth, it intended to "comprehend the cosmos, the totality of all there is." Habermas states four points, which characterize philosophy since, as he puts it, "the death of the last great systematic philosopher of undisputed rank." His first point: "The unity of philosophy and science has since become problematic. Philosophy's claim to be the basis of science had to be renounced in favor of physics as soon as philosophy lost the competence to develop and justify a cosmology on its own, not just in dependence on the research results of natural science." Finally, ". . . in positivism, epistemology resigns itself to becoming a theory of science— in other words, an *ex post facto* reconstruction of the scientific method." His second point: "The unity of philosophy and tradition too has since become problematic. After the deliverance of physics from the philosophy of nature, and after the collapse of metaphysics, theoretical philosophy either regressed to a form of theory of science or turned into a formal science itself. This cut the tie between practical and theoretical philosophy. With the Young Hegelians, with the systematic motivations that were unfolding then in Marxism, existentialism, and historicism, practical philosophy achieved independence . . . It thus became impossible for philosophy to keep serving as a prop for socio-cosmic world images; not until now could it turn into a radical critique." His third point: ". . . but it was only after both the cosmological and the transcendental philosophical basis for a unity of practical and theoretical philosophy were shattered, and after the place of ultimate grounds had been taken by a self-reflection confined to the sphere of the history of the species, that philosophy, significantly turning toward the utopian and the political, came to show an interest in emancipation and reconciliation which until then had been interpreted in a religious sense." And finally, his last point, "Germinating in philosophy from the beginning was the contradiction between the rational claim that cognition is universal and the culture-elitist restriction

of access to philosophizing to a few." Thus, "Without revising the way in which this educated elite understood itself, an institutionally safeguarded diffusion of academic philosophy began at the moment when philosophy had given up its real systematic claim. On that basis its academic type served as a leaven for the formation of bourgeois ideologies. Philosophy achieved an altogether different effectiveness by way of Marx, in the labor movement: there, at last the elitist barriers that had brought philosophy into conflict with itself appeared to fall. This also may have been in Marx's mind when he maintained that if philosophy is to be realized, it must be voided." Habermas continues, "Philosophical thought after Hegel has passed into a new medium. A philosophy that makes us conscious of the four structural changes mentioned above cannot be understood as philosophy any longer: we understand it as critique. Critical of the philosophy of origins, it dispenses with ultimate grounds and with an affirmative exegesis of the whole of things in being. Critical of the traditional definition of the relationship of theory and practice, it is grasped as the reflective element of social activity. Critical of the totality claimed equally for metaphysical cognition and for the religious interpretation of the world, it turns its radical critique of religion into a basis for accepting the emancipatory interest that guides cognition. Critical, finally, of the elitist manner in which traditional philosophy is understood, the new philosophy insists on universal enlightenment including enlightenment about itself."

The rejection of traditional philosophy, and art, is part of the same understanding that critically defines itself and projects a future. As I discussed in Part Two, philosophy (even as myth or ideology) as used in art, is ultimately framed by the discourse of art, rather than by its larger 'philosophical' assumptions. Philosophies of art, posited external to an art practice, approach art with a philosophic ontology. Such an attempt of correlation of one (the art) to the other (the ontology) provides a framework which is already given within the philosophic system. In its concretion it is art, as a practice, that makes meaning; the meaning cannot be externally imposed by an abstract system. Under such circumstances art always appears idealist.

Art is not autonomous, that is, it is not an ahistorical transcendent category. Yet, certainly there is a human activity we call art that can be perceived and conceived of as having its own qualities. Those processes in culture which we give the name art are 'unique' in the sense that they are "distinctive and not replaceable" and have "a particular function which is not interchangeable with other forms." Art can be seen first as a sign and as an experience of the world, a designation which points to the specific unique form that it takes. Art as a locus of activity, is neither

above nor beyond lived experience, nor parasitic to it. It is *part* of it. Because "consciousness is discovered through reflection," art, as an engaged (socially mediated) reflection is embedded *in the world*.

My initial reasons in the sixties for attempting to use language as a model for art (in 'theory' as well as introducing it as a 'formal' material in art practice) stemmed from my understanding of the collapse of the traditional languages of art into that larger, increasingly organized, meaning system which is the modernist culture of late capitalism. Traditional languages of art are controlled zones where specialized, fetishized markets are allowed to follow their own circular paths displaying 'freedom' safely out of the way of those mechanisms of organized meaning—which in varying ways amount to the increased institutionalization of everyday life. Conceptual art, as a critical practice, finds itself *directly* embedded in that realm of organized meaning; but historical understanding means that that work begins to understand itself; it becomes critical of those very processes of organized meaning in the act of self-understanding. It criticizes this system through the act of criticizing itself. The point made in the sixties about "breaking out of the traditional frame of painting and sculpture" and the kind of work necessitated by such a break seeing what art 'means' outside of such a traditional language, provided the possibility of seeing how art acquires meaning. In a sense it momentarily bared the mechanism. This 'success' of conceptual art was in fact its destruction, its self-denial. Its critical cogency gave it authority; and authority, now, only comes in institutional forms. Conceptual art then seemed to take two forms, either it evolved into a stylistic paradigm competitive with, while extending, traditional art, or it withdrew into theory.[10] This paper, then, speaks from my critical, and intimate, relationship with both. The limitation of early conceptual art was that while it was able to 'de-mystify' the traditional language of art, and show its social and cultural (conceptual) context dependency to the extent that it did, the analytic, scientist methodological tools it used were ahistorical and formalistic, its circularity became entropically bogged down in its own institutionalization.

4

It should be clear, therefore, that a critique of the new modernism cannot be an external but only an internal affair, that it is part and parcel of an increasing self-consciousness (in the heightened, dialetical sense we have given to that term), and that it involves a judgement on ourselves fully as much as a judgement on the works of art to which we react. The ambiguity, in other words, is as much in the revolutionary's own position as it is in the art object: insofar as he is himself a product of the society he condemns, his revolutionary attitude is bound to presuppose a nega-

tion of himself, an initial subjective dissociation that has to precede the objective, political one.

Fredric Jameson[11]

Unless the anthropologist confronts his own alienation, which is only a special instance of a general condition, and seeks to understand its roots, and subsequently matures as a relentless critic of his own civilization, the very civilization which objectifies man, he cannot understand or even recognize himself in the other or the other in himself.

Stanley Diamond[12]

Without an analytic knowledge of cultural determinants we would never know our specific limitations, but without a dialectical transparency we could never emancipate ourselves from them. In sum, the effective possibility of an emancipatory anthropology depends on a conscious knowledge of infrastructural determinants and on the complementary theses that self-awareness creates the possibility of a 'modifiable preordained destiny'.

Bob Scholte[13]

A radical conceptual art, as critical practice, would need to realize a program *from* its understanding of the meaning of our meaning systems. The 'demystification' of early conceptualism collapsed into style because of the naivete of its scientistic, *instrumental* tools. Located in the trajectory of an architectonic model, it couldn't *see itself;* it internalized its belief in the 'progress' of science and modernism. Lacking self-reflexivity, it took the ethno-logic of western civilization as being one and the same as the abstract non-location of modernist culture. Thus, it saw itself as natural and inevitable, rather than as an historical moment in human consciousness.

For these reasons, 'consciousness' in the function of self-reflexivity should be operating within the elements of the work (proposition) of art itself. In this way the *subject* of the maker is present and 'humanifies' the work. The proposal is for work which understands itself as a context which mediates (as it is mediated by and is part of) the social context. The purpose of this is to eliminate the duality of subject and object which permeates the 'objectivity' of bourgeois thought. Our work must bring together, then, the work and its maker in the process of locating both in society and history. The contextual or situational 'screen' of that location forms art, artist, and the relationship between them. Indeed, it is this relationship which gives art-making, still, an aspect to it which seems to make it one of the least alienated activities in our time. As culture-making (or consciousness formation) the process of art-making, as a mechanism, brings together subject and object. In this sense, art-making uses our cultural thought processes to *make from* that very reality which includes it. (The point is this: to the extent that we can 'see art' we can 'see culture'

and project a future; the 'other' is us, what must be negated.) In proposing in this section, as I am, a *particular* direction for art, I do so to show by extended example how *such* a particular, in fact, instantiates the *general* point of this paper. In one way, the tautological model of art, as a form and conception, is a closed object which fragments and separates us. We see that art, as a form of consciousness, must include us within it, if we ever hope for meaning to be restored, or control over those forces which shape our lives. In another way, thought within culture can be seen as a tautology: ". . . at its extreme limit thought tends somehow to unravel itself, and it is this more than anything else that justifies the description of dialectical thought as tautological—tautological in the ontological sense, as part of a dawning realization of the profound tautology of all thought. What is meant goes deeper than mere logical tautology, even though the basic temporal form is the same: there, where a proposition had seemed to link two separate, independent entities, they suddenly turn out to have been the same thing all along. . . ." (Jameson)[14]

For work to reflect the hermeneutic tension of "demystification and restoration of meaning" it begins with the present. The understanding which forms itself as a production of consciousness is "an historical act, and as such is always connected to the present." Art, as such an understanding, "articulates the model of art, the purpose of which is to understand culture by making its implicit nature explicit—internalize its 'explicitness' (making it, again, implicit) and so on. Yet this is not simply circular because the agents are continually interacting and socio-historically located. It is a non-static, in-the-world model. . . ."[15] What I am suggesting is that within art, as explained, is an activity which is a critical demystifying tool, it is the formed understanding which is itself part of modernism and at the same time it is the alternative, the 'other' which is *implicit* in modernism. The development of a critical practice from, and with, art is the rise of a practice whose 'material' is itself the language or meaning systems of modernist bourgeois culture. Such a practice can have no "special" form of its own, for its language is the very understanding *itself* of the culture, when that understanding seizes its inherently human engaged character. This practice is what I have referred to elsewhere as the work of the 'artist as anthropologist'.[16]

Art has 'interpreted' modernism, which in its turn has 'interpreted' art, and so on. Something is learnt (as well as taught) throughout the circle. In understanding the particularity of art, and seeing the particularity embedded within the generality of modernism one learns something simultaneously about the 'generality' of art, and the (ideological) particularity of modernism. Thus in being known *as itself*, modernism is made visible and accountable; no longer the transparent field of consciousness seen as 'natural', it can be seen as humanly made, and directed. Those

polarities of the circle "demystification and restoration of meaning" can be seen as joined by the will toward emancipation. Indeed, the struggle for emancipation inherent in the work of demystification has within it an initial restoration of meaning so absent in alienated work. Beyond that, 'restored meaning' cannot be described or projected, for its actualization speaks of a consciousness concretized within real social, cultural space.

That could have ended this text. It is, in fact, the point at which texts like this one usually end. As an article, as a lecture, this text seems to take itself for granted. It contains the word art or artist 122 times, makes reference to meaning 51 times, mentions culture 41 times, points to modernism 27 times, talks about language 26 times, includes the word context 12 times, and so on. The audience it presupposes is intended to know something about the philosophy of science; appreciate the implications of encroaching institutionalization; assume with the author that 'bourgeois' means bad, know why, and share his goal for an alternative; first understand and then apply the concept of hermeneutics to art; know the distinction between *parole* and *langue*, form and content, explicit expression and implicit understanding; and follow a somewhat mangled presentation of Habermas' concept of recent philosophical history and glean its relevance to this context. But, indeed, what *is* this context that we are within?

This text wants to talk about other possibilities, 'alternatives' seizable from the present. To talk about these things, in order to grasp them, this text has to explain and define; but the nature of such a discourse is that its 'explanations and definitions' seem to be knowable only from *within*. To the extent that what was said was meaningful, it was authoritative. One's acceptance of such 'authority' seems to emanate from one's comprehension of the text as a system which speaks of other larger systems (of which then that 'whole' becomes a part). This text as a form contradicts me. The contradiction is between what is wanting to be said and the authority of known forms through which it must speak. Is there a sense in which we could say that because of the instrumental character of modernist culture, all 'perceived forms' are inherently conservative? Forms are forms as parts of systems. The system is itself a form and thus recognizable—one's associations of it with *prevailing* social reality. It is here where one begins to talk of the institutionalization of culture; 'understanding' becomes technological—a pragmatized recognition of bureaucratic-like power relations. The elimination of the human subject from its systems has given modern science and art the freedom of 'self-generation': it can project its own reality because the space it occupies is not that of lived human experience, but an abstract space of its own making. No longer encumbered by being connected to the human scale of concrete reality, modernist culture has the authority to generate not only the forms,

but their apparent necessity. Rather than being in ecological harmony with the natural world, we are propelled in disequilibrium toward a world where culture is the only space left. So the freedom of the self-perceiving subject in the world becomes the freedom of the madman; 'meaning' becomes identified *as* the syntactic structure of the cultural reality.

The history of modern culture is the history of the domination of nature; the mechanism now seems bent on 'eliminating' nature altogether. Those crystalline forms designed to only speak of themselves at their root deny as they fear an unknowable 'nature'. Humanity, with its connections to the natural world increasingly severed, loses sight of itself as it loses sight of its 'other'. We cannot be critical of what we cannot see; our description here is of a blind self-replicating mechanism without either conscience or direction. This modern technological culture—in the hands of American and multi-national corporations or Soviet-style state capitalist bureaucracies—tend to consume and transform authentic cultural forms felt as 'local' and humanly real. The actual space of one's life is no longer consequential; the 'real world' becomes the picture of the world which the media projects. It is 'international' and occupies no real space other than that of the bureaucratic culture of power relations. The political implications of the world now being made are enormous; my struggle within culture is political, certainly, but for us to be effective it must be more than that: our very conceptions of both culture and politics, as part of a discourse which trivializes both, must be critically understood *as* they are re-made for human use. All of the revolutions in the name of politics in the past two hundred years failed to spare us from what we now must face. Nothing can be as apolitical as looking for politics where it consciously presents itself; nothing as empty of genuine culture as a *political* ideology which is only that.

Can we speak of such things in this context, and do they affect this discourse? I have said that this text as a form contradicts me. As an artist I have found that all the forms I use contradict me; 'seeing/understanding' art has in some part consisted of the tension between my meaning/use of forms and their *given* social and cultural meaning/use. Can one attempt to 'see art' and void formalist entrapment? The question is crucial, the answer would be banal. At this end of culture, in this context, freedom is still felt; a brief against the politics of formalism undeniably seems absurd. But it is precisely because of such freedom that we *can* still see. This is the lacuna between high art and mass culture. We are in the midst of an oasis in an expanding desert. Modern science and art have created "forms with a life of their own"; that recurrent nightmare of science fiction where machines take over the world is a leitmotif of dread, an understanding that what modern technology at present is doing to our physical world, it is simultaneously doing to our 'spiritual', cultural world as well. Our

difficulty in seeing it isn't simply because we can't see ourselves, it is because culture is that very mechanism through which we see.

Finally then, beyond (or more accurately *before*) this writer's goal of a critical practice, and the role of demystification and restoration of meaning, and all the human motives behind those things said: this form, this context *speaks*. What we make of what is said is our choice. If its limitations and contradictions can become a syntactic self-reflexivity which emerges as part of the dialogue, it will be through our collective and individual resistance to that process which makes our hopes and desires identical with those didactic forms foisted as mere instrumentalities toward an 'inevitable' future. Where is our work? Wherever we find ourselves. Meaning is made *by* humans, *for* humans, and it is this 'making of meaning' which connects us in a real way to each other and to the world. Only the formalists of the left or right sanctify some forms and banish others; thus we have the aesthetics of bureaucratic culture posing as the ethical might of false traditions. Formalism as an ideology has taught us to locate 'meaning' in its *form*; for forms can be controlled and inventoried, bought and sold. Because of the need for control, the power of 'making meaning' is left to professionals who can be made accountable. But 'making meaning', that is, culture, is not the collected sum of numerous fragmented forms, but the process through which they come into being. Everyone's work is part of that process; indeed, in a large part it defines what we mean by human. My point here has been simple, perhaps deceptively so: through seeing our art we can see our culture; those who have no say in their culture, have no say in their future. It is through making the effort to *see* that our 'frame of discourse' is *itself* made visible, *as* it limits and defines the visible. Our frame of discourse is with us; we make it as we try to leave it. When we pretend to have left it, we speak in ignorance *as* it speaks through us. It is in seeing it that we confront it, in terms which force its alteration. It is such 'alterations' which, within an engaged understanding such as art, suggest a critical and emancipatory enterprise.

Notes

1. Karl Marx, quoted in Fredric Jameson, *Marxism and Form* (Princeton: Princeton University Press, 1971), p. 116.

2. Ibid., pp. 200–202.

3. Jürgen Habermas, "Why More Philosophy?" in *Social Research* 38, no. 4 (Winter 1971), pp. 650–651.

4. Stanley Diamond, "Anthropology in Question," in *Reinventing Anthropology* (New York: Random House, 1969), p. 410.

5. Herbert Marcuse, quoted in William Leiss, *The Domination of Nature* (New York: George Braziller, 1972), pp. 202–203.

6. Richard E. Palmer, *Hermeneutics* (Evanston: Northwestern University Press, 1969), p. 87.

7. Ibid., p. 118.

8. David M. Rasmussen, *Mythic-Symbolic Language and Philosophical Anthropology* (The Hague: Martinus Nijhoff, 1971), p. 145.

9. Paul Connerton, "Introduction," in *Critical Sociology* (New York: Penguin, 1976), p. 19.

10. See my comments on Art & Language in "1975" [reprinted in this collection, pp. 129–143] and "Work" [pp. 145–151].

11. Jameson, p. 414.

12. Diamond, p. 402.

13. Bob Scholte, "Discontents in Anthropology," in *Social Research* 38, no. 4 (Winter 1971), p. 806.

14. Jameson, p. 341.

15. Joseph Kosuth, "The Artist as Anthropologist" [reprinted in this collection, p. 124].

16. Joseph Kosuth, "The Artist as Anthropologist," "1975," and "Work."

COMMENTS ON THE SECOND FRAME

I do not believe we can go on posing a change of institutions and a change of attitudes as alternatives. From each polarity follows a rigid programme: in the first case, destruction and then innovation of institutions, imagined at some finite point in time; in the second case, a rejection of politics and social activity, with criticism becoming an activity in itself only by an acceptance, however sullen, of all other existing social habits and structures. Each position shares a negative character: an intransigent group against the whole social structure; an intransigent group against the whole intellectual structure. As such, each corresponds to the positive needs of many intellectuals in our society; each attitude, I may say, forms almost every day in my own mind. Basically, they are the last, and of course serious, positions of our pre-democratic politics; change, there, is essentially against others; to change with others is seen as compromise. Each group, similarly, accepts the liberal separation between individuals and societies, and the related separation between cultural content and cultural institutions; the divergence comes only when one or other separate entity is seen as decisive.

. . . The individuals and the institutions will have, essentially, to change together, or they will not change at all. And my reason for going on working on these lines is that I know, from observing myself and others in very different institutions, that this is a continuing process, in which the moments of choice and of direction are often subtle and delicate, though the commitments they lead to are often profound. What I have tried to envisage is a radical change which yet includes a human continuity, and I believe the pressure for this, in our actual society, is the most intense and valuable pressure we have. The job of any of us working in this field is articulation, for it is when it is articulate that the pressure becomes a discipline and a programme.

Raymond Williams

First published in *Was Erwartest Du . . .?* ed. Christine Bernhardt (Cologne: Galerie Paul Maenz, 1977).

The problem of showing in galleries is more than simply 'a problem', it is unavoidably part of the *material* of present work. Institutional forms, such as galleries, museums or magazines, frame and give meaning to work. The critical and theoretical point made in the late sixties about "breaking out of the traditional frame of painting and sculpture" and the kind of work necessitated by such a break; seeing what art 'means' outside of such a tradition, provided the possibility of seeing how art acquires meaning. In a sense it momentarily bared the mechanism. Momentarily, that is, before it acquired the kinds of institutional authority which precedes as well as describes 'cultural power' in art. The conservative character of the present system is made clear when one sees the 'history' of one's activity become the collection of its arrested forms. With the value transferred from the arena of human action toward consciousness to, instead, a chronology of rapidly inflated 'monuments' which while intended as a 'celebration' function as barricades. Breaking out of the first frame (painting and sculpture) for some provided a cleared arena in which to construct new (and thus 'real' for the moment) work, but the modernist tradition has its own dynamic, if not ethic, and while one's activity may begin in the real world, it ends in the institutional world of 'style'. When your activity is perceived as a style, it has been alienated from reality. It is what is 'real' about one's activity that attracts, but in the present crisis of meaning (without the concrete base a community provides) the *conventions* of 'tradition' must be reformed. But art-making is a process, an on-going dynamic, not the static sum of its residue. It is more the work of the coming to consciousness which 'breaks' a frame, than in the newsworthiness of a frame being broken. For those of us who see art as making meaning, cultural structures and social contexts in their historical embeddedness now are unavoidably as much the material of our work as was language, in a sense, some ten years ago, a theoretical and practical 'passage' out of the institution of painting and sculpture.

To "see art as making meaning" means of course that one cannot allow one's art to be passively defined by whatever uncritical frame a context provides. The point isn't "to show or not to show," but to show with intent, critical and precise. Or, as the case may be, to *not* show with intent, both critical and precise, if the strategic vectors of one's work demands it. (Of one's *work*, not posture—though I think the reasons would be specific, not general).[1] The point is that unless one's work *organizes* the cultural context and its social use, *meanings will be provided.* One thing is to be sure: conventions cluster about art done for *any* social use. Collective work, collaborative work, and individual work all have their heuristic points and all are limited by the conventions which surround their historical use. The idealist philosophical scaffolding upon which most 'fine' art practice relies has necessitated and maintained that art

must be *profound* and transcend the particular; writ large, it must be all art for all time. While such generalized art pretends to a kind of 'classicism', it is compelled to internalize all the conventions of its history and the social order which organizes that history. And even if such work is not framed by the institutions and conventions of painting and sculpture, it will be by the gallery or museum, or ultimately by the 'art community' in the media. It cannot escape meaning if it is to be known. The struggle with 'meaning contexts', whether they take the form of institutional and traditional frames *within* the 'fine' art world, or utility (advertising propaganda, or amusement) *outside,* force the artist to make work which is particular as well as partial. It must be particular to the situation (to take the responsibility of asserting its own meaning) and partial because, whatever the work, it is a form of communication, and as such it has by necessity to convey information through the use ('misuse', alteration, extension, expansion, deconstruction, etc.) of the rules and models of that particular situation. The task is to 'use' those 'rules and models' in a conscious, critical way. In this way the concrete and historically real 'moment' becomes part of one's work.

Armed revolution can also be seen as a kind of cultural act, one that every governmental entity on this earth has abundantly prepared itself against. At some levels of 'development' such revolutions initiate a necessary, however temporary, change. Historically, however, the change initiated has been one of bureaucratic form; liberation having been felt only during the transient period of 'anarchy' before the emergence of new masters. Armed revolution, when viewed as a cultural act, is seen as a period piece: a conception of change and society which provides no change and a similar society. The forms for actual change in our society are yet to be created, though created they must be, for effective forms for change will be tooled from the actual conditions and historical location of our cultural space and consciousness. It is in this sense that 'the next revolution', to be truly emancipatory, must be effectively cultural. If our hope is to change society, we can only do so in ways the present order cannot control by force. The work of understanding, theoretically and practically, the processes and mechanism of culture, while part of the meaning structure of *this* society (because it's *our* consciousness), has potentially a larger utility of revolutionary intent: the ability to create consciousness is an integral part of the actual ability to create the social world. To be sure, this point is not lost on the present order either. But since *apparent* freedom (rather than actual freedom) is the super-ego of bourgeois institutions, the present ordering of consciousness has within it the potential space for more than only an 'intervention' but rather the possibility of a continuing activism at the base points of cultural growth. Such an activism would be based on a dynamic perhaps specific to humans. Beyond

simple survival is an on-going human process of creativity which produces consciousness as it changes the material world. And while techniques are rapidly being developed which allow more and more manipulation and control, the complexity and power of that 'creative process' is such that the world is still available to be made by all of those that inhabit it. I think that there is a specific and important role for artists as part of that process. The present zone of tactical warfare is culture.

A characteristic of *cultural* revolution is that it is a process (and one of struggle) at the level of growth and direction, value and meaning. Such cultural change occurs collectively, not individualistically; but individual work provides that collectivity with the clarity of specific and concrete human experience in the form of both material and 'intellectual' production, which is shared and collectively experienced, and individually felt as real. By calling it a 'revolution' one means a radical change, both in the quality and meaning of life, and in our concept of 'change' itself.

The way out of the isolation and alienation of specialization which plagues art, along with all the other forms of productive life, begins for artists with their taking responsibility for the kinds of meaning which accrue to their work (or, the absence of any meaning) and seeing what the effective implications of such meanings are within that larger constellation of organized experience we call culture. In other words, it takes more than feet to dance. Work which perpetuates the conventions of its making (and thereby its meaning) is engaged as much in a political act as it is a cultural one. Taking responsibility for one's work is part of the process of the development (or reclamation) of the human-based community which is inherent, if latent, in the mechanism and process of culture.[2] Seeing art as a specialized task, as we have been taught to, is dependent on our acceptance of authority in the guise of traditions and conventions long since emptied of everything but their form. Such traditional frames of art—and one thinks easily of present-day quality commodities such as paintings—are a layer of mystification which stands between you and those institutional frames which define art (and culture) for *all* of us regardless of our work. It seems necessary now to develop a positive negative relationship to institutional structures by initiating cultural activity ("art" in some contexts) which makes opaque the transparent institutional frame. Call this work the breaking of the second frame.

Notes

1. The substitution of a 'hard' political line for 'art theory' (much less a cultural theory) within a 'soft' art practice, proved to have disastrous results for some former associates

of mine.* To the extent that the group continues at all, it does so now only as a provincial self-pleading ideology. One is reminded of Sartre's comment, "Valéry is a petit bourgeois intellectual, no doubt about it. But not every petit bourgeois intellectual is Valéry. The heuristic inadequacy of contemporary Marxism is contained in these two sentences."

2. I think some comment should be made concerning those artists also represented by Paul Maenz† that have not been asked to contribute (or worse, on their part refused to): if these issues are relevant at all they are relevant to everybody, and it won't do to isolate those artists that have bothered to consider the problematic aspects of their roles as artists as 'specialists' or stylists of 'political art'. In a real way these issues are more relevant to those not participating than those that are. I understand PM's desire to respect equally the relationship he has with *all* the artists in his gallery, but there's a funny thing about politics, 'neutrality' is elusive, and there is a political responsibility for everyone engaged in 'cultural work'. If one sees one's work as 'creative' then it has both political responsibility and content. I don't think PM can be excluded from this.

*Kosuth refers here to the regrouped, smaller Art & Language that followed the demise of the original group.
†Paul Maenz had previously asked the artists represented by his gallery to respond to a questionnaire about art and politics, and the future role of the gallery. Kosuth refers to those artists who, although invited, did not participate. Artists who did participate were: Terry Atkinson, Michael Baldwin, Daniel Buren, Victor Burgin, Hans Haacke, Mel Ramsden.

A LONG NIGHT AT THE MOVIES

Perhaps part of going to "far away exotic places" is the instant evaporation of one's conception of a place like China. All the impressions—fictional, news accounts, history lessons, fashion and food—go together to make up what one assumes to be China; one knows nothing else, that must be China. It's *not* China, of course, much less The People's Republic of China. All one has experienced is this culture's conception of China. Visiting The People's Republic is as much about coming to feel the texture of one's own culture as it is about looking at modern day China.

I say "looking at" and not "seeing," because for us it was virtually impossible to "see" China. In nearly three weeks of being corralled into a temporary transient community as an over-fed, protected and pampered tourist, one experienced not the daily life that the Chinese people experience, but frames, lenses, screens. Whether it is the projected screen of one's taught assumptions, or all those lenses through which tourists seem duty-bound to look, or that frame provided by the warmth, humor and unswerving dedication of our guides, one comes away from The People's Republic of China with a cinematic memory. Our trip was a narrative, and it was written by the Communist Party of The People's Republic.

Usually, in other far away exotic places, I have found that one is forced to experience, at least in some measure, the texture of people's lives through the normal attempts to get through one's day. Simply trying to order food in a restaurant, asking directions to an historic site or attempting to get a shoe repaired, one begins to create a sense of the "real world." But for us, our isolation and organization as a group forced us to experience

From *Art in America* 67, no. 2 (March–April 1979), pp. 21–22.

China as an audience experiences a film. That texture of daily life was there to be gazed at passively, not to be entered.

The media romance which surrounds China in the West, particularly among the left, was certainly part of the baggage I carried with me to The People's Republic. That baggage was radically replaced, but without my ever getting to "know" China. It was replaced by a concrete experience: the known quality of a particular *lack*; I was forced to confront through my ignorance and exclusion the space I did occupy: the *other* side of the lens, the frame, the screen of ideology. The confrontation with the opacity of "their" ideology made visible to me the ideological character of the tools, always thought by us to be neutral, through which ideology becomes visible to us. The view through the lens didn't show us China; what we saw was our own reflection. The space that separated me from the Chinese people is precisely that space which will comprise the battleground of political struggle in the future. The space I'm discussing is, of course, the cultural, an ideological space of subjectivity. It is in this space that the emerging global culture, in which all the major industrial powers have a role (and have convinced themselves they have a stake), constitutes the greatest threat to human liberation and survival. This international cultural process is bureaucratization, which is replacing cultures felt as authentic and locally real with a social circuitry more politically and economically "efficient."

What did I learn from this trip? Certainly an admiration for the Chinese people, and their ability, as a people, to change their world. The obvious success of the Chinese Revolution is that today the Chinese people have a guaranteed life: food, shelter, clothing, medical attention, education. But this *economic* success, evolved from past actions, does not describe that space which connects their world with ours in the present: that global space of international culture discussed above. One of the most disturbing things I learned on this trip was the absolute lack of consciousness of— let alone a critical relationship toward—the cultural problems of advanced industrialization in a country which will have a large role in shaping the future.

As for the China that we met, I feel it was a projection of an abstract and idealized China which showed us the Party/State's line on its own identity. This product of bureaucratic theater was not concerned with *us*, as artists, as students of politics, as particular kinds of Americans, or just as people. We were a *group*, an instrumentality within the circuitry of foreign relations and trade. The dehumanizing and abstracting quality of bureaucratic culture which we are all increasingly subjected to cannot deal with the subjectivity of particular individuals, but can only see and speak to *like kinds*—other bureaucracies, other forms of authority. Our scientistic, technological culture has taught us the efficiency of speciali-

zations and instrumental formalisms. Bureaucratic structures, as social entities, are an intertwined mesh of opportunism and compromise. They see the world as a network of power relations. The resulting culture replaces the concrete space oriented to the scale of an individual's life and human need with a strategic, mathematical description of the network of social and economic power—a social space determined by the cultural fiction of alienated global politics.

The ruling bureaucracies of *all* countries are collaborating culturally even as they play the combative game of competitive power politics. We have been taught to look for the *differences* between political and economic systems to see where our future might lie, but it is here where people are being politically disenfranchised, for it is precisely within the implicit *agreements* on our "inevitable" future that our *present* is being made—without our say. It is within this *cultural* space, and not the outdated polarities of "left" and "right," where a mobilization for survival must begin. There is certainly no greater political disenfranchisement than the irresponsible exploitation of the earth's resources in the name of "progress." The encroaching bureaucratization of culture is the marriage of left and right sight unseen. What has emerged is a global two-party system, and as Americans we know too well how empty that is of real political choice.

The increasing growth of bureaucratic culture—whether through multinational corporations or state socialism—tends to decrease the growth of a cultural space we, perhaps sentimentally, call "free." Culture is, of course, that process of making meaning (and consciousness) within relationships—relationships with objects, other people, larger social groups, activities, the natural world, and so on. Consciousness assumes subjectivity; freedom, even happiness, demands a meaningful sense of a shared subjectivity with others. The bureaucratization of culture is a subtle violence: one's subjective space is made politically or economically instrumental, without recognition of its self-contained value. The political nature of culture cannot be understood without an understanding of how denied subjectivity is experienced: it is helplessness, powerlessness, loss of self. It is the awake experience of the denial of all those things which define consciousness for the conscious: for all those with hopes and desires toward a future they make from the meaning the present gives them.

TEXT/CONTEXT: SEVEN REMARKS FOR YOU TO CONSIDER WHILE VIEWING/READING THIS EXHIBITION

1. Text/Context: It is the intention of this work to further make/show the nature of the activity ('making meaning') to be a contingent, contextual aspect of cultural processes (with art being a concrete instance). The work for this exhibition consists of three parts: the first, 'external', consists of billboards placed in a public space, usually reserved for advertising; the second being within the specialized context of the gallery. The materiality of ideology (as language, as art) can be seen to be concretized as specific instrumental forms *as* the subject is located in relation to a discourse which is simultaneously fixed and contingent. The suggestion of a subject behind the billboard (through the use of signifiers that depend on context) strains that 'natural horizon' which the authority (institutional or corporate) of public discourse constructs and maintains. The discourse *assumes* a certain subject as the support for the production of particular 'fixed' meanings. The problematicity of a 'subject behind the billboard' is that the ideological texture of the discourse is made visible: the reader, as subject, is assumed to be 'constructed' in relation to that discourse. What is presupposed is a subject which not only precedes the specific reader as a subject, but is assumed and experienced by the reader as consistent and (more) intelligible. The question of what it 'means' is made critical by the tension between the assumed meaning projected by the subject behind the text, and the habituated and institutional meaning that the authority of the billboard as a media projects. But this tension makes visible the material of the cultural form (as language, as ideology)

First published as a flyer printed in conjunction with the exhibition *Text/Context* (New York: Leo Castelli Gallery, May–June 1979).

while it ruptures the 'natural' landscape of similar signs. The third stage of the work is also concerned with meaning generating within the art context. This work consists of 'Fragments'. The meaning of the fragment, like the text it is a fragment of, is contingent and partial. The 'whole text' is on the street for a short time, usually a month. Memories, and photographs, of course remain. The apparently meaningless fragments (the only way this work can be owned privately) receive their meaning from the art market through their connections to social and cultural contexts which are external to the fragment. The individualized fragmentation is an attempt to recognize the eclipse of one assumed context of meaning; this deliberate 'erasure' is but another face of an act which includes the re-location (or attempted re-assertion) of the market-given meaning. The relation of part to whole is a device, in this case, which describes both the internal and external organization.

2. As a model conceptual art has been replete with oppositions. The rubric 'Texts as Artworks': apparently arbitrary fragments of texts, useless (dead?) displayed in galleries, museums, on living room walls—that is, functioning in hot spots reserved for the high entertainment of rich experiential enlightenment—and failing, implying that it must be there for another reason, it must 'mean' something else; yet all the while *connecting*, being able to be *read*. Using the social connective of a common language, yet speaking about *something else*. Traditional art makes us a passive spectator, the authority of the frame of tradition demands that kind of relationship. We are always in an audience, always outside looking in. By using the 'common language', but in a way which was neither narrative or instrumental (one couldn't see past the language, it wasn't transparent or 'natural') I intended to reverse the process, put us all inside looking out. By connecting all the 'viewers' by the language several things occurred. For one, the mystified experience of aesthetic contemplation was ruptured. Texts are human marks, language is daily, banal; no magical worlds to enter, no theatrical suspension. The individualizing profundity of contemplation was denied. Such texts, as art, initially demystify themselves: they reorganize the nature of the relationship between the 'viewer' and the work. Rather than isolating the viewer as an individual faced with an enigma ('abstract' art) or projecting him/her into another, fictional space ('realism') such work connects the viewer/reader on the level of culture through the language of the text *while* denying the viewer/reader the habituated narrative or pragmatic/instrumental role and meaning for the text. Once connected with the text, the viewer, as reader, is active and part of the meaning-making process. By being inside looking out, the viewer/reader looks for meaning *within relationships,* relationships established within and between social and historical contexts.

3. A desire to deny the mystified transcendental nature of art is an expression of the will to grasp the present concrete reality and re-make the world; in seeing art as 'concrete' and formed materials (painting, sculpture) we were uncritically accepting the transcendental abstraction 'art'. Conversely, in attempting to 'see' and critically grasp that larger ('abstract') context of art (within culture and society) we force a real relationship with the genuinely concrete: the meaning of art as embedded within our history and our culture. Thus the demystification of the forms and materials of art provide for a genuinely human relationship with them.

4. (Idealism:) Modernism, its inherently self-referential dynamic 'sees' only the forms of its own making: it can only exist as a self-conceived formalism.

5. (Idealism:) Realism, instrumental art (advertising, 'Political' art), the need to instrumentalize its own materiality (transparently constructing a fictional space or point beyond itself toward external objectives) means it can't take its own (social, cultural, political) location into account *as a material part of this world*. As a practice such work denies the philosophical implications and political character of culture; it assumes a separation between form and content, theory and practice. Work which presupposes the possibility of political content within a 'given' cultural form is taking an idealist position; the implication is that politics is located as content, and forms are neutral, perhaps transcendental. Philosophically, as a politics of culture, they are agreeing with the formalists: the actual practice of art is apolitical, it only waits for the artist to become 'politicized'.

6. There is an 'art discourse' and there is another discourse which we can problematically call 'mass culture'. The first is specialized, limited, elitist. Since the first is a kind of reserve zone of 'freedom', within which meaning-making is to occur, it maintains a certain autonomy. The second 'discourse', although related, is significantly different from the first because it is, increasingly, the cultural discourse in which people's lives are embedded for meaning. If one thinks of culture as a kind of connecting public space (once, community space) which gives forms and projectivity to individual personal hopes and desires, an anticipation of a life which shapes that life, then one sees traditional culture as giving meaning to the social and material world of a people. In industrial societies mass culture has eclipsed that social space and internalized certain values within the cultural process itself. Those that attempt to engage in a cultural practice without an understanding of how that cultural process effects and is effected by their activity are simply blinding themselves to the very mechanisms they must change if change is ever to occur.

7. Precisely because of the supposed 'autonomy' of art, modernism pro-
vides a context in which meaning-making mechanisms of the cultural
dynamic reveal themselves: not as sociological revelation, but rather, due
to the particular quality of art, as a moment in practice. It is from this
space within practice that one can begin to seize an understanding and
develop the tools for change. The political aspect of cultural practice or
processes themselves must be made clear; that culture, because it is the
production of consciousness on an inter-subjective, community scale is
already inherently 'political'—because everyone 'makes culture'. Our role,
as artists, is the development of specialized tools for understanding those
very mechanisms of culture. (The problems start with fetishization of
these categories of 'culture', 'politics' and so on. They aren't different
things, but different faces of the same thing.) But to say art is simply
'specialized tools of understanding' is already making it too passive, too
academic. Art is a practice, and insofar as it makes consciousness, it
participates in making the world. It is for this reason that the politics
have to be critically seen as *within* the making process, a process which
begins here, in our social, cultural and historical location.

1979

Painting is finished . . .
Donald Judd (quoted by Dan Flavin, *Artforum*, Dec. 1965)

'Aural' art, as Walter Benjamin has pointed out, historically originated in a ritual use—first magical; then religious. And art based on aura has continued to depend on, if not the ritualized space of the museum, then the ritualizing of a tradition. Benjamin defines aura as a "unique phenomenon of a distance however close it may be," and certainly that belief in painting we have learned—whereby the paint on the canvas is somehow magically *different* than the paint on the wall next to it—is precisely that effect which the cult value of painting trades. Benjamin continues, "The essentially distant object is the unapproachable one. Unapproachability is indeed a major quality of the cult image. True to its nature, it remains 'distant, however close it may be'. The closeness which one may gain from is subject matter does not impair the distance which it retains in its appearance." It is approaching a half-century since Benjamin wrote these words in "The Work of Art in the Age of Mechanical Reproduction," and it should be an obvious point that the media-world which has evolved since the invention of photography goes well beyond Benjamin's insights, written as they were in the thirties. It would seem the Frankfurt School's (prophetic?) dread of the 'total system' (". . . the increasingly closed organization of the world into a seamless web of media technology, multinational corporations, and international bureaucratic control . . .") is a more

First published in *Symposium über Fotografie* [ex. cat.] (Graz: Akademische Druck-u. Verlagsanstatt, 1979), pp. 37–44.

accurately sober assessment of the present cultural terrain. Yet, Benjamin's concept of aura is useful, in fact, because of the effect these cultural changes have had on recent art practice. That conflict between mass culture and an 'elite' modernism which Benjamin attempted to address, continues no less abated, and that activity we could once call 'avant-garde' might deserve reconsideration—locating itself now, as it does, *between* the two.

To consider the art historical context within which modernism evolved one must trace, if briefly, the origins of painting's increasingly isolated social situation. The decline of the church as the center of cultural and social life eroded painting's popular base, necessitating that shift which ultimately ended with indirect social support as institutionalized modernism in the museums. The period which saw the beginning of radical changes in painting—as it moved into the private sphere—also signals the period of the technological successes of science, and the eclipse of religion by science as the dominant epistemology. While we can speak of these shifts in either long term or relatively specific chronological terms, there is no doubt that the developments of Nineteenth Century technology including photography play a crucial role in this shift. That celebrated marriage of science and art, photography, seemed at the time to join together how we look at the world, art, with how we were coming to know it, science.

The conflicts (and mutual influence) between painting and photography in fact registered the beginning of a struggle between the two which would shape them both. As well, it began the process of the demise of the dominant art of the time, painting, and the cultural belief system of the world which accompanied it. The cultural epistemic shift of which photography was a part, initiated not just the forms of mass culture, but altered the conceptual space of 'advanced' art as well. One understanding of the avant-garde (tracing the history of modernism parallel with the invention of photography) could see the formal investigations and transformations of modern painting as a working out (if not the 'running out') of the very belief system of painting itself.

With painting, each mark presents itself as an opinion. Because one assumes each gesture has behind it a human subject with intention, it presumes a signification. Those marks which collectively make a painting, construct for the habituated viewer a believable fiction; a fiction which becomes its own self-justification. Not unlike a language appears to a non-speaker, it is inaccessible but has the authority (as a kind of cultural 'logic') of *a* language. We know (because of the 'speaking subject') that *something* is apparently being said: in the case of the painting, that meaning we give it now, is so, for the most part, external to the painting itself. That is, it can signify only through its positionality in relation to a

particular art historical discourse. Thus, while it presumes an interiority (personal, subjective) its capacity to 'make meaning' is linked to an exterior and virtually *prior* discourse (*Art* history). The autonomous private language of painting forces its own isolation. Outside of an art critical-historical/market complex it would collapse, failing as it does to generate much meaning of its own. Its only other function being that of decoration, either domestic or corporate.

The major trend in 'advanced' painting at the earlier part of this decade was the monochrome. The list of artists (Ryman, Marden, Martin, Baer, Mangold, Humphrey, Irwin and so on) is not a short one; clearly it became the preoccupation of contemporary abstract painting. Now, the monochrome, the 'empty' canvas, is a self-description of present day work. Painting has collapsed into itself; it is an ahistorical act of self-erasure— only seeing history as tradition, it blinds itself to the present and erases its own historical location. The tools necessary for it to engage itself with the present are those very tools which are omitted by the conception of its own self-definition. As it is, now, for painting, the present is only a moment of exchange between an abstracted art historical tradition and a future as a quality commodity, and its present cultural life is the social activity of that exchange. Originally, the empty canvas was a radical gesture, an attempt at the monochrome is discussed in terms of 'quality': the techniques of its making, the subtle evolution of formal changes, aspects of the color, and so on. The art historical processes of authentication that are already applied to *proven* 'masterpieces' are ritually encantated over the empty canvases, giving to them a market life where none other exists. As a radical gesture the meaning was intended to lie outside the work, although mobilized by it. Now, because painting can no longer pretend to experimentation (much less 'radicality'), we are expected to search *inside* the work, for that aura of quality which is intended to be its meaning. When it is found there it is less the product of artistic discovery than of that taste which has been produced by the art critical-historical/market complex. Having as it does no engaged relationship with the world such work exhibits change formalistically, as part of the endless interaction between the marketplace and taste; with the creation of need and the 'change' which satisfies the two faces of the same process. Formal invention, without question, plays its part in what remains of that 'avant-garde'. The task of invention is not to reproduce the forms of that given reality, but rather to alter the relations to that reality in such a way that the ideological (and ethnological) constructs which create divisions such as those between 'art' and 'reality' become in fact *visible* within the operations of signification; formal invention (when perceived as such) is itself but a conceptual by-product of that structure which organizes perception and provides meaning. (Investment of the 'new' in the forms

themselves, as is the predilection of the taste industry, is the process of the commodification of knowledge in the realm of art.) Thus, the locus of an engaged practice of art must be within the framework of the institutionalized culture of industrial society, for that signifying structure presents itself, now, as the horizon of all signification.

While it would be impossible to discuss photography in the terms in which I have set out without the preceding critique of painting, it should perhaps be noted first that as necessary as it is the critique ultimately conveys more passion toward painting, even negatively, than it would seem to merit; and secondly, the motivation of artists toward their practice, whatever it is, is not what is at question here. What is, is the collective meaning of that enterprise. There is a kind of collective weight to all artistic production; some degree of interdependence is undeniable. The problematic of painting, its limits which are the limits of modernism, has bearing on future art practice. Painting's fundamental failure—that autonomy which severs it from a productive connection to present society—is a result of that same historical process which provided the conditions from which photography came to be.

That painting was capable of radical cultural experimentation in the greater part of this century goes without question. When seen as a process from outside of the historical space of modernism, painting ends completed and confirmed through that work which, in the past several years, had to negate it in order to proceed. Such work, which originally constituted a cultural eclipse, has evolved as the conceptual schema through which the development of actual alternatives begins to assert itself within practice. Increasingly, the nature of that practice is such that the established institutional forms can no longer provide (at least at the point of production) a working context. The capacity of institutionalized modernism to re-fill (fulfill?) the gap it makes of a lack has been a sight to behold. The period of reaction—the 'other' history of art in the seventies—more 'lasting painting' monochromes, photo-realism, pattern-painting, 'new image' painting, and so on, have been primarily market-sustained movements cut adrift from the historical connection which should constitute the cultural roots of an art practice; it is in such a climate that the notion of an 'avant-garde' seems absurd. I am sometimes told 'conceptual art' ended art history; if that is the case, so be it: if from that we can retrieve the practice of art under another name.

PART TWO

The questioning of the fictions of 'source' and 'origin' is made through an attention to the reality of language, to forms of the articulation of division and difference, to structures (understanding structures as 'that

which puts in place an experience for the subject whom it includes'). Our concept of the author and that of Man, of which the former is a particular expression, are interdependent with an elision of that reality.

Steven Heath

Although photography has had a direct participatory influence in the experimental art of this century, its most direct effect on art practice began at the beginning of the sixties, with work such as Rauschenberg's which mixed the dominant style of painting at the time (abstract expressionism) with photographic imagery. As well, there is Warhol's and other 'pop' artists' use of photo silkscreens in ways which were less composed, and less painterly. My use of photography (in works from 1965 such as *One and Three Chairs*) came about through an attempt to make work which didn't signify that it was art *a priori*, because of its form. Since I saw the nature of art to be *questioning* the nature of art, I felt the form the work took shouldn't end the questioning process, but begin it. As I said at the time, a painting—which brings with it a media-defined tradition—says *this* is the nature of art, that magical aura and belief system of the painting and the fictive space that it constructs. So the photographs used were always clean, cool, factual, almost scientific—as uncomposed as I could manage, and always taken by someone else, in order to make clear that they were art in their *use* (in *relation*) not through the aesthetic choice, composition, or craftsmanship. Photography was usable as a device because it could be employed to present a matter-of-fact presentation of the world (the 'objective' detachment of science) while the photography itself, as a cultural object, was pervasive to the point of being 'naturalized' as a given part of the world. I could still, at that point, retrieve the photograph from the sphere of its more prevalent pragmatic role (as a 'neutral' device) and engage it in a signifying activity, devoid as it was of any painterly associations. An important point to remember here is that photography, as a medium, is employed as a *means*—no more than paint, photography cannot be considered as an end in itself; it is for this reason that such work begins what some have referred to as the *post*-modern period. 'Fine Art' photography has long suffered from the conservativism which plagued painting; attempting to make its technical definition a modernist virtue, it permitted formal invention only to the extent it didn't rupture its conceptual isolation.

The perpetual drive toward 'fine art' acceptability seemed to foreclose any possibility of escape from its captivity within the Realism/Modernism controversy; while it seemed to repress its 'modernity' it seemed doomed to receive acceptance in the terms which painting was attempting to leave behind. It's ironically that very isolation which permitted me (and others) to find photography a useful, and *non*-artistic tool. The rate however at which photography gained acceptance within the 'avant-garde' after its

use by artists in the early seventies not only altered the reading of *any* photograph used within an art context (as photography accumulated new uses as art, it became associated with 'avant-garde' practice) but also meant that the barriers between 'fine art' and photography were finally down. What that activity beginning to be called 'conceptual art' in fact did was to convey a kind of conceptual respectability to an activity which, laboring as it did as a media-defined activity, was perceived as craft. The recent 'recuperation' of 'Photography' as another 'fine art' medium is part of the process of *re*-structuring which is the cultural by-product of our economic machine. One aim of a practice engaged with alterations of meaning (and thereby perception) is the rupture of the structures of fixed meanings and the interdependent sets of separation which they produce. By contrast, what the autonomy of painting suggests is that there is a 'real' world of which it is separate; the postulation of its own 'subjectively' constructed artifice (that's art) implies that the rest of the world as given is naturally real. Of course, the attempts to constrain photography as a modernist practice cannot hope for the kind of autonomy with which painting is associated—the nature of photography (as we have discussed) makes that impossible. However, one thing has become clear: the institutionalization of modernism is the structure which—with painting continuing to function as its causal nexus—exerts a kind of centrifugal force through which it maintains a system of changes within fixed meanings. All the while, of course, it adheres to this structure any artistic activity not content with the signifying implications of *other* economic bases than that complex of art criticism, art history, and the art market. So, photography, as well as 'conceptual art', became assimilated into a structure which re-makes it in its own likeness; rather than being eclipsed, painting re-emerges as a contender within yet again another modernist battle. Beyond that false controversy which is its own death-throes, at the climax of that last modernist morality play, painting offers itself as its own 'alternative'.

PART THREE

'Reality', that is, needs to be understood not as an absolute and immutable given but as a production within which representation will depend on (and dialectically, contribute to) what . . . Althusser has described as 'practical ideology', a complex formation of montages of notion, representations, images, and modes of action, gestures, attitudes, the whole ensemble functioning as practical norms which govern the concrete stance of men in relation to the objects and problems of their social and individual existence; in short, the lived relation of men to their world. In this sense, the 'realistic' is not substantial but formal (a process of significant 'fictions') . . . [in regard to art, then] it may be described in the notion of the vraisemblable *of a particular society, the generally*

received picture of what may be regarded as 'realistic' . . . Evidently, this vraisemblable *is not recognised as such, but rather as, precisely, 'Reality': its function is the naturalization of that reality articulated by a society as the 'Reality' and its success, is the degree to which it remains unknown as a form . . .*

Steven Heath

The visual receiving system in its untrained state has only very limited powers. We are perhaps deceived by the fact that the eye is a sort of camera. Contrary to what we might suppose, the eye and brain do not simply record in a sort of photographic manner the pictures that pass in front of us. The brain is not by any means a simple recording system like a film . . . Many of our affairs are conducted on the assumption that our sense organs provide us with an accurate record independent of ourselves. What we are now beginning to see is that much of this is an illusion, that we have to learn to see the world as we do . . . In some sense we literally create the world we speak about . . . The point is to grasp that we cannot speak simply as if there is a world around us of which our senses give true information. In trying to speak about what the world is like we must remember all the time that what we see or what we say depends on what we have learned; we ourselves come into the process.

J. Z. Young*

Photography, as invention, was both art and science. The view it gave us of the world was in some measure acceptable because it was a product of our vision of the world; and it did so as part of that same process which seemed to impart 'truth': science. It is this suggested 'scientific detachment' which lends to photography a sense of *objectivity*. Unlike the marks of the painting, the photo seems to organize its 'opinions' *in relation to the world*; even when the photos have clearly been manipulated, the 'opinions' seem to have all the more force, with the suggested 'participation of the world' articulating that 'opinion' as a difference.

In a sense it is a construction of the 'unreal' by the 'real'. By 'unreal' I mean that which is made visible through articulation and separates itself from the *vraisemblable*, the 'seamless web' which culture constructs; it is the act of *structure breaking*, which 'making' is. The 'real' here means *blindness*, it is that structured world of given significations which organize us politically within an ideologized 'sanity'.

The photograph, then, as an artifact which signals a kind of break from the cultural belief system of which painting is a part, speaks of more than itself. In 'making from' photographic culture one constructs from the world as presented—not simply as 'content' *within* the photos (though, as I mentioned above, this tends to connect and make concrete) but what one is using is a signifying system of relations. This system, as part of the

*From *Doubt and Certainty: A Biologist's Reflections on the Brain* (Oxford: Clarendon Press, 1951).

vraisemblable, seems to construct meaning 'naturally'; I mean by that, of course, that use of photography in advertising, the news media, 'domestic culture', and so on which increasingly is the cultural format of intersubjective space in our society. It is in relation to this intersubjective space that one must have effect, if one is ever to have any effect at all. The shift away from the 'aura' and the preciousness of objects toward an understanding of the creative process as a kind of mediation of meaning through an intervention and manipulation in the 'real' world—the 'real' being not simply ideologized space and the cultural 'materials' with which it is constructed, but also the nature of the play of relations with which it maintains its equilibrium. This might suggest a resolution of the conflict between 'the avant-garde' and mass culture. The last of which, Adorno commented, "Both are torn halves of an integral freedom, to which however they do not add up."

ON AD REINHARDT

The different colored blacks of Reinhardt's paintings presented an internal structure which described the square of the whole painting in relation to its larger context and discourse. All nine squares are simply black if seen alone, yet they are made visible by that relationship of difference which articulates separate parts at the same moment the whole of the painting is seen. The relationship of the internal squares is the same as the relationship of the external squares, of one painting after another, all black, and part of the same process we see in Ad Reinhardt's art. But that discourse which constrained the meaning of Reinhardt's work is also that same discourse which his work expanded, as all of his work becomes one work and part of something larger. Ultimately, Reinhardt's only relationship with color—like his relationship with all the other qualities by which paintings presume to be judged—was that of negation. As he stated in an interview: "You can paint anything, and you can paint out anything. You can begin with anything and get rid of it. I already got rid of all that other stuff. Someone else doesn't have to do it." Painting itself had to be erased, eclipsed, painted out in order to make art. His painting of "the last paintings anyone can make," like the circularity of his writing, began (in American art) that self-reflexive spiral which was also painting's self-erasure in the act of its very completion. Reinhardt's denial of painting (as it was then conceived) was his attempt to make art itself visible through that 'other' which his painting then constituted. Since the dis-

First published in *Cover* (Spring/Summer 1980), p. 10. From a panel with Lucy Lippard, Barbara Rose, and Richard Serra at the Solomon R. Guggenheim Museum, New York City, February 1980.

course of art was painting this could only be done through painting but because he drained his work of all those qualities of which paintings were made, he made the parameters of the discourse itself visible. As he said in his writings (which his practice reflected), assertions about art can only be made negatively; in this way, his assertion of art itself was the positive by-product of those acts of negation. Paul Connerton, in discussing Hegel, has stated: "The negative connotes those historical forces which are incompatible with a certain form of social life and which act upon it destructively, but forces which nonetheless arise inevitably out of the particular social structure which they negate and surpass. Human rationality has a history which consists—in the criticism in life and in thought—of the constraints imposed by each of its specific historical forms. Hence, this understanding of critique implies a particular narrative structure in which the potentialities for development of a given mode of thought or a given social condition are latent within the very structure of the initial terms." The conflict of that ethno*logic* which is within the tradition of painting begins with modernism's own self-conception. The circular act of self-understanding, in an attempt to transcend itself, erases the old as part of a process which makes the new visible to itself as it redefines what is visible in the old. Ad Reinhardt's paintings, for many of us, were a kind of passage. His contradictions were the contradictions of modernism being made visible to itself. After Reinhardt, the tradition of painting seemed to be in the process of completion, while the tradition of art, now unfettered, had to be re-defined. The struggle for that redefinition, regardless of the demands of the art critical-historical/market complex, is a long one; it is that tradition of art as painting that Reinhardt spoke of, which ends completed and confirmed through that work which, for over a decade, had to negate painting in order to proceed. The remnants (in America) of what we once called avant-garde have, by and large, had to re-locate themselves once again outside of the official palaces of culture. Meanwhile, the art critical/historical market complex promotes as *new art* photo-realism, pattern painting, 'new-image' painting, and so on—ending the period of experimentation, increasingly, in the museums and galleries. There may be those here tonight who will suggest that this recent painting is Reinhardt's legacy. Although such work bears a superficial relationship to Reinhardt the painter, it is I believe, antithetical to Reinhardt the artist. Reinhardt's life-long fight against that market complex was as much an act of resistance to the commodification of art as it was an understanding that artists must take responsibility for the meaning of their work, that it can't really be trusted to the art critics and historians whose own careers make their relationship with art similarly creative. In the late Sixties, the Greenberg Regime might have succeeded in depicting Reinhardt as a minor color painter, but Reinhardt's own framing, which was as much

part of his activity as an artist as the painting of his paintings, stood in the way.

In evaluating the work of Ad Reinhardt, all of his output must be considered, not just that aspect of his work which satisfies those conceptions of tradition maintained by official culture, whereby the status quo is described as 'quality'. Those paintings, as objects, are hanging there, and without question they are wonderful. But Reinhardt the artist-as-critic would no doubt have had problems with tradition as simply the institutionalization of modernism, as well as the increased bureaucratization of our cultural space. This, as a process, has changed the meaning of not only that painting tradition which Reinhardt so strongly valued, but it has heightened our political awareness of that other tradition, from which the concept of the 'avant-garde' originally began and for which, with an understanding of Ad Reinhardt as a moral presence, his work will continue to be valuable for many generations of artists to come. In closing, I would like to quote from Fredric Jameson:

It should be clear, therefore, that a critique of the new modernism cannot be an external but only an internal affair, that it is part and parcel of an increasing self-consciousness (in the heightened, dialectical sense we have given to that term) and that it involves a judgement on ourselves fully as much as a judgement on the works of art to which we react. The ambiguity, in other words, is as much in the revolutionary's own position as it is in the art object: insofar as he is himself a product of the society he condemns, his revolutionary attitude is bound to presuppose a negation of himself, an initial subjective dissociation that has to precede the objective, political one.

ON PICASSO

My mother once said to me, "If you decide to become a soldier, you will become a general; if you decide to become a priest, you will become Pope . . ." Well, instead I decided to become an artist and I became Picasso.

attributed to Pablo Picasso

In many regards Pablo Picasso is modernism itself. The artist and his work embody both the best and the worst of art in our century. From the height of the brilliance of the early Cubist work to the depth of the commercial and institutional hype which surrounds 'a Picasso' regardless of its merits as art, there is much to be learned from him and what happened to his work. At this point unfortunately, Pablo Picasso stands as a negative model—as a kind of warning. Obviously, I'm not speaking of those great works as they were when one could actually see them—and when they had an effect on artists and the public alike—but of what they mean now; for the meaning of Picasso's work has been eclipsed by a larger meaning and role.

Part of the problem lies with the artist himself—at that point when Picasso stopped making art and began painting Picassos. This process was painfully visible in his recent retrospective; it is a potentially fatal side-effect of success for any artist. It seems the weight of artists' own histories severely inhibits movement away from that space they already occupy. Perhaps it is that the artists' experience of their own work, as a making

First published without title in "Picasso: A Symposium," in *Art in America* 68, no. 10 (December 1980), pp. 10–11.

process, loses primacy to the world's view, as the art historian constructs it. Would it be a parody of modernism's vaunted self-referentiality to describe this point as the one where the artist stops thinking like an artist and starts working like an art historian?

While such a state of affairs is a kind of by-product of an art historian's experience of art—art-historical 'facts' in the form of objects organized by style—the problem is seldom clear for the artists, and much less for the public. Artists experience art as a making process; what they make art *from* is, or can be, completely diverse, but what that process does is connect them to their own time and their own culture. The view of art that art historians teach is usually in conflict with the working experience of the artist, but this conflict seldom reaches crisis proportions until one is a 'success': a living, working artist trying to do new work while still a part of 'art history'.

For such artists, 'style' takes the shape of their personal form of cultural authority, with the art-historical/market complex providing constraints which put into conflict the ability of such artists to experiment or take risks, and simultaneously maintain their life. In short, success means becoming institutionalized: both having power and representing it; if you risk changing its representation you risk losing it, and all that goes with it.

We've seen with Picasso, first, and perhaps more than with anyone else, what can happen to the meaning of an artist's work through the glorification and mystification of the artist himself. Picasso became more than institutionalized, he became deified as the modernist superhero. For many, my criticism here of Picasso will be experienced as a kind of sacrilege. Such a resistance to any form of criticism is worrisome because it suggests the lack of a real discourse, which is precisely the problem with institutionalized modernism: either one is part of the art-historical/market complex (a speaker), or one is outside (a listener). Further, in the case of Picasso, the lack of a real critical discourse in relation to the work suggests that one is not confronting those ideas and experiences which productively provoke thought and new art, but that, in fact, one is only confronting *authority*. Institutions such as the Museum of Modern Art see 'professionalism' in terms of their ability to organize the public perception of works of art toward such ends.

Our view of the work of an artist like Picasso is impossible to separate, now, from that view of the artist and his work which has been carefully constructed by institutions such as the Museum of Modern Art. I think it is important for artists to consider what the fetishized obsession with an artist like Picasso actually represents in terms of the cultural practices and art historicizing which affect living artists; in other words, it is important to realize how institutions use the dead to keep the living in

line. Since living artists can fight for the meaning of their work, they are in competition with art historians, who are dependent on the use of artists' production for the meaning *they* make. For that reason, the Museum of Modern Art, for example, has a better time of it with the work of dead artists. The Museum of Modern Art's thirty-year history of hostility toward contemporary art (while it was being made) is due in large part to its commitment (both economic and intellectual) to the preservation and promotion of European modernist masters. The reason the Museum of Modern Art functions as *The* Museum of *Modern* Art and not as *a* museum of *contemporary* art is that contemporary art—particularly that work which is experimental and anti-traditional—is judged not in its own terms (having a somewhat different history and culture) but, always unsatisfactorily, against that horizon of meaning of European modernism, of which Picasso reigns supreme as a kind of papal presence.

The work of living artists which the Museum of Modern Art grudgingly supports is nearly always an unhappy middle road between its formalist view of modernism and what living artists are actually thinking—the result being a celebration of mediocrity. Beyond the occasional and minimally necessary purchases (with someone else's money) of 'key historical works', there seems to be little real feeling or understanding of contemporary work. The museum's exhibitions in this area end in being more of an art-market-necessitated overview of new products than an intelligent examination of the ideas younger artists are working with (a perfect example: the recent "Printed Art," curated by Riva Castleman). There is little sustained involvement with the works of either individuals or 'tendencies' which are purchased or exhibited; it's always a one-shot deal, being as it is a function more of necessity than commitment.

The frame of the institution around each of Picasso's works erases what could once be seen there, as surely as if they were painted out. Unavoidably the authority of culture reflects the needs of the corporate state, and increasingly, as our culture becomes more and more bureaucratized, 'success' as an artist must begin to be seen as our ability to resist that process of institutionalization which robs us of the opportunity to take personal responsibility for the meaning we make. It is in this sense that art is inherently political, not as content to be illustrated; it is in those terms that we see what is possible—the meaning that we make as artists speaks of this.

phŏt′ograph (-ahf), n., & v.t. 1. Picture,
likeness, taken by means of chemical
action of light on sensitive film on basis
of glass, paper, metal, etc. 2. v.t. Take ~
of (person etc., or abs.); (quasi-pass.) *I
always* ~ *badly* (come out badly in ~).
Hence photŏg′rapher[1], photŏg′raphy[1],
nn., phŏtográph′ic a., phŏtográph′ic-
ALLY adv. [PHOTO-+-GRAPH]

1. *One and Three Photographs,* 1965.

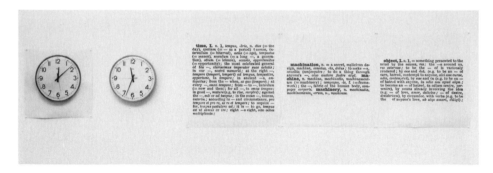

2. *One and Five Clocks*, 1965, Tate Gallery, London.

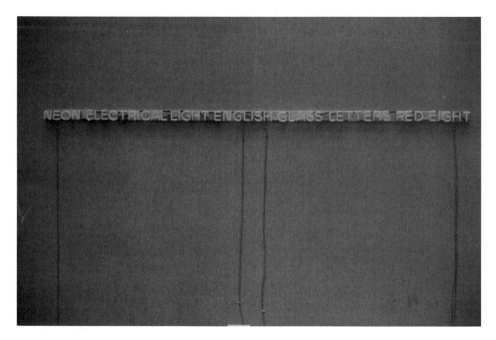

3. *One and Eight—A Description*, 1965.

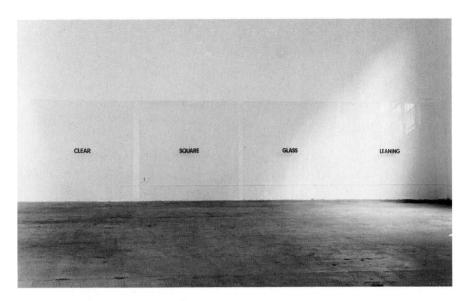

4. *Clear Square Glass Leaning*, 1965,
Giuseppe Panza di Biumo Collection, Milan.

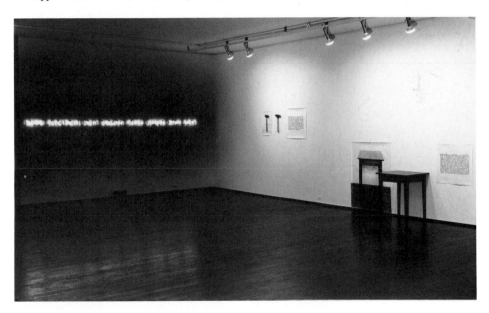

5. Installation View, Leo Castelli Gallery,
New York, December 1972.

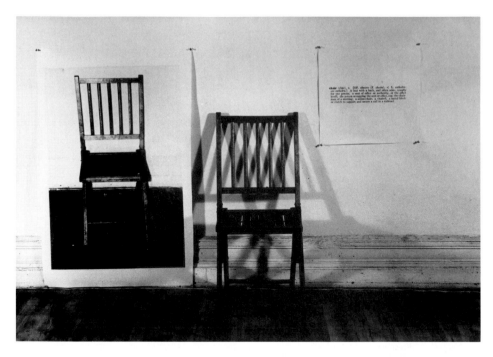

6. *One and Three Chairs*, 1965, The Museum
of Modern Art, New York.

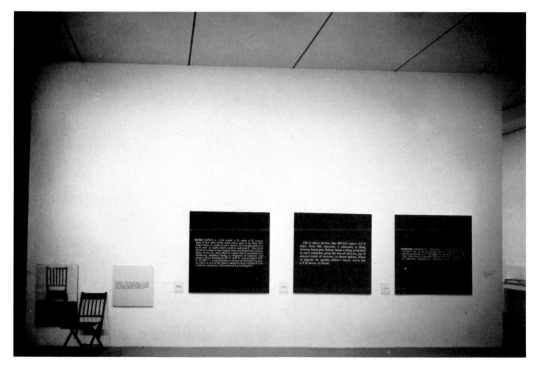

7. Installation View, *Information*, The
Museum of Modern Art, New York, July–
September 1970.

wa·ter (wô'tĕr, wät'ĕr), *n.* [ME.; AS. *wæter;* akin to G. *wasser;* IE. **wodōr* < base **wed-,* to wet; cf. WET, WASH], **1.** the colorless, transparent liquid occurring on earth as rivers, lakes, oceans, etc., and falling from the clouds as rain: it is chemically a compound of hydrogen and oxygen, H_2O, and under laboratory conditions it freezes hard, forming ice, at 32° F. (0° C.) and boils, forming steam, at 212° F. (100° C.). **2.** water in any of its forms, or in any amount, or occurring or distributed in any specified way, or for any use, as drinking, washing, etc. **3.** *often pl.* a large body of water, as a river, lake, sea, etc.

8. *Titled* (Art as Idea as Idea), [water], 1966.

meaning, n. **1**, = that which exists in the mind (e.g. yes, that is my —, *mihi vero sic placet, sic hoc mihi videtur;* see INTENTION, WISH, OPINION; **2**, see PURPOSE, AIM; **3**, = signification, *significatio* (of a word), *vis* (= force of an expression), *sententia* (= the idea which the person speaking attaches to a certain word), *notio* (= original idea of a word; see IDEA), *intellectus, -ūs* (how a word is to be understood, post Aug. t.t., Quint.); it is necessary to fix the — of the verb "to be in want of," *illud excutiendum est, quid sit* CARERE; to give a —. to a word, *verbo vim, sententiam, notionem sub(j)icĕre;* well- —, see BENEVOLENT.

9. *Titled* (Art as Idea as Idea), [meaning], 1967.

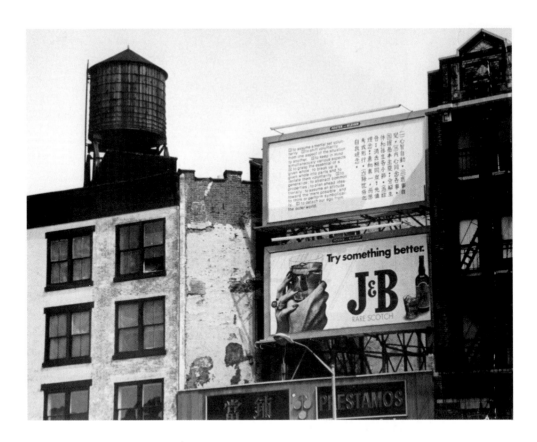

10. *The Seventh Investigation* (Art as Idea as Idea), Context B: Public-General, Chinatown, New York, 1969.

11. *The Seventh Investigation* (Art as Idea as Idea), Context C: Installation View, *Conceptual Art, Arte Povera, Land Art*, Galleria Civica d'Arte Moderna, Turin, June–July 1970.

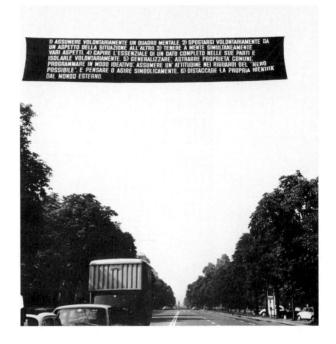

12. *The Seventh Investigation* (Art as Idea as Idea), Context D: Political, *The Daily World*, September 5, 1970.

13. *The Seventh Investigation* (Art as Idea as Idea), Context Λ: Label Installation, *Information*, The Museum of Modern Art, New York, July–September 1970.

14. *The Second Investigation* (Art as Idea as Idea), Presentation Photo, *When Attitudes Become Form*, Kunsthalle, Bern, March–April 1969.

15. *The Second Investigation* (Art as Idea as Idea), Van Abbemuseum, Eindhoven, 1968–69.

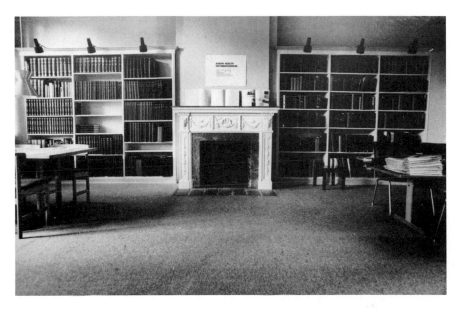

16. *Information Room*, Installation View,
Kunsthiblioteket Lyngby, Denmark, April–
May 1970.

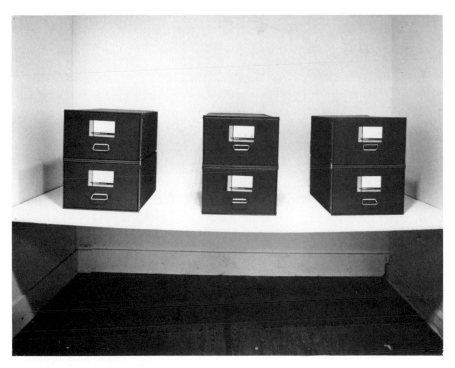

17. *The Seventh Investigation* (Art as Idea as
Idea), Installation View, Protech-Rivkin Gal-
lery, Washington, D.C., January 1971.

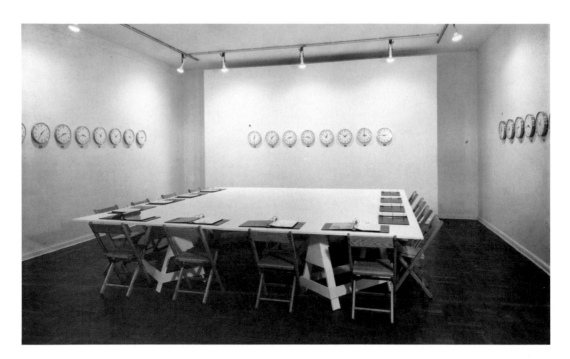

18. *The Eighth Investigation* (Art as Idea as Idea), Proposition 3, Installation View, Leo Castelli Gallery, New York, October 1971.

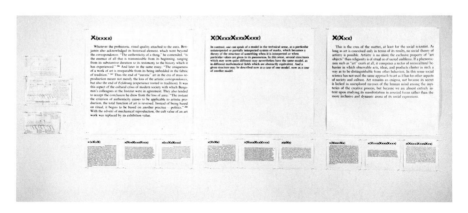

19. *The Ninth Investigation* (Art as Idea as Idea), Proposition 11, 1972–73.

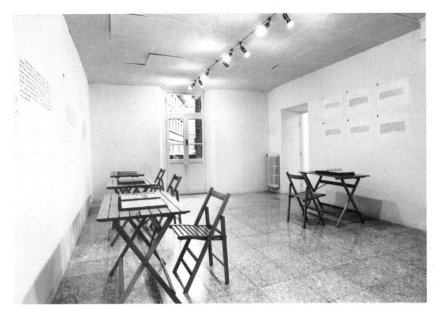

20. *The Ninth Investigation* (Art as Idea as Idea), Proposition 2, Installation View, Galleria Sperone-Fischer, Rome, December 1972.

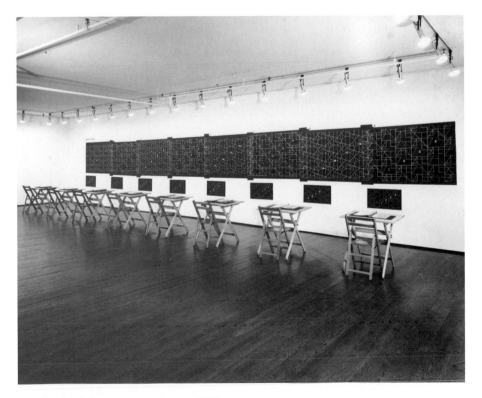

21. *The Tenth Investigation*, Proposition 4, Installation View, Leo Castelli Gallery, New York, January–February 1975.

B¹

Finalement, bien entendu, je dois ramener cette conversation à l'art. C'est ma 'place' et sous de différentes formes, la façon avec laquelle j'organise ma compréhension du monde. (C'est peut-être de cela qu'il s'agit dans tout travail essentiellement.) Mes constantes attaques contre la tradition doivent être comprises comme des attaques contre des conceptions particulières (et habituelles) de la tradition. L'art est une description de la réalité à travers une interprétation de la tradition. C'est dans l'interprétation qu'on peut juger la valeur de l'activité — comme une réelle traduction de la réalité sociale. Dans ce sens, le 'vrai' travail est une fusion historique de la réalité vécue par un individu (ou des individus) avec 'l'optimisme' constitué qui est propre à l'ethnologie de la civilisation.

B²

Instruções (ver antes de tudo as instruções A³) : Os quatro cartazes serão colados molhados sobre uma superfície plana, de preferência uma parede ordinária, utilizando a cola de decorador e uma escova/pincel. A parede sobre a qual eles serão colados deve ser situada de maneira a ser visível para o público. Os cartazes serão colados verticalmente, da esquerda para a direita, e espaçados de 15 cm aproximadamente, o bordo superior estando a 200 cm do solo aproximadamente. Na medida em que se trata de cartazes estes devem ser tratados como tais, quer dizer que não é preciso fazer atenção com a finalidade de preservá-los.

B³

voiR · A².

من الفن ليس وصف الواقع عن طريق تفسير التقاليد سامية

B⁴

ملاحظات : يجب أن تكون اللغة المختارة هي لغة البلد المقام فيه هذا العمل ٠ وعلى « المشترك » (أو المشتركة) أن يكتب بخط يده ، مستعملا أداة كتابة غير قابلة للذوبان ، ما يلي : في المساحة A² يكتب اسمه وسنه وعنوانه ومهنته واتجاهه السياسي ، بالإضافة الى تاريخ استلامه لهذا العمل وتاريخ وضعه ومكان وضعه (يجب أن يكون هذا البيان مفصلا بقدر الإمكان) ٠ أما في المساحة B³ فيكتب « المشترك » (أو المشتركة) بطريقة تلائمه وتخصه ــ المعنى الذي يستشفه لهذا العمل وعن الدور (ان وجد) الذي تلعبه عبارة الفنان D⁵ في تكوين هذا المعنى ٠ وفي المساحة C⁴ يكتب « المشترك » (أو المشتركة) عبارة يختارها لشخص له تأثير خاص عليه وتلائم المعنى « الاجتماعي » ٠ وأما في المساحة D¹ فيناقش « المشترك » (أو المشتركة) بطريقة مباشرة بقدر الإمكان ، دوافعه للتطوع « كمشترك » ، ويضيف ايضا اية اقتراحات لتحسين هذا العمل على أساس اجابة « المشتركين » في المساحة B³ ٠ هذا علما بأنني (جوزيف كوزوت) اتحمل مع « المشترك » او المشتركة) مسؤولية اي معنى قد يأخذه هذا العمل في المكان الموضوع فيه ٠

22. *Practice*, 1975.

23. *Practice*, Installation View, Eric Fabre
Gallery, Paris, November 1975.

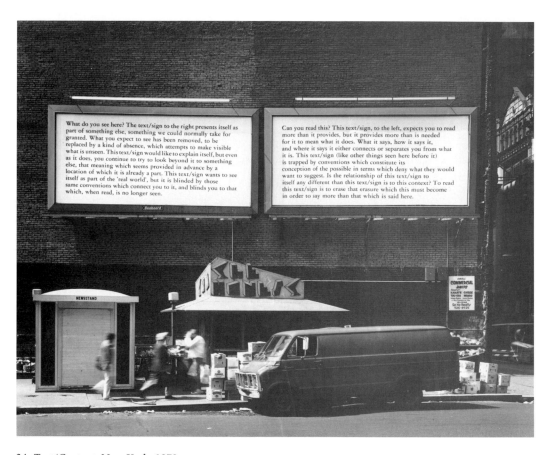

What do you see here? The text/sign to the right presents itself as part of something else, something we could normally take for granted. What you expect to see has been removed, to be replaced by a kind of absence, which attempts to make visible what is unseen. This text/sign would like to explain itself, but even as it does, you continue to try to look beyond it to something else, that meaning which seems provided in advance by a location of which it is already a part. This text/sign wants to see itself as part of the 'real world', but it is blinded by those same conventions which connect you to it, and blinds you to that which, when read, is no longer seen.

Can you read this? This text/sign, to the left, expects you to read more than it provides, but it provides more than is needed for it to mean what it does. What it says, how it says it, and where it says it either connects or separates you from what it is. This text/sign (like other things seen here before it) is trapped by conventions which constitute its conception of the possible in terms which deny what they would want to suggest. Is the relationship of this text/sign to itself any different than this text/sign is to this context? To read this text/sign is to erase that erasure which this must become in order to say more than that which is said here.

24. *Text/Context*, New York, 1979.

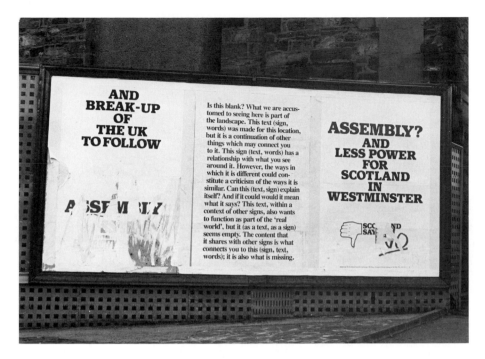

25. *Text/Context*, Edinburgh, 1979.

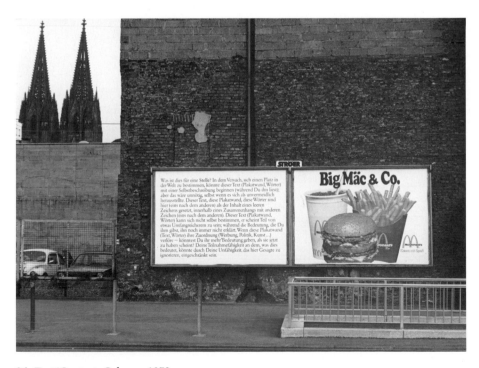

26. *Text/Context*, Cologne, 1979.

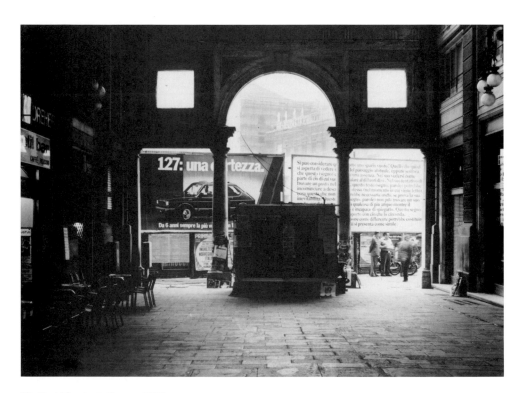

27. *Text/Context*, Genoa, 1979.

NOTES ON *CATHEXIS*

. . . thought proceeds in systems so far remote from the original perceptual resides that they have no longer retained anything of the qualities of those residues, and, in order to become conscious, need to be re-inforced by new qualities.

Sigmund Freud[1]

This work attempts to understand the *conditions* of content, with, finally, the process of understanding those conditions becoming the 'content' of the work. By 'content', of course, I refer not to meaning as a kind of instrumentality, but rather, 'what are those conditions which permit the construction of meaning?' The material of this work is *relations*, and to establish those relations 'things' are used. The desire is to construct the work (the meaning it makes as art) below the surface of the fragments of other discourses (systems of meaning). The *re-making* of meaning with given parts (a combination of 'found', made, and mis-used) is meant to cancel parts of some meanings with parts of other meanings, permitting the viewers to trap themselves on one of various surfaces (not unlike a kind of labyrinth) and assume the meaning of the whole within an eclipse by a part (the vulgar example will be those that see the work in relation to Dada or Baselitz). In short, for those able to see beyond the 'form' of the work (how it's made) there is to be seen that combination of relations which is the work (what is made). Such 'seeing', however, is only a momentary event, a point of understanding that structure of relations

Portions originally published as a flyer in conjunction with the exhibition *Cathexis* (New York: Leo Castelli Gallery, February 1982); later expanded and published in *Bedeutung von Bedeutung: Texte und Dokumentation der Investigationen über Kunst seit 1965 in Auswahl* (Stuttgart: Staatsgalerie Stuttgart, 1981).

which construct all works of art, and in this sense such works can be experienced as models of art itself.

All of the elements used within these works suggest a 'meaning'; it is the simultaneous presence of such meaning with a juxtaposition of 'arbitrary' meanings which signifies through what becomes a kind of *cancellation*. The painting, the text, the colored X's all seem to signify. In the use of the painting it is readable in a way quite specifically different than the text. The painting seems to be denied its monologue. When viewed 'normally' the fictive space of the painting permits the viewer an entrance to a credible world; it is the power of the order and rationality of that world which forces the viewer to accept the painting (*and* its world) on its own terms. Those 'terms' cannot be read because they are left unseen: the world, and the art which presents it, is presented as 'natural' and unproblematic. Turning the image 'upside-down' stops that monologue; one no longer has a 'window to another world', one has an object, an artifact, composed of parts and located here in this world. One experiences this as an *event*, and as such it is an act which locates and includes the viewer. As an event it is happening now (in the real time of that viewer) because the viewer, as a reader, experiences the language of the construction of what is seen. That cancellation of habituated experience which makes the language visible also forces the viewers/readers to realize their own subjective role in the meaning-making process.

With normal usage either the text or the image is subservient to the other. Here, both have equal weight. The text does not 'explain' the image, nor does the image 'illustrate' the text. The text is read 'inside-out' and the image is viewed 'upside-down'. The internal meaning of both is contingent—brought together and made whole—on its function as a *part* of something else (that work of art). It defines and re-constructs the significance of its internal order in relation to its external function. The tension within the construction of both, and that which articulates the difference between them, also articulates *as a whole* that sameness which joins them.

The following, a close reading of one of the texts, is used here as a device through which to consider the work as a whole:

An order and location is provided, here, which presents (1) a construction of itself (a meaning, a 'picture') (2) through that cancellation (3) which its own limits find unrecognizable (4).

(1) This refers both to a literal *order* (the colored X's indexed to the images and presented as an 'order' within the text—thereby directing an order simultaneously to each other) as well as the *order* necessitated by language—the text's syntax and the painting's composition, first, internally

and independent of each other and, secondly, in relation to each other. The *location* is the 'formal choice', which in terms of order is arbitrary yet which provides meaning through its relations with other elements which make the whole. *Location* is the 'stuff' of construction when context becomes a function. *Provided* is a reference to that cultural context out of which and for which it, as a 'whole', is made and can be seen to exist. *Here* is a telescoping location beginning with a function—a word—within language's sliding/shifting to include those larger function(s) and location(s) of the text/sentence, the image, the construction of image and text as a text and as 'an image', the work of art as a context in relation to various histories (specific to the artist, general to this century) and, finally, that moment which finds us *here* looking at that (this).

(2) *Meaning* made through the use of other *'meanings'* (*'pictures'*), forms used/constructed to signify through history and practice—such use being the material of both language and art. The understanding is of an object which *constructs* itself through a self-reflexivity in relation to its own *'meaning(s)'* and their implicitly contingent nature.

(3) Refers to the making of meaning through rupturing that horizon of meaning provided by tradition. We have an image of a painting—distanced, removed from its own location, scale changed, color eliminated—which has a different history and a world-view which accompanies that history. It is a 'picture of the world' which has been turned upside-down (not a trick of style within a bankrupt expressionist genre). The reverse image of a painting at once 'quotes' itself as a cultural artifact (located and readable within a history) yet simultaneously denies itself as an instrumental reference (via photography) to, simply, that painting; its reversal—as an act—locates it here and now and 'congeals' it with the text into one object-function.

(4) In contrast to the thinking of the recent past which concerned itself with the limits of a medium (Modernism) the suggestion here is that tradition is an institutionalized network of meaning relations experienced as a form of authority; thus we need to see that the patterns of meanings and forms are arbitrarily related, and finally, an understanding of the mechanism(s) of art—how meaning is 'made'—suggests both a liberating act as well as a description of the infinite possibilities of human meaning.

The meaning of the whole, finally, is not a 'picture', but the knowledge acquired from the path of that process which makes any picture visible. In perception the eyes are no more important than what they see, because it is the mind which organizes the function of both, and the kind of meaning of what is seen has been established long before one looks. Making 'something new to look at' is a futile and empty act if its only audience is the eyes. It is within those structures of the process of the

making of meaning where any 'creative' work is done, for while there is endless repetition in our visual world, productive work comes from that which has been made meaningful from *all* sources, and it is the structures of relation between these sources which give meaning, not just to the forms of art, but to the whole of our perceptual world. It is through the kind of meaning we make of that world that we define ourselves, as our actions shape what is there to be perceived. As artists our task is clear although not simple: truly 'creative' work is dependent on changing the *meaning* of what we see, a process which is impossible without an understanding of those structures which construct meaning. Formal regurgitations within a recent history of taste which presumes old and familiar meanings are ultimately consumed and forgotten.[2] That which becomes part of the shared history and culture of a community are those ruptures of given meaning which intersubjectively locate a people. The connection which gives one a sense of self and community results from a process which sees no distinction between the cultural and the political: sharing a history means taking responsibility for the meaning of the life that is shared. The power of authentic work of any period receives its strength from such integration; it is a power which will be lost to the making process if artists fail to recognize the fragmented texture of our social context and continue to avoid the risks of reconceptualizing the nature of our activity—an act necessary for the preservation of all that is human in the idea of 'tradition'.[3]

Notes

1. Sigmund Freud, *Papers on Metapsychology: The Unconscious*, vol. 14 of *The Standard Edition of the Works of Sigmund Freud* (London: Hogarth Press & The Institute of Psycho-Analysis, 1953), pp. 201–202.

2. That 'bundle of relations' which makes meaning possible includes history, just as it must—for example—include madness. The quality of 'History' produced by the art history of Modernism, however, has ended up as a kind of market formalism, and Modernism is being perpetuated, now, through the form chosen for its self-denial. Modernism's demise has, of course, been apparent for some time and the market's role in the 'meaning-making' mechanism has permitted it to depict that demise in a fashion favorable to its own ends. Much of the work one sees in galleries now as 'new' reflects this, but that doesn't permit one to dismiss it. It's already part of the discourse, but I suspect what it all means isn't what many people are banking on. The paradox of much recent art is that in proclaiming freedom from the historicism of Modernism they may have succeeded in the ultimate Modernist triumph: a 'significant' movement without any important works.

3. Finally, of course, in a realm where 'finally' is contingent, the question must present itself as to whether this text, not unlike the work and texts which precede it and become part of it, is not in its own way another surface, a trap, an apparent exit within a labyrinth which makes visible not the 'outside' but defines, and re-defines, the perimeter of that 'inside'.

NECROPHILIA MON AMOUR

I have friends, whose opinions I respect, who maintain that for me to consider the work that I discuss here is to lend credibility to it. They say if we all remain silent it will quietly disappear, like photo-realism or pattern painting. I disagree, for two reasons. First, the issues at stake have become too crucial to ignore any longer, and second, because I don't really think the, uh, 'shelf life' of weak work can be terribly extended by even reams of verbiage; but I do think that relevant work can suffer from a lack of a critical dialogue. Artists who don't risk asking themselves hard questions about what they are doing, and about what others are doing, can't grow. The dialogue is necessary in order to see the work, and find out its relationship with the world. Simply looking at work won't do it; we're just too close to it.

We set up a discussion situation with people—other artists—who share a community and a problem.* In some sense we are defined by our relationship to that problem—the problem being, from my point of view, the aftermath of what is unhappily titled 'The End of Modernism', or, to be more upbeat, 'The Beginning of Post-Modernism'. Some of us around that table, I suppose, have been participants in one, the other, or both. But no one would want to press such claims; art historians jealously guard their preserve—when we're as 'smart' as they we just get called self-serving. What is more relevant is that we are functioning artists, now. And we

First Published in *Artforum* 20, no. 9 (May 1982), pp. 58–63.

*The discussion to which Kosuth is referring was organized by *Artforum* in New York. Participants were Kathy Acker, Sandro Chia, Philip Glass, Joseph Kosuth, Barbara Kruger, David Salle, Richard Serra, and Lawrence Weiner.

know Ad Reinhardt had a point when he said, "In art, the end is always the beginning." The locus of the conversation was the effect we've had on each other's present work because of, rather than in spite of, the kind of baggage we brought with us to that table. This wasn't discussed, but it organized the discussion.

Anyway, as I have repeatedly said—and those who understand the value of hyperbole will appreciate it—artists work with meaning, not form (if such a separation were possible). To think the reverse is tantamount to saying that when you speak you think in terms of grammar (let's see: I need a noun, a verb, a subject) rather than in terms of what you want to express. The analogy, once stated, is limited; language functions instrumentally in a way art does not. In art, the tradition of organized meaning functions as authority; it speaks louder than any individual can. The individual artist must rupture the forms of that authority; that is, he or she makes meaning by cancelling, redirecting or reorganizing the forms of meaning that have gone before. It is in this sense that the art of this century—the 'avant-garde' tradition—is associated with the political. Since the demise of that historicist discourse called Modernism, a kind of generalized vacuum of meaning has seemed to develop. The discourse previously framed and gave meaning to work, but it now appears to have disintegrated. The art of the late '60s bared the mechanism of Modernism, in a sense, and much of the self-reflexivity became, as a style, simply self-consciousness. Many younger artists, a couple of whom participated in the discussion which is the subject here, as art students naturally found some of us to be the representations of authority, and therefore of institutionalized meaning. The antithesis to what we appeared to represent, the rupture-device, seemed easy: use painting. To speak positively first, the better work in this category is more complicated than that; often it's not simply painting but a reference to painting, a kind of visual quotation, as if the artists are using the found fragments of a broken discourse. (One thinks of the beach scene in *Planet of the Apes*). Such work has critically internalized the issues of the late '60s and early '70s, and in some ways, even if through negation, is tied to that earlier work. (One of the more charitable things I could say is that when the best of the work of certain younger artists is compared with the worst of the art that preceded it, the latter could be described as a test posing as an illustration and the former as an illustration posing as a test.)

I'm often asked what I have to say about this 'rebirth' of painting, since I have always maintained that painting was dead. Actually, when I first described it as dead I was a kid—and I was projecting into the future. Let's just say that it's dying—although a slower and more agonizing death than I at first thought. Of course, what one is talking about is the death of a particular belief-system, the death of certain meanings. In fact, this con-

tinuation of painting as a kind of 'painted device' is a necessary part of that 'dying' process. Work that had a critical relationship to painting external to it provided painting with a kind of meaning from the outside, as the other half of a dialectic. Obviously, such work couldn't directly eclipse it in any widespread or permanent way because the dynamic of painting, due to the power of its rich history, had been established as a cultural institution for too long; customs can live on as formal conventions long after they've lost their meaning. I think the work of this period that will remain with us will do so *in spite* of the fact it's painted. As for the rest, it continues the death of painting through its uncritical extolling of painting's past virtues while it simultaneously devalues those same traditional qualities through bad craft and an intentional undermining of an earlier era's concept of 'quality' through the confused identification of formal invention with the use of what becomes too simply 'what those other guys left behind'. In other words, such work devalues those same qualities that provide the authority from which it speaks—as a process it is in an entropic tailspin. Such work, unlike my generation's critique of painting, is neither reflexive nor external, but becomes naively internalized; in short, it becomes actualized in practice as a kind of terminal illness. It seems that many artists are cannibalistically revisiting the earlier art of this century and cancelling it through inflated but empty celebrations marketed as 'formal invention.' This erasing of earlier meaning seems destructive, rather than creative, precisely because the critical relationship is lacking. By using the earlier work as 'nature'—something found, to be used—and not 'culture', it is being depoliticized as an institution with economic and social meaning. It is through that (missing) critique and reflexiveness that one historically locates oneself and takes responsibility for the meaning one makes, which is the consciousness one produces. It's that distancing that describes one's own historical location; self-knowledge and the production of knowledge itself is impossible without it. The power of the work we see in museums is exactly this. It is the authenticity of the cultural production of a human being connected to his or her historical moment so concretely that the work is experienced as real; it is the passion of a creative intelligence to the present, which informs both the past and the future. It is not that the meaning of a work of art can transcend its time, but that a work of art describes the maker's relationship to her or his context through the struggle to make meaning, and in so doing we get a glimpse of the life of the people who shared that meaning. (For this reason, one can never make 'authentic' art—in the sense given here—by simply attempting to replicate the forms of an earlier powerful art.)

In this sense *all* art is 'expressionist'. But one must understand the complexity, even delicacy, of the way in which a work of art must be so

singularly the concrete expression of an individual (or individuals) that it is no longer simply about that individual, but rather, is about the culture that made such expression possible. Because of this, Expressionism, as an institutionalized style, by focusing on the individual artist in a generalized way (abstracting that which must remain concrete) has become the least expressive art of our time. It is the preferred art form for the artists who have the least to say, because they count on the institution of Expressionism to do their talking for them. The "Wild Ones" couldn't be tamer.

Let's talk about money. The art market, which by nature is conservative—particularly in this country—loves paintings. Every illiterate, uncultured dingbat (rich or not) knows that paintings are art, are great investments, and look swell over the couch. Forget whatever historical necessity was thoughtfully felt by some artists for a return to painting; the market is delighted to have paintings hip again; it can pretend that the last 20 years didn't happen, celebrating old hacks and new opportunists indiscriminately. How has this happened? That 'vacuum of meaning' caused by the collapse of the previous discourse (Modernism) and the, as yet, noticeable nonarrival of a replacement ('post-Modernism' is more of a notion than a discourse) has meant that new work is increasingly given its meaning by movement within the art market. Careers are made, not on new ideas, but new taste: as the cliche goes, art has begun to function in earnest as expensive fashion. Artists unheard of three years ago are commanding $40,000 a painting—prices it used to take artists a whole career to arrive at. Once, the idea of art historical importance stabilized the market value of an artist's work, but prices no longer reflect this—how could they? Now they reflect speculation on short-term market scarcity; and the mode of painting is ideally suited to marketing scarcity. However, there may be problems in paradise. Sales at those prices are either between dealers (who don't seem to keep the work for very long) or to, well, people who know little about art and take the dealers' advice on *à la mode* investments. At those prices people get nervous, and when somebody else becomes chic, the newly arrived will unload (since their relationship to the work is superficial to begin with) and prices will most probably come crashing down—something not unlike what happened to the Greenberg gang in the late '60s. The pity is that all this has very little to do with the art; certainly very little to do with the artist's relationship to his or her work. But in the end it does because such pressure makes it very difficult for artists to go in the direction that their work is taking them. In such a situation there isn't sufficient time for the work to be evaluated on its own terms and establish its own meaning. How many of us can be unaffected in our evaluation of work that got too hot too fast and then too cold too fast? When a work goes from $40,000 to, say, $8,000, will we still be able to see the ideas of the artist, or will we be looking

instead at lapels too wide—or simply at 'failure'? I think there is a certain responsibility of the artist to fight for the meaning of her or his work. It is as much a part of the making process as the manipulation of materials; without that struggle art becomes just another job.

The inarticulate murmurs of the art critical/historical establishment in the face of this market onslaught is noteworthy. Most of the 'criticism' is promotional, with the critics, like the dealers and collectors, trying to pick the 'winners'. Now this is certainly not new; some form of it is how careerism works. But with all the hoopla in the market and public media the dearth of analytical writing about this 'new art' isn't just appalling, it's frightening. I used to talk, in quasi-conspiratorial terms, about an art critical/historical market complex (to mangle Eisenhower), but I'm willing to put that away in order to appeal to those critics (well, anyway, people who like to write about art) who fancy themselves as intellectuals (is that illegal yet?), to speak up. Sure, money talks, but it doesn't have to be a monologue. I used to complain that artists had to struggle with art historians and critics for control of the meaning of work, but at least they have a name, a face, and ideas for which they can be held accountable.

There is something going on in the art world, it's taking different forms in various countries, but its implications for this country are potentially profound. In America we tend to see cultural events in international terms: we can have no 'national' character yet, not in the profound sense, and so we made Modernism itself our culture. By exporting our provincialism we re-formed other cultures and made the mess look 'universal'. Our conception of Modernism spread with our economic and political power. Because our culture didn't evolve from one place on the globe, we increasingly saw our location as a place in time—this century—rather than a place on Earth. We have exported a synthetic culture without a history—McDonald's, Coca-Cola, Hilton Hotel environments, and so on. To the extent that local cultures gave up their culture for ours, they of course lost control over the meaning-making mechanisms within their lives, and became politically and economically dependent on us. But both here and abroad something happened in the late '60s—maybe the Vietnam war broke the bubble of our sales pitch. More and more, I think, artists in other countries began to re-examine the context of their life and their art—as the art we were making at the time necessitated—and they began to look less and less to America for 'guidance'. Nonetheless, experimental or 'advanced' art—the remains of what an earlier era called 'avant-garde'—in this country has been supported by Europeans for the past 20 years. But it's all rather paradoxical, at the least. While we were dependent on Europe for not just money but that discourse that provides meaning (the heavier intellectual production), they were dependent on that relationship to feel anchored in the 20th century, at least this half of it. It seems to be

changing. The significance of, uh, 'bye-bye to Modernism' is that the European can look to his or her own culture for a context in which to work, but the Americans, as usual, will have to start again from scratch. The alienation our popular culture breeds hasn't just turned off the Europeans, it's turned us off. Making art, even just being involved with it, is one of the least alienating activities in our society. If that is subsumed by the forces of our economy, it's a very bad sign—not just for our cultural life, but for our political life as well. Beyond the value of the work itself, the reason that Clemente and Chia will have an easier time of it then, say, Salle and Schnabel, is that even while addressing the issues of Modernism, the best contemporary Italian art has always indexed itself to its own history and culture. Contemporary Italian art never seemed to export well before; outside of Italy it always seemed less 'international' than the work of other countries. Some of the chauvinistic painting going on elsewhere in Europe is, of course, simplistic and vulgar, but whatever our judgement of it, one thing is certain: it will force a radical re-evaluation of American art, not just there, but here.

In our sociopolitical system, cultural engagement is expressed in economic terms; we can't get away from that. Thus it won't do to cast all art dealers and collectors as ogres. There have been great, creative dealers in this century who have been essential to the art being in the world; the warning being issued here is about the direction and character of a *system*, not a moralizing about individuals. (Regarding the moral problem, it is up to you, dear reader, to consider what your relationship is to the problem.) Beyond the obscenity of the present government administration, artists seem demoralized. I've seen, and I keep seeing, artists who have been working for years lose the personal meaning of their work as they begin to doubt their own history: it's as though the value of their work is only the commercial value set by the market (if that were the case LeRoy Neiman and Andrew Wyeth would be among the greatest artists of our age). Denied the historicism of Modernism, denied the culture and history of an older nation, how will artists in America—and those who care about art—resist the almost total eclipse of meaning? The art market has been there all along, as has criticism of it, but what I'm discussing is a significant change in the quality of the relationship younger, supposedly radical, artists have with it, and the effect it is having on their work. Who we are, both as individuals and as a people, is inseparable from what our art means to us.

ART AND ITS PUBLIC

If one wanted to make a work of art which was a blank, an absence, a cancellation, somehow a work devoid of meaning, it would clearly be impossible. That is because we have already given meaning to the work by indicating that it is a work of art, and neither that act, nor art itself, is as simple as it appears. What could we make which would indicate nothing, be connected to no history, avoid any reference? The problem is not as much formal as it is conceptual: every work of art presumes an audience, a community which shares a discourse and a social context. That is, works of art are made, not so much of forms and manipulated materials, but of meanings. And the meanings are comprised of the relations between relations, which is why anything can be used in a work of art, theoretically, and satisfy our inherited definition of what constitutes a work of art. Whether in fact, in practice, that work of art is recognized as such is the result of two overlapping arenas of immense complexity—both being dialectically poised but experienced as separate.

One arena is the community of artists who collectively, through individual effort, define what is meaningful at a particular historical moment concretely within the practice of their activity. Interwoven with this community, socially, culturally and economically, is a community comprised of art historians, critics, dealers, collectors, and managers of cultural institutions (and those wanting to become any of the above). The work of the second group is putting the work of the first group in the world.

Paper given at Mountain Lake Symposium III (October 7–9, 1982). The theme of the symposium, organized by Ray Kass, was "Art and Its Public." Other participants were Gerald Graff, Derik Guthrie, Donald B. Kuspit, George Rochberg, Ingrid Sischy.

Because it entails selection, explanation, and ultimately depiction, it is perceived as a creative activity, and in corporate America (and to a lesser extent in Europe) it increasingly is taking over the creative power of defining the picture of art itself to the world—which is to say what the work means.

The second arena is the mass cultural context in which the first arena is embedded, and is the process by which corporate America constructs a picture of reality for most of its citizens. The waning of the artists' ability to fight for the meaning of their work is a reflection of the increased power of the mass cultural machine to reduce cultural processes to economic power relations; the ever increasing institutionalization and bureaucratization leads to the commodification of art.

Yet, the cultural mechanism of this society gave birth to both the forms of mass culture and experimental art. And since the nature of mass culture is anti-self-reflexive (it, in fact, depends on a naturalization of the cultural), experimental art—as inherited from modernism—has the capacity to be both self-reflexive of its own discourse as well as that of mass culture. Even if its social and economic support systems tend to be elitist, its specialization—not unlike science for example—necessitates an informed participation and commitment of individuals, who, because of their social location, can conceptualize such an activity as part of their cultural horizon. (In other words, basically folks like us.)

Even with the specialized realm of experimental art, the present problems take forms particular to the specialization: increasingly as contemporary art represents respectability, social prestige and institutional authority, it becomes a cultural power with an economic form. In this regard the art historical market complex tends to function as a validating process which makes that form the ultimate meaning of the work. Previously there was a dialogue of ideas within art practice and the market economically reflected the social engagement with that interchange; more recently, it seems that the market has its own dynamic, the centripetal force of which pulls the artist into the market monologue. This, of course, as I said, reflects the general trend on a global scale within advanced industrial societies (regardless of their politico-economic systems) toward the institutionalization and bureaucratization of culture, where cultural forms are less the reflection of individuals and more trophies reflecting an institutional power which celebrates the corporate state's self-serving concept of the individual.

I do not think it is possible for the experimental artist, who by necessity must function as a specialist, to have a direct effect on mass society. The marketing necessities of the advertising or entertainment industries which constitute mass culture are prescriptive of the kind of meaning we are permitted to make. And, as well, it is very difficult to address mass

culture in terms meaningful to the art context except on a secondary level—with the first indexing itself to the issues of the art discourse. The reasons why ultimately the terms of the meaning of such work is indexed to art is that a viewer with no understanding of art, embedded only in mass culture, would probably not understand the meaning of the work as intended by the artist, whereas a speaker of the 'art discourse' also has internalized mass culture and can 'read' the art within the forms of mass culture; thus there is 'specialization', but also a de-coding of mass culture.

Thus, the paradox and problematic of our situation is that on one hand, the need for commitment and focus in order to grasp the subtle complexity of a more experimental art tends to draw its participants from that social class which already sees such activity as part of its cultural context—thereby making it elitist; and on the other hand, that same specialization is necessary in order to rupture and make visible—as cultural and account-able—the invisible, seamless 'naturalized' world-view constructed by mass culture. There are many younger artists in New York whose work, in various degrees, deals with aspects of mass culture. (I'm thinking of Cindy Sherman, Robert Longo, Sarah Charlesworth, Barbara Kruger, Martin Guttmann and Michael Clegg—to mention only the ones that come to my mind.) This stands as an alternative to an increasingly familiar list which includes Baselitz, Lüpertz, Immendorff, Fetting, Salomé, Chia, Cucchi, Paladino, Schnabel, Rifka, and so on and so on. The latter work must feed on aura and ambiguity as a mystification of the individual to the point where any asserted meaning that interferes with the institutional-ized authority of its role as a reference to the blue-chip forms of pre-60's art is cancelled. It's individualized Expressionism without a movement, because previously Expressionism shared cultural roots and an historical location which bespoke a signifying passion. Now, post-70's Expression-ism is a style device, detached and strategic, chosen from the racks of art history which are as available as the tubes of paint and stacks of brushes that sit with unabashed presumption in every art store.

Interestingly, work not related but significantly different from the work of the first group is that of Hans Haacke and Victor Burgin. The aggressive lack of ambiguity, as art works, poses another set of problems. Such lack of ambiguity gains for the work political points (in some circles) but it reduces the elements used within the work to simply 'carriers' of a mes-sage, as though form itself is devoid of content; thus permitting the formal elements to separate themselves from the content and be judged on what are ultimately conservative grounds for art: the familiar definition of art as illustration. Often as it is with much so-called political art the pro-gressive message demands a conservative form. Much of such work is neither that 'experimental' as art, nor that successful as left-wing advertising.

I spoke earlier of the erosion of the power of artists to fight for the meaning of their work. The political implications of this are enormous and this goes straight to the heart of the original political history of the concept of an 'avant-garde'. Although transformed and reformed by historical necessity, and with its practitioners subsisting in the basement of the art world (unless called to glory), something remains of the original intention and it is a survival instinct: without it in mass cultural society, art as we know it would probably perish. There can be no humanizing influence in a cultural activity where there is no political life or social value.

ON YVES KLEIN

The strength of Yves Klein's work, like all important work, is that to see it you must see art as an artist does—as a process, as a struggle to make and cancel meaning and re-form it; those objects, that physical residue of that activity, is simply the trace of such a life. Yves Klein was one of the few artists who could teach us this, and in a particular way: his work, like the best art, didn't provide answers, it raised questions. The more conventional forms of his activity remain, get celebrated, and seem more conspicuous, of course, because life tends to be conventional and people want art to match it. This exhibition, like so many exhibitions, teaches us a lot about an artist's work by showing what by necessity must be left out. (Parenthetically, I would add: for the artists here today—those who can read—I suggest you read the excellent catalogue *as well as* look at the objects which made it into the exhibition. The point being that artists who only see the objects in art are doomed to *make* art like an art historian—probably the route to money and mediocrity.) For Yves Klein, whose first work was to sign the sky, exhibitions like this one can only be a shadow of the real activity that made his work important, because, as we know, the sky will never fit into a museum.

One of the lessons to be learned about the art of our century, and Klein's work shows this, is that if art is a game, it is about making rules, not following them. Klein's work has the power of authenticity because it

Unpublished notes for a speech delivered at "Yves Klein: Conquistador of the Void," a panel discussion in conjunction with the Yves Klein retrospective at the Solomon R. Guggenheim Museum, New York, November 21, 1982.

was singular, uncompromising, no one else could have done it. In this sense it was the expression of one human being. But the work wasn't *about* these things, it wasn't *about* being expressive, it was expressive in the act of one man trying to make art visible to himself, and doing so in a way which helped *others* see it.

A NOTE TO READERS

Cathexis, among other things, celebrated 'picture blindness': the art context, always vulnerable to the most conservative aspects of popular culture, increasingly couldn't see the art for the pictures. I offered a corrective lens. Some actually suggested that they were upside down; art can never be upside down, but pictures can. Others were confused because they said "you use language, where's the language?"; I thought, it's in the art—even when it's a picture—but pictures seem to make them blind, so they can't see the art or the language: language can't be upside down, but words can.

Next, now, *Hypercathexis.* It represents, among other things, a cancellation, a blindness also, and a framed formalism. Is there a difference between *Cathexis* and *Hypercathexis* beyond that organization of perception which is that 'moment' my work represents? To perceive of course means to 'see', which we know is not as simple as looking. Since the pictures have made viewers 'language blind' let's have a look, I thought, at what we can't see. Of course, the part that becomes viewable, immediately comes up dead. Blind and dead, I thought I would make art for the 1982–83 season. We have grammar being discussed by mutes. Will the hand signals work or is no one listening?

There is no lack of paradox for work like *Hypercathexis,* I admit. That horizon which the present art context provides is comprised—in its public form—of commercial droolings increasingly lacking, rather than forming, a history or culture of their own, yet imparting, as a model of practice, a kind of ossified formalism because of that unconsciousness. In the sixties

First published in *Ars 83,* vol. 2 [ex. cat.] (Helsinki: Ateneumin Taidemuseo, 1983), p. 22.

we had formalism as an active ideology; now we have it as an apolitical nervous breakdown.

There is, of course, always a context for work, which we know, transcends (while it attempts to transform) any 'season'. The material of my work is not form, even while the work speaks of grammatical formalisms, it's about meaning, even when meaning must be cancelled or denied, here, at its parts, so the activity—there, as a whole, can signify.

The new work *Fort! Da!* addresses itself to two aspects of my work, one which has been somewhat secondary in the past few years. This is what I call 'the form of presentation'. My earliest work used photography (work like *One and Three Chairs* from 1965, for example) and I used it then as a *non*-art device as an alternative to painting *within* the art context; I used photography in a way which was detached and indexed to the *general* use of photography in the culture, rather than the craft of a 'fine art' of photography. It was a neutral device then; other than its use by Rauschenberg and Warhol in paintings with silkscreens, photography was not used within the context of experimental art. In the late sixties photography got picked up by other artists and became part of the repertoire of conceptual art, and the 'earthworks' brought home to the gallery. I've used photography continuously in work since that time, but always in a way which masked, to some degree, the photographic process. The reason for that is clear: the critique of the modernist practice of painting was based on the limitation of a media-defined activity. To simply replace painting with photography was the wrong emphasis. I'm not involved with the craft of photography, I never take my own photographs even—it's not the photograph itself which is 'expressive', it is its function within a device as *that* concept of art as posited in the work. But within this twenty-year period something clearly has changed: photography has become art pervasive. Simultaneously, certain art devices (use of language, installations, etc.) initiated by work like mine in fact became themselves institution-

First published as a flyer, "Statement [text for wall panel]" (New York: Leo Castelli Gallery, 1985).

alized as style/cultural authority. So that 'form of presentation' of this new work is to turn these two situations—situated within my work—upon themselves, making both visible in a kind of mutual self-cancellation. This is directly related to the second aspect of the work, which is the operative role of the viewer. I always considered the 'spectator' to be an important part of the making process. My work never, I believe, pandered to the presumptions of the viewer—in fact, I feel that the 'making process' hinges on rupturing those presumptions. I don't mean by that simply to purvey 'new forms' which re-confirm endlessly the same meaning systems, but rather engage a serious re-examination within the practice of art of those meaning systems. One must take into account *all* of those elements which participate in making meaning. This, it seems to me, calls for art to be a test, not an illustration.

ON MASTERPIECES

The 'masterpieces' are those works which deny the possibility, now, of *masterpieces*. The best work, in our time, are works which show the process of art. Such work includes the viewer as part of the conversation, joining them to the cultural and historical context of the artist which produced the work. Artists experience art as a process. Art historians experience art as a series of 'masterpieces'.

Since I begin with the premise that artists fundamentally work with meaning, not materials, it then follows that the choice of materials is essentially arbitrary and outside of the lived meanings that, within a particular historical and cultural moment, they provide. For this reason context is a major element in the work of our time. The presentation of earlier works of art tend not only to eliminate that context, but to *re*-contextualize work in order to *re*-construct new meanings needed by the curator or institution. This is easier to do with work framed as 'master-pieces' because it suits the needs of a public taught to see work as having a fixed meaning. This provides for the curator, then, an established vocab-ulary with which then they can creatively maintain their own art histor-ical discourse.

This discourse is experienced as 'objective' and permits, within its dynamic, the continual introduction and re-assessment of 'masterpieces'; 'masterpieces' are then re-used to spin new historical scenarios, etc. Con-versely, work which successfully resists such reification by constructing meanings contingent on a signifying context inappropriate to such framing is forced to make for itself a disjunctive cultural life. Such work is a

Unpublished response to a questionnaire by the Musée de l'Art Moderne, Paris, 1985.

constant reminder that the artists are the first producers taking respon-
sibility for the meaning they produce, and that they experience art as
continuous, and primary. It is such a sense of continuity which integrates
artists with their own historical moment and provides the opportunity, if
not necessity, for a critical relationship with a re-presentation of their
production (and, by extension, all cultural production) as a reifed frag-
mentation of meaning into objects vying for status as 'masterpieces'. A
simplistic scenario puts the artistic struggle in this century between Pablo
Picasso and Marcel Duchamp. If one wants to understand the art of the
next century, one understands that Picasso made 'masterpieces' and he
belongs to the collectors; Duchamp didn't, and he belongs to the artists.

A PRELIMINARY MAP FOR *ZERO & NOT*

We have a cluster of contingencies: a text, which represents an order of arbitrary forms which make a systemic sense (believable while they teach belief). The words are meaningful, contingently, in relation to the sentence, and the sentence to the paragraph. The paragraph, from *The Psychopathology of Everyday Life* by Sigmund Freud, is meaningful in relation to the exegesis of Freud's work. The use of Freud's work, in this context, is contingent on understanding its use by the 'author' of *Zero & Not* (beginning with *Cathexis* in 1981) as a kind of conceptual 'architecture'—a ready-made order that, while anchored to the world, provides, as a theoretical object, a dynamic system. This text, though, is also just a device: a surface, a skin. There is another syntax, also anchored to the world, which is the architecture of rooms which also orders this work. While the order remains there, the gaps and omissions (the entrances, exits, views in and out—that which puts the work in the world) rather than disrupt the order clarifies and qualifies the room (the world) and art (that which is Not, but within this order, is). The cluster of 'arbitrary' orders has also a 'made' order which unifies it, beyond the unification given to it by the architecture of the room(s) itself. It begins with a counting-off of the paragraphs, repeated until the walls are full; and that cancellation which constructs as it erases, suggesting 'one thing' (a field of language itself) present, while removed. Not just absence presented, it is language reduced to words, making the texture of reading itself an arrival at language, an arrival which constructs other orders, ones that

First published in *Chambres d'amis* [ex. cat.] (Ghent: Museum van Hedendaagse Kunst, June 1986), pp. 102–107.

blind as they make themselves visible. The numbers separate the para-graphs as they unify the work. This provides the field in which the color-coding systemically underscores, repeatedly, the fragments that make up the unitary paragraph, a made-up order which constructs (or deconstructs) the paragraph differently than the other order (of the world) which makes the paragraph with sentences. And differently, too, than that order which made rooms out of windows, doors, changing ceilings, and those walls which presume the lives which will be lived within them.

QUA·QUA·QUA

Modernism began in or about December, 1910.

Virginia Woolf

Modernity invests its trust in the power of the present moment as an origin, but discovers that, in severing itself from the past, it has at the same time severed itself from the present.

Paul de Man

Sometime in 1971 I found myself thinking about a forthcoming show at the Castelli gallery, then on 77th Street. It was only my second show, the first one had been two years earlier when I was 24 years old. I was both honored and excited, but also troubled by the showing context, as I had been the first time, and I was perplexed as to why. The gallery was the one I respected most in the world; the art I had learned most from I had usually seen there first—the gallery was for me history itself, and you could *walk* in it. But now that I was showing there, and had a personal relationship with the place I began to re-think the meaning of my earlier experiences. I realized that, psychologically, as a young man—and American at that—I had turned that space into a kind of historical, maybe historicized, *theater* which I had romanticized and thereby fictionalized. I saw it not as simply a valued residue of human history—of particular humans and a particular history—but as the physical embodiment of a history I was always outside of and looking in. There was an authority to that historical form which didn't, it seemed, include me. The gallery, as

First published in *Implosion: Ett Postmodern Perspektiv* [ex. cat.] (Stockholm: Moderna Museet, 1987), pp. 70–73.

an historical institution, concretely manifested a *link* that connected me to a history that wasn't mine, and no romantic form I respected could make it so. I was standing in the present, but I was feeling also where it had come from, a path made from the experiences of others.

I realized that, as part of a generation—one simply *there*, I had gotten to the point where the *Ecole de Paris* and Modernism itself was as far from the reality of my daily life as were the works of Manet and Velasquez, even as important as that work was to me. I could learn from many things but Picasso just wasn't part of my life, even slightly so. It was *all* of equal distance from the life I knew. I realized that perhaps unlike the American artists of the fifties, I could not say I shared a history with them. The world had changed, and so had the discourse which formed me in it.

So standing there in the gallery and sensing what felt like 'authentic' history, yet one which precluded me, also brought me back to a consideration of *why* I was there. The paradox was that I had found myself in a kind of intersection, arrival without a sense of direction: from the point of practice, as I saw it, this inherited history experienced its own form as one of completion, not engagement. Nonetheless I also realized that those artists such as Johns, Warhol and Judd were obviously the same ones who had made Modernism visible, and thereby began a process which severed that 'link'. It was their work which made Modernism 'readable' and removed from me: one could say that they articulated Modernism so well that they made it possible for those of us that followed to end it, as some have claimed.

The work I would be showing, *The Eighth Investigation*, was an installation using clocks, tables and notebooks which used interdependent groupings of information in a contingent and contextualized way. I had seen earlier works of mine, such as the work in the 'One and Three Objects/Subjects' series or the negative definitions, become quickly conventionalized into the generally conflated history of painting—even though *I* saw these works as a *rupture* of that history. If your work is the process of signification itself—what I saw as a concept of a practice of *art*, retrievable from a tradition-heavy history of painting and sculpture—then obviously the context of the gallery itself became part of the work. If there was an internal problematic to the work it could, in any case, only be experienced as that interface with the world which the gallery, as a meaning-giving system, uncritically represented. *The Eighth Investigation* (most recently seen as part of the Panza di Biumo collection in the opening exhibition of MOCA Los Angeles's Temporary Contemporary) was, among other things, a device to disrupt the contemplative space of the painted 'windows' which formed that 'historical theater'. People were obliged to participate in the work. One couldn't 'see' the work by just looking (an attribute of art of any consequence) however this work heuristically (and

anti-formally) pushed the point. Also, by forcing the viewer into the *process* of the work, it became an *event* which located and included the viewer. Events, in this sense, take place in the real time of that viewer and include them in the real-time location of the work—and historically connect them to it—while the viewers experience their own subjective role in the meaning-making process.

So it seemed important for me to recognize the texture of an historicized environment which that space represented, and use it. In wanting to show that art was more than the things employed in its construction—its 'furniture' and form—I was hoping to break both the habituated ways of seeing as well as the meaning of what was seen there in that space.

Devices, methods, ways of working—call it what you wish—I used in the mid-sixties employed language and detached pseudo-scientific style uses of photography (*Photography* being still a fine-artsified *craft* at the time, outside of the context of art). By language I mean both texts, *as well as* in terms of relations internal to the photographs and texts, but also between them and the world. In the late sixties photography really became indentifiable (because it was, contextually, 'new') as a kind of art *style*— which was exactly what I was trying to avoid in the first place by using it. Some years later I was able to again use photography after it had so much become part of the artist's kit-of-possibilities (without the heavy aura baggage of paint) so as to construct an ideological presence as part of an alternative practice to Modernist painting.

For all these reasons then, by 1971, I felt compelled to present work which organized that space in ways which would disrupt the seamless flow of a history which wasn't mine. Understanding that not everyone walking into the installation would make the effort to get engaged with it (they could choose to get into it or not, but they couldn't fake it) I thought I should at least provide a kind of 'map' showing the relation of this work to the world, so to speak. The test I put on the wall, this 'map', began by outlining the contingent circles employed within the work itself and proceeded, with no sense of hierarchy, to more theoretical—yet extra-systemic—frames of meaning. In one of the last entries I described the work as 'Post-modern'. To my knowledge, at least, it wasn't a term that existed but it was, for the reasons I mention at the beginning, how I was experiencing my own work in relation to that sense of history which the space provided.

I realize, of course, such reminiscence is useless until it places history at our disposal, framed by a present relevance. Finally, the point to my comments above concerns work before us *now*—both mine and others— to construct a present shaped by a shared history, one that must be seen as a critical understanding, if it is to be seen at all. The 'second agenda' of the art of this century is becoming visible now as what is recoverable

after the smoke clears from the spectacle of heroic Modernism. This other agenda simply speaks of a practice of art which neither loses sight of itself *nor* of that mass cultural horizon which forms us. The forms of authority of a traditionalized practice beget, repetitiously, not only their own forms but the authority to make them.

Post-modernism has become a term associated with many things, much of it bad. It's used as a rationalization for some of the most reactionary sentiments our culture has seen in some time, much of it being the worst aspects of Modernism running amok with a botched face-lift. It's in keeping with Modernist history that its death-rattle would present itself as its own alternative in painting and architecture and be a howling financial success to boot. There has been another tradition begun within Modernism to heroic painting and marketed aura. The present exhibition I feel, presents this 'tradition' well. As Rolf Ahlers has said, "The reflective assimilation of a tradition is something else than the unreflected continuity of tradition."

NO EXIT

I suspect that we have not yet gotten rid of God, since we still have faith in grammar.

Friedrich Nietzsche

Men fight and lose that battle, and the thing they fought for comes about in spite of their defeat, and when it comes, turns out to be not what they meant, and other men have to fight for what they meant under another name.

William Morris

I. TO REMIND

Insofar as its public reception was concerned, Conceptual Art was defined at birth in relation to formalism and, by critics like Lucy Lippard, in the language of Minimalism. The strategic reason (from my point of view at the time) for emphasizing dematerialization and anti-objectness was the immediate necessity to break away from the formalist terms of the time, that is, from an aestheticized art philosophically conceived of in terms of shapes and colors employed for the good of 'superior taste'. By removing the formalist defined 'experience', it seemed obvious (our heuristic point went) that the condition of art would have to be looked for elsewhere. In this regard, what we initiated was a kind of readymade by negation. This removal, or cancellation, was really a defetishizing of the Duchampian readymade in the form (both figuratively and, in my case, literally) of a

First published in *Artforum* 26, no. 7 (March 1988), pp. 112–115.

negative photograph of our inherited horizon of artistic meaning, and the simultaneous act of its positive negation.

We have seen how such heuristic devices became identified (as in *product* identification) with individual artists, as a kind of mutant 'style'. It is as though the social event of that initial cultural rupture fixed a conversation, as a product of a time, into the shadow cast by its reified moment. As artists, we had a choice: to resist this misidentification, or to readdress this celebration as *part* of the process. These two possibilities, of course, defined the struggle of the enterprise at that time as much as it would over the years define the limits and historical location of such work.

But to understand the present relevance of Conceptual art, it must first be *separated* from such work, which should be seen as post-Minimalism. Those artists who chose the latter, it can be seen since, have fairly consistently made work that neither evolved in relation to cultural or social change in the world, nor engendered much enrichment of our understanding of art (save what particular members of the critical establishment gleaned from the production of others and applied to them.) By and large, such work continues to be basically stuck in a '60s frozen moment, with the *gesture* of that initial act representing a sole philosophical moment of practice. The replication of basically that same act over a 20-year period, however—whether or not it is a betrayal of original aims—certainly eclipses whatever those original aims were, offering up instead the empty meaning of an ossified 'style'.

The context of Minimalism, in the mid '60s, was that moment when the two major forces in American art, Pop art and formalism, were just beginning to reach full stride. Pop art, because of unprecedented public interest and support, and formalism, due to an equally unprecedented hegemony in the art-historical/critical complex and its vast institutional support system, seemed to be part of a power horizon detached from the social and cultural unrest taking place in society. In such a context, Minimalism arrived as the beginning of the end of Modernist 'avant-garde' art movements. But that should not diminish for a minute the force and clarity with which that rupture made its debut. While Clement Greenberg and Michael Fried were shoring up their minions and extolling an art that naturalized the prevailing institutions (inside of art and out), the Minimalists presented objects (*not*, at least *then*, 'sculptures') which were *outside* the space of institutionalized pictorial fictions, *and in the world.*

It was precisely this world, which contextualized and provided meaning for *things* (even theoretical 'things') used as art, and, furthermore, dealt with the effect of such meanings *on the world*, which gave rise to work such as mine. From my point of view at the time, Minimalism—as important as it was to us—still functioned as sculpture (and we now see it *became* sculpture), which meant that its dispute with formalism could

be trivialized as one of taste (just a cooler one). Though Minimalism created the context in which it could emerge, Conceptual art, to be understood, must be defined in terms of a *difference*. Post-Minimalism took the formalist, and Modernist, concern with the limits of materials and techniques, used Conceptual art's strategic device of negating that concern, and institutionalized this practice as a negative formalism. This provided the Modernist agenda with a revitalized 'avant-garde' face without letting go of the premise that the repository of central artistic concern was still in the object, if only in its absence. In this regard, post-Minimalism's primary concern is with a radicalization of alternative *materials* rather than alternative *meanings*. But it is issues of meaning—the process of signification—that define Conceptual art and have made it relevant to recent art practice. The substantial import of such work, it would seem to me, has been the radical reevaluation of how an artwork works, thereby telling us something of how culture itself works: how meanings can change even if materials don't.

With the subsequent 'opacity' of the traditional language of art (painting and sculpture) in the sixties, the objects (paintings or sculptures) themselves began to lose 'believability' (the language was losing its transparency). One was always in a position of being 'outside' the work and never 'inside'. With that began, through the sixties, an increased shift of locus from the 'unbelievable' object to what was believable and real: the context. Objects or forms employed became more articulations of context than simply and dumbly objects of perception in themselves.[1]

"(Notes) on an Anthropologized Art," 1974

II. TO PROPOSE: THE 'MADE-READY' AND THE READYMADE

A.

It says no medium is pure. It is . . . the art of *bricolage*, of throwing disparate things together. It asserts that there can no longer be the isolated work of originality or genius that extends the possibilities of a medium. There can be no such originality; one cannot initiate one's work from oneself.[2]

In the discussion of recent art, commentary like that immediately above is not atypical. The presumption in such a comment is, of course, that traditional 'primitive construction' techniques of auratic art are basic to art production—despite the fact that an alternative practice (in the form of the readymade) has existed for over sixty years.

But the reason we must reject such a traditional practice is because it masks, within the aged baggage of a 'symbolic' value system, the *actual* signifying structure from which meaning is generated. There is no 'hidden' meaning in the metaphysical sense that the interpretive needs of an auratic art suggest. Rather, it is a *layering* of levels of meaning and *the*

relations between them that subvert the banal reading of 'goal-seeking' elements of mass culture, and make possible 'original' work from such a *bricolage*. Indeed, it is only in constructive appropriation—what I'll call here the *'made-ready'* that the process of art is accountable and demystification is possible. The cultural system—with its visible social anchors—is part of the analyzable given, not removed from criticism through incorporation into an auratic, heroic cosmology.

Practitioners of the 'made-ready' are not guilty of the apocalyptic program of which they are accused. Obviously, what one person sees as the end, another sees as the beginning. So, first, it must be recognized that such appropriation is *another* practice of art—a practice that by its nature subverts, redirects, or negates theoretical assertions (or anything else) initiated elsewhere. Second, one must recognize the formalist bias in statements such as, "In reducing themselves to their most primitive elements they would have exhausted all possibility of further innovation; no further advance would be possible,"[3] which locates the meaning of art *in* 'elements' rather than in the signifying dynamic inherent in the relations *between* elements and between them and the world.

Artistic activity consists of cultural fluency. When one talks of the artist as an anthropologist one is talking of acquiring the kinds of tools that the anthropologist has acquired—insofar as the anthropologist is concerned with trying to obtain fluency in another culture. But the artist attempts to obtain fluency in his own culture. For the artist, obtaining cultural fluency is a dialectical process which, simply put, consists of attempting to affect the culture while he is simultaneously learning from (and seeking the acceptance of) that same culture which is affecting him. . . . Now what may be interesting about the artist-as-anthropologist is that the artist's activity is not outside, *but a mapping of an internalizing cultural activity in his* own *society. The artist-as-anthropologist may be able to accomplish what the anthropologist has always failed at. A non-static 'depiction' of art's (and thereby culture's) operational infrastructure is the aim of an anthropologized art.*[4]

"The Artist as Anthropologist," 1975

My initial reasons in the sixties for attempting to use language as a model for art (in 'theory' as well as introducing it as a 'formal' material in art practice) stemmed from my understanding of the collapse of the traditional languages of art into that larger, increasingly organized, meaning system which is the modernist culture of late capitalism. Traditional languages of art are controlled zones where specialized, fetishized markets are allowed to follow their own circular paths displaying 'freedom' safely out of the way of those mechanisms of organized meaning—which in varying ways amount to the increased institutionalization of everyday life. Conceptual art, as a critical practice, finds itself directly *embedded in that realm of organized meaning; but historical understanding means that the work begins to understand itself; it becomes critical of those very processes of organized meaning in the act of self-understanding. It criticizes this system through the act of criticizing itself. The point made in the sixties about "breaking out of the traditional frame of painting*

*and sculpture" and the kind of work necessitated by such a break—
seeing what art 'means' outside of such a traditional language, provided
the possibility of seeing how art acquires meaning. Conceptual art then
seemed to take two forms, either it evolved into a stylistic paradigm
competitive with, while extending, traditional art, or it withdrew into
theory. This paper, then, speaks from my critical, and intimate, relation-
ship with both.*[5]

Within the Context, *1977*

I have focused, then (both in my work and in texts like those cited above),
on the development of an art that is truly an alternative practice. We have
no need for the isolated avant-garde *gesture*, which by necessity must feed
off a traditional support and become its unwilling collaborator. Nor, for
that matter, do we need the practice of artists who, having the right
political message, nonetheless parasitically use the given *forms* of art, be
they borrowed from an alternative practice or not, as though they were
transcendent categories just waiting to be filled with the 'correct' content.[6]
Fundamentally, both perpetuate a conservative idea of art's potential.
What separates Conceptual art from both is the understanding that artistic
practice locates itself directly in the signifying process and that the use
of elements in an art proposition (be they objects, quotations, fragments,
photographs, contexts, texts, *or whatever*) functions not for aesthetic pur-
poses (although like anything in the world, a proposition can also *be*
aesthetic), but rather as simply the constructive elements of a *test* of the
cultural code.

The 'made-ready' and the tradition of the readymade have shown us
what the process of art is; the path of that showing has meant the devel-
opment, through its self-reflection, to the critical location of an ideological
self-knowledge; this alternative tradition sees art, simply put, as a *ques-
tioning* process. The various scattered agendas of formalism survive,
finally, with only themselves—object and project—offered up in produc-
tion; art, there, is seen as an *answering* process, satisfying society's system
of commodity need.

B. A PRELIMINARY MAP FOR *ZERO & NOT*

*We have a cluster of contingencies: a text, which represents an order of
arbitrary forms which make a systemic sense (believable while they teach
belief). The words are meaningful, contingently, in relation to the sen-
tence, and the sentence to the paragraph. The paragraph, from* The Psy-
chopathology of Everyday Life *by Sigmund Freud, is meaningful in
relation to the exegesis of Freud's work. The use of Freud's work, in this
context, is contingent on understanding its use by the 'author' of* Zero &
Not *(beginning with* Cathexis *in 1981) as a kind of conceptual 'architec-
ture'—a ready-made order that, while anchored to the world, provides,
as a theoretical object, a dynamic system. This text, though, is also just
a device: a surface, a skin. There is another syntax, also anchored to the*

world, which is the architecture of rooms which also orders this work. While the order remains there, the gaps and omissions (the entrances, exits, views in and out—that which puts the work in the world) rather than disrupt the order clarifies and qualifies the room (the world) and art (that which is Not, but within this order, is). The cluster of 'arbitrary' orders has also a 'made' order which unifies it, beyond the unification given to it by the architecture of the room(s) itself. It begins with a counting-off of the paragraphs, repeated until the walls are full; and that cancellation which constructs as it erases, suggesting 'one thing' (a field of language itself) present, while removed. Not just absence presented, it is language reduced to words, making the texture of reading itself an arrival at language, an arrival which constructs other orders, ones that blind as they make themselves visible. The numbers separate the paragraphs as they unify the work. This provides the field in which the color-coding systemically underscores, repeatedly, the fragments that make up the unitary paragraph, a made-up order which constructs (or deconstructs) the paragraph differently than the other order (of the world) which makes the paragraph with sentences. And differently, too, than that order which made rooms out of windows, doors, changing ceilings, and those walls which presume the lives which will be lived within them.[7]

Artist's statement, Chambre d'Amis *catalogue, 1986*

The use of Sigmund Freud's theoretical work as a 'made-ready'—from my *Cathexis*, 1981, through *Modus Operandi*, a 1987 series of exhibitions in the United States and Europe—has permitted me to employ various strategies (and, for my problematic, risks) while continuing with the committed agenda outlined above. The theoretical object—the system of thinking of Sigmund Freud—was chosen not only for its rich generative complexity, for its use within a variety of discourses, and for the unchartable impact of its practical implication, but also because of its internalization in society and in that culture which forms, and dialectically describes, both. The pervasive influence of Freud continues to generate an effect on our reading of numerous cultural codes. We know where it locates itself, we can't say where it doesn't. 'Looking for meaning' in a Freudian context, out of context, provides a certain self-reflexivity in an *art* context about that process itself.

Beyond any instrumentalized sense of a 'made-ready' stands a prior 'made-ready': my own history. This means, to some extent, that we begin with a psychologically organized approach, a 'target' ethnology. There are frames of references and like any other artist who has worked for over 20 years, I must account for my own work always, if only partially. Therefore, some of the bricolage of my practice negates by positively including reused fragments of prior work—out-of-context but reframed—so that one 'text' is cancelling itself in another. In this way, individual 'works' maintain equal weight, and cancel with finality, the psychologized ordering of auratic work and its unknowable suggested metaphysics.

My use of Freudian 'cosmography' as a made-ready has a dual role. First, it provides a larger signifying structure which can locate specific art propositions, and a theoretical context which is nonassertive (a negated theoretical presence rather than a 'to-be' interpreted lack). In other words, it provides a 'made-ready' conceptual architecture. But these houses don't close; there is no 'inside' or 'outside'. Second, this Freudian cosmography functions as a 'meaning-active' material for the construction of works; the setting up and the cancelling out: a negated presence and a positive absence.

<div align="center">C.</div>

Such texts, as art, initially demystify themselves: they reorganize the nature of the relationship between the 'viewer' and the work. Rather than isolating the viewer as individual faced with an enigma ('abstract' art) or projecting him/her into another, fictional space ('realism') such work connects the viewer/reader on the level of culture through the language of the text while they deny the viewer/reader the habituated narrative or pragmatic/instrumental role and meaning for the text. Once connected with the text, the viewer, as reader, is active and part of the meaning-making process. By being inside looking out, the viewer/reader looks for meaning within relationships, *relationships established within and between social and historical contexts.*[8]

"Text/Context," 1979

When viewed 'normally' the fictive space of the painting permits the viewer an entrace to a credible world; it is the power of the order and rationality of that world which forces the viewer to accept the painting (and *its world*) *on its own terms. Those 'terms' cannot be read because they are left unseen: the world, and the art which presents it, is presented as 'natural' and unproblematic. Turning the image 'upside-down' stops that monologue; one no longer has a 'window to another world', one has an object, an artifact, composed of parts and located here in this world. One experiences this as an* event, *and as such it is an act which locates and includes the viewer. As an event it is happening now* (in the real time of that viewer) *because the viewer, as a reader, experiences the language of the construction of what is seen. That cancellation of habituated experience which makes the language visible also forces the viewers/readers to realize their own subjective role in the meaning-making process.*[9]

"Notes on Cathexis," *1981*

The 'equal weight' that I referred to in section B can describe as well the relationship between the viewer/reader and the artist/author, and their joined moment as the collaboration of signification. The dialectical spin of such signification is the final construction which remakes and re-forms the 'made-ready', creating a dynamic constellation; signifying as it constructs itself within those cultural codes that punctuate the interface of meaning between the viewer/reader and the artist/author. The construc-

tion of the participating viewer/reader is not simply the completed and final work, no more than the act of reading, or viewing, is the act of possession.

The practice of the 'made-ready' has clarified, within its constructions, how *specific* elements (or forms) used within art, as within language, are by and large arbitrary; the sense can only be understood in the systemic whole. And it is such a systemic whole that not only makes possible the production of further meaning, but joins the viewer/reader and artist/ author within a *social* whole as well.

Notes

1. Joseph Kosuth, "(Notes) on an Anthropologized Art" [reprinted in this collection, pp. 98–99].

2. John Rajchman, "Postmodernism in a Nominalist Frame," in *Flash Art*, no. 137 (November–December 1987), pp. 50–51.

3. Ibid., p. 51.

4. Joseph Kosuth, "The Artist as Anthropologist" [reprinted in this collection, pp. 120–121].

5. Joseph Kosuth, *Within the Context: Modernism and Critical Practice* [reprinted in this collection, p. 161].

6. "As a practice such work denies the philosophical implications and political character of culture; it assumes a separation between form and content, theory and practice. Work which presupposes the possibility of political content within a 'given' cultural form is taking an idealist position; the implication is that politics is located as content, and forms are neutral, perhaps transcendental. Philosophically, as a politics of culture, they are agreeing with the formalists: the actual practice of art is apolitical, it only waits for the artist to become politicized." Kosuth, "Text/Context" [reprinted in this collection, p. 181].

7. Joseph Kosuth, "A Preliminary Map for *Zero & Not*" [reprinted in this collection, pp. 221–222].

8. Joseph Kosuth, "Text/Context" [p. 180].

9. Joseph Kosuth, "Notes on *Cathexis*" [reprinted in this collection, p. 200].

'PHILOSOPHIA MEDII MARIS ATLANTICI', OR, RE-MAP, DE-MAP (SPEAK IN THE GAPS)

Early Realization: You can have a map of Manhattan which shows only the fire hydrants. Within the map it is accurate for what it shows, the problems arise only *outside* of the map.

I.

We don't *live* within any map, but still we continually try to use them. As it is with any picture of the world, it defines *as a picture* our relationship with the world. Could we imagine a 'complete' map, one which accurately and totally described the world? Above everything else it wouldn't be useful. Maps can only be useful insofar as they *omit* articulately.

In many ways it is the process of eliminating which positively constructs any 'picture'. Within our culture of a constant bombardment of signification—let's call it 'meaning aggression'—what we *don't* include increasingly plays a positive role. Artists are finding it necessary to leave out, cancel, ignore, erase, misuse, disregard, sort of *dis*-appropriate, a variety of possible meanings in order to be able to speak in the gaps.

What is left out, of course, is very much part of the conversation. It can only be spoken about, perhaps by necessity, that way.

The 'creative' contextualizing of the whole of the production of art itself is also taking place in a parallel production. Critics, curators, and art historians also articulate by *leaving out* selectively. As artists we collec-

First published in *Europa Oggi* [ex. cat.] (Florence and Milan: Centro Di and Electa Spa, 1988), pp. 51–53.

tively share an experience of reification of a strange sort: a communal hostile affection toward the shows we are left out of. These are the ones, first, that we *always* remember, but more importantly: we understand that our non-presence has been an important part of the basic material which constructs the meaning of that exhibition.

The productive process of exclusion seems to work within this organizing system in two ways. Let's call them 'external' or 'internal'. That which is 'external' is usually institutional. Ask, for instance, a European artist what he or she thinks of the Whitney Museum, or a German artist what's in the French Pavilion this year. Another example would be my relationship, as an American artist, with this exhibition about Europe. Such an 'external' context can be seen as simply *naturally* given, like here is the mountain on the map, and, yes, *there* is the mountain. As 'professionals' we are trained to see it as the same mountain. The other, clearly constructed but *hoping* to be naturalized context, 'internal' is occasionally resented by artists. In this we may be making a mistake. We are not considering the important productive function which our non-presence plays. Recently, for example, I've taken particular pleasure in not participating in Muenster *or* Documenta, L.A. County Museum's history of the avant-garde, as well as commemorating my ten year anniversary as a non-participant in the Venice Biennale by non-participating in *this* year's Biennale (even though I've kept, and used, a studio in Italy for the past 17 years). I find these meaningful exclusions even though others continually want to point out to me the shows that I *have* been in.

It's very much a question of attitude, of course. I know why I would be invited to a group show at Barbara Gladstone and why I wouldn't be to one at Marian Goodman, and I savor that knowledge.

The problematic, however, lies in the hermeneutic shadow cast by large meaningful group exhibitions where the basis of exclusion is inconsistent or unclear. If we can't learn we don't grow as artists, and the culture suffers. Not knowing why, however, doesn't preclude that one isn't aware, nonetheless, of a positive role for one's non-presence. For example, I've had a kind of ghostly non-presence in Benjamin Buchloh's articles for years and have maintained a stronger presence that way than I suspect I ever could have as an acceptable participant. This way I've been able to help a whole group of artists without the risk of being called an opportunist. More, of course, than I can say for them—but that's why they've insisted on my non-participation in the first place. It's not simply that I enjoy, for another example, being the flaw in the Schaffhausen collection. There are many collections. For the artist, being in one or another has relative value. But letting your negative presence build a positive pressure within a good one, that's useful for everyone. I don't know whether its simply a refreshing way of having a conspicuous role without having been

'bought', or the manifestation of an integral critique of a curatorial process. But on the level of discourse such a 'presence' can project an equivalence—showing again that productive work, if meaningful, is its own reward.

II.

Let's re-map our earlier conversation about maps, and consider this text, put here. I'm invited to write, in fact, as a witness to this 'map' of Europe. The opening of Italy's first museum of contemporary art is an important occasion and I am honored. I am an American in Europe, also, and this text must address that. Here, perhaps my participation/non-participation represents the presence, unavoidably, of those parts of the conversation not said but without which nothing could be said. Although we speak of American art and European art—and much within both—we know these differences have become increasingly syntactic—in the face of semantic necessity.

Language, that is, 'to speak' speaks of this: everything cannot be said at once. Some words must follow other words—without which all would be meaningless even if all are not of equal importance. Without the larger text there are no words to value.

For now there is probably no American art, no European art, only celebrated differences within *one* thing. In an 'International' show it's possible to see 'Europe and America' in spite of how closely formed they are. Within that the difference seems more often useful than relevant. As an American artist I've often felt European until I'm here. I've experienced American exclusions because I'm too European and European exclusions because I am, after all, American. We have a global market economy and a multinational mentality, but without difference we feel we lose the possibility of a culture where knowing can be more than pragmatic.

From any anthropological perspective culture, finally, comes out of the earth. A people make their tools of survival from their specific place on earth and the hunting, farming or linguistic equipment they form speaks first of this. By and large European cultures are homogeneous because their shared experience *is* this. That shared experience constitutes a history and a culture. The plot of land called America also once had a culture which similarly evolved there, but which no longer exists. We know why it doesn't and the product of that is a European culture which, simply put, is not at home. The malaise of living in a culture without its roots in the earth has been well-documented by others elsewhere, but as art goes, if we wish to read our 'maps' intelligently there are further considerations. America, although a part of European culture, is Europe's 'other'. We are its self-witness, alternatively its super-ego and its id. Denied a

connected earthly 'place' American culture found a different location: a place in time. We need not know *where* a McDonald's or a Hilton is, but we know *when* it is: our century and now. The American exportation of this understanding has so successfully undermined locally experienced cultures based on *where* that they seem inauthentic and 'out of time'.

The American, as a European, has the time in which to say it, but not a place from which to speak. Europe provides that discourse—the history and the culture—which makes meaning possible. As Americans we have a sense of the century, but look to the source for meaning. Europeans, however, are de-centered and understand the necessity to re-direct a conversation that time has forced them to share. American artists come to Europe as European artists go to America; both as two halves of a dialectical whole, and both recognizing what they see missing in each other.

HISTORY FOR

Since the sixties, I've tried in much of my writing to distinguish, clarify, and define a practice I've called conceptual. I've tried various distinctions: 'reactive vs. conceptual' (1969), 'modernist vs. postmodernist' (1971), 'naive vs. anthropologized' (1972), 'stylistic conceptual art vs. radical conceptual art' (1977), and so on. For much of the eighties, such apparently subtle distinctions seemed unnecessary—and we know why. The present situation again demands such clarification, although my doing it at this juncture is problematic. Much of my theoretical writing in the sixties and seventies articulated a practice of art struggling to have effect. However, writing by artists seems to suggest a different ontology than that of critics and art historians: by taking subjective responsibility for our cultural production we cannot lay claim to psuedo-scientific 'objective detachment'. Therefore, by some paradoxical twist, my historicizing can be considered suspect because I was, and am, actually engaged. The rather absurd insinuation is that career needs of the professional art writer twenty years removed are more of a direct path to historical accuracy.

In a recent article ("No Exit," *Artforum*, March 1988), I found that a certain historical distancing, plus the effect of particular professional art writers (who were not there at the time) on the public perception of our work not only necessitated a clarification, but also suggested the terms by which to do it. I need not comment here on the rather bizarre experience of watching the working context one is within becoming institutionalized around one. I've watched the terms of our art historical institutionalization with increasing alarm as others plunder the residue

First published in *Flash Art* (Milan), no. 143 (November–December 1988), pp. 100–102.

of past production for their own theoretical needs. Worse, from the point of view of any accurate historical sense, they provide a kind of theoretical scaffolding to the production of particular artists who had none at the time, and are incapable of articulating one *now*. Yes, we know such things as philosophy are *in* the work, but if that is the case, then it is the responsibility of the artist to defend *that* meaning against the theoretical encroachment of others. (But, I suppose, the idea is that someone else's theory is better than none at all).

Should I be specific? From the point of view of its more popularized reception, conceptual art (my term stuck, though indiscriminately) seemed to constitute a kind of 'unified front' of divergent practices. These merged to form a 'competitive paradigm' to the ossified formalism of the Official Art of the sixties. We had land art, anti-form, Arte Povera, performance, video, and so on. To the extent that conceptual art was associated with minimalism—and it couldn't have come into being without it—minimalism offered it the possibility of having a cultural and market life. Early (though limited) support by minimalist critics also helped to distinguish the two and, we have seen, confuse them. Sadly, minimalism's easy assimilation into the mainstream as another kind of form in the history of sculpture basically constitutes the cleansing of its philosophical, much less ideological, weight. What of conceptual art's assimilation? Two examples suffice: minimalism's heavy presence in the Saatchi Collection and the total absence of conceptual art of the sixties, or the recent exhibition at the downtown Whitney Museum of "The Art of the Sixties," a strong presence of minimal works, but no conceptual art. This has become a common format. To the extent that conceptual art received popular acceptance, it was presented by the art critical establishment as a version of *postminimalism*—the standards of formalist authority being what they are. (I should add, from my perspective, minimalism should ultimately be perceived as 'pre-conceptualism'.)

The postminimalist framing of conceptual art, by and large, has been a by-product of the nascent Greenbergianism implicit in early *October* writing. *October* emerged partly as a response to *The Fox* by members of the art critical establishment that, although recently disaffected Greenbergians, were not ready to acknowledge an art practice they had ignored earlier at *Artforum*. In the intellectual desert of the New York art world, any consistent body of theory was welcome and *October* had it, and it has not been without effect. That *The Fox* was tough on *October* has not been forgotten. No surprise then, that to this day, no member of *The Fox* editorial board has been cited, quoted, referred to, much less reproduced in *October*.

The critical establishment is rightfully sensitive to the meanderings of their intellectual betters and, whether or not 'ideologically' aligned with *October*, *October's* 'acceptable' list has by and large stuck. Robert Pincus-

Witten's postminimalism may not be Rosalind Krauss's, but the production promoted is not all that different. In any case, now within such a *creative* panorama of history and theory, the post-minimalist framing of conceptual art has found its most articulate and doggedly persistent rewriting in the work of Benjamin Buchloh.

Among those *not* familiar with the work his writing attempts to help, Buchloh's texts deserve the respect that they get. For the rest of us, the reality of the reception of some of the work he argues for simply does not support his claims for it. Unquestionably, however, it is not uninteresting to witness the process of inauthentic work being validated by authentic theory. One is reminded of Clement Greenberg and the claims he made for the work he supported. In fact, the claims he made outlived the work. (The ironic exception, of course, was Frank Stella whom he mysteriously didn't support.) Whatever puritanical needs motivate aspects of Buchloh's critical choice within his theory, they seem misplaced. At this end of the 20th century, critical assessment of the market and its codes would seem to be more useful than its outright dismissal. (It's of course sheer folly to suggest that anyone we have heard of working today is independent of the market and Buchloh's list is no exception.) More importantly, such apparently laudable if misplaced concerns actually mask a more serious theoretical shortcoming.

The point to be made here, and it is striking, is that while all of these writers represent divergent 'ideological' backgrounds, they represent the critical establishment. And in spite of their claims, they constitute in various ways the continuation of the traditional idea of the practice of art. That idea—the physical trace of painting and sculpture—continues through them to be rationalized. Although they would all deny it, they represent the market's need to hang on to a sentimental mode of technology, even if it obscures a new role and understanding of art.

Though minimalism created the context in which it could emerge, conceptual art, to be understood, must be defined in terms of a difference. Postminimalism took the formalist and modernist concern with the limits of materials and techniques, used conceptual art's strategic device of negating that concern, and institutionalized this practice as a negative formalism. This provided the modernist agenda with a revitalized 'avantgarde' face without letting go of the promise that the repository of central artistic concern was still in the object, if only in its absence. In this regard, postminimalism's primary concern is with a radicalization of alternative materials rather than alternative meanings. But it is issues of meaning—the process of signification—that define conceptual art and have made it relevant to recent art practice. The substantial import of such work, it would seem to me, has been the radical re-evaluation of how an artwork works, thereby telling us something of how culture itself works: how meanings can change even if materials don't.

"No Exit"

Simply put, then, postminimalist work can be seen as having easily identifiable repetitive forms heavily cloaked with 'avant-garde' intent, but ultimately functioning as a product identifiable *style*. In short, the practice ends by not being an investigation (i.e., philosophically meaningful), but rather an exercise in art market *formal* continuity, even at the expense of theoretical consistency. In this regard a decorative use of words should not be confused with an investigation of language, nor should an embellished use of context necessarily indicate an investigation into meaning, Buchloh's efforts notwithstanding.

For me, from the beginning a defining characteristic of conceptual art was an understanding of art as a post-philosophical activity which, as a practice, constitutes an investigation into the production of meaning in culture. While this was reflected in my work and my writing beginning in 1965, I found the initial response to my work, around 1967, increasingly contextualized within a frame of reference almost exclusively individualistic, the terms virtually expressionist as a rationale. My proselytizing— partly a response to this situation—led me to find artists engaged in a conceptual practice in places as diverse as Denmark, Yugoslavia, Thailand, Japan, Canada, Argentina, Chile, Australia, and various cities around the U.S. as well as Europe, some of whose work is discussed in "Art after Philosophy." Much of this work was framed by the cultural traditions of its national context, not 'international', and for that all the more interesting. The problems for me were at home, in New York City, where the conversions to conceptual art by former painters were matched in quantity by its detractors in the art establishment. While organizing "Conceptual Art and Conceptual Aspects" for Donald Karshan at The New York Cultural Center—the first American museum presentation of such work—in 1970, I hoped that the title and organization of the show would help keep the focus and save the agenda. It was the first of several attempts I made at separating conceptual art from another kind of work which can now be seen as postminimalism.

It was the beginning of a process, however, which was to isolate me in New York. I found myself caught, basically, between American postminimalism on one side and my relationship with certain individuals in England (known somewhat later as Art & Language) on the other. The productive early years of the Art & Language group while I was engaged with it (albeit trans-Atlantically) were, I am sure, as valuable for me as I know it was for them. Without getting into a discussion of the personalities which formed it (and for that reason doomed it), suffice it to say that Art & Language was basically an art theory think-tank discussing the possibility of a practice and dominated by individuals who ultimately didn't have one. Those of us who did, had, by and large, left by 1975. The few that remained foundered until re-discovering painting after its re-

emergence in the early 1980s—apparently so happy to have a practice at last that they didn't mind cancelling the meaning of the original group and its work.

At the beginning of this text I made reference to a certain struggle on my part to maintain a particular clarity in our conception of 'conceptual art'. In some regard, that list of distinctions listed above constitutes an attempt to maintain a separation between what I considered historically unique and particular aspects of my practice and vision of art and its other postminimalist manifestations. What I have attempted to do, and not without tremendous criticism, has been to acquire and maintain a cultural voice sufficiently strong to be heard, yet maintaining a path independent of postminimalist concerns. My fear, and to some extent it has been justified, has been that conceptual art's bridge to mainstream art through postminimalism has blunted and unfocused the potential of its mission. It is my hope that the present revaluation of such work will clarify these issues and make the productive possibilities available to others at a moment in history when art must be re-invented if its potential is ever to be realized.

THE PLAY OF THE UNSAYABLE: A PREFACE AND TEN REMARKS ON ART AND WITTGENSTEIN

Ethics and aesthetics are one and the same.
Wittgenstein

PREFACE

Ludwig Wittgenstein's task in the *Tractatus*, as I see it, was a clarification of language. First, he wanted to give language a scientific, clear, specific, and sure basis: to articulate what *could* be spoken. His second agenda, to show what *could not* be spoken, was, by necessity, to be left unsaid through omission. But this agenda is, I think, incomplete, because his insight was, in part, also an acknowledgment of the collapse of the authentic voice of the traditional philosophical enterprise to speak of such things. If one takes as *language* the systemic organization of our cultural codes—our inherited *cultural horizon,* within which meaning is made (and consciousness formed)—then one can see that it is precisely here, manifested as art, where the constructive elements for indirect assertions are to be found.

The task of Ludwig Wittgenstein's early work was the construction of a general critique of language in which it can be seen that logic and science had a proper role within ordinary descriptive language. The result of this is a representation of the world parallel to mathematical models of physical phenomena. This leads to his second (and perhaps more important) point, that by falling *outside* the limits of this descriptive language, the

First published in *Das Spiel des Unsagbaren: Ludwig Wittgenstein und die Kunst des 20. Jahrhunderts* [on. oat.] (Vienna. Wiener Secession, 1989).

questions of value, ethics, and *meaning of life* must be the objects of another kind of insight and treatment. It is this second aspect of language where Wittgenstein's insights prove most useful in relation to art.

The activity I would like for us to review is our collective concept of what we call art now, and from that to consider what future role we can propose for it. It can be seen, I believe, that the assorted elements of the activity we call art now comprises a practice much more specific than we would suspect. This *cluster* of play collectively constitutes an implicit understanding of itself as a kind of *post-philosophical* activity. The work I am referring to here cannot be simply explained as the latest continuance of an *avant-garde* tradition. While that tradition may continue, in varying degrees, as art's inherited political culture, it in no way explains the increasing interest and presence of contemporary art in our society. In contrast to the immediate gratification of the entertainment commodities of mass culture, such work appears specialized and obscure, if not esoteric and elitist. Yet socially and economically, such artifacts have not only had continued cultural presence in this century, but the audience and participants for such work continue to grow, not decline.

The world that has arrived at the late 20th century has great difficulty in distinguishing the meaning of our accumulation of cultural forms out-side the networks of power relations, economic or otherwise. In some sense this can be seen as a *meaning crisis*. In the era of the crumbling of ideologies, when the religion of science offers its spiritual poverty, society feels the risk of living adrift of meaning. Art, that text looking for a context, risks suffering for the flexibility of its manifestations as it con-tinues to re-locate itself within those structures which make meaning. In our present so-called *Post-modern* time the traditional historicist ration-ales of art have increasingly become a process of market validation rather than historical understanding. Such models of art, when internalized by young artists or art historians, increasingly provide a context in which the market makes the meaning and gives the value. If art is more than the fashions of expensive decoration and it is to be more than the mindless regurgitation of traditional forms ignorant of tradition, then you will understand the importance of a reconsideration of no less than our fun-damental understanding of the role of art. This exhibition on the 100th anniversary of the birth of Ludwig Wittgenstein, presents itself as an appropriate occasion to re-think not just *how* art functions, but *why*.

1. The desire to understand cultural formation, and particularly art, in relation to language is the initial foundation to actualize a Wittgensteinian insight: drawing out the relation of art to language began the production of a language whose very function it was to *show*, rather than *say*. Such artworks function in a way which circumvents significantly much of what

limits language. Art, it can be argued, *describes* reality. But, unlike language, artworks—it can also be argued—simultaneously describe *how* they describe it. Granted, art can be seen here as self-referential, but importantly, not *meaninglessly* self-referential. What art shows in such a manifestation is, indeed, *how* it functions. This is best revealed in works which feign to *say*, but do so as an art proposition and reveal the difference (while showing its similarity) with language. This was, of course, the role of language in my work beginning in 1965. It seemed to me that if language *itself* could be used to function as an artwork, then that difference would bare the device of art's language-game. An artwork then, as such a *double mask*, provided the possibility of not just a reflection on itself, but an indirect double reflection on the nature of language, through art, to culture itself. *"Do not forget,"* writes Wittgenstein, *"that a poem, even though it is composed in the language of information, is not used in the language-game of giving information."*

2. Wittgenstein's *"unsayable"* constituted the significant value, because for him it underscored exactly those elements that cannot be verified by language. We can note, however, a process of cultural verification which occurs in art when the *language-game(s)* of art accommodate an additional shift, and adjust to a new *rule.* The change (rupture, inclusion) becomes institutionalized and is incorporated into the *reality* of the game, thereby forming part of the horizon of culture which produces consciousness. Wittgenstein found the necessity creatively to keep a separation between *fact* and *value.* This functions well as a model for us. The facts of an artwork do not, as cultural value, necessarily provide their own direct meaning. This is one of the major objections to both the *naturalized* aesthetic/decorative and expressionist theories of art, as well as one of the chief dangers of the presence of the market, in the meaning-making mechanism of art. It was Wittgenstein's project to preserve silently what was of value.

3. (Expressionism). The *self* is grammatical—it punctuates. Thus it cannot be named because every attempt to do that would presume it. It can be shown, and, as art, it can represent the limits of the world (culture, history) as a manifestation of it. As we *name art* we name the world, and make visible the self. The *language of information*—even in its most philosophical form—is incapable of such *descriptions*: the self and the world, within the realm of such language, shares no empirical moment.

4. Except what was the aesthetic *object*, we have with contemporary art now the possibility of that *object* being not limited to sensual escape but to a systemic conceptual leap—to a *discourse* which, by necessity, includes a reconceptualization of the world, insofar as the meaning-object

which engendered this leap could not be *seen* without an experience of it as representing an idea in the world.

5. We are confronted with a riddle when we confront the basic questions of life, and speculative language is not capable of solving it, for it is not to *be solved.* What we *are* capable of doing is showing the nature of the riddle as its cultural formation is historically grasped, through the codes of the living in their own time.

6. *"In mathematics and logic, process and result are equivalent"*
Wittgenstein

Works of art, as *punctuation*, are not a material of *content*, but rather marks of positioning within the interaction of a context.

7. It probably began here: an understanding that art had to make visible its own internal definition as it was perceived by the culture which had inherited it. The modernist project began a process in which the self-conceptualization of a practice shifted to see not just its own limits, but institutionalize those limits as a form of self-knowledge. It is here that the practice of art took on a philosophical aspect; the history of art in the 20th century, by and large, is a record of this process.

8. One question remains unsaid: What is *this* text? This text owes its existence to the parentheses of my practice as an artist. This text speaks from that first and last. While philosophy would want to speak of the world, it would need to speak of art as part of that, if only to deny it. That which permits art to be seen as *part of the world* also nominates it as an event in social and cultural space. No matter what actual form the activity of art takes, its history gives it a concrete presence. Framed by such a presence then, this theory is engaged as part of a practice. Such theory I'll call primary. Secondary theory may be no less useful (in many cases *more* useful) but the point I'm stressing is that it has a different ontology. Primary theory is no more interesting than the practice, *in toto,* is. However, theory not linked to an art practice is an unconcretized (or *unfertilized*) conversation after (or before) the fact. It is the *fact* of an artistic process which, having a location as an event, permits the social and cultural weight of a presence independent of pragmatic language. It is, in fact, the nominated presence of the process which *allows* secondary theory its *external object* to *be* discussed. Secondary theory, like philosophy in general, ultimately locates itself as an activity which attempts to explain the world that the external *presence* represents. It may be theory discussing theory, but the discussion of secondary theory always presumes the location of its subject, at some level, as having linkage to the *world.* Behind every text about art rests the *possibility* of an artwork, if not the presence of one.

Texts *about* artworks are experienced differently than texts that *are* artworks. It is abundantly clear by now, that we do not need to have an object to have an artwork, but we must have a difference manifested in order to have it seen. That *difference* which separates an artwork from a conversation also separates, fundamentally, primary theory from secondary theory.

The work of art is essentially a *play* within the meaning system of art; it is *formed* as that *play* and cannot be separated from it—this also means, however, that a change in its formation/representation is meaningful only insofar as it effects its *play*. My point above is that primary theory is *part* of that play, the two are inseparably linked. This is not a claim that the commentary of secondary theory can make. *Talking about art* is a parallel activity to making art, but without *feet*—it is providing meaning without an *event context* that socially commits subjective responsibility for consciousness produced (making a world). Standing guard, just out of sight, is the detached priority of an implied *objective* science.

One can perhaps, as well, understand the texture of the difference I am referring to between primary and secondary texts in the way primary texts are treated *by* secondary texts. I am considering here the treatment of artist's writings by art critics and historians. Beneath the often condescending *special* status such texts are given (used, like artworks are, as *nature* for the historians and critics to make *culture* from) there lurks a kind of philosophical unease, as though this sleeping Dracula may awaken, daylight or not, a professional stake through his heart or not; and ravage *their* countryside. (Well, here we are.)

9. One of the lessons for art which we can derive from the *Philosophical Investigations* is that I believe the later Wittgenstein attempted with his parables and language-games to construct theoretical *object-texts* which could make recognizable (*show*) aspects of language that, philosophically, he could not assert explicitly. This aspect of philosophy, *as a process to be shown*, resists the reification of the direct philosophical assertion.

The works in this exhibition—potentially viewed as specialized or obscure—should not be seen as self-contained *pictures of the world* in the way of much traditional art. The *direct* assertion of either a depiction *of* the world (a view) or *in* the world (an expression) *in terms of art* can reflect only the social location of a conservative institutionalized perspective. Such work reflects *the presumed view* of a unified society, as well as an earlier philosophical bias and world-view that is no longer credible. By such standards the work shown here will certainly fail, and thus seem *esoteric*. These works, not unlike Wittgenstein's later philosophy, suggest such *pictorial statements* (be it exterior/*view* or interior/*expression*) are a limited understanding of art's *language* and role. The

work included in this exhibition becomes meaningful, like language, on the surface of its play; everything in art is *simply put* before us, as it is often said. The *direct assertions* referred to above presume an ability to reveal *deep meaning* about the world, *directly.* What art *reveals* as a deeper meaning is shown, indirectly, as our cultural mechanisms are revealed (what I once called our 'ethnologic'). The potential of art lies in this *putting before us* a *manifestation* concretized as a cultural formation, and not as a (primary) theoretic assertion. This role for art would then suggest a practice which looks at *what* is used, and *how* it is used *outside* (as well as inside) of art's use of *meaning;* this will provide the culturally formed location of the *why* it is used. Indeed, it is this passage from *outside* to *inside,* (and what it tells us about the nature of the process of the practice) which, for the moment, is central to any understanding of art's post-philosophical role.

10. Part of the process which has limited our conception of art are the institutionalized paths *meaning* itself is permitted to take. As long as art is conceived of as only a *vehicle* for meaning, and the meaning of meaning remains closed, art's self-depiction will remain the very embodiment of society's resistance to transformation. Art offers no such *deep meaning* in those terms. The meaning of art is how we *describe* it. The *description of art*—which art itself manifests—consists of a dynamic cluster of *uses,* shifting from work to work, of elements taken from the very fabric of culture—no different from those which construct reality day to day.

Until artists abandon their presumed, uncritical and unexamined *meaning* for art, and instead consider closely their *uses* of elements within their work, and the function of that work within its larger cultural societal framework, art will continue along its path of atrophy into the decorative and fashionable. Until we extricate art from being the pragmatic agent of *expression* or depicted meaning, it will not gain that critical sense, which, if only implicitly, sees the terms of such meaning as petrified, and as such, functions as a signal-switch of power relations, like philosophy: a conduit closed and circular, severed from any social purpose. The illusion of the window of belief in both painting and philosophy remains, today, as a *deus ex machina* holding the viewer's position in check.

STATEMENT FOR *EX LIBRIS, FRANKFURT (FOR W.B.)*

The work that I have made for the city of Frankfurt constitutes, in some regard, a monument to Walter Benjamin. We begin with the 'nature' of architecture, and realize that architecture's conception of art, even at its most practical point, is always formalistic. *Ex Libris, Frankfurt (for W.B.)* was made for its specific context. It is framed by the cultural and intellectual history of Frankfurt, as well as the buildings at Braubachstrasse 30–32. It was the influence of Walter Benjamin's text "Art in the Age of Mechanical Reproduction" which helped suggest to me an exit from the loop of traditional painting issues in the mid-sixties. Benjamin wrote: "The instant the criterion of authenticity ceases to be applicable to artistic production, the total function of art is reversed. Instead of being based on ritual, it begins to be based on another practice—politics." The use of photography, public media, or neon were initially employed to construct a proposition about art while they simultaneously denied the traditional criterion for it. This permitted a view of art at the moment of its critical rupture. A necessary part of the agenda, then as now, has been the need for an art which can have the signifying function of art, and yet maintain a break with a culture which still depends on aura to provide meaning. The ritualized celebration of the 'authentic' which an auratic art now proclaims is the market baptism of the *in*authentic. By the same token, we might question the politics of an art which uses the illustration of *Politics* to mask its own lack of political reflexivity within its self-conception.

Written for an outdoor exhibition organized by the Kunstmuseum Frankfurt for the summer of 1990.

Many of the complex issues which Walter Benjamin attempted to address remain with us and part of the mission of this work is to remind us of that. The 'naturalized' landscape of urban architecture presumes its community, takes for granted the social reality which it participates in constructing. *Ex Libris, Frankfurt (for W.B.)* intends to articulate, illuminate, and punctuate. Within the social grammar which culture provides, the punctuation begins with art.

TEACHING TO LEARN
(A CONVERSATION ABOUT 'HOW' AND 'WHY')

Don't, for heaven's sake, be afraid of talking nonsense! But you must pay attention to your nonsense.
Ludwig Wittgenstein

It seems we begin with two points: an institution and a conversation. An art school, simply put, is a representative of the institutionalization of art. It represents the world as a collection of rules, practices, traditions, habits—about art—that are organized within a social order. The presumptions and prescriptions that are taught there are a *de facto* description of what art is. When you describe art, you are also describing how meaning is produced, and subjectivity is formed. In other words you are describing reality. By teaching a description of reality you are engaged in constructing it, and in this sense an art school is a political institution as much as a cultural one (insofar as one can separate them to begin with).

The conversation is inherited along with the institution (they form part of it) but that discourse is formed, possibly transformed, by the living. The discourse, when it is the choosing of *how* art is to be made, takes a certain form, prioritizes certain meanings. The most prevalent institutionalized form has been a concept of art which presumes itself to be either painting or sculpture. In order to liberate art from such a formalistic and prescriptive self-conception it was the agenda of work such as mine in the mid-sixties to critique that institution while it simultaneously provided an alternative to it. Any other role envisioned for art by necessity follows this transformation of our conception of it. For art schools then,

Introduction to forthcoming publication by the Hochschule für Bildende Kunst, Hamburg.

as for art, there is really only one process: this is a questioning process as to art's nature. This inquiry itself constitutes an institutional critique because the art student then sees his or her activity as being less one of learning a craft or trade (how) but rather as one which is fundamentally philosophical (why).

Since the role of all institutional forms is inherently conservative there is a process basic to an art school which attempts to promulgate and preserve whatever other institutionalized forms of culture exist concurrent with it. Thus, the prescriptive nature of an art school based on craft and tradition (or an updated version of that) means, that the institution is there to provide the *answers* as to what art is. In other words it engages in legitimizing the status quo of existing forms and norms: they know what art is and they are simply teaching it. This attitude teaches the inherited past of the art school. From the guilds of artists and craftsmen to the Academy and then the trade school in the recent past, artists have been taught how to make art, but not to ask why. Inquiries of a more philosophical nature have been seen as the preserve of the university and not appropriate to the 'trade school' demands of teaching the artist. What this has also taught, however, is that art—and culture itself—is apolitical. Importantly, even profoundly, this view, not limited to institutions as you will see, sees art's *process* itself as apolitical. Whether the *content* of an artwork is politicized or not is less of a problem for the institutionalized view of art than artworks that do not leave intact their conception of what art is, and by extension, what an art school should be. In this way such artworks question their authority, a much more political act than the *symbolic* 'acting-out' of the use of political content within an artwork which, as art, does not question its own institutional presumptions.

2

Because of the importance of this point in understanding the political life of art (and its relation to the teaching of art) it is necessary to clarify certain popularized misconceptions on this subject. From the political cultural point of view Hans Haacke's work, for example, regardless of the critical potential of his content within its temporal context, does not fundamentally challenge the self-conception of institutionalized art forms. While Haacke's adoption in the early seventies of a conceptual-style format as the carrier of his political content was successful as a device for questioning society, it was incapable of questioning its own participation in that society as an institution itself. Worse, by positing political consciousness as content and locating it outside of the questioning process of art itself he helped reinforce formalistic presumptions about art and left for the public perception the political eunuch of a conceptual art *style;*

some works with political content and some without. This not only reinforced traditional presumptions about art, it thwarted the radical heuristic of conceptual art, safely locating 'political' outside of art's deeper institutional structure. It is difficult not to presume that Haacke fundamentally sees art itself as neutral and devoid of political meaning without the injection of a political message. It is hard, also, not to conclude that his work, while intended to be on the left, masks a philosophical agreement with the institutionalized traditional point of view about art. I find this potentially dangerous because it promotes a conception of culture which de-politicizes art and our understanding of the cultural processes of society in general. So, while such work can perhaps score some short-term political points, in fact its effect on our understanding of the political aspects of art's process is, by contrast, a quite conservative one. This work cannot be critical of itself because, at its roots, it holds to a model of art that does not question the meaning of its own process internally, thereby neutralizing its capacity to critically evaluate the process of the production of its meaning externally in relation to the cultural horizon of social meaning. As a political agenda we have here a blunt instrument, where, in fact, we need to understand the mechanisms of our culture if we are ever to politically evaluate the world we are helping to produce. Understanding art, and not just utilizing it for an end, is how we begin to understand that production. This political responsibility begins with the artist questioning the nature of art itself. It is, for my generation, how our institutional critique began, and it has nothing to do with art for art's sake as some conservatives on the left would have you think. Indeed, without that fundamental beginning one cannot change our conception of art—nor know, much less use, the role of culture in our society. Those institutional mechanisms which resist change in our conception of culture are one and the same as those which resist change in our society.

As I see it, then, the teaching of art is an important part of the production of art. In many ways it is the tableau where society, in practical terms, makes visible the limits of its conception of art as it attempts to regenerate the institutional forms that depict its *self*-conception. When our view of art is limited, so is our view of society. If questions aren't asked in art schools, away from the conservative heat of the art market, where then? If the political responsibility of a cultural reflexivity (*why*) is not taught along with a knowledge of the history of *how* artists have made meaning, then we are doomed to be oppressed by our traditions rather than informed by them. The teacher of art, as a teacher and an artist, can do no more than participate with the students in asking the *questions*. This, rather than attempting to provide the *answers* as art schools traditionally do, realigns the priorities from the beginning. The

first lesson, taught by example, is that what is to be learned is a process of thinking and not a dogma in craft or theory.

The teacher is not the representative of the institution, but one artist among several sharing a conversation. What is said has its own weight. If a teacher is any good he or she learns as much as the students. The 'answers', if there are any, are formed by all of the participants in the conversation within the context of their own lives, and their practical effect only within that larger conversational process; the shared discourse of a community. It is in the making of meaning—art—as a discourse that art students experience themselves as they begin the process of making the world. The concept of art shared by such a teaching process has institutional critique basic to it, but, by necessity it must avoid that as its sole description. Because art is the teaching of art (although the format changes), description quickly becomes prescription. What this concept of art really reflects is the responsibility of the artist to be a whole person: a political being as well as a social and cultural one.

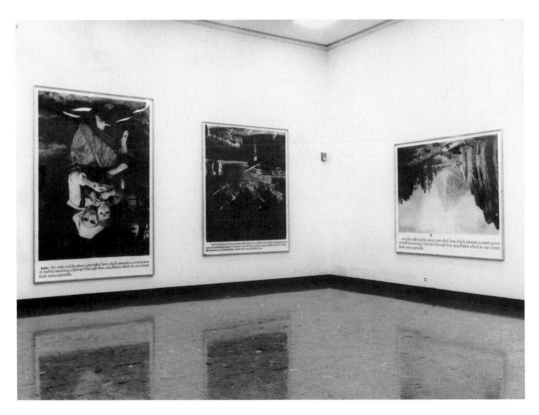

28. Installation View, Staatsgalerie, Stuttgart,
September–November 1981.

✕✕ ✕✕ That which presents itself, here, as a whole can only be recognized as a part of something larger (a 'picture' out of view), yet too inaccessible for you to find *the* location (a 'construction' which has just included you).

29. *Cathexis 8*, 1981.

✕✕✕✕ What seems to be constructed here (when you can see the surface) makes an order from the parts not yet read and the locations not yet seen.

30. *Cathexis 9*, 1981.

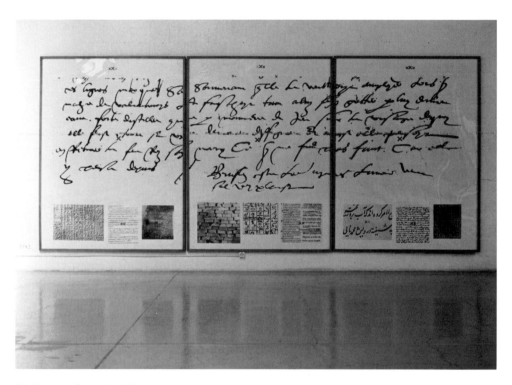

31. *Hypercathexis 5*, 1982.

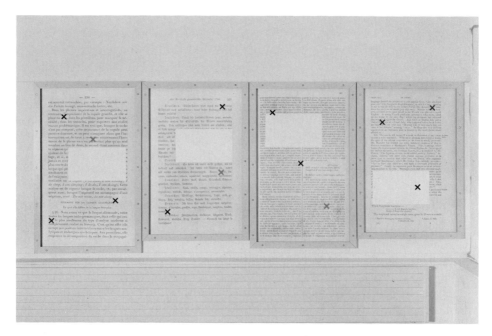

32. *Intentio (Project)*, Installation View,
Musée des Beaux-Arts de la Chaux-de-fonds,
Switzerland, June 1985.

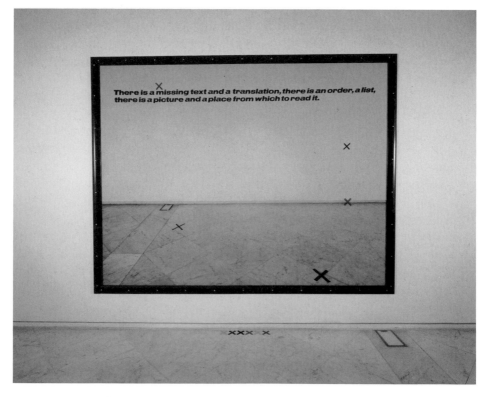

33. *Fort! Da!*, Installation View, Lia Rumma
Gallery, Naples, May–June 1985.

From this it seems to follow that the factor of attention in mistakes in speaking, reading and writing must be determined in a different way from that described by Wundt (cessation or diminution of attention). The examples which we have subjected to analysis have not really justified us in assuming that there was a quantitative lessening of attention; we found something which is perhaps not quite the same thing: a *disturbance* of attention by an alien thought which claims consideration.

34. *It Was It*, 1986.

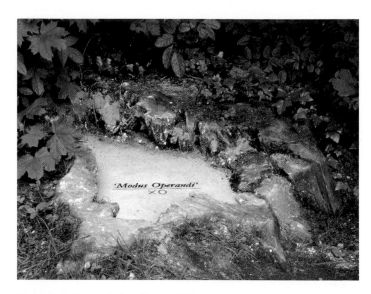

35. *Modus Operandi*, Installation View,
Promenades, Parc Lulline, Geneva, June–
September 1985.

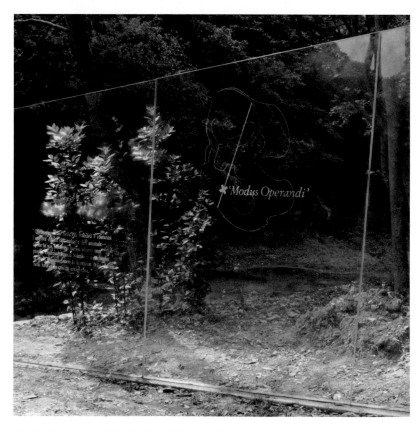

36. *Modus Operandi (Celle, To C.L.)*, Installa-
tion View, Fattoria di Celle, Prato, 1986.

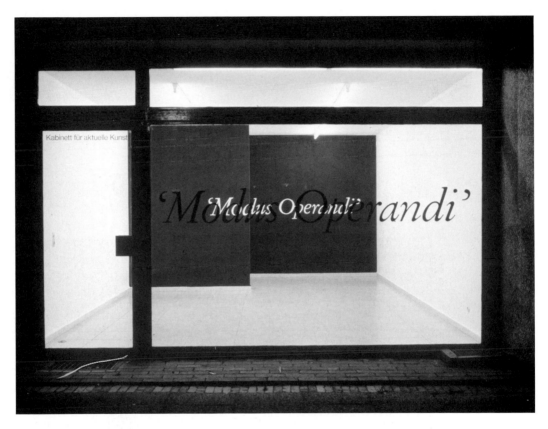

37. *Modus Operandi*, Installation View, Kabinett für Aktuelle Kunst, Bremerhaven, November 1988.

38. *Legitimation #3*, 1987. Musée d'Art Contemporain, Nîmes, France.

39. *Modus Operandi (S.B.)*, Installation View, Dr. John Tatomer, Santa Barbara, 1988.

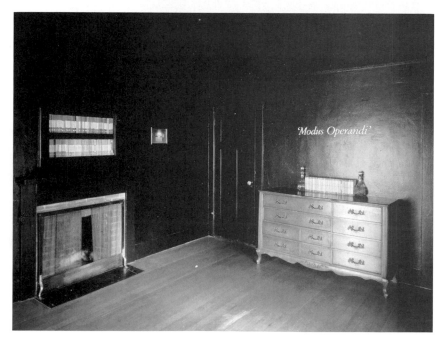

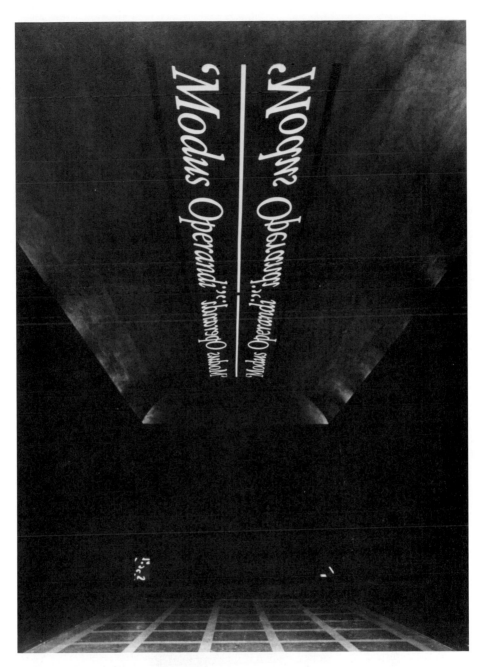

40. *Modus Operandi (Naples)*, Installation
View, Museo di Capodimonte, Naples,
November 1988.

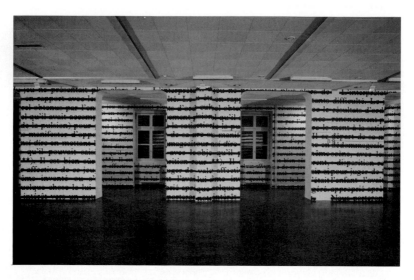

41. *Zero & Not*, Installation View, Musée St. Pierre, Lyons, June–July 1985.

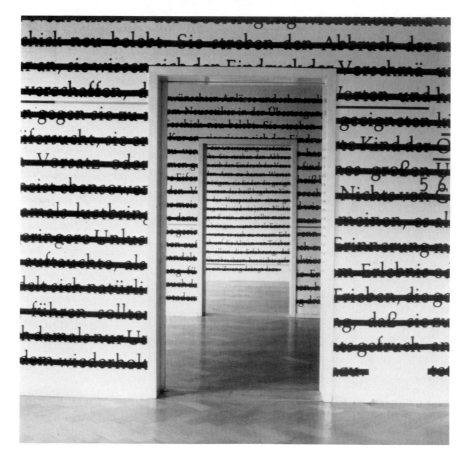

42. *Zero & Not*, Installation View, Achim Kubinski Gallery, Stuttgart, October–November 1985.

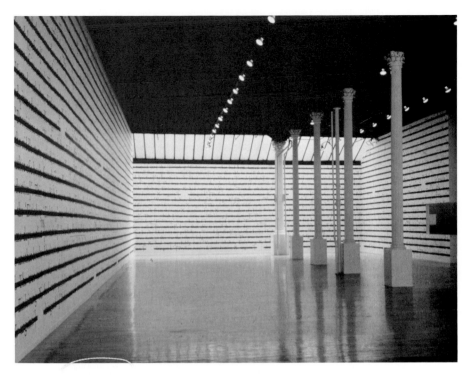

43. *Zero & Not*, Installation View, Leo Castelli Gallery, New York, May–June 1986.

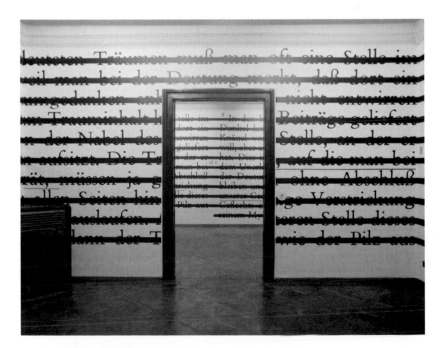

44. *Zero & Not*, Installation View, The Sigmund Freud Museum, Vienna, October 1989.

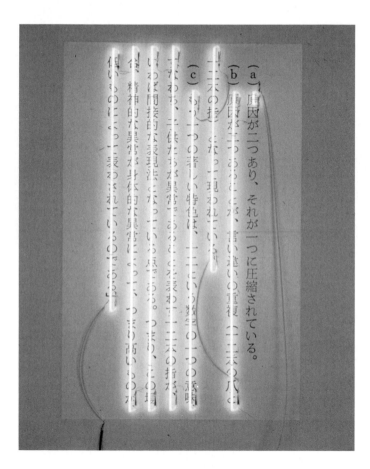

45. *Word, Sentence, Paragraph (Z. & N.),*
1986.

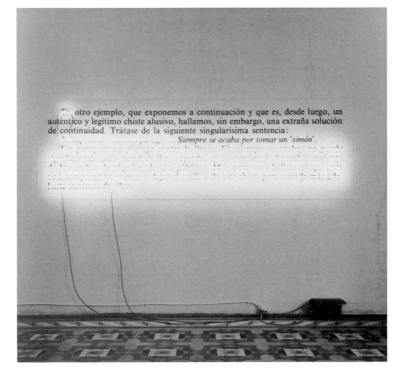

46. *Word, Sentence, Paragraph (Z. & N.),*
1989.

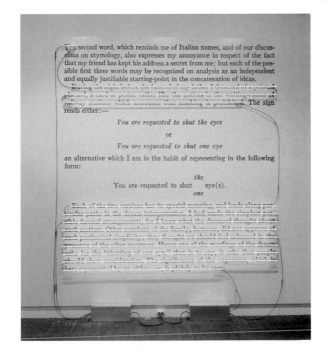

47. *Word, Sentence, Paragraph (Z. & N.),*
1987.

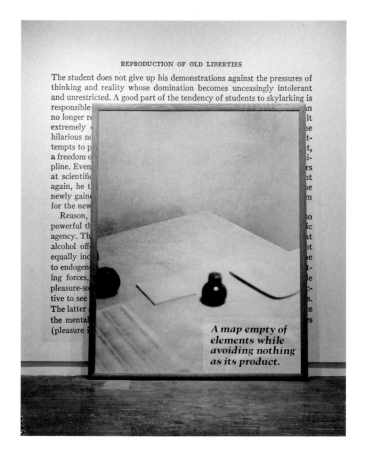

48. *Q&A/F!D! (to I.K. and G.F.) #8*, 1987.

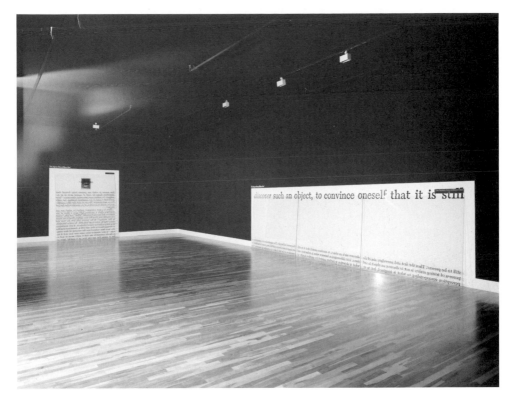

49. *The Square Root of Minus One*, Installation View, Leo Castelli Gallery, New York, October 1988.

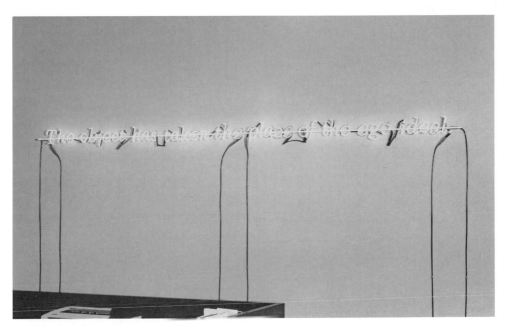

50. *C.S. #3*, 1989.

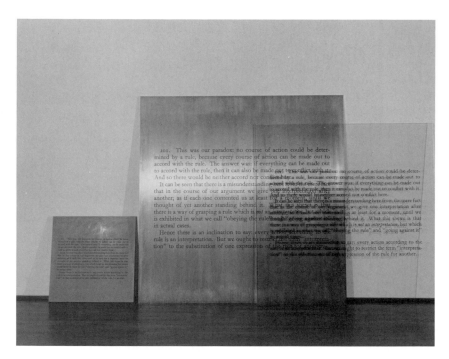

51. *201 (+216, After Augustine's Confessions)*, 1989.

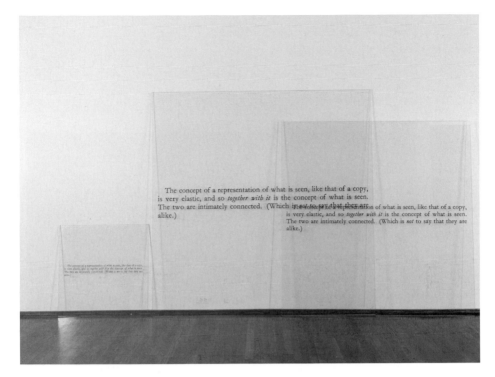

The concept of a representation of what is seen, like that of a copy,
is very elastic, and so *together with it* is the concept of what is seen.
The two are intimately connected. (Which is *not* to say that they are
alike.)

The concept of a representation of what is seen, like that of a copy,
is very elastic, and so *together with it* is the concept of what is seen.
The two are intimately connected. (Which is *not* to say that they are
alike.)

52. *No Number #1 (+216, After Augustine's
Confessions),* 1989.

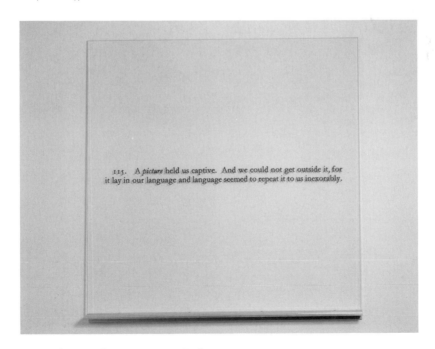

115. A *picture* held us captive. And we could not get outside it, for
it lay in our language and language seemed to repeat it to us inexorably.

53. *115 (+216, After Augustine's Confes-
sions),* 1990.

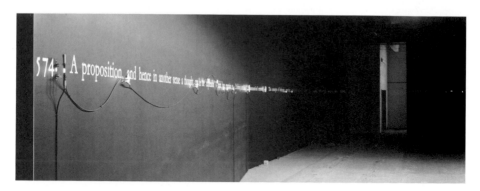

54. *(A Grammatical Remark) G.R.—Montreal*, Installation View, Centre d'Art Contemporain, Montreal, September 1989.

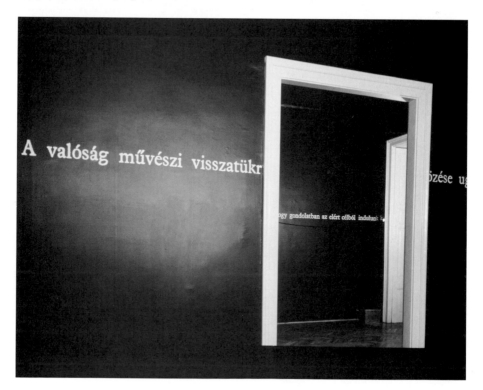

55. *(A Grammatical Remark) G.L./L.W.—Budapest*, Installation View, Knoll Gallery, Budapest, October–December 1989.

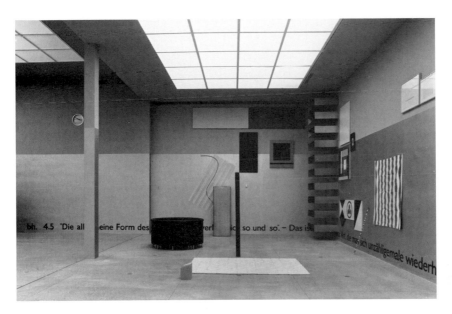

56. Installation, *The Play of the Unsayable:
Ludwig Wittgenstein and the Art of the 20th
Century*, Wiener Secession, Vienna, September 1989.

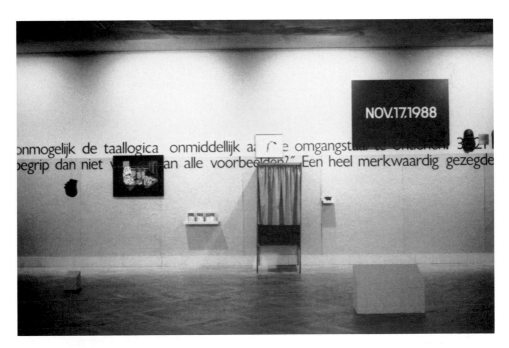

57. Installation, *The Play of the Unsayable:
Ludwig Wittgenstein and the Art of the 20th
Century*, Palais des Beaux-Arts, Brussels,
December 1989.

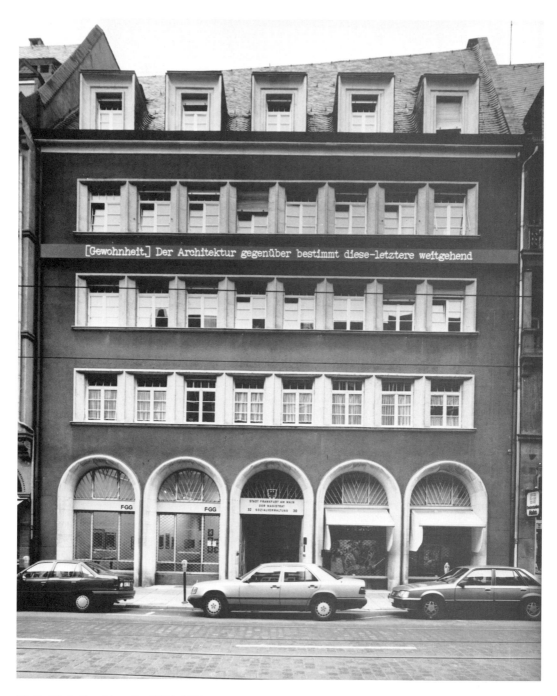

58. *Ex Libris, Frankfurt (for W.B.)*, 1990.

JOSEPH KOSUTH: A BIBLIOGRAPHY

1. WRITINGS, INTERVIEWS, AND STATEMENTS BY THE ARTIST

1966

Kosuth, Joseph, and Christine Koslov. "Ad Reinhardt: The Art of an Informal Formalist: Negativity, Purity, and the Clearness of Ambiguity." Manuscript from the School of Visual Arts, New York, 1966.

1967

Kosuth, Joseph. "Statement." *Non-Anthropomorphic Art by Four Young Artists* [exhibition catalogue]. New York: Lannis Gallery [Museum of Normal Art], February 1967.

Kosuth, Joseph. "Achille Lauge [review]." *Arts Magazine* (New York) 41, no. 7 (May 1967): 65.

Kosuth, Joseph. "American Drawings and Paintings [review]." *Arts Magazine* (New York) 41, no. 7 (May 1967): 66.

Kosuth, Joseph. "Anonima Group [review]." *Arts Magazine* (New York) 41, no. 7 (May 1967): 57.

Kosuth, Joseph. "Artists at Work [review]." *Arts Magazine* (New York) 41, no. 7 (May 1967): 64.

Kosuth, Joseph. "George Bellows [review]." *Arts Magazine* (New York) 41, no. 7 (May 1967): 62.

Kosuth, Joseph. "Gerald Garston [review]." *Arts Magazine* (New York) 41, no. 7 (May 1967): 65.

Kosuth, Joseph. "Gerhard Marcks [review]." *Arts Magazine* (New York) 41, no. 7 (May 1967): 60.

Kosuth, Joseph. "Mario Yrisarry [review]." *Arts Magazine* (New York) 41, no. 7 (May 1967): 61.

Kosuth, Joseph. "Selected Drawings [review]." *Arts Magazine* (New York) 41, no. 7 (May 1967): 60.

Kosuth, Joseph. "Walter Sickert [review]." *Arts Magazine* (New York) 41, no. 7 (May 1967): 61.

Kosuth, Joseph. "Anne Dunn [review]." *Arts Magazine* (New York) 41, no. 8 (Summer 1967): 60.

Kosuth, Joseph. "Bykert Group [review]." *Arts Magazine* (New York) 41, no. 8 (Summer 1967): 59.

Kosuth, Joseph. "Charles Mattox [review]." *Arts Magazine* (New York) 41, no. 8 (Summer 1967): 56.

Kosuth, Joseph. "Homage to Morandi [review]." *Arts Magazine* (New York) 41, no. 8 (Summer 1967): 56.

Kosuth, Joseph. "James Jarvaise [review]." *Arts Magazine* (New York) 41, no. 8 (Summer 1967): 64.

Kosuth, Joseph. "John Marin [review]." *Arts Magazine* (New York) 41, no. 8 (Summer 1967): 56.

Kosuth, Joseph. "Merchants and Planters of the Upper Hudson Valley [review]." *Arts Magazine* (New York) 41, no. 8 (Summer 1967): 54.

Kosuth, Joseph. "Reinhardt, Christensen, Kuwayama, Blakelock [review]." *Arts Magazine* (New York) 41, no. 8 (Summer 1967): 58.

Kosuth, Joseph. "Robert Ryman [review]." *Arts Magazine* (New York) 41, no. 8 (Summer 1967): 63.

Kosuth, Joseph. "The Star Garden (A Place) [review]." *Arts Magazine* (New York) 41, no. 8 (Summer 1967): 54.

Kosuth, Joseph. "Al Hopkins [review]." *Arts Magazine* (New York) 42, no. 1 (September–October 1967): 57.

Kosuth, Joseph. "15 People Present Their Favorite Book [review]." *Arts Magazine* (New York) 42, no. 1 (September–October 1967): 61.

Kosuth, Joseph. "Lewis Adler [review]." *Arts Magazine* (New York) 42, no. 1 (September–October 1967): 62.

Kosuth, Joseph. "Lyonel Feininger [review]." *Arts Magazine* (New York) 42, no. 1 (September–October 1967): 52.

Kosuth, Joseph. "Elias Friedensohn [review]." *Arts Magazine* (New York) 42, no. 2 (November 1967): 55.

1968

Kosuth, Joseph. "Editorial in 27 Parts." *Straight* (New York) 1, no. 1 (April 1968): n.p.

Kosuth, Joseph. "Notes on Specific and General." Notes written in 1968; published for the first time in this collection.

1969

Kosuth, Joseph. "Statement [The Fifth Investigation]." *1969 Annual Exhibition* [exhibition catalogue]. New York: Whitney Museum of American Art, 1969.

Kosuth, Joseph. "Interview and Statement." *Prospect '69* [exhibition catalogue]. Düsseldorf: Städtische Kunsthalle, 1969.

Rose, Arthur R. "Four Interviews with Barry, Huebler, Kosuth, Weiner." *Arts Magazine* (New York) 43, no. 4 (February 1969): 22–23, ill. Reprinted in *Arts Magazine* 63, no. 6 (February 1989): 44–45.

Kosuth, Joseph. "Art after Philosophy I." *Studio International* (London) 178, no. 915 (October 1969): 134–137. Reprinted in Italian in *Data* (Milan) 2, no. 3 (April 1972): 39–45.

Kosuth, Joseph. "Art after Philosophy II." *Studio International* (London) 178, no. 916 (November 1969): 160–161.

Lippard, Lucy R., ed. "Time: A Panel Discussion." *Art International* (Lugano) 13, no. 9 (November 1969): 20–23, 39.

Siegelaub, Seth, moderator. "Art without Space [Symposium with Robert Barry, Douglas Huebler, Joseph Kosuth, and Lawrence Weiner]." New York: WBAI-FM, November 2, 1969.

Kosuth, Joseph. "Art after Philosophy III." *Studio International* (London) 178, no. 917 (December 1969): 212–213.

Kosuth, Joseph. "Footnote to Poetry." Notes written in 1969; published for the first time in this collection.

1970

Kosuth, Joseph. *Function Funzione Funcion Fonction Funktion.* Turin: Sperone Editore, 1970.

Kosuth, Joseph. "Information 2." *Conceptual Art and Conceptual Aspects* [exhibition catalogue]. New York: New York Cultural Center, 1970, pp. 29–59.

Kosuth, Joseph. "Statement." *Information* [exhibition catalogue]. New York: Museum of Modern Art, 1970, n.p., ill.

Kosuth, Joseph. "Statement [The Seventh Investigation, Proposition 3]." *Software* [exhibition catalogue]. New York: The Jewish Museum, 1970, p. 68, ill.

Kosuth, Joseph. "Correspondence: Kosuth Replies to Claura." *Studio International* (London) 179, no. 919 (February 1970): 44.

Kosuth, Joseph. "Introductory Note by the American Editor." *Art-Language* (Coventry) 1, no. 2 (February 1970): 1–4.

Siegel, Jeanne. "Joseph Kosuth: Art as Idea as Idea [interview]." WBAI-FM, New York, April 7, 1970. Published in Jeanne Siegel, *Artwords: Discourse on the 60s and 70s* (Ann Arbor, Michigan: UMI Research Press, 1985), pp. 221–231, ills.

Kosuth, Joseph. "A Short Note: Art, Education and Linguistic Change." *The Utterer* (New York, April 1970), n.p.

Kosuth, Joseph. "An Answer to Criticisms." *Studio International* (London) 179, no. 923 (June 1970): 245.

Kosuth, Joseph. "Project for '48-Page Exhibition.' " *Studio International* (London) 180, no. 924 (July–August 1970): 30.

Kosuth, Joseph. "Note Introductive." *VH101* (Zurich), no. 3 (Autumn 1970): 49–53, ills.

Brøgger, Stig, and Erik Thygesen. "Art as Idea as Idea: Conversation with Joseph Kosuth [interview]." Danish Radio, November 1970. Published in Danish in *Profil* (Copenhagen), no. 1 (January 1989): 10–15, ills.

Kosuth, Joseph. "Notes on *Crane*." Notes written in 1970; published for the first time in this collection.

Kosuth, Joseph. "Influences: The Difference between '*How*' and '*Why*.' " Notes written in 1970; published for the first time in this collection.

1971

Kosuth, Joseph. *The Sixth Investigation 1969, Proposition 14.* Cologne: Gerd de Vries, 1971, ills.

Kosuth, Joseph. "The Sixth Investigation, Proposition 2." *Art as Idea as Idea* [exhibition catalogue]. Buenos Aires: Centro de Arte e Communicación, 1971. In English and Spanish.

Kosuth, Joseph. "Kosuth on His Works." *Flash Art* (Milan), no. 22 (February–March 1971): 2, ill.

Restany, Pierre. "Tre riposte di Kosuth a quattro domande di Restany [interview]." *Domus* (Milan), no. 498 (May 1971): 53–54, ill. In English and Italian.

Kosuth, Joseph. "Painting versus Art versus Culture (or, Why You Can Paint if You Want to, but It Probably Won't Matter)." Lecture delivered in 1971; published for the first time in this collection.

1972

Kosuth, Joseph, curator. *The Air-Conditioning Show: 1966* [exhibition catalogue]. New York: Visual Arts Gallery, 1972. Flyer.

1973

Kosuth, Joseph. *Joseph Kosuth: Investigation über Kunst & 'Problemkreise' seit 1965* [exhibition catalogue]. Lucerne: Kunstmuseum Luzern, 1973, 5 vols. Includes texts by Terry Atkinson, Michael Baldwin, Philip Pilkington, Mel Ramsden, David Rushton, and Terry Smith.

Kosuth, Joseph. "Statement." *Deurle 11/7/73: Congress of Conceptual Art* [exhibition catalogue]. Deurle, Belgium: Museum Dhont-Dhaenens, 1973, n.p.

1974

Kosuth, Joseph. "(Notes) on an Anthropologized Art." *Kunst bleibt Kunst: Projekt '74* [exhibition catalogue]. Cologne: Kunsthalle, 1974, pp. 234–237. In English and German.

1975

Kosuth, Joseph. "Plan (for Proposition 4) and A Notice to the Public." *The Tenth Investigation, Proposition 4*. New York: Leo Castelli Gallery, 1975. Flyer.

Kosuth, Joseph. "The Artist as Anthropologist." *The Fox* (New York) 1, no. 1 (1975): 18–30.

Kosuth, Joseph. "1975." *The Fox* (New York) 1, no. 2 (1975): 87–96.

Kosuth, Joseph [contributor]. "For Thomas Hobbes I." *Art-Language* (Coventry) 3, no. 2 (May 1975): 1.

Kosuth, Joseph [contributor]. "Rambling: to Partial Correspondents." *Art-Language* (Coventry) 3, no. 2 (May 1975): 46–51.

Kosuth, Joseph. "Statement [21 September 1973]." *Der Löwe* (Bern), no. 5 (July 31, 1975): 51–52.

1976

Kosuth, Joseph. *Teksten/Textes*. Antwerp: International Cultureel Centrum, 1976. In Dutch and French.

Kosuth, Joseph. "Work." *The Fox* (New York) 1, no. 3 (1976): 116–120.

1977

Kosuth, Joseph [contributor]. *An Anti-Catalogue*. New York: The Catalogue Committee of Artists Meeting for Cultural Change, 1977.

Kosuth, Joseph. "Comments on the Second Frame." In *Was Erwartest Du . . .?*, ed. Christine Bernhardt. Cologne: Galerie Paul Maenz, 1977, n.p. In English and German.

Kosuth, Joseph [contributor]. *Piero Sartogo: immagine reale e virtuada* [exhibition catalogue]. Florence: Centro di, 1977, ills.

Kosuth, Joseph. *Within the Context: Modernism and Critical Practice*. Ghent: Coupure, 1977.

Kosuth, Joseph, Sarah Charlesworth, and Anthony McCall. "International Local [video-taped discussion]." New York: Loeb Student Center, New York University, May 10–May 14, 1977. Published in *Discussion*, ed. Annina Nosei Weber. New York, Norristown, Milan: Out of London Press, 1980, pp. 61–70.

1979

Kirchengast, Michael, and Fudiger Wischenbart. "Capital 'P' Photography, Capital 'P' Politics [interview with Joseph Kosuth]." *Kunstforum International* (Mainz), no. 35 (1979): 82–84, ill.

Kosuth, Joseph. "1979." *Symposium über Fotographie* [exhibition catalogue]. Graz: Akademische Druck-u. Verlagsanstalt, 1979, pp. 37–44, ill. In English and German. Reprinted in French in *Artistes* (Paris), no. 16 (Summer 1983): 18–22, ills.

Kosuth, Joseph. "Seven Remarks for You to Consider while Viewing/Reading This Exhibition [*Text/Context*]." New York: Leo Castelli Gallery, 1979. Flyer.

Kosuth, Joseph. "A Long Night at the Movies." *Art in America* (New York) 67, no. 2 (March–April 1979): 21–22.

1980

Meyer, Ursula, moderator. "Time and Space Concepts in Conceptual Art [panel discussion]." in *Time and Space Concepts in Art*, ed. Marilyn Belford and Jerry Herman. New York: Pleiades Gallery, 1980, pp. 129–157.

Kosuth, Joseph. "Artworld Predictions for the '80s." *Art Letter* (New York) 9, no. 1 (January 1980): 1–2.

Kosuth, Joseph. "On Ad Reinhardt." *Cover* (New York) (Spring/Summer 1980): 10. Reprinted in English and German in *Durch* (Graz), no. 5 (1988): 59–62.

Kosuth, Joseph. Statement in "Picasso: A Symposium." *Art in America* (New York) 68, no. 10 (December 1980): 10–11.

1981

Kosuth, Joseph. "Notes on *Cathexis*." New York: Leo Castelli Gallery, 1981. Flyer.

Kosuth, Joseph. *Bedeutung von Bedeutung: Texte und Dokumentation der Investigationen über Kunst seit 1965 in Auswahl* [exhibition catalogue]. Stuttgart: Staatsgalerie Stuttgart, 1981. In English and German.

Linders, Kris. "Three Questions and One Answer [interview]." *GEWAD* (Ghent) 2, no. 1 (September 1981).

Fischer, Hervé, and Stéphane Rona. "La crise de l'avant-garde [interview]." +/o (Brussels) 9, no. 34 (October 1981): 32. In English and French.

1982

Kosuth, Joseph. "Necrophilia Mon Amour." *Artforum* (New York) 20, no. 9 (May 1982): 58–63.

Kosuth, Joseph. "Art and Its Public." Paper given at Mountain Lake Symposium III (October 7–9, 1982); published for the first time in this collection.

Kosuth, Joseph. "On Yves Klein." Notes for a speech delivered at a panel discussion at the Solomon R. Guggenheim Museum, New York, November 21, 1982; published for the first time in this collection.

1983

Kosuth, Joseph. "A Note to Readers." *Ars '83* [exhibition catalogue]. Helsinki: Ateneumin Taidemuseo, 1983, vol. 2, p. 22, ills. In English, Finnish, and Swedish.

Kosuth, Joseph. "*Cathexis* 48, 1982." *Bomb* (New York) 1, no. 5 (1983): 56, ill.

Kosuth, Joseph. "Statement." *Whitewalls* (Chicago), no. 8 (1983): 34.

1984

Bonito Oliva, Achille. "Joseph Kosuth: New York, 1971." In *Dialoghi d'artista*. Milan: Electa Editrice, 1984, pp. 158–171, ills.

1985

Kosuth, Joseph. "Seven Questions." *Donald Baechler: Hamburger Gemalde* [exhibition catalogue]. Hamburg: Galerie Ascan Crone, 1985, pp. 5–10. In English and German.

Kosuth, Joseph. "Statement [Fort!Da!]." New York: Leo Castelli Gallery, 1985. Text for wall panel.

Ducret, André. "L'art de la présentation (de l'art): un entretien avec Joseph Kosuth." *Archi-Bref* (Geneva), no. 50 (March 1985): 7–10, ills.

Trimarco, Angelo. "E di scena Freud [interview.] *Paese Sera* (Rome), July 16, 1985, p. 5.

Ponti, Lisa Licitra. "Kosuth's Modus Operandi: conversazione a Napoli." *Domus* (Milan), no. 665 (October 1985): 76–77, ills. In English and Italian.

Ducret, André, and Catherine Queloz. "Joseph Kosuth [interview]." *AEIOU* (Rome) 6, no. 14–15 (December 1985): 78–87.

Kosuth, Joseph. "On Masterpieces." Response to a questionnaire by the Musée de l'Art Moderne, Paris; published for the first time in this collection.

1986

Kosuth, Joseph. "Well I asked for it." *Museumjournaal* (Amsterdam) 31, no. 3/4 (1986): 221–222, ills.

Taylor, Paul. "Interview with Joseph Kosuth." *Flash Art* (Milan), no. 127 (April 1986): 37–39, ills.

Kosuth, Joseph. "A Preliminary Map for *Zero & Not.* " *Chambres d'amis* [exhibition catalogue]. Ghent: Museum van Hedendaagse Kunst, 1986, pp. 102–107, ills.

1987

Kosuth, Joseph. *L'arte dopo la filosofia: il significato dell'arte concettuale.* Translated and with an introduction by Gabriele Guercio. Genova: Edizioni Costa & Nolan, 1987, ills.

Kosuth, Joseph. "Comments." *The Success of Failure* [exhibition catalogue]. New York: Independent Curators, Inc., 1987, p. 30, ill.

Kosuth, Joseph. "Qua-Qua-Qua." *Implosion: Ett Postmodern Perspektiv* [exhibition catalogue]. Stockholm: Moderna Museet, 1987, pp. 70–73, ill. In English and Swedish.

Melo, Alexandre. "Joseph Kosuth: A arte faz o mundo [interview]." *Expresso* (Lisbon), September 19, 1987.

Kosuth, Joseph. *"Modus Operandi."* The Paris Review (Paris) 129, no. 105 (Winter 1987): 121–131 and cover.

1988

Kosuth, Joseph. " 'Philosophia Medii Maris Atlantici', or, Re-map, De-map (Speak in the Gaps)." *Europa Oggi/Europe Now* [exhibition catalogue]. Florence and Milan: Centro Di and Electa Spa, 1988, pp. 51–53. In English and Italian.

Kosuth, Joseph. "Ten Questions for Franz Erhard Walther." *Franz Erhard Walther 1963– 1983* [exhibition catalogue]. New York: John Weber Gallery, 1988, pp. 4–5.

Kosuth, Joseph. "To Remind." *Concept Art* [exhibition catalogue]. Copenhagen: Stalke Galleri, 1988, pp. 47–49.

Melo, Alexandre. "Interview with Joseph Kosuth." *Spazio Umano* (Milan), no. 4 (1988): 8–46, ills. In English, French, German, Spanish, and Italian.

Beller, Thomas, and Margaret Sundell. "Interview: Kosuth." *Splash* (New York), no. 2 (February 1988): n.p.

Kosuth, Joseph. "No Exit." *Artforum* (New York) 26, no. 7 (March 1988): 112–115.

Simon, Joan. "Gordon Matta-Clark: Reconstructions [interviews with 4 Artists]." *Arts Magazine* (New York) 62, no. 10 (Summer 1988): 84–85.

Kosuth, Joseph. "Joseph Kosuth's Five Recent Details [project]." *Journal of Contemporary Art* (New York), no. 2 (Fall–Winter 1988): 46–51, ills.

Kosuth, Joseph. "History For." *Flash Art* (Milan), no. 143 (November–December 1988): 100–102, ills. Reprinted in Russian in *Flash Art* (Soviet Edition), no. 1 (1989): 74–76, ills.

Kosuth, Joseph. "T.D.O.T.F.T.P.O.T.S.T.T.O.O.T.S." *New Observations* (New York), no. 63 (December 1988): 13–15, ills.

1989

Joseph Kosuth: Interviews. Preface by Charles Le Vine. Stuttgart: Edition Patricia Schwarz, 1989.

Kosuth, Joseph. "Joseph Kosuth Responds to Benjamin Buchloh [November 19, 1989]." *L'art conceptuel, une perspective* [exhibition catalogue]. Paris: Musée d'Art Moderne de la Ville de Paris, 1989, p. 40. In English and French. Reprinted and revised in Spanish in *Arte conceptual, una perspectiva* [exhibition catalogue]. Madrid: Fundación Caja de Pensiones, 1990, pp. 25–26.

Kosuth, Joseph. "The Play of the Unsayable: A Preface and Ten Remarks on Art and Wittgenstein." *Das Spiel des Unsagbaren: Ludwig Wittgenstein und die Kunst des 20. Jahrhunderts* [exhibition catalogue]. Vienna: Wiener Secession, 1989, n.p. In English and German.

Kosuth, Joseph. "La scena, l'icona." In *L'immagine: Arte, Scienza, Teoria*, ed. Giovanni Damiani. Milan: Pragma, 1989, pp. 237–245, ills.

Rose, Arthur R. "The Return of Arthur R. Rose." *Arts Magazine* (New York) 63, no. 6 (February 1989): 46–49, ill.

Braet, Jan. "Kijken hoe Kunst werkt [interview]." *Knack* (Brussels), no. 20, May 17–23, 1989, pp. 146–151, ills.

Kosuth, Joseph. "Bemerkungen über die Ausstellung zum 50. Todestag von Sigmund Freud" and "Kein Ausweg." *Sigmund Freud House Bulletin* (Vienna), special edition (Summer 1989): 7–8, 15–21, ills.

Bourriaud, Nicholas. "Ludwig Wittgenstein & l'Art du XXe Siècle [interview]." *Galeries Magazine* (Paris), no. 34 (December 1989–January 1990): 94–101, 139, ills. In English and French.

1990

Devolder, Eddy. "Entretien avec Joseph Kosuth [interview]." +/o (Brussels), no. 55 (February 1990): 5–7, ills.

Kosuth, Joseph. "Statement for *Ex Libris, Frankfurt (for W.B.).*" Written for an outdoor exhibition organized by the Kunstmuseum Frankfurt for the summer of 1990; published for the first time in this collection.

Kosuth, Joseph. "Teaching to Learn." Published for the first time in this collection.

2. PERIODICAL AND NEWSPAPER ARTICLES

1967

Brown, Gordon. "Kosuth, Kozlov, Rinaldi, Rossi [review]." *Arts Magazine* (New York) 41, no. 7 (May 1967): 61.

1968

Lippard, Lucy R., and John Chandler. "The Dematerialization of Art." *Art International* (Lugano) 12, no. 2 (February 1968): 31–36, ill.

"A Hint, A Shadow, A Clue." *Time* (New York), June 14, 1968, p. 63.

Junker, Howard. "The New Art: It's Way, Way Out." *Newsweek* (New York) July 29, 1968, pp. 56–63, ill.

Burnham, Jack. "Systems Esthetics." *Artforum* (New York) 7, no. 1 (September 1968): 30–35.

Brown, Gordon. "The Dematerialization of the Object." *Arts Magazine* (New York) 43, no. 1 (September–October 1968): 56, ill.

Demoriane, Helene. "La rêve américaine: le Grand Canyon: les jeunes artistes américains." *Connaissance des arts* (Paris), no. 200 (October 1968): 27–31.

Chandler, John. "The Last Word in Graphic Art." *Art International* (Lugano) 12, no. 9 (November 1968): 25–26.

Terbell, Melinda. "Joseph Kosuth at Gallery 669 [review]." *Arts Magazine* (New York) 43, no. 2 (November 1968): 61.

Livingston, Jane. "Joseph Kosuth [review]." *Artforum* (New York) 7, no. 4 (December 1968): 66–67, ill.

1969

Battcock, Gregory. "Painting Is Obsolete." *New York Free Press*, January 23, 1969, p. 7.

Perreault, John. "Art: Disturbances." *The Village Voice* (New York), January 23, 1969, pp. 14, 18.

Ashton, Dore. "New York Commentary [review]." *Studio International* (London) 177, no. 909 (March 1969): 135–137.

Perreault, John. "Art: Off the Wall." *The Village Voice* (New York), March 13, 1969, pp. 13–14.

Rose, Barbara. "Problems of Criticism, Pt. IV: Beyond Objects." *Artforum* (New York) 7, no. 9 (May 1969): 46–51.

Shirey, David L. "Impossible Art—What It Is." *Art in America* (New York) 57, no. 3 (May–June 1969): 32–47, ill.

Junker, Howard. "Idea as Art." *Newsweek* (New York), August 11, 1969, p. 81.

Burnham, Jack. "Real Time Systems." *Artforum* (New York) 8, no. 1 (September 1969): 49–55, ill.

Harrison, Charles. "Against Precedents." *Studio International* (London) 178, no. 914 (September 1969): 90–93, ill.

Shapiro, David. "Mr. Processionary at the Conceptable." *Art News* (New York) 68, no. 6 (September 1969): 58–61, ill.

Schjeldahl, Peter. "New York Letter [review]." *Art International* (Lugano) 13, no. 8 (October 1969): 76.

Plagens, Peter. "557,087 at the Seattle Art Museum." *Artforum* (New York) 8, no. 3 (November 1969): 64–67, ill.

Siegelaub, Seth, in conversation with Charles Harrison. "On Exhibitions and the World at Large." *Studio International* (London) 179, no. 917 (December 1969): 202–203.

Sweet, David. "Correspondence: The Case for Conservation." *Studio International* (London) 179, no. 917 (December 1969): 205.

1970

Atkinson, Terry, Michael Baldwin, David Bainbridge, and Harold Hurrell. "Status and Priority." *Studio International* (London) 179, no. 918 (January 1970): 28–31.

Claura, Michel. "Correspondence: Conceptual Misconceptions." *Studio International* (London) 179, no. 918 (January 1970): 5–6.

Ashton, Dore. "Correspondence: Kosuth: The Facts." *Studio International* (London) 179, no. 919 (February 1970): 44.

Atkinson, Terry, and Michael Baldwin. "From an Art & Language Point of View." *Art-Language* (Coventry) 1, no. 2 (February 1970): 25–60, ill.

Burnham, Jack. "Alice's Head: Reflections on Conceptual Art." *Artforum* (New York) 8, no. 6 (February 1970): 37–43, ills.

Harrison, Charles. "Notes Towards Art Work." *Studio International* (London) 177, no. 919 (February 1970): 42–43.

Alloway, Lawrence. "Artists and Photographs." *Studio International* (London) 179, no. 921 (April 1970): 162–164, ill.

Celant, Germano. "Conceptual Art." *Casabella* (Milan), no. 347 (April 1970): 40–49, ills.

Goldin, Amy, and Robert Kushner. "Conceptual Art as Opera." *Art News* (New York) 69, no. 2 (April 1970): 40–43, ill.

Kramer, Hilton. "Art, Xeroxphilia Rages Out of Control." *New York Times*, April 11, 1970, p. 27.

Ratcliff, Carter. "Conceptual Art and Conceptual Aspects: New York Cultural Center [review]." *Art International* (Lugano) 14, no. 6 (Summer 1970): 133–134.

Schjeldahl, Peter. "Don't Just Stand There– Read!" *New York Times*, August 23, 1970, section 2, p. 19.

Karshan, Donald C. "The Seventies: Post-Object Art." *Studio International* (London) 180, no. 925 (September 1970): 69–70.

Reise, Barbara. "Correspondence: Joseph Kosuth." *Studio International* (London) 180, no. 925 (September 1970): 71.

Kirili, Alain. "Passage du concept comme forme d'art aux travaux d'analyse." *VH101* (Zurich), no. 3 (Autumn 1970): 38–45, ill.

Millet, Catherine. "L'art conceptuel comme sémiotique de l'art." *VH101* (Zurich), no. 3 (Autumn 1970): 2–21, ills.

Harrison, Charles. "A Very Abstract Context." *Studio International* (New York) 180, no. 927 (November 1970): 194–198, ill.

1971

Burnham, Jack. "Problems with Criticism." *Artforum* (New York) 9, no. 5 (January 1971): 40–45.

Glueck, Grace. "Museum Presents Wide Media Range [review]." *New York Times*, February 12, 1971, p. L26, ill.

Davis, Douglas. "The Last International? [review]" *Newsweek* (New York), February 22, 1971, p. 64.

Kennedy, R. C. "Galerie Daniel Templon, Paris [review]." *Art International* (Lugano) 15 (February 1971): 54–55.

Rushton, David, and Philip Pilkington. "Aspects of Authorities." *Art-Language* (Coventry) 2, no. 1 (February 1971): 38–50.

Millet, Catherine. "Joseph Kosuth." *Flash Art* (Milan), no. 22 (February–March 1971): 1–2, ill.

Battcock, Gregory. "The Wings of Man." *Arts Magazine* (New York) 45, no. 5 (March 1971): 24–27, ill.

Ratcliff, Carter. "New York Letter [review]." *Art International* (Lugano) 15, no. 5 (May 1971): 32–39, 45.

Green, Denise. "Castelli Gallery [review]." *Arts Magazine* (New York) 46, no. 2 (November 1971): 64.

"In View." *Art & Artists* (London) 6, no. 67 (November 1971): 8–9, ill.

Rosenstein, Harris. "Joseph Kosuth [review]." *Art News* (New York) 70, no. 7 (November 1971): 75.

Trini, Tommaso. "Galleria Toselli, Milano [review]." *Domus* (Milan), no. 504 (November 1971): 51.

Baker, Kenneth. "Castelli Gallery [review]." *Artforum* (New York) 10, no. 4 (December 1971): 86–87.

Martin, Henry. "From Milan and Turin [review]." *Art International* (Lugano) 15, no. 10 (December 1971): 76, ill.

Tomassoni, Italo. "Dall'oggetto al concetto. Elogio della tautologia." *Flash Art* (Milan), no. 28–29 (December 1971–January 1972): 14–15.

1972

Celant, Germano. "Kosuth." *Casabella* (Milan) 36, no. 363 (1972): 34–39, ills.

Ashton, Dore. "New York Commentary: Abracadabrizing Art." *Studio International* (London) 183, no. 940 (January 1972): 39.

Trini, Tommaso. "Joseph Kosuth." *Data* (Milan), no. 3 (April 1972): 24–29, ills.

Atkinson, Terry, and Michael Baldwin. "Information." *Art-Language* (Coventry) 2, no. 2 (Summer 1972): 18–19.

Harrison, Charles. "Art & Language Press." *Studio International* (London) 183, no. 945 (June 1972): 234–235.

Marchan-Fiz, Simon. "Documenta 5 de Kassel [review]." *Goya* (Madrid), no. 109 (July 1972): 46.

Del Pesco, Daniela, and Mariantonietta Picone. "Note sull'arte concettuale." *Op.Cit.* (Naples), no. 25 (September 1972): 5–34, ills.

Kozloff, Max. "Trouble with Art as Idea." *Artforum* (New York) 11, no. 1 (September 1972): 33–37.

Louw, Roelof. "Judd and After." *Studio International* (London) 184, no. 949 (November 1972): 171–174, ill.

Davis, Douglas. "Radicals Defined." *Newsweek* (New York), December 18, 1972, pp. 69–70.

1973

Barilli, Renato. "Le due anime del concettuale." *Op.Cit.* (Naples), no. 26 (January 1973): 63–88, ills.

Barrio-Garay, Jose Luis. "Crónica de Nueva York [review]." *Goya* (Madrid), no. 112 (January 1973): 241, ills.

Cohn, Joshua. "Joseph Kosuth at Castelli [review]." *Art in America* (New York) 61, no. 1 (January 1973): 116–117, ill.

Ratcliff, Carter. "New York Letter [review]." *Art International* (Lugano) 17, no. 1 (January 1973): 62.

Baker, Elizabeth C. "Joseph Kosuth: Information Please." *Art News* (New York) 72, no. 2 (February 1973): 30–31, ills.

Sitelman, Paul. "Castelli Gallery [review]." *Arts Magazine* (New York) 47, no. 4 (February 1973): 68–70, ill.

Boice, Bruce. "Books: Art & Language." *Artforum* (New York) 11, no. 7 (March 1973): 86–87.

Boice, Bruce. "Joseph Kosuth: Two Shows [review]." *Artforum* (New York) 11, no. 7 (March 1973): 84–85, ills.

Felix, Zdenek. "1969: Konzept-Kunst." *Du* (Zurich) 33, no. 4 (April 1973): 267, ill.

Altamira, A. "Accademismo e nuove alternative." *NAC: Notiziario Arte Contemporanea* (Milan) 6, no. 5 (May 1973): 10.

Menna, Filiberto. "Le investigazioni linguistiche di Kosuth." *Qui Arte Contemporanea* (Rome), no. 11 (June 1973): 27–30, ills.

"Joseph Kosuth." *Heute Kunst* (Düsseldorf), no. 2 (July–August 1973): 22–23, ills.

Trimarco, Angelo. "L'arte dopo la filosofia (una riflessione)." *Proposta* (July–October 1973): 8–9.

Dorfles, Gillo. "Valori socio-estetici nelle tendenze concettuali." *NAC: Notiziario Arte Contemporanea* (Milan) 6, no. 8/9 (August–September 1973).

Krauss, Rosalind. "Sense and Sensibility: Reflections on Post-60s Sculpture." *Artforum* (New York) 12, no. 3 (November 1973): 43–53.

Vergine, Lea, ed. "Arte Concettuale." *NAC: Notiziario Arte Contemporanea* (Milan) 6, no. 11 (November 1973).

Felix, Zdenek. "Joseph Kosuth: Investigationen über Kunst und Problemkreise seit 1965 [review]." *Du* (Zurich) 33, no. 12 (December 1973): 948–949, ill.

Jeffery, Ian. "Art Theory and Practice: Art Theory and the Decline of the Art Object." *Studio International* (London) 186, no. 961 (December 1973): 267–271.

1974

Morschel, J. "Joseph Kosuth im Westfälischen Kunstverein [review]." *Das Kunstwerk* (Stuttgart) 27, no. 1 (January 1974): 83–84.

Kaprow, Allan. "The Education of the Un-Artist III." *Art in America* (New York) 62, no. 1 (January–February 1974): 85–91, ill.

Agnetti, Vincenzo. "From: 'Enclosed Here is a 40 Minute Sound Tape.'" *Data* (Milan) 4, no. 11 (Spring 1974): 24–31.

Scalafani, Richard J. "Review: *Conceptual Art*, ed. by Ursula Meyer." *Journal of Aesthetics and Art Criticism* (Cleveland) 32, no. 3 (Spring 1974): 443–444.

Beret, Chantal. "Art Conceptuel: Joseph Kosuth." *Art Press* (Paris), no. 10 (March–April 1974): 16–17, ills.

Morris, Lynda. "Art-Language." *Art Press* (Paris), no. 10 (March April 1974): 18–19.

Thwaites, John Anthony. "Cologne [review]." *Art & Artists* (London) 9, no. 97 (April 1974): 42.

Stephano, Effie. "Paris [review]." *Art & Artists* (London) 9, no. 101 (August 1974): 42.

Burn, Ian, Mel Ramsden, and Terry Smith. "Joseph Kosuth Says That the Group Is a Cultural Ghetto." *Art-Language* (Coventry) 3, no. 1 (September 1974): 54–56.

Binkley, Timothy. "Book Review." *Journal of Aesthetics and Art Criticism* (Cleveland) 33, no. 1 (Fall 1974): 109–111.

Baumgartel, Gerhard. "Denk-Kunst und bildnerisches Denken—Kritik der Concept Art." *Kunstforum International* (Mainz), no. 12 (December 1974–January 1975): 88–111, ills.

1975

Heinemann, Susan. "Joseph Kosuth [review]." *Artforum* (New York) 13, no. 8 (April 1975): 76–77, ill.

Teyssedre, Bernard. "Art sociologique." *Opus International* (Paris), no. 55 (April 1975): 16–28.

Scalafani, Richard J. "What Kind of Nonsense Is This?" *Journal of Aesthetics and Art Criticism* (Cleveland) 33, no. 4 (Summer 1975): 455–458.

Beuttner, Stewart. "Joseph Kosuth's Tenth Investigation, Proposition 5 [A Group Statement, Written by 11 Students and Faculty of Lewis & Clark College]." *Arts Magazine* (New York) 50, no. 2 (October 1975): 86–87, ills.

Robbe, Lon de Vries. "Het Kunstconcept van Concept Kunst." *Museumjournaal* (Amsterdam) 20, no. 6 (December 1975): 241–250, ill. [summary in English, p. 1].

Da Vinci, Mona. "The Fox and Other Fairytales." *Soho Weekly News* (New York), December 25, 1975, p. 17.

"Joseph Kosuth." *Triquarterly* (Evanston), no. 32 (Winter 1975): n.p., ills.

1976

Ratcliff, Carter. "Notes on Style." *Arts Magazine* (New York) 50, no. 2 (May 1976): 90–93.

Russel, Charles. "Toward Tautology: The *Nouveau Roman* and Conceptual Art." *MLN* [*Modern Language Notes*] (Baltimore), 91, no. 5 (October 1976): 1044–1060.

1977

Perrone, Jeff. "Words: When Art Takes a Rest." *Artforum* (New York) 15, no. 10 (Summer 1977): 34–37, ill.

Marmer, Nancy. "Art and Politics '77." *Art in America* (New York) 65, no. 2 (July–August 1977): 64–66.

Fagiolo, Maurizio. "Concetti di marciapiede?" *Il Messaggero* (Rome), August 20, 1977, p. 3, ill.

1978

Hertz, Richard A. "Philosophical Foundations of Modern Art." *British Journal of Aesthetics* (Oxford) 18, no. 3 (Summer 1978): 237–248.

D'Amore, B. "Usi e abusi delle matematiche nelle arti visive 2." *D'Ars* (Milan) 19, no. 87 (July 1978): 22–41, ill.

1979

Henning, Edward B. "The Trouble with Conceptualism." *Art International* (Lugano) 22, no. 8 (January 1979): 53–59.

Dawson, Charles. "What Is This before You?" *Vanguard* (Vancouver) 8, no. 1 (February 1979): 28, ill.

Cortenova, Giorgio. "Riflessione (lo specchio, la specularità)." *G7 Studio* (Bologna) 4, no. 3 (March 1979): 3–11, ill.

Kramer, Hilton. "Modern Art Museum Reopens in Chicago [review]." *New York Times*, March 24, 1979, p. 10.

Elliot, David. "Photos at MCA Are More Itch Than Effort [review]." *Chicago Sun-Times*, April 1, 1979, ill.

Filler, Martin. "Park Avenue Palazzo; Interior Design; Apartment in New York." *Progressive Architecture* (New York) 60 (May 1979): 116, ill.

Starenko, Michael. "Art after Photography." *New Art Examiner* (Chicago) 6, no. 9 (June 1979): 5, ill.

Morgan, Robert C. "Conceptual Art and the Continuing Quest for a New Social Context." *Journal: Southern California Art Magazine* (Los Angeles), no. 23 (June–July 1979): 30–36.

"Kosuth in Europa." *Domus* (Milan), no. 597 (August 1979): 53, ills.

Broos, Kees. "Het beeld van de taal." *Openbaar Kunstbezit* 23, no. 5 (October 1979): 149–159.

1980

Schmalriede, Manfred. "Konzeptkunst und Semiotik." *Kunstforum International* (Mainz) 42, no. 6 (1980): 35–47, ills.

Schwarz, Michael. "Über den Realismus politischer Konzeptkunst." *Kunstforum International* (Mainz) 42, no. 6 (1980): 14–34, ill.

Blau, Douglas. "Yvon Lambert Presents 'Artemisia,' Paula Cooper Gallery [review]." *Artforum* (New York) 18, no. 9 (May 1980): 79.

1981

Von Kageneck, Christian. "Minimal und Conceptual Art aus der Sammlung Panza [review]." *Das Kunstwerk* (Stuttgart) 34, no. 1 (1981): 72.

Wirth, Günther. "Joseph Kosuth: Staatsgalerie Stuttgart, Kunsthalle Bielefeld [review]." *Das Kunstwerk* (Stuttgart) 34, no. 6 (1981): 72–73, ill.

Ratcliff, Carter. "Modernism & Melodrama." *Art in America* (New York) 69, no. 2 (February 1981): 105–109.

Lawson, Thomas. "Last Exit: Painting." *Artforum* (New York) 20, no. 2 (October 1981): 40–47.

"Joseph Kosuth: Fiche Artiste No. 12." *Artpress* (Paris), no. 54 (December 1981): 51, ill.

Millet, Catherine. "L'art de la fin de l'art . . . 10 ans après." *Artpress* (Paris), no. 54 (December 1981): 6–9, ill.

Morgan, Robert C. "Conceptual Art and Photographic Installations: The Recent Outlook." *Afterimage* (New York) 9, no. 5 (December 1981): 8–11.

1982

Landry, Pierre. "Joseph Kosuth, *Cathexis.*" *Parachute* (Montreal), no. 26 (Spring 1982): 36–37, ill.

Acker, Kathy. "Impassioned with Some Song We." *Artforum* (New York) 20, no. 9 (May 1982): 66–69.

Castle, Ted. "Bouquet of Mistakes: Artists Talk about Their Works." *Flash Art* (Milan), no. 16 (Summer 1982): 54–55.

Celant, Germano. "Framed: Innocence or Gilt?" *Artforum* (New York) 20, no. 10 (Summer 1982): 49–55, ill.

Kind, Phyllis. "To the Editor, contra Kosuth." *Artforum* (New York) 21, no. 4 (December 1982): 4–5.

Kuspit, Donald B. "To The Editor." *Artforum* (New York) 21, no. 4 (December 1982): 5.

1983

Trimarco, Angelo. "Dall'america: Warhol e Kosuth." *Op.Cit.* (Naples), no. 56 (January 1983): 5–13.

Bordaz, Jean-Pièrre. "Joseph Kosuth: Galerie Eric Fabre [review]." *Flash Art* (Milan) no. 111 (March 1983): 69.

De Duve, Thierry. "Who's Afraid of Red, Yellow and Blue?" *Artforum* (New York) 22, no. 1 (September 1983): 30–37, ill.

Zimmer, Bill. "Joseph Kosuth." *Avenue* (New York) 8, no. 4 (December 1983–January 1984): 126.

1984

Nittve, Lars. "Ars 83: Ateneum, Helsinki [review]." *Artforum* (New York) 22, no. 8 (April 1984): 92.

Mollet-Vieville, Ghislain. "Des corps dans le décor." *Public* (Paris), no. 3 (September 1984–February 1985): 40–41, ill.

1985

Gauthier, Michel. "Matières grises." *Conséquences* (Paris), no. 5 (Winter–Spring 1985): 21–39.

Indiana, Gary. "Seduction and Production [review]." *The Village Voice* (New York), March 19, 1985, p. 91, ill.

Le Vine, Charles. "Discussing the Experience of an Organizing Rupture: Comments on the Recent Work of Joseph Kosuth." *Artefactum* (Antwerp) 2, no. 9 (June–August 1985): 2–7, ills.

McEvilley, Thomas. "I Think, Therefore I Art." *Artforum* (New York) 23, no. 10 (Summer 1985): 74–84, ill.

McEvilley, Thomas. "Leo Castelli Gallery [review]." *Artforum* (New York) 23, no. 10 (Summer 1985): 107–108, ill.

Lanert, Petra. "Alle Jahre Wieder?: Joseph Kosuth in Stuttgart [review]." *Nike* (Munich), no. 11 (December 1985/January–February 1986): 16–17, ill.

1986

Canning, Susan M. "Chambres d'Amis [review]." *Museumjournaal* (Amsterdam) 31, no. 3/4 (1986): 220–222, ills.

Russell, John. "Joseph Kosuth's 'Zero & Not' at Leo Castelli [review]." *New York Times*, June 6, 1986, p. C18, ill.

Indiana, Gary. "Cancelled Texts: Joseph Kosuth at Leo Castelli [review]." *The Village Voice* (New York), June 10, 1986, p. 77, ill.

Grauman, Brigid. "The Great Spare Room Show [review]." *The Bulletin* (Brussels), no. 25, June 26, 1986, pp. 18–21, ills.

Nickas, Robert, and David Robbins. "Shrink Rap." *Arts Magazine* (New York) 61, no. 1 (September 1986): 92–93, ill.

Tazzi, Pier Luigi. "Albrecht Dürer Would Have Come Too." *Artforum* (New York) 25, no. 1 (September 1986): 124–128, ill.

Le Vine, Charles. "Kosuth's 'Zero & Not.' " *Artefactum* (Antwerp) 3, no. 15 (September–October 1986): 2–7, ills.

Bordowitz, Gregg. "Geography Notes: A Survey." *Real Life Magazine* (New York) 16 (Autumn 1986): 12–17, ill.

Gildemyn, Marie-Pascale. "Gent '86: un été pour l'art contemporain [review]." *+/o* (Brussels), no. 42 (October 1986): 65–66, ill.

Indiana, Gary. "Rooted Rhetoric: Castel del'Oro [sic], Naples [review]." *Flash Art* (Milan) no. 130 (October–November 1986): 83–84, ill.

Newman, Michael. "My House Is Your House: 'Chambres d'amis' at Ghent [review]." *Artscribe* (London), no. 60 (November–December 1986): 62–64.

Indiana, Gary. "Clegg and Guttmann and Joseph Kosuth at Jay Gorney [review]." *Art in America* (New York) 74, no. 12 (December 1986): 137, ill.

Princenthal, Nancy. "Kosuth at Ground Zero." *Art in America* (New York) 74, no. 12 (December 1986): 126–129, ills.

Mueller, Cookie. "Art & About [review]." *Details* (New York) 5, no. 6 (Holiday 1986): 75–76, ill.

1987

Jones, Ronald. "Clegg & Guttmann & Joseph Kosuth at Jay Gorney [review]." *Artscribe* (London), no. 61 (January–February 1987): 74–75.

Wulffen, Thomas. "Joseph Kosuth at Anselm Dreher [review]." *Artscribe* (London), no. 61 (January–February 1987): 83–84, ill.

Robbins, David. "Joseph Kosuth: Absolute Responsibility." *Arts Magazine* (New York) 61, no. 8 (April 1987): 62–63, ill.

Schwabsky, Barry. "Diversion, Oblivion, and the Pursuit of New Objects: Reflections on Another Biennial [review]." *Arts Magazine* (New York) 61, no. 10 (June 1987): 78–80, ill.

Castle, Frederick Ted. "Occurrences/New York [review]." *Art Monthly* (London), no. 108 (July–August 1987): 9–12.

Morera, Daniela "Joseph Kosuth." *Vogue Italia* (Milan), no. 450 (September 1987): 478–483, ill.

Handweg, Joan. "Kosuth Work Purchased by UAM." *University Art Museum Calendar* (Berkeley), October 1987, pp. 1–2, ill.

Wilson, William. "The Galleries: La Cienega Area [review]." *Los Angeles Times*, October 30, 1987, p. 14, ill.

"Album: Joseph Kosuth." *Arts Magazine* (New York) 62, no. 3 (November 1987): 100–101, ills.

Mantegna, Gianfranco. "Biennial Exhibition [review]." *Tema Celeste* (Syracuse) 5, no. 3 (November 1987): 64–65, ill.

Gardner, Colin. "Languages of the Subconscious: Margo Leavin Gallery, Los Angeles [review]." *Artweek* (Los Angeles) 18 (November 14, 1987): 7, ill.

Cameron, Dan. "Joseph Kosuth: Jay Gorney Modern Art [review]." *Tema Celeste* (Syracuse) 5, no. 4 (December 1987–February 1988): 57, ills.

Castello, Michelangelo, and Demetrio Paparoni. "Editorial." *Tema Celeste* (Syracuse) 5, no. 4 (December 1987–February 1988): 19–21, ill.

1988

Morgan, Robert C. "The Making of Wit: Joseph Kosuth and the Freudian Palimpsest." *Arts Magazine* (New York) 62, no. 5 (January 1988): 48–51, ills.

Morgan, Robert C. "Joseph Kosuth: Jay Gorney Modern Art [review]." *Flash Art* (Milan), no. 138 (January–February 1988): 122, ill.

Melo, Alexandre. "Cómicos Gallery, Lisbon [review]." *Flash Art* (Milan), no. 139 (March–April 1988): 127, ill.

Jones, Ronald. "Joseph Kosuth: Jay Gorney Modern Art [review]." *Artscribe* (London), no. 69 (May 1988): 79–80, ill.

Morgan, Stuart. "Doghouse." *Artscribe* (London), no. 69 (May 1988): 7–9, ill.

Cotter, Holland. "Museum Talk: Art & Language." *Art in America* (New York) 76, no. 6 (June 1988): 142–147.

Obalk, Hector. "Cinq pièces de Joseph Kosuth (pour les comprendre puis les juger)." *Art Press* (Paris), no. 127 (July–August 1988): 42–43, ill.

Hess, Elizabeth. "¿Mi casa es su casa? [review]" *The Village Voice* (New York), August 2, 1988, p. 89, ill.

Walsh, Robert. "Visual Statements" *Vanity Fair* (New York) 51, no. 9 (September 1988): 154, ill.

Smith, Roberta. "Kosuth Takes a Turn for the Psychological [review]." *New York Times*, September 30, 1988, p. C30, ill.

Bourriaud, Nicholas. "Joseph Kosuth." *New Art International* (Paris) 3, no. 3 (October– November 1988): 16–21, ills.

Mollet-Vieville, Ghislain. "Exposition: Art Conceptuel I." *Galeries Magazine* (Paris), no. 27 (October–November 1988): 96–99, ills. In English and French.

Russell, John. "For '60s Devotees, a Show Fraught with Nostalgia [review]." *New York Times*, November 27, 1988, p. 39.

Salvioni, Daniela. "Spotlight: Joseph Kosuth." *Flash Art* (Milan), no. 143 (November– December 1988): 131, ills.

Staniszewski, Mary Anne. "Conceptual Art." *Flash Art* (Milan), no. 143 (November– December 1988): 88–97, ills.

Decter, Joshua. "New York in Review: Joseph Kosuth [review]." *Arts Magazine* (New York) 63, no. 4 (December 1988): 105, ill.

Lingner, Michael. "Kunst als Kunstdefinition: Joseph Kosuth im Kabinett für aktuelle Kunst [review]." *Punkt: Kunst im Nordwesten* (Bremen) 5 (December 1988): 15–16, ill.

Perreault, John. "Sleepers Awake?" *The Village Voice* (New York), December 13, 1988, p. 113.

Galligan, Gregory. "More Post-Modern Than Primitive [review]." *Art International* (Paris), no. 5 (Winter 1988): 61–62, ill.

1989

Baker, Kenneth. "Artists in Residences." *House and Garden* (New York) 161, no. 1 (January 1989): 38–40, ill.

Morgan, Robert C. "The Situation of Conceptual Art." *Arts Magazine* (New York) 63, no. 6 (February 1989): 40–43, ills.

Lingner, Michael. "Kunst als Kunstdefinition." *Wolkenkratzer Art Journal* (Frankfurt), no. 2 (March–April 1989): 74–75, ill.

Evans, Steven. "Joseph Kosuth at Leo Castelli [review]." *Artscribe* (London), no. 75 (May 1989): 80–81, ill.

Ruyters, Marc, and Wim van Melders. "Joseph Kosuth: Taal is Kunst [matig]." *Kunst & Cultuur* (Copenhagen, May 1989): 8–11, ills.

"Joseph Kosuth: Knoll Galéria, Budapest." *Müvészet* (Budapest), no. 8 (August 1989): 50–55, ills.

Berger, Maurice, Catherine Millet, and Catherine Francblin. "L'art conceptual: L'avant et l'après." *Art Press* (Paris), no. 139 (September 1989): 30–47, ill.

Mandl, Erich. "Ludwig Wittgenstein in der Wiener Secession." *Vernissage* (Vienna), no. 7 (September 1989): 41–43.

Levy, Alan. "Wittgenstein Centennial." *International Herald Tribune* (Paris), September 1, 1989, p. 7.

Schollhammer, Georg. "Wittgenstein: die Verzweiflung der Moderne." *Der Standard* (Vienna), September 13, 1989, p. 11, ill.

Johnson, Daniel. "Pieces of a Great Mind." *The Daily Telegraph* (London), September 15, 1989, p. 18.

Hapgood, Susan. "Joseph Kosuth: Language and Its [Dis]Contents." *Contemporanea* (Turin) 11, no. 7 (October 1989): 44–49, ills.

Mahr, Peter. "Wittgenstein: Secession, bis 29.10.1989 [review]." *Kunstforum International* (Mainz), no. 104 (November–December 1989): 347–350, ills.

Steffen, Barbara. "View." *Artscribe* (London), no. 78 (November–December 1989): 9–11, ill.

Dewulf, Bernard. "Kosuth-Wittgenstein." *Kunst & Cultuur* (Copenhagen, December 1989): 51–52, ill.

Vankeerberghen, Veronique. "Wittgenstein, ou montrer l'indicible." *Art & Culture* (Brussels) 4, no. 4 (December 1989): 24–25.

Bourriaud, Nicholas. "Joseph Kosuth, entre les mots." *Artstudio* (Paris), no. 15 (Winter 1989): 94, 103, ills.

Foray, Jean-Michel. "Art Conceptuel: une possibilité de rien." *Artstudio* (Paris), no. 15 (Winter 1989): 44–67.

1990

Gross, Roland. "Der Vordenker der Konzeptkunst." *Der Tagesspiegel* (Berlin), January 4, 1990, ill.

Cumps, Jean. "En contrepoint à l'exposition Wittgenstein au Palais des Beaux-Arts." *+/o* (Brussels), no. 55 (February 1990): 14–15, ills.

Prat, Véronique. "La collection d'art contemporain d'un 'galeriste' parisien." *Le Figaro Magazine* (Paris), no. 14140 (February 10, 1990): supplement, pp. xiv–xv, ill.

Draxler, Helmut. "Wittgenstein: Wiener Secession [review]." *Artforum* (New York) 28, no. 7 (March 1990): 173.

Avgikos, Jan. "Tell Them It Was Wonderful: Wittgenstein and the Nature of Art." *Artscribe* (London), no. 80 (March–April 1990): 66–69, ills.

3. BOOKS

Aloisio, Leo, and Filiberto Menna. "Analisi delle proposizioni concettuali." In *Critica in atto*. Rome: Centro Stampa Accademia, 1973. Originally delivered as a lecture at the Incontri Internazionali dell'Arte, Rome, March 1972.

Arnason, H. Harvard. *History of Modern Art*. New York: Harry N. Abrams, Inc., 1985, pp. 703, 705, ill.

Avella, Leonardo. *L'effimero spaziale e la nuovanuova immagine*. Siena: Edizioni il Ceccio, 1985, p. 40.

Baker, Kenneth. *Minimalism*. New York: Abbeville Press, 1988, pp. 90, 92, 94.

Barilli, Renato. *L'Arte Contemporanea: Da Cezanne alle ultime tendenze*. Milan: Feltrinelli, 1985, pp. 318–319, ill.

Battcock, Gregory, ed. *Idea Art*. New York: E. P. Dutton, 1973, pp. 70–101.

Battcock, Gregory, ed. *Minimal Art: A Critical Anthology*. New York: E. P. Dutton, 1968, p. 431, ill.

Bocchi, Giancarlo, ed. *Arte e Pratica Politica*. Parma: Edizioni Tra, 1979, pp. 60–65, ill.

Bonito Oliva, Achille. *Europe/America: The Different Avant-Gardes*. Milan: Franco Maria Ricci Editore, 1976, p. 182, ill.

Bourel, Michel. "Art Conceptuel." *Art Conceptuel I* [exhibition catalogue]. Bordeaux: Musée d'Art Contemporain, 1988, pp. 9–12.

Britt, David, ed. *Modern Art: Impressionism to Post-Modernism*. Boston, Toronto, London: Little, Brown and Company, 1989, pp. 381–382, ill.

Buchloh, Benjamin H. D. "De l'esthétique d'administration à la critique institutionelle (Aspects de l'art conceptuel)." *L'art conceptuel, une perspective* [exhibition catalogue]. Paris: Musée d'Art Moderne de la Ville de Paris, 1989, pp. 25–53. In English and French.

Burnham, Jack. *The Structure of Art*. New York: George Braziller, 1971, pp. 153–155.

Celant, Germano. *Arte Povera*. Milan: Mazzota, 1969. English edition, New York: Praeger Publishers, 1969, pp. 98–101.

Celant, Germano. *Precronistoria 1966–69*. Florence: Centro Di, 1976, pp. 25–26, 43, 56–58, 61, 64, 86, 89, 106–108, 112–113, 131, 133, 138–139, 142, 151–152.

Celant, Germano. *Unexpressionism: Art beyond the Contemporary*. New York: Rizzoli, 1988, pp. 282–291, ills.

Celant, Germano. "Untitled, 1975." In *1970–1975 Paul Maenz Köln*. Cologne: Paul Maenz, 1975, pp. 24–25, 60–61, 84–85, ills. Text in English and German.

Corà, Bruno. "Joseph Kosuth 'Modus Operandi': Cancellato, Rovesciato." *"Modus Operandi": Cancellato, Rovesciato. Un Opera di Joseph Kosuth al Museo di Capodimonte* [exhibition catalogue]. Naples: Electa Napoli, 1988, pp. 12–19.

Czartoryska, Urszula. *Op Pop-Artu do Sztuki Konceptualnej*. Warsaw: Wydawnictwa Artystyczne i Filmowe, 1976, pp. 267, 275, 334, ills.

Daval, Jean-Luc. "Dans le courant de l'art conceptuel." *Skira Annuel no. 1*. Geneva: Editions d'art Albert Skira, 1975, pp. 38–59, ill.

Davis, Douglas. *Art Culture: Essays on the Postmodern.* New York: Harper & Row, 1977, pp. 14, 16, 62.

De Duve, Thierry. *Resonances du Readymade: Duchamp entre avant-garde et tradition.* Nîmes: Editions Jacqueline Chambon, 1989, pp. 236, 242, 250, 270, 279, ill.

De Fusco, Renato. *Storia dell'arte contemporanea.* Rome and Bari: Laterza, 1983, pp. 260, 273, 277–278, 404, ills.

Del Guercio, Antonio. *Storia dell'arte presente: Europa e Stati Uniti dal 1945 a oggi.* Rome: Editori Riuniti, 1985, pp. 117, 120, 131, ill.

De Vries, Gerd, ed. *On Art: Artists' Writings on the Changed Notion of Art after 1965.* Cologne: DuMont Schauberg, 1974, pp. 136–175, 243, 262–263. In English and German.

Dexeus, Victoria Combalia. *La Poética de lo Neutro: Análisis y Crítica del Arte Conceptual.* Barcelona: Editorial Anagrama: 1975, pp. 87–105.

Diacono, Mario. *Verso una nuova iconografia.* Reggio Emilia: Collezione Tauma, 1984, pp. 231–235, ill.

Dorfles, Gillo. *Ultime tendenze nell'arte d'oggi,* 6th ed. Milan: Feltrinelli, 1984, pp. 14, 15, 19, 22, 132, 134, 136, 138, 139, 144, 151, 183, 186, 193, 194, ill.

Faust, Wolfgang Max. *Bilder werden Worte.* Munich: Carl Hanser Verlag, 1977, pp. 24–25, 196, 231, 242, 290.

Filippuci, Dante. *Nell'arte concettuale il valore non fa poblema.* Perugia: Editore Urbani, 1975, p. 10.

Foncé, Jan. "Upon Reflection: Conceptualizing Conceptual Art(ists)." *Concept Art* [exhibition catalogue]. Copenhagen: Stalke Galleri, 1988, pp. 34–39. In English, French, German, and Dutch.

Freedman, Martin. "The Sixties: Remembrance of Things (Recently) Past." *A View of a Decade* [exhibition catalogue]. Chicago: Museum of Contemporary Art, 1977, pp. 7–17.

Gintz, Claude. "L'art conceptuel, une perspective." *L'art conceptuel, une perspective* [exhibition catalogue]. Paris, Musée d'Art Moderne de la Ville de Paris, 1989, pp. 13–23. In English and French.

Glozer, Laszlo. *Westkunst: Zeitgenössische Kunst seit 1939.* Cologne: DuMont Buchverlag, 1981, pp. 315, 490, ill.

Gookin, Kirby. "Joseph Kosuth and the Early Investigations." Master's thesis, Columbia University, 1984.

Gottlieb, Carla. *Beyond Modern Art.* New York: E. P. Dutton, 1976, pp. 344–345, 371, 373, 377.

Groh, Klaus. *If I Had A Mind. . . . Concept Art/Project Art.* Cologne: DuMont Aktuell, 1971, n.p., ill.

Guercio, Gabriele. "Formés dans la résistance; Barry, Huebler, Kosuth et Weiner contre la presse américaine." *L'art conceptuel, une perspective* [exhibition catalogue]. Paris, Musée d'Art Moderne de la Ville de Paris, 1989, pp. 65–81. In English and French.

Guercio, Gabriele. "Rooted Rhetoric: Imperfections in Humanism." *Rooted Rhetoric: Una Tradizione nell'Arte Americana* [exhibition catalogue]. Naples: Guida Editori, 1986, pp. 12–21. In English and Italian.

Harrison, Charles. "Art Object and Artwork." *L'art conceptuel, une perspective* [exhibition catalogue]. Paris, Musée d'Art Moderne de la Ville de Paris, 1989, pp. 55–61. In English and French.

Hartt, Frederick. *Art: A History of Painting, Sculpture, Architecture*, 3rd ed. New York: Harry N. Abrams, Inc., 1989, p. 950.

Hertz, Richard, ed. *Theories of Contemporary Art*. Englewood Cliffs, N.J.: Prentice-Hall, Inc., 1985, pp. 93–102, 103–106, 146, 180, 263.

Hoet, Jan. "Chambres d'amis: een Museum op avontuur." *Chambres d'amis* [exhibition catalogue]. Ghent: Museum van Hedendaagse Kunst, 1986, pp. 11–22.

Honnef, Klaus. *Concept Art*. Cologne: Phaidon, 1971, pp. 63–67, ills.

Hunter, Sam, and John Jacobus. *American Art of the Twentieth Century*. New York: Harry N. Abrams, Inc., 1973, pp. 465, 495, ills.

Hunter, Sam, and John Jacobus. *Modern Art: From Post-Impressionism to the Present*. New York: Harry N. Abrams, Inc., 1976, p. 319.

Inboden, Gudrun. "Joseph Kosuth: Künstler und Kritiker der Moderne." *Joseph Kosuth: Bedeutung von Bedeutung: Texte und Dokumentation der Investigationen über Kunst seit 1965 in Auswald* [exhibition catalogue]. Stuttgart: Staatsgalerie, 1981, pp. 10–27. In English and German.

Janson, H. W. *History of Art*, 3rd ed. Revised and expanded by Anthony F. Janson. New York: Harry N. Abrams, Inc., 1987, p. 723, ill.

Johnson, Ellen, ed. *American Artists on Art*. New York: Harper & Row, 1982, pp. 134–137.

Johnson, Ellen. *Modern Art and the Object*. New York: Harper & Row, 1976, pp. 42–43.

Jones, Ronald. "The Beauty of Circumstance." *The Beauty of Circumstance* [exhibition catalogue]. New York: Josh Baer Gallery, 1987, n.p.

Jouan, C. "Le mot." *Cadres en l'aire* [exhibition catalogue]. Rennes: Centre d'Histoire de l'Art Contemporain, 1987, pp. 16–17, ill.

Juhl, Carsten. "The Cognitive in the Work of Art." *Exchange of Meaning: Translation in the Work of Joseph Kosuth* [exhibition catalogue]. Antwerp: Museum van Hedendaagse Kunst and International Cultureel Centrum, 1989, pp. 78–113. In English, French, and Dutch.

Kelly, Mary. "Re-viewing Modernist Criticism." In Brian Wallis, ed., *Art After Modernism: Rethinking Representation*. Boston: David R. Godine, Inc., 1984, pp. 87–103, ill.

Kirshner, Judith Russi. "Words at Liberty." *Words at Liberty* [exhibition catalogue]. Chicago: Museum of Contemporary Art, 1977, pp. 3–14.

Knight, Christopher. *Art of the Sixties and Seventies: The Panza Collection*. New York: Rizzoli, 1983, pp. 52–53, 234–237, 264, ills.

Kuspit, Donald B. "Flak from the 'Radicals': The American Case against Current German Painting." In Brian Wallis, ed., *Art After Modernism: Rethinking Representation.* Boston: David R. Godine, Inc., 1984, pp. 137–151.

Lebovici, Elisabeth. "L'ombre sans doute." *Le Fragment et le Hérisson* [exhibition catalogue]. Olonne sur Mer: Cahiers de l'Abbaye Sainte-Croix, 1986, n.p.

Levanto, Yrjänä. "Käsitetaide—ajatuksjen Atlantis [Conceptual Art—An Atlantis of Ideas]." *Ars '83* [exhibition catalogue]. Helsinki: Helsingfors, 1983, pp. 24–38, ills.

Le Vine, Charles. "Open the 'Open' Work of Art." *Rooted Rhetoric: Una Tradizione nell'Arte Americana* [exhibition catalogue]. Naples: Guida Editori, 1986, pp. 124–133. In English and Italian.

Lippard, Lucy R. *Changing: Essays in Art Criticism.* New York: E. P. Dutton, 1971, pp. 262, 310, ill.

Lippard, Lucy R. *Overlay: Contemporary Art and the Art of Pre-History.* New York: Pantheon Books, 1983, p. 96.

Lippard, Lucy R. *Six Years: The Dematerialization of the Art Object from 1966–1972.* New York: Praeger Publishers, 1973, pp. 14, 24–25, 30, 64, 72–73, 113–114, 127–133, 174–175, ills.

Lippert, Werner. "Über Concept Art." *Concept Art, Minimal, Arte Povera, Land Art: Sammlung Marzona* [exhibition catalogue]. Bielefeld: Kunsthalle Bielefeld, 1990, pp. 54–63, ills.

Lucie-Smith, Edward. *Art Now.* New York: Morrow, 1981, pp. 420–430, 437, ill.

Lynton, Norbert. *The Story of Modern Art,* 2d ed. Oxford: Phaidon Press, Ltd., 1989, pp. 288, 377, ill.

Maenz, Paul, and Gerd de Vries. *Art & Language.* Cologne: DuMont Schauberg, 1972, pp. 74–108. In English and German.

Maenz, Paul, and Gerd de Vries. "Joseph Kosuth. 'Kunst existiert nur in der Form von Praxis." *Joseph Kosuth: Beiträge zur Konzeptuellen Kunst 1965–1976* [exhibition catalogue]. Bremen: Kunsthalle, 1976, n.p.

Menna, Filiberto. "L'arte concettuale." In Franco Russoli, ed., *L'Arte Moderna,* vol. 14. Milan: Fratelli Fabbri Editori, 1978, ills.

Menna, Filiberto. *Critica della critica.* Milan: Feltrinelli, 1980, pp. 13–20.

Menna, Filiberto. *La linea analitica dell'arte moderna: le figure e le icone.* Turin: Einaudi, 1975, pp. 85–91, ills.

Menna, Filiberto. "La trahissons des images," in *Studi sul surrealismo.* Rome: Officina, 1977, pp. 320–333.

Meyer, Ursula. *Conceptual Art.* New York: E. P. Dutton, 1972, pp. 152–171, ills.

Migliorini, Ermanno. *L'arte e la città.* Florence: Edizione d'arte il fiorino, 1975.

Migliorini, Ermanno. *Conceptual Art.* Florence: Edizione d'arte il fiorino, 1972, pp. 119–128, ills.

Millet, Catherine. "Joseph Kosuth." *Joseph Kosuth: Investigations sur l'art et problématique, 1965–1973* [exhibition catalogue]. Paris: Musée d'Art Moderne de la Ville de Paris, 1974, n.p., ill.

Millet, Catherine. *Textes sur l'art conceptuel.* Paris: Editions Daniel Templon, 1972, pp. 53–56.

Minimal & Earth & Concept Art. Poland: Jazzpetit, 1982, pp. 254–302, ills.

Morgan, Robert C. "Beyond Formalism: Language Models, Conceptual Art and Environmental Art." *An American Renaissance: Painting and Sculpture since 1940* [exhibition catalogue]. New York: Abbeville Press, 1986, pp. 147–157.

Morgan, Robert C. "The Role of Documentation in Conceptual Art: An Aesthetic Inquiry." Ph.D. diss., New York University, 1978.

Morton, L. H. "Theories of Three Conceptual Artists: A Critique and Comparison [Kosuth, LeWitt, Atkinson]." Ph.D. diss., Ball State University, 1985.

Nittve, Lars. "Implosion." *Implosion: Ett Postmodern Perspektiv/A Postmodern Perspective* [exhibition catalogue]. Stockholm: Moderna Museet, 1987, pp. 13–39. In English and Swedish.

O'Doherty, Brian. *Inside the White Cube: The Ideology of the Gallery Space.* San Francisco: The Lapis Press, 1976, pp. 63–64, ill.

Osterwold, Tilman. " 'Blow Up': Zeitgeschichte." *Blow Up* [exhibition catalogue]. Stuttgart: Württembergischer Kunstverein, 1987, pp. 11–21, ill.

Pansera, Anty, and Maurizio Vitta. *Guida all'arte contemporanea.* Marietti: Casale Monferrato, 1986, pp. 185, 187, 188.

Phillips, Lisa. "Art and Media Culture." *Image World* [exhibition catalogue]. New York: Whitney Museum of American Art, 1989, pp. 57–93, ill.

Phillipson, Michael. *Painting, Language and Modernity.* London, Boston, Melbourne, and Henley: Routledge and Kegan Paul, 1985, p. 106.

Pincus-Witten, Robert. *Eye to Eye: Twenty Years of Art Criticism.* Ann Arbor: UMI Research Press, 1984, pp. 143, 185.

Poinsot, Jean-Marc. "Deni d'exposition." *Art Conceptuel I* [exhibition catalogue]. Bordeaux: Musée d'Art Contemporain, 1988, pp. 13–21.

Prinz, J. "Art Discourse: Discourse in Art (1960–1985)." Ph.D. diss., University of Southern California, 1986.

Prinzhorn, Martin. "Shift and Replacement." *Exchange of Meaning: Translation in the Work of Joseph Kosuth* [exhibition catalogue]. Antwerp: Museum van Hedendaagse Kunst and International Cultureel Centrum, 1989, pp. 16–23. In English and Dutch.

Robins, Corinne. *The Pluralist Era: American Art, 1968–1981.* New York: Harper & Row, 1984, pp. 26–29, 32–33, ill.

Rorimer, Anne. "Photography-Language-Context: Prelude to the 1980's." In Catherine Gudis, ed., *A Forest of Signs* [exhibition catalogue]. Cambridge, Mass., and London: MIT Press, 1989, pp. 129–153, ill.

Russell, John. *The Meanings of Modern Art.* New York: The Museum of Modern Art and Harper & Row, 1981, p. 398.

Sandler, Irving. *American Art of the 1960s.* New York: Harper & Row, 1988, pp. 138, 294, 350, 352, 354, 357, ills.

Sauer, Christel. *Die Sammlung Fer.* Cologne: Verlag Gerd de Vries, 1983, pp. 94–97, 206–207, ills. In English and German.

Schug, Albert. "Kunst—Sprach—Denken—Wirklichkeit." *Kunst bleibt Kunst* [exhibition catalogue]. Cologne: Kunsthalle, 1974, pp. 38–51. In English and German.

Semin, Didier. "Deux cent trois mots en garamond corps onze." *Le Fragment et le Hérisson* [exhibition catalogue]. Olonne sur Mer: Cahiers de l'Abbaye Sainte-Crox, 1986, n.p.

Siegel, Jeanne. *Artwords: Discourse on the 60s and 70s.* Ann Arbor: UMI Research Press, 1985, pp. 221–231, ills.

Siegelaub, Seth. "Quelques observations à propos du soi-disant 'Art Conceptuel': Extraits d'entretiens non publiés avec Robert Horvitz (1987) et Claude Gintz (1989)." *L'art conceptuel, une perspective* [exhibition catalogue]. Paris, Musée d'Art Moderne de la Ville de Paris, 1989, pp. 85–94, ill. In English and French.

Smith, Roberta. "Conceptual Art." In Nikos Stangos, ed., *Concepts of Modern Art.* New York: Harper & Row, 1981, pp. 256–272, ill.

Stella, Frank. *Working Space.* Cambridge, Mass., and London: Harvard University Press, 1986, pp. 127, 130, ill.

Sumpf, Joseph. "Approaching Kosuth." *Exchange of Meaning: Translation in the Work of Joseph Kosuth* [exhibition catalogue]. Antwerp: Museum van Hedendaagse Kunst and International Cultureel Centrum, 1989, pp. 58–77. In English, French, and Dutch.

Thomas, Karin. *Kunst—Praxis Heute.* Cologne: DuMont Schauberg, 1972, pp. 118–120, ills.

Thomas, Karin, and Gerd de Vries. *DuMont's Künstler Lexikon von 1945 bis zur Gegenwart.* Cologne: DuMont Buchverlag, 1977, pp. 66, 209–210, ill.

Trimarco, Angelo. *Confluenza: arte e critica di fine secolo.* Milan: Guerini, 1990, pp. 119–157, ills.

Trimarco, Angelo. "Modern Postmodern." *Rooted Rhetoric: Una Tradizione nell'Arte Americana* [exhibition catalogue]. Naples: Guida Editori, 1986, pp. 138–145. In English and Italian.

Trimarco, Angelo. *La parabola del teorico: L'arte e la critica.* Rome: Officina, 1982, pp. 7–29, ills.

Van der Marck, Jan. *American Art: Third Quarter Century* [exhibition catalogue]. Seattle: Seattle Art Museum, 1973, pp. 88–89, 117–118, ill.

Von Mechelen, Marga. "Language as Art: Art as Language: A Study of the Journals *Art-Language* and *The Fox.*" Ph.D. diss., Arnhem, 1978.

Waldman, Diane. "New Dimensions/Time-Space: Western Europe and the United States." *1971 Guggenheim International* [exhibition catalogue]. New York: Solomon R. Guggenheim Museum, 1971, pp. 15–26, ill.

Walker, John. *Art since Pop.* London: Thames & Hudson, 1975, pp. 54–55, ill.

Wedewer, Rolf, and Konrad Fischer, eds. *Konzeption-Conception.* Cologne and Opladen: Westdeutscher Verlag, 1969, n.p., ills.

Weiss, James. "Words and Images in American Art since 1968." Ph.D. diss., Yale University [forthcoming].

Welchman, John C. "Translation/(Procession)/Transference: Joseph Kosuth and the Scene/Seen of Writing." *Exchange of Meaning: Translation in the Work of Joseph Kosuth* [exhibition catalogue]. Antwerp: Museum van Hedendaagse Kunst and International Cultureel Centrum, 1989, pp. 24–57. In English and Dutch.

Zaccharias, Thomas. *Blick der Moderne: Einführug in ihre Kunst.* Munich and Zurich: Verlag Schnell & Steiner, 1985, p. 73, ill.

Zaunschirm, Thomas. "Psycho Art." *Locations* [exhibition catalogue]. Innsbruck: Tiroler Landesgalerie im Taxispalais, 1988, p. 37, ill.

4. EXHIBITIONS CURATED BY JOSEPH KOSUTH

Lannis Gallery [Museum of Normal Art], New York, N.Y. *Fifteen People Present Their Favorite Book,* Summer 1968. Artists included: Carl Andre, Jo Baer, Mel Bochner, Julia B. De Forest, Dan Graham, Joseph Kosuth, Christine Kozlov, Sol LeWitt, Robert Mangold, Robert Morris, Ad Reinhardt, Michael Rinaldi, Ernest Rossi, Robert Ryman, and Sinan Tanju.

Visual Arts Gallery, New York, N.Y. *The Air-Conditioning Show,* 1972. Artists included: Terry Atkinson and Michael Baldwin.

Galerie Philip Nelson [Octobre des arts], Lyons. *Transitional Objects,* October 18–December 21, 1985. Artists included: Alan Belcher, Gregg Bordowitz, Michael Clegg and Martin Guttmann, Mark Dion, Andrea Fraser, Sylvia Kolbowski, and Ken Lum.

Visual Arts Gallery, New York, N.Y. *Group Exhibition,* February 16–March 5, 1989. Artists included: Michael Barberian, Frank Finizio, Chris Orlow, and Douglas Wada.

Sigmund Freud Museum, Vienna. *Der Sigmund Freud Gesellschaft,* September 23–October 18, 1989. Artists included: John Baldessari, Pierpaolo Calzolari, Georg Herold, Jenny Holzer, Ilya Kabakov, and Franz West.

Wiener Secession, Vienna. *Das Spiel des Unsagbaren: Ludwig Wittgenstein und die Kunst des 20. Jahrhunderts,* September 13–October 29, 1989. Artists included: Carl Andre, Giovanni Anselmo, Terry Atkinson/Michael Baldwin, John Baldessari, Giacomo Balla, Robert Barry, Guillaume Bijl, Stig Brøgger, Marcel Broodthaers, Stanley Brouwn, Daniel Buren, Werner Büttner, Andre Cadere, Sarah Charlesworth, Michael Clegg and Martin Guttmann, Hanne Darboven, Braco Dimitrijević, Gino de Dominicis, Marcel Duchamp, Dan Flavin, Günther Förg, Robert Gober, Dan Graham, Peter Halley, Jenny Holzer, Jasper Johns, Ronald Jones, Donald Judd, Ilya Kabakov, On Kawara, Ellsworth Kelly, Imi Knoebel, Joseph Kosuth, Friedl Kubelka-Bondy, Bertrand Lavier, Louise Lawler, Sherrie Levine, Sol LeWitt, El Lissitzky, Thomas Locher, Ken Lum, René Magritte, Kazimir Malevich, Piero Manzoni, Alan McCollum, Robert Morris, Reinhard Mucha,

Bruce Nauman, Claes Oldenburg, Blinky Palermo, Hirsch Perlman, Francis Picabia, Michelangelo Pistoletto, Richard Prince, Robert Rauschenberg, Man Ray, Gerhard Richter, Cindy Sherman, Robert Smithson, Wolfgang Staehle, Haim Steinbach, Frank Stella, Cy Twombly, Jan Vercruysse, Franz Erhard Walther, Andy Warhol, Peter Weibel, Franz West, Christopher D. Williams, and Heimo Zobernig.

Palais des Beaux-Arts, Brussels. *Das Spiel des Unsagbaren: Ludwig Wittgenstein und die Kunst des 20. Jahrhunderts,* December 17 1989–January 28, 1990. Artists included: those listed above, plus Barbara Bloom, Giorgio de Chirico, Jan van Oost, Ad Reinhardt, Jeff Wall, and Michel Zumpf.

INDEX